ASIA

FAR
EAST

JAPAN

NORTH
AMERICA

HAWAII

Pacific Ocean

Ocean

AUSTRALIA

NEW ZEALAND

Ray Manley's World Travels

Dedicated to Herbert and Eleanor Ullmann

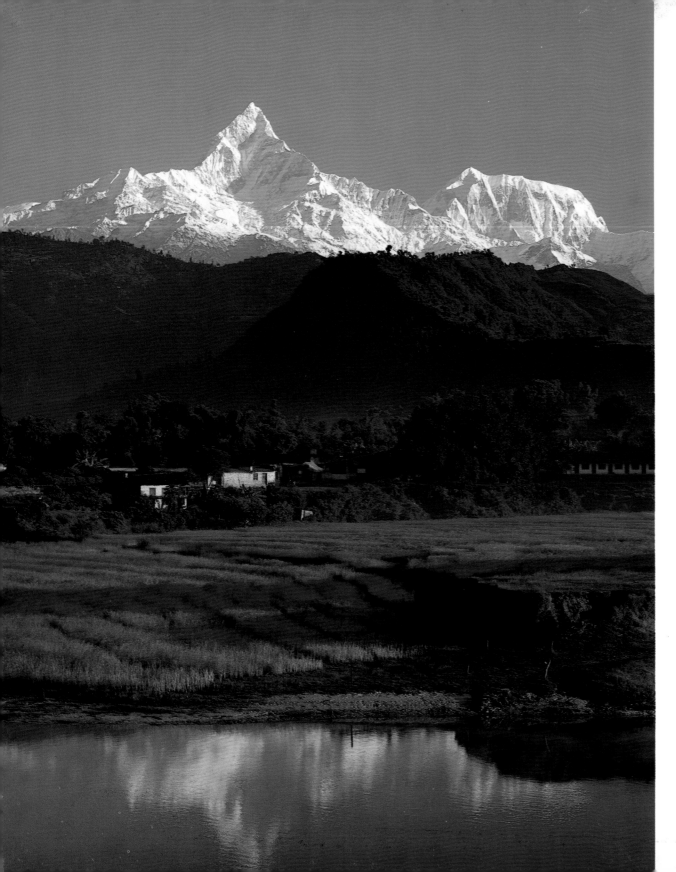

Acknowledgments

Special thanks to: Mr. Lawrence B. Fisher, director of advertising, Stearns-Roger Corporation, whose industrial assignments since 1955 have been the nucleus of many of the Manleys' foreign travels.

Walter and Robert Shostal, New York City
George Hall Travel Agency
My partners, Naurice Koonce, Mickey Prim and Alan Manley

Lithographed by Shandling Lithographing Co. Inc.
Separations by American Color Corporation
Binding by Roswell Bookbinders
Typography by Tucson Typographic Service, Inc.
Designed by Stanley G. Fabe

All photographs are from the files of the SHOSTAL agency, New York City

All photographs were made with a 5x7 Linhof camera and 120 mm, 180 mm, 210 mm, and 360 mm Schneider lenses, using Ektachrome sheet film.

Printed in U.S.A.
Library of Congress Catalog Card Number: 78-53785
ISBN: 0-931418-01-1

Fishtail, Pokhara, Nepal
PHOTOGRAPHY DATA:
Left, early morning, long lens.

Zamboanga, Philippine
PHOTOGRAPHY DATA:
Right, Afternoon, normal lens.

Ray Manley's World Travels

Photography by Ray Manley

Text by Ruth Manley

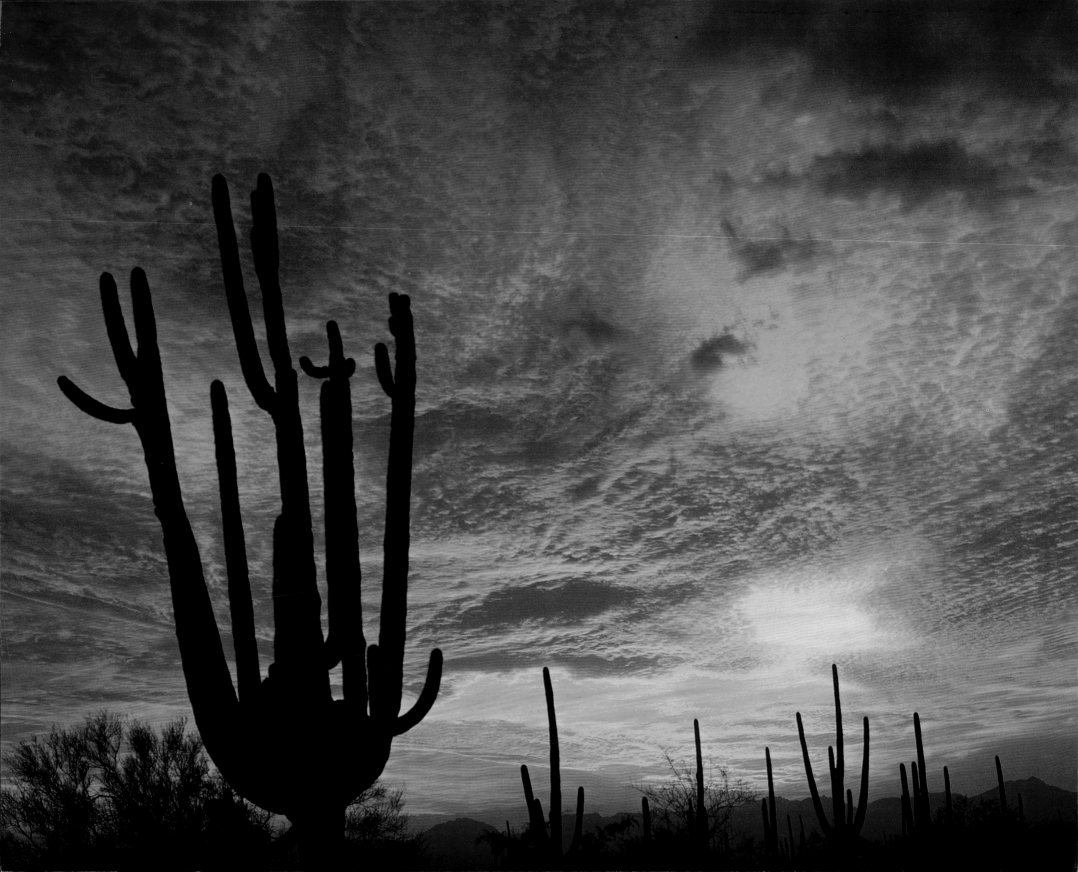

World Travels / Contents

Arizona Sunset
PHOTOGRAPHY DATA:
Sunset, normal lens.

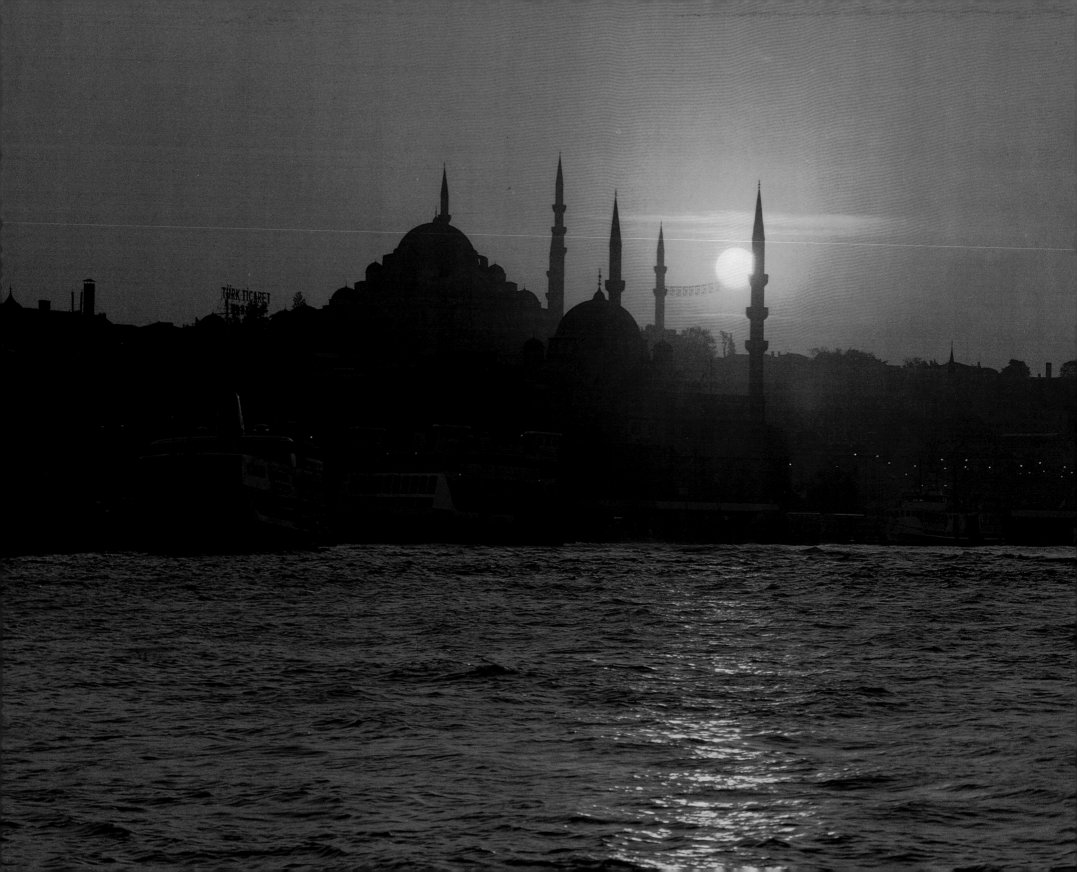

Preface

Ray Manley's WORLD TRAVELS is a world tour through pictures. Hundreds of thousands of words could be written about the joys and the frustrations of travel. But people travel to *see* places—natural wonders as well as those built by man, ancient and contemporary. Colorful people add interest to a country but are not the primary reason for travel. Dancing girls, swaying palms, and costumed natives are often a substitute for the lack of scenic and architectural treasures of the world.

Our travels for photographic purposes have taken us around the world five times and to South America three times, with additional trips to Europe, New Zealand, and the South Pacific. Each previous circle trip was made from east to west in order to be in Japan for the spring cherry blossom festival and on to Bangkok and India before the monsoon season. Our last tour was made in reverse, so we could photograph Europe during the spring and summer, proceeding on to the warmer countries during the early fall, and to India, Burma, and Thailand after the

monsoon season. This proved to be the most successful direction—we had almost continuous sunshine throughout Asia and North Africa. Asian weather is more predictable since most areas have a wet and a dry season. After the monsoons the skies are clearer, the grass greener, and, even more important, the temperatures have dropped considerably.

The greatest drawback was the length of time involved in order to take advantage of all these weather conditions in one trip. We worked 162 consecutive days and saw not one familiar face.

We had previously photographed many of our subjects up to five times. New stimuli were needed and we chose a number of areas off the beaten path to visit. It will be these places which will be described in greater detail.

After seeing twenty museums or temples or cathedrals, people yearn for variety. For this reason, many of the unusual places we visited are included, in addition to the usual tour spots. It is our belief that never before has such a number and variety of places been assembled in one book.

Even with jet flight, this world is still a big one and takes much time to traverse. If one is realistic, he knows a trip around the world cannot always be on a magic carpet (not with security checks, customs and baggage handling delays), yet a trip well planned is worth all frustrating moments.

We hope our pictorial presentation is an inspiration to a well-planned tour or at least provides an armchair journey to many of the photogenic places in the world.

Istanbul

LEFT: The minarets of Süleymaniye Mosque lend their distintive silhouette to an evening view of historic Istanbul.

PHOTOGRAPHY DATA: Sundown, long lens.

There are two phrases that have proven meaningful in my lifetime as a photographer. First, a photographer must ''go back'' time after time. One rarely is fortunate to arrive at any of the scenic wonders of the world at *the* best time. Good planning can improve the odds, but often study of a subject is required: best angle, time of day, time of year, plus obstacles such as scaffolding, haze, automobiles, wires, country fairs in front of a cathedral, and birds. The second phrase is part of a well-known song—''those faraway places with strange-sounding names.'' This phrase has haunted me for many years and I often catch myself humming the tune.

Shwe Degon Pagoda in Rangoon, Burma, has been one of those ''faraway places with strange-sounding names'' and it has drawn me to one of the lesser visited areas of the world. My first visit was in 1961 during April when it was very hot but before the monsoon rains. This 326-foot gold-covered temple was everything I had expected—and more. The top is covered with sheets of solid gold and 5,000 precious stones (rubies, diamonds, and sapphires), each larger than a lady's fingernail. The lower portion is covered with gold leaf applied inch by inch by its faithful worshippers. During a 1972 earthquake it suffered considerable damage; during our 1973 visit repairs were underway. We were very disappointed but impressed by the 330 feet of bamboo scaffolding. Our November 1977 visit was a joy difficult to express. The scaffolding had just been removed and the final days of an important festival were being celebrated. Worshippers of all ages were preparing gifts of food, lighting thousands of candles, and sweeping the acres of marble floors. We were so impressed that we returned on five separate occasions during our six-day visit in Burma. It was truly a highlight of our trip. The monsoons had not quite left the area and our first four days were frustrating as we waited for the heavy rains to cease. On the fourth afternoon the skies turned a brilliant blue with the thunderheads receding on the southern horizon. I exposed my allotted film, and more, but it was well worth it. As a side comment, the present accommodations in Rangoon are best at a Russian-designed hotel a few miles into the country. Our guide ''Daisy'' provided us with a great deal of insight into the lives of these very pleasant people.

Since 1958—our first coverage of Europe—we've experienced about all the hazards one could list, yet the rewards of the ''good'' days are worthwhile, and by ''going back'' we've eventually been successful in photographing nearly every subject on our long list. One subject that has eluded our camera is Mount Fuji only a few miles from Tokyo. Four three-week trips to Japan have been quite productive, but never has this famous mountain shown itself to me in its true beauty. I've mentioned scaffolding and other hazards that mar a photographer's subject; among them are swallows and pigeons. How can a hundred black spots in the sky area of a photograph be explained? In Wengen, Switzerland, while waiting for better lighting on the Jungfrau, local farmers completely ruined my foreground by dismantling the hay drying racks. Trucks have pulled up to unload cargo just as the sun came out in a German village. Even more frustrating was a local Thai contractor's two gold-melting furnaces built in front of the Temple of the Emerald Buddha.

It would be hard to believe that the Taj Mahal was my second most elusive subject. Only by ''going back'' a fifth time since 1961 did I find the sky blue, the grass green, the fountains on, no scaffolding, and had in my possession a required permit to use a tripod. We returned for a second day's coverage even though the photography of the first day was satisfying. This time, in no hurry, we looked for additional viewpoints and thoroughly enjoyed the beauty of this masterful wonder of symmetry as well as the color of thousands of saris worn by visitors dressed in their finest on a Friday (a free admittance day).

When you've admired Arizona's Monument Valley, the Temple of Rameses on Lake Nasser, or Iguassu Falls in Brazil, it takes an impressive spectacle to make a great impact on me. Such a spectacle exists—''Fishtail'' as seen from Fishtail Lodge at Pokhara, a few hundred miles west of Kathmandu, Nepal.

Mt. Cook, New Zealand
PHOTOGRAPHY DATA:
Late afternoon, normal lens.

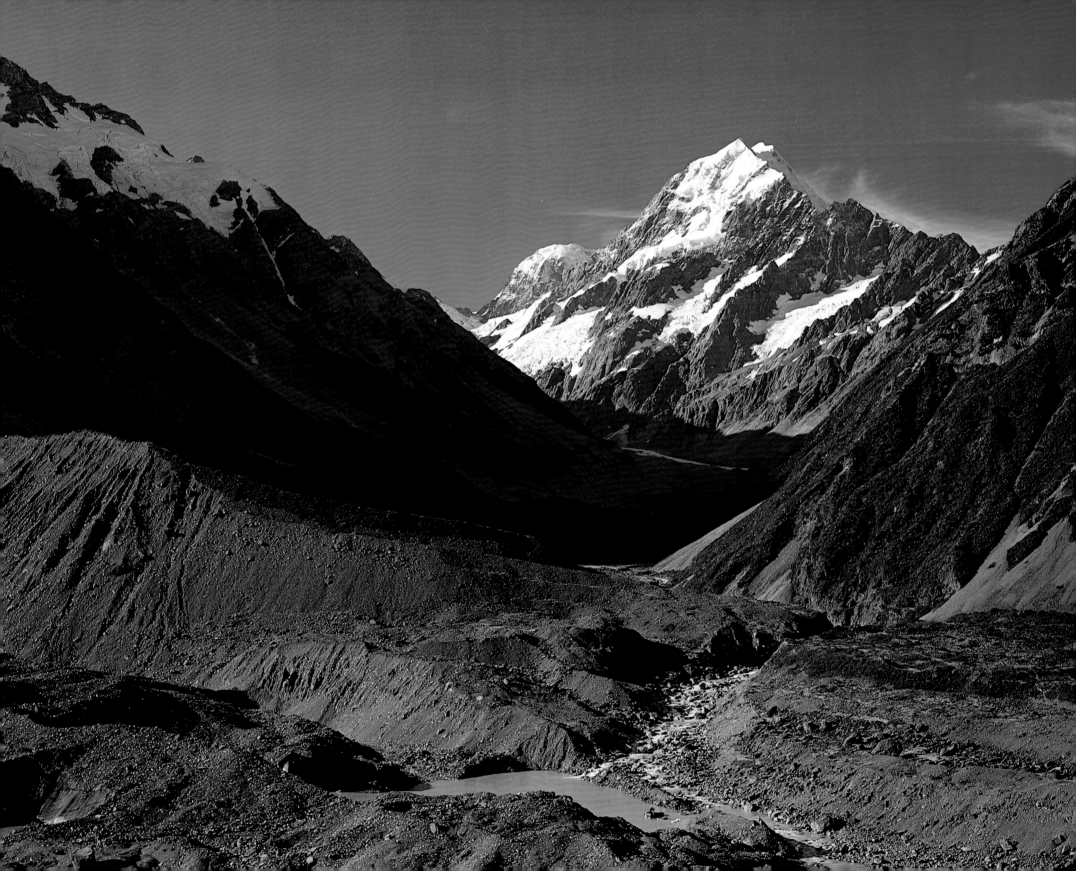

The 23,000-foot horn rises above a small lake in front of the bungalows. Just before sunrise when the sky is clear, you are awakened in time to watch the sun come up. First the sunrise creates a golden image fast turning to yellow and then a dazzling white. This lonely sentinel dominates the northern horizon. It is the one mountain in the world that is as photogenic as Switzerland's Matterhorn, yet twice as high. ''Fishtail'' is part of the Annapurna range of the Himalayas. Perhaps if you are a trekker, you could find a better location from which to see this spectacle, but I was satisfied for once viewing it from my lounge chair in front of my cottage. What a place!

I have often been asked why I continue to photograph such places as the Arch of Triumph, the Coliseum, and London's Big Ben. Each of these places is exciting to a person visiting them for the first time. It is the printed media's need for new pictures that requires change of lighting and viewpoint. For a photographer, it is a perpetual challenge to obtain better and different pictures.

Those who have been travelers know that great repetition of museums, cathedrals, and temples can become tiring, regardless of how impressive they may be. Variety and climactic happenings are essential to continued interest. Others label a number of places as ''tourist traps'' and perhaps the greatest ''trap'' of all might be Venice, Italy. I'll agree only in part, for many places are so popular that some unpleasant happenings are bound to occur, yet this place is filled with masterpieces of art, architecture, and indescribable color and photographic possibilities. If one can have a new objective for a repeat visit, even Venice or Florence can be exciting. Use your travel experience to help you enjoy a repeat visit and to avoid the undesirable. I will admit to having visited Venice eight times—twice during its Regatta Historical —and I have never enjoyed it more than on my last visit. It is quite a challenge to outmaneuver those unionized gondoliers who won't move for under $10.00! Try walking along the canals early in the morning when only you and the pigeons are competing for space.

On each of our extended coverages, we have tried to photograph several out-of-the-way places that have long been a part of that haunting song. Some are far away, and some have strange-sounding names. They add a little more to my feeling for adventure. One such place is Angel Falls, some 800 miles south of Caracas, Venezuela, discovered by Jimmy Angel, also from Tucson, Arizona. Although this trip is somewhat easier now, it was an expedition in 1969. From our guide's home near Canaima camp, we traveled fifty miles upriver in a dugout canoe accompanied by three local Indians. Rudy Truffino, our ''Dutchman'' guide, took us past great waterfalls, abandoned diamond mines, numerous rapids, and magnificent tropical forests to his base camp at the foot of the world's highest waterfall. At sunrise on the third morning we were anxious to photograph the falls, but the clouds were hiding our elusive subject. We were determined to wait it out and had allowed seven days for the trip. At about 10:00 on that third morning the clouds parted and the sight before us was unbelievable. From a mesa (a flat-topped mountain) 5,000 feet above us came a ribbon of water falling into a mist for 3,212 feet. It was partially hidden by a horizontal cloud and the falls appeared to pass through it on their way to the moss-covered rocks below. Water cascaded another 1500 feet to the stream at our feet. I made about thirty exposures in a matter of a few minutes as the clouds closed in like a curtain and our moment of ecstacy was over. Yet, the exhilerating feeling of having seen and photographed this elusive wonder lingers in my memory after many years as the greatest thrill in my photographic career. I have refused to even consider ''going back' again, for it would be impossible to even imagine that it could impress me as it did that first time. This was one of the few times I hit it right the first visit and didn't have to go back.

A ''strange-sounding name'' is Zamboanga. This village of beautiful flowers lies at the southern tip of Mindanao, one of the thousands of Philippine islands. Having been away from home for many months, we were tempted to end our trip. While in Bangkok, a newspaper ad announced Pan Am's newly scheduled non-stop flight to California and we really wanted to get aboard. Even though we were anxious to get home, Ruth felt that I would always regret giving up on Zamboanga, as I had

wished for some time to photograph the colorful sailboats (called vintas) and the Muslim houses built on stilts. We stayed with our scheduled plans and were rewarded with superb picture subjects: colorful sunsets and clouds that seemed to explode as they rose higher and higher. Malaysian settlers have lived here for hundreds of years, fishing and gathering shells which are exported throughout the world.

Our last destination was a five-day visit to Hong Kong. I had begun our assignment with 1,450 sheets of color film and had but 13 left. Needless to say, I looked for some time before exposing any of this precious film, for it could not be purchased anywhere along the way. On the fifth evening, I stood on the roof of a 27-story apartment building overlooking the typhoon shelter a few miles east of downtown Hong Kong. I had planned a double exposure, a technique where one exposure records the sky and a silouhette of the peak and buildings; a second exposure after total darkness would record the streaks of car lights and the ferry boats crossing the great harbor, and of course, the many lighted buildings. Down to four sheets of film, I made the first exposure of a mediocre sky but it kept improving as clouds from a typhoon front moved westward. Within twenty minutes these clouds were turning yellow, then orange, and finally into a pretty good sunset. It was on this last stage that I exposed my last sheet of film. Within two hours it was totally dark and my exposure for the foreground lights was made. I could do no more, for all my film had been exposed.

A feeling of relief came over me as I sat there in the darkness. It had been a long trip and Ruth and I had worked every day since our arrival in Ireland over five months previously. I felt that this was a fitting end to a long, hard battle. Yes, it is a constant fight to keep up enthusiasm and when people express their envy of our long so-called vacations, we can only smile and agree that it is an interesting way to earn a living. It really is sunrise-to-sunset work day after day. If it is cloudy, you are looking for subjects that will be good when the sun shines; and when the sun does shine, you're making the most of it.

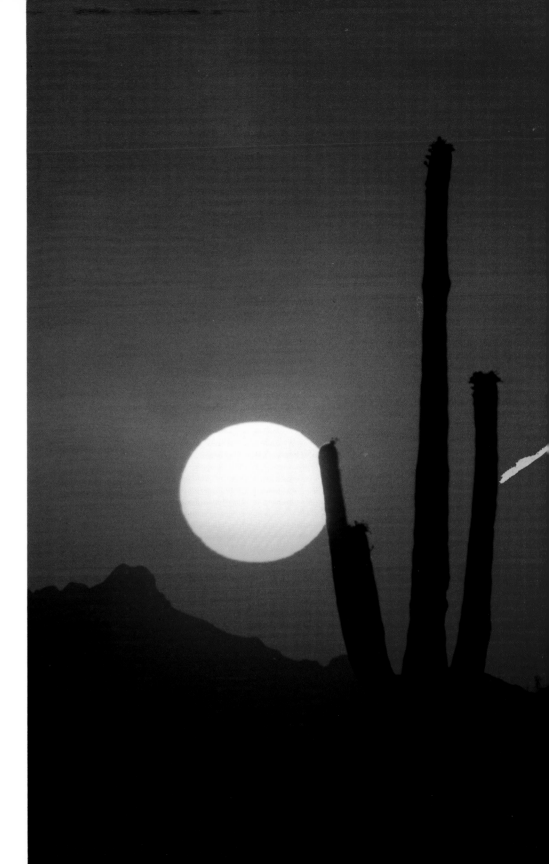

Sunset Over Tucson Mountains, Alan Manley

PHOTOGRAPHY DATA: Sundown, 1000 mm lens.

PHOTO INFORMATION

It would be inappropriate to attempt to present specific technical information for each photograph. It should be helpful, however, to inform the traveler of the time of day each photograph was taken as an aid in determining a good exposure. All photographs were made with daylight Ektachrome film with an A.S.A. speed of 64. Four Schneider lenses, from 120 mm (wide angle), 180 mm (medium), 210 mm (medium), to 360 mm (long) were used.

The camera used was a 5 × 7 Linhof Technica. Haze, polaroid, and orange-red filters were used. For those using 35 mm cameras, the 28 mm, 55 mm, and 135 mm lens would approximate those used.

Today's photography is more involved than during past journeys. Security inspections at airports should not be taken lightly. Even though many X-ray machines claim safety for film, several exposures can cause film fogging. Others are not safe at all. Insist upon a physical inspection for your film. Make it simple by keeping all your film with you in one bag. Some inspectors may try to force you to put your camera and film bag through the X-ray machine, but hold your ground. There is no country that forces this type of inspection.

Keep your film as cool as possible and have it processed soon after exposure. If your trip lasts no longer than thirty days, bring your film home with you—although it would be wise to process a roll along the way as a check on your procedures. Buy all the film you expect to use at least a month prior to your trip. Expose a roll and have it processed. Many people have been disappointed with totally blank or badly exposed film that could have been saved with a pre-trip checkup.

The Rock of Cashel, Ireland

RIGHT: On a grassy hill above the town of Cashel stand the ruins of a 10th-century round tower and the 13th-century Cathedral of St. Patrick. An 18th-century archbishop, it is said, used his perogative to "borrow" the Cathedral's lead roofing for the construction of his own palace.

PHOTOGRAPHY DATA: Morning, sporadic sunlight, normal lens. This lighting situation is difficult to meter. Bracketing exposure is essential.

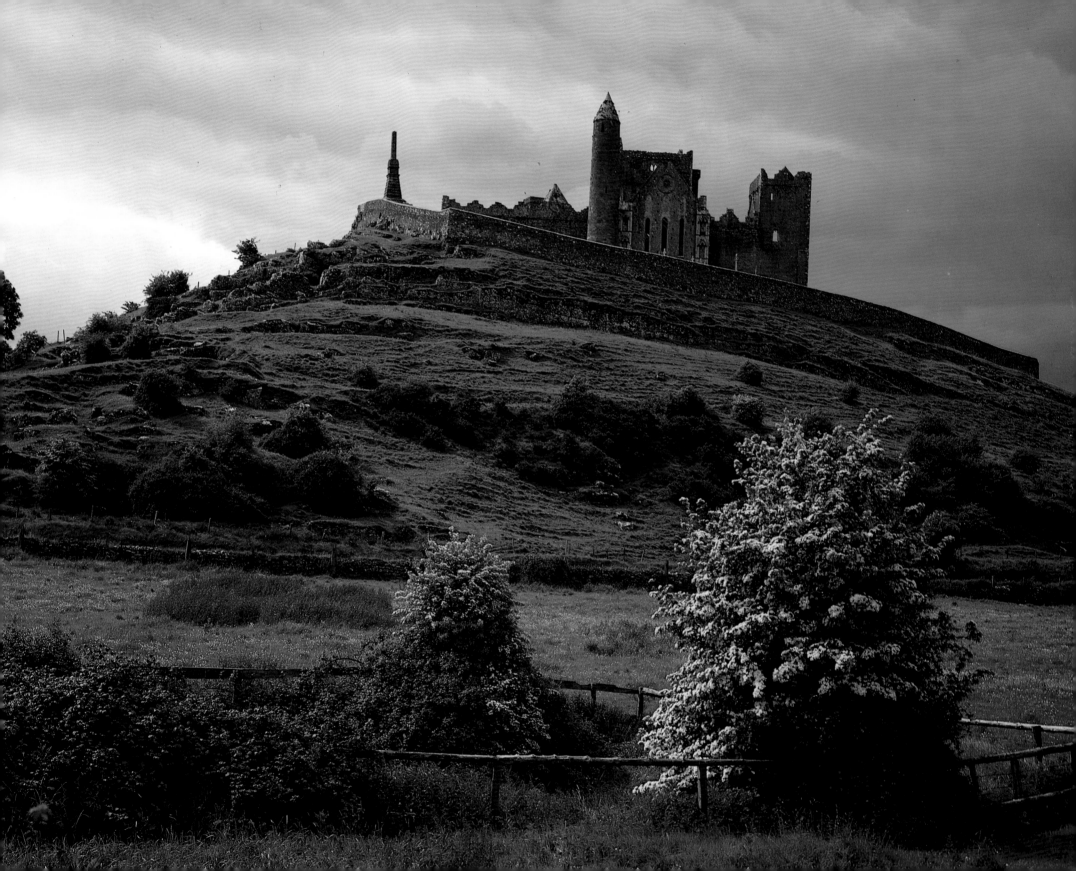

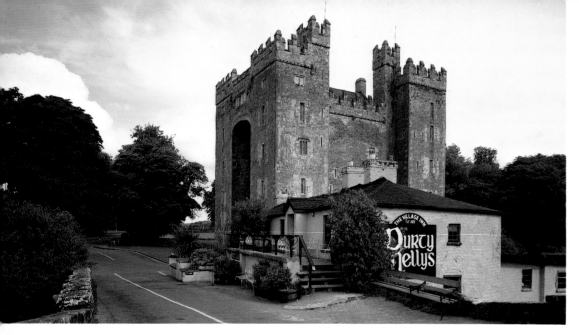

Bunratty Castle, Ireland

ABOVE: Ireland has an abundance of castles in varying sizes and conditions — some in ruins and some restored to almost original state.

Overlooking the Shannon River stands the 15th-century fortress, Bunratty Castle. It is believed that William Penn, the Founder of Pennsylvania, lived in this castle for a short time while still an infant.

An added dividend to your visit here may be a medieval banquet and musical entertainment by costumed colleens. "Durty Nellies," the famous and ancient pub next door to Bunratty is a favored stopover both before and after the banquet.

PHOTOGRAPHY DATA: Morning, wide-angle lens.

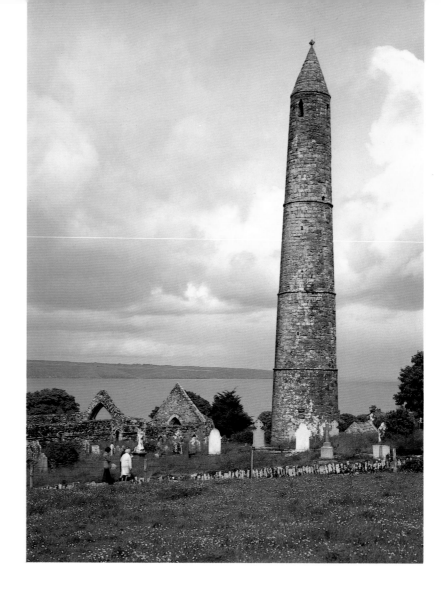

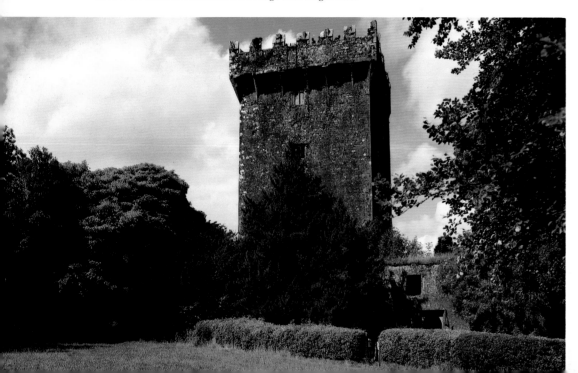

Blarney Castle, Ireland

LEFT: Our common expression, "It's just blarney," is said to be the result of Lord Blarney's annoying habit — failure to keep his promises. "Blarney, Blarney," said Queen Elizabeth in disgust. "He never means what he says."

Kiss the Blarney Stone, according to legend, and be forever endowed with the gift of eloquence. But to go through the contortions required to kiss the stone is difficult since the Blarney Stone is set in a parapet on top of the old castle ruins.

PHOTOGRAPHY DATA: Afternoon light, normal lens.

Ardmore Castle, Ireland

LEFT: Ardmore Castle's tall watchtower is in excellent condition compared to most towers of this era, which have been wholly or partially destroyed during enemey attacks. Portions of the castle date from the 12th century although it wasn't fully completed until 1602.

PHOTOGRAPHY DATA: Morning light, normal lens.

Monasterboice, Ireland

RIGHT: Monasterboice was a monastery founded by St. Buite, who died in 521 A.D.; however, no building from that date survives. The belfry tower of stone and the Celtic crosses date from the 10th century. Monasterboice is best known for its three Celtic carved stone crosses — the finest is the large Cross of Muiredach.

PHOTOGRAPHY DATA: Afternoon light, wide-angle lens.

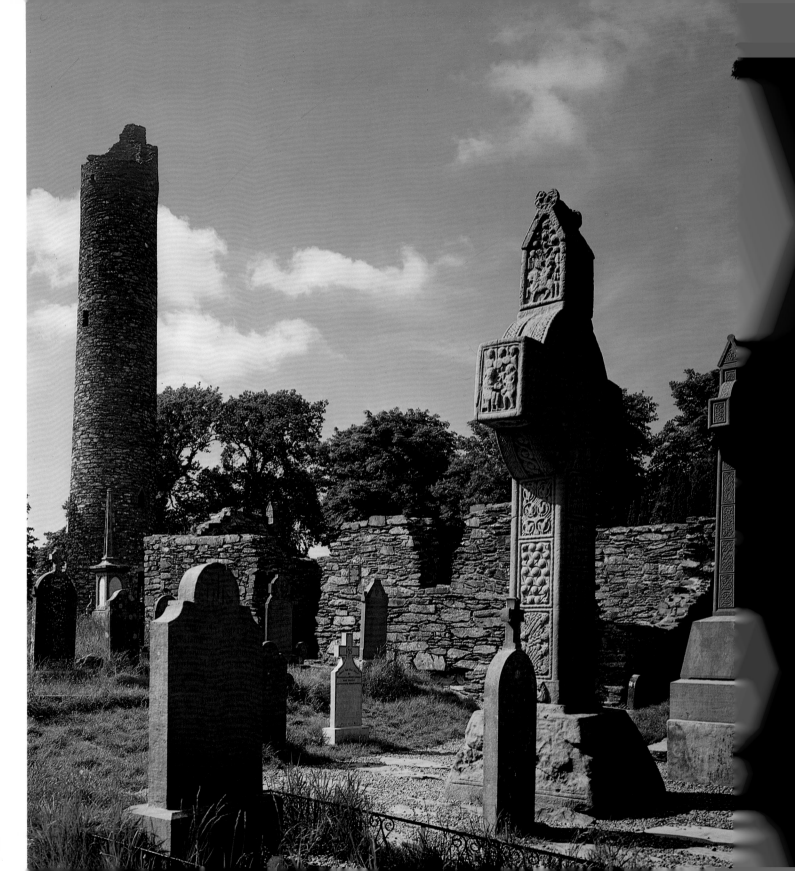

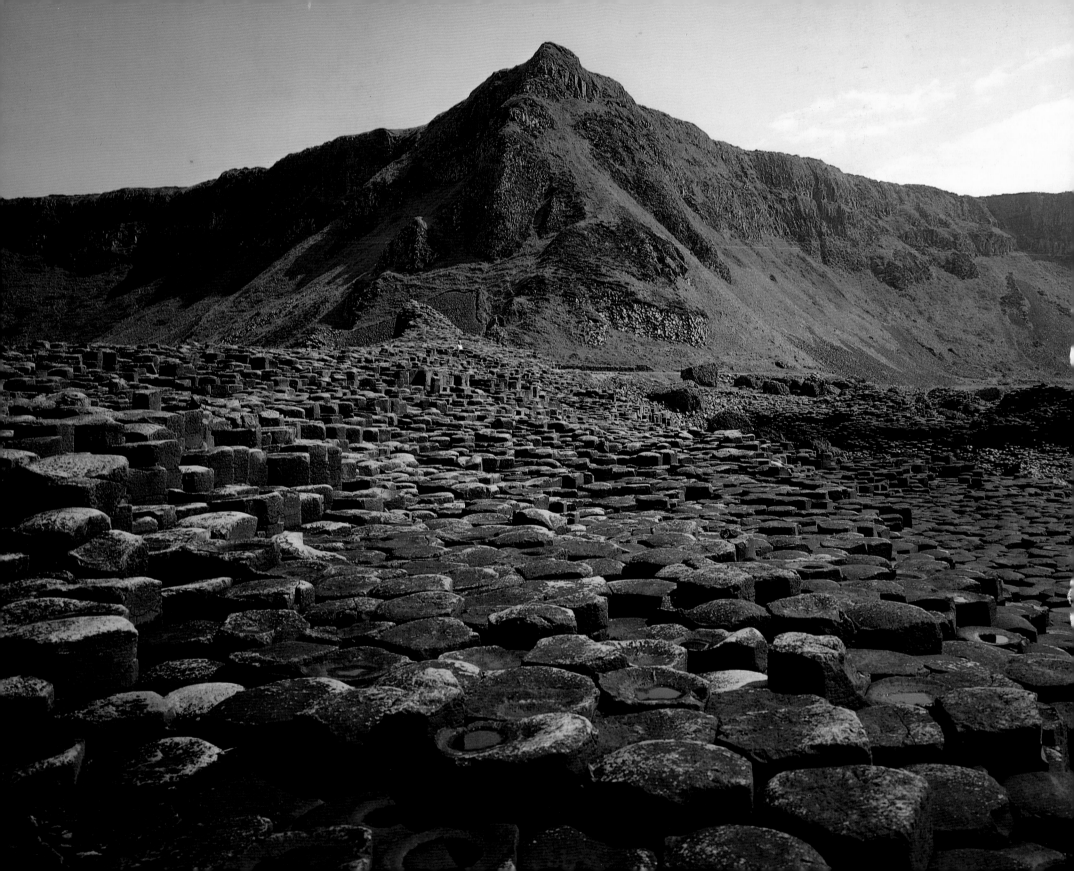

The Giant's Causeway, Northern Ireland

LEFT AND BELOW: It's easy to understand the belief in the legend that the Giant's Causeway was a road on which giants could travel across to Scotland. Its basalt pillars or stepping stones are so closely identical in size and shape that it would seem that no accident of nature could have fashioned them. Volcanic action is believed to have formed them; a molten lava flow cooling and contracting into pillars shaped this unique stone pavement. The Giant's Causeway is located near the town of Coleraine in Antrim County on the coast of Northern Ireland.

PHOTOGRAPHY DATA: Midday, normal lens.

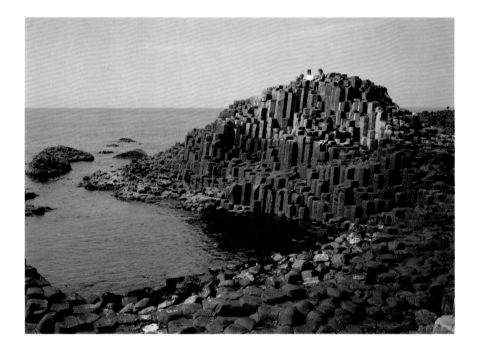

Sea Coast, Northern Ireland

RIGHT: This unique portion of the sea coast is encountered near Dunluce Castle and not far from the Giant's Causeway. The lush green countryside, the white cliffs with the ocean incessantly lashing against them, and the wind whipping up white caps on the waves are exhilarating.

PHOTOGRAPHY DATA: Late morning, normal lens, haze filter. Gusty breezes could easily knock over your tripod.

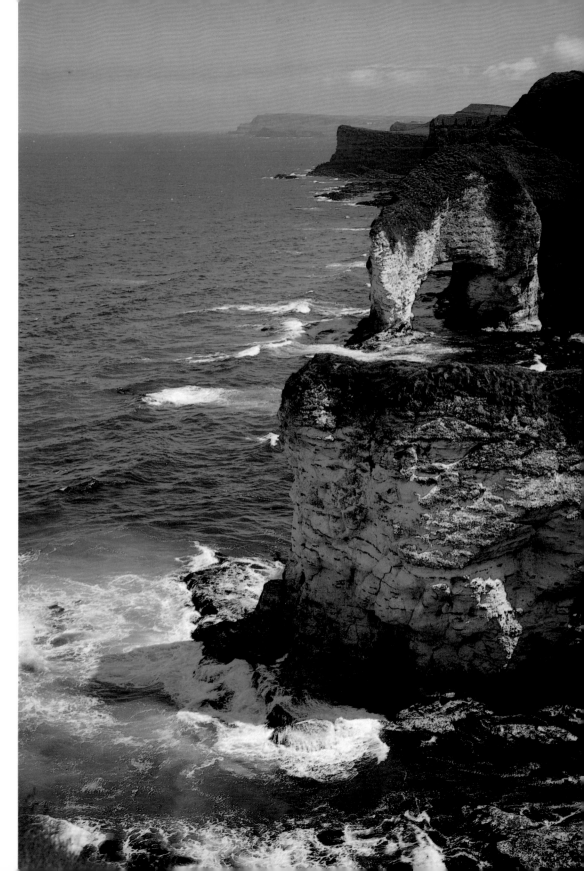

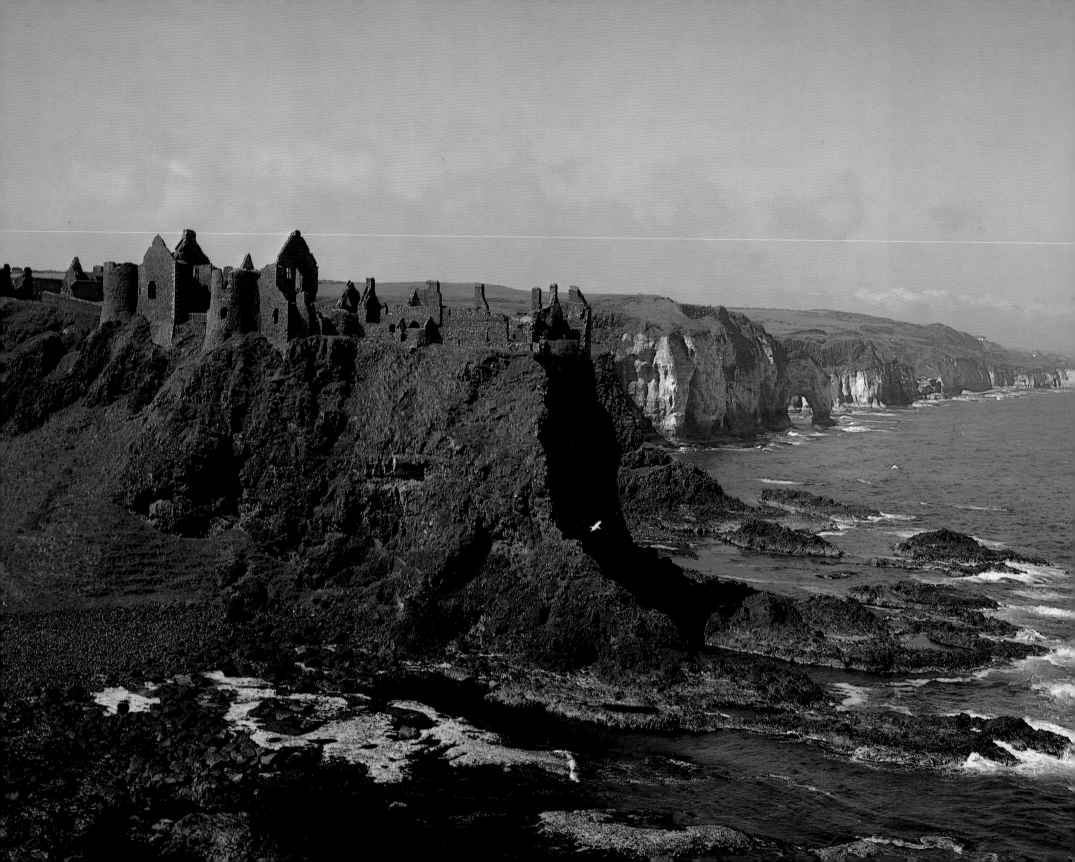

Dunluce Castle, Northern Ireland

LEFT: On a rocky cliff near the town of Portrush, are found the ruins of a medieval fortress, Dunluce Castle. In 1588 a Spanish Armada ship, with 1,300 men aboard, foundered on the rocks in a violent storm off the coast near here. Five men, who were the only survivors, found sanctuary in Dunluce Castle. Some of the treasure from the wreck is said to have been salvaged by the Lord of Dunluce.

PHOTOGRAPHY DATA: Early morning, normal lens. The fog lifted about 9:30.

Harlech Castle, Wales

RIGHT: Harlech Castle was built by the labor of 1,000 men during the 13th century. The ocean used to reach the base of the cliff on which it is perched and gave the castle protection from that direction. Harlech was the last stronghold to submit to the British in 1647. Its gallant defense inspired the words of the famous ballad ''The March of the Men of Harlech,'' now a national song of Wales.

PHOTOGRAPHY DATA: Morning light, wide-angle lens.

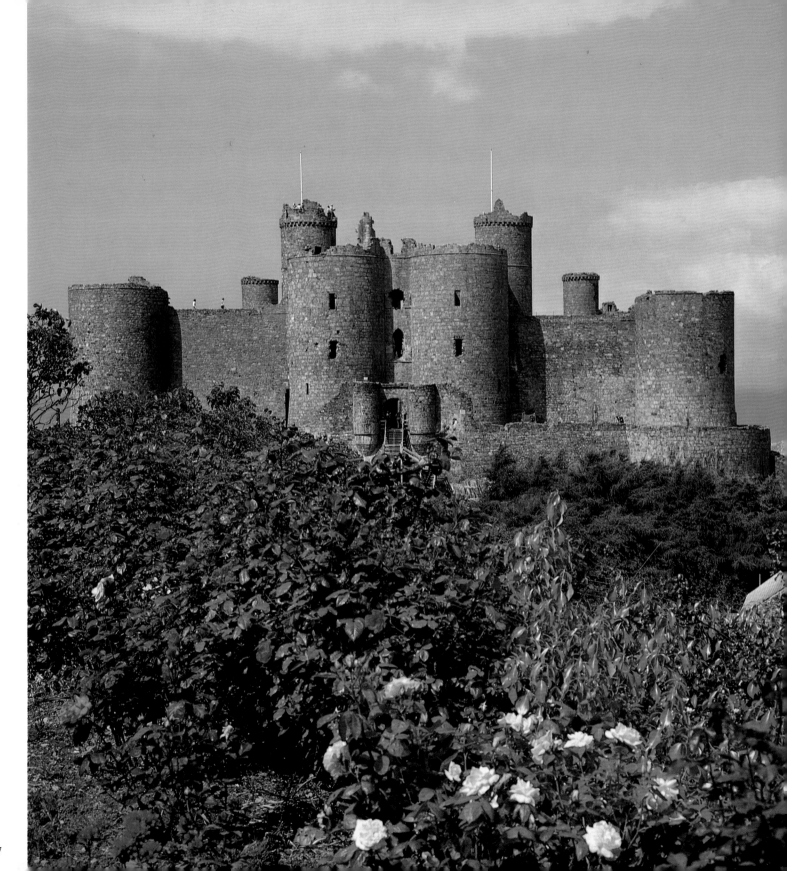

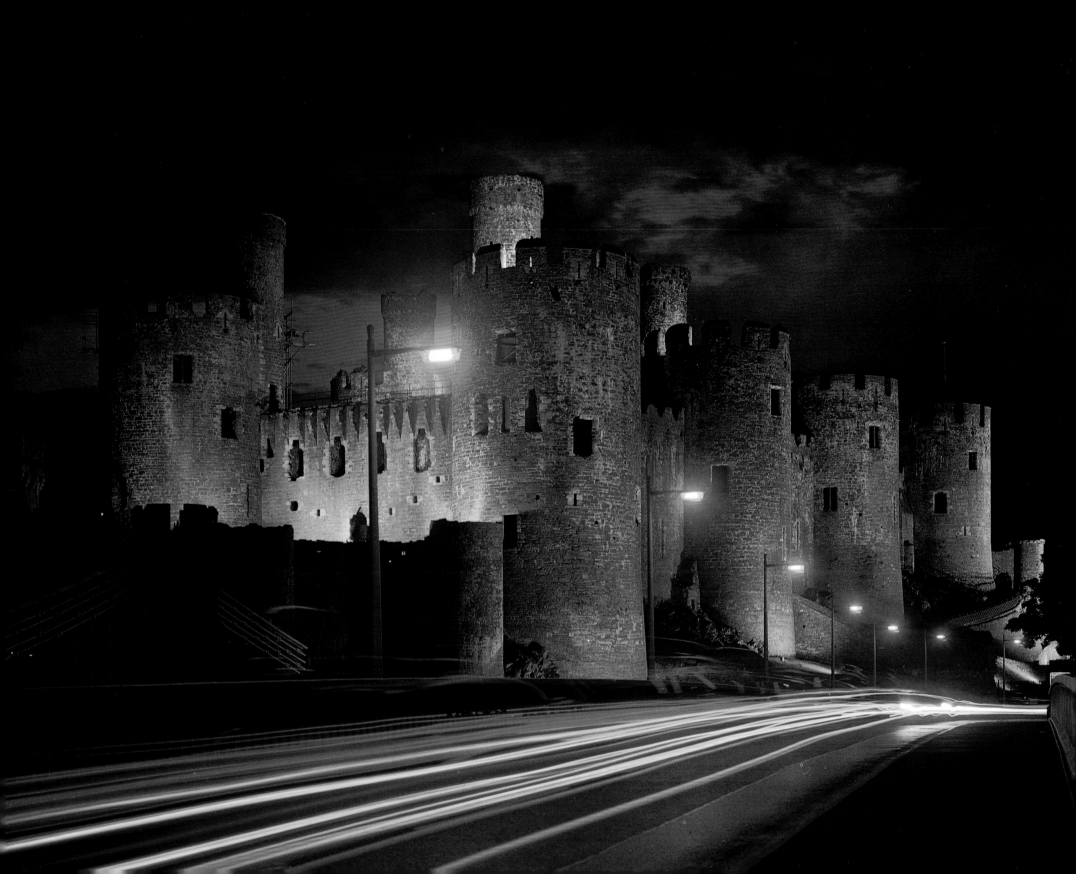

Conway Castle, Wales

LEFT: Thomas Telford designed the early suspension bridge used to reach Conway Castle. Built in 1826, it is considered a classic of that period. The 13th-century castle has substantial walls and great towers and is found in the seaside resort town of Conway in north Wales.

PHOTOGRAPHY DATA: Night, wide-angle lens, time exposure.

Caernavon Castle, Wales

BELOW: Construction of Caernavon Castle was begun in the year 1285 by Edward I and was completed 37 years later. The castle walls surrounding the town are almost intact.

English rule was established in Wales in 1285 by Edward I after the overthrow of the Welsh monarchy. Edward II, who was born in Caernavon Castle, was proclaimed the first Prince of Wales. To this day the eldest son of England's monarch inherits the title of Prince of Wales.

PHOTOGRAPHY DATA: Morning light, normal lens. A greater choice of camera locations is available at low tide.

Llanbedr, Wales

UPPER RIGHT: While driving in Wales from Harlech to Bangor, in the village of Llanbedr we caught sight of this enchanting rose-covered Victoria Hotel with the date 1642 on it. Queen Victoria's name must have been a later addition, since she was crowned Queen in 1837. The gas pump on the corner brings an incongruous modern touch to this ancient setting.

PHOTOGRAPHY DATA: Midmorning, wide-angle lens.

Penrhyn Castle, Bangor, Wales

LOWER RIGHT: Originally an 8th-century castle, the present structure was rebuilt on the same site in 1840. Huge ancient oak trees and spacious grassy lawns surround the manor.

PHOTOGRAPHY DATA: Midday, normal angle lens.

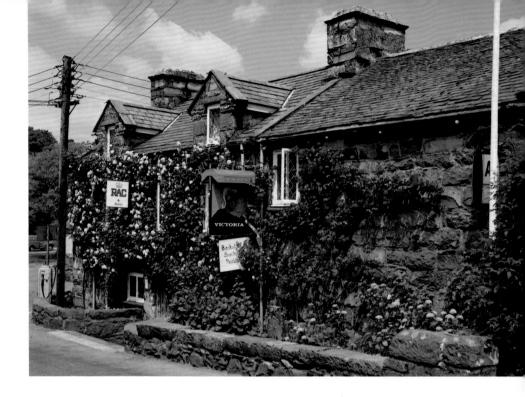

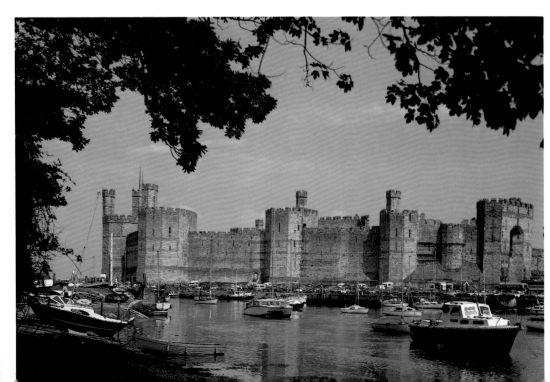

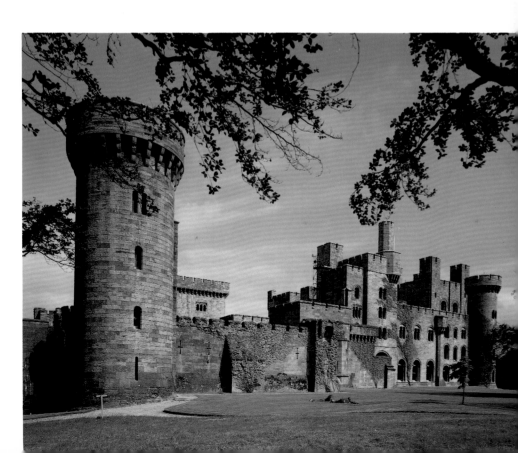

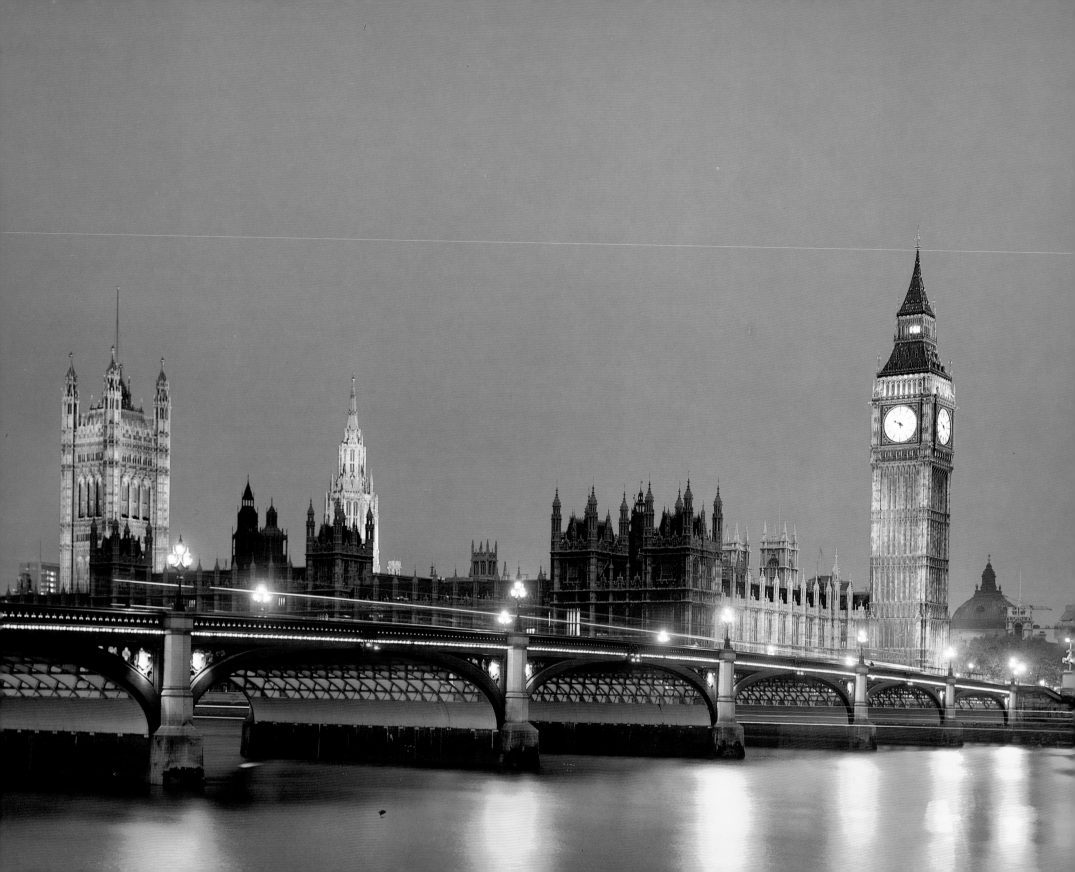

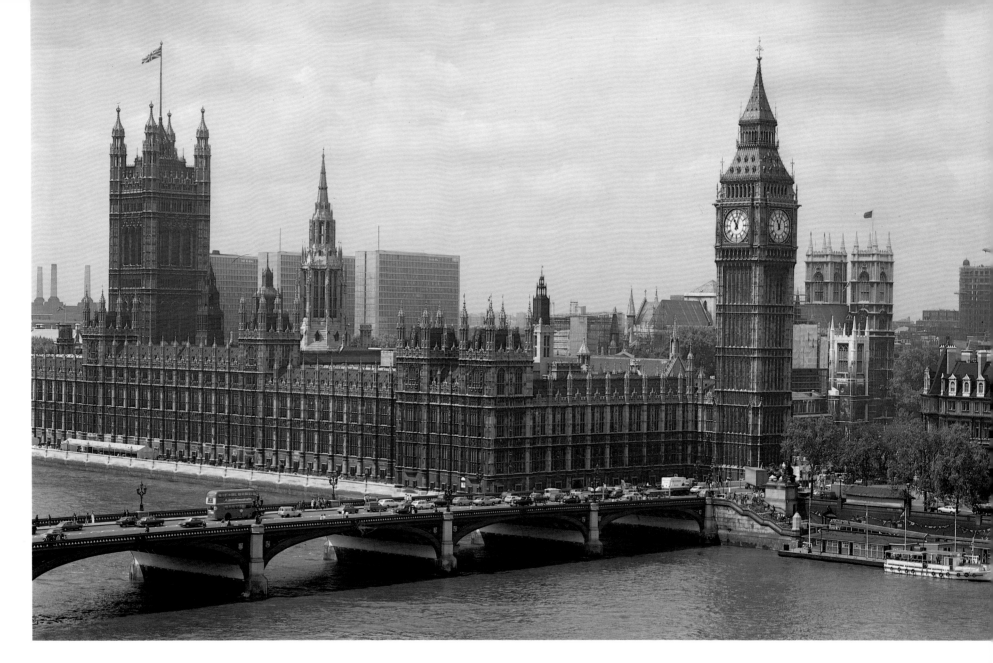

Houses of Parliament (Westminster Palace) London, England

By the River Thames stands Great Britain's majestic seat of government, the House of Parliament. Designed by Sir Thomas Barry and built between 1836 and 1860, it is a well-recognized landmark on the London skyline. The clock tower, familiarly know as Big Ben, has been a beacon for Greenwich mean time for over a century. London's night lights bring an eerie and breathtaking appearance to the Houses of Parliament and Westminster Bridge.

PHOTOGRAPHY DATA: LEFT: Dusk, normal lens. This is a double exposure. Note: the film buckled on one end during the two-hour delay between exposures.

ABOVE: Late morning, long lens. Taken from roof of county hall.

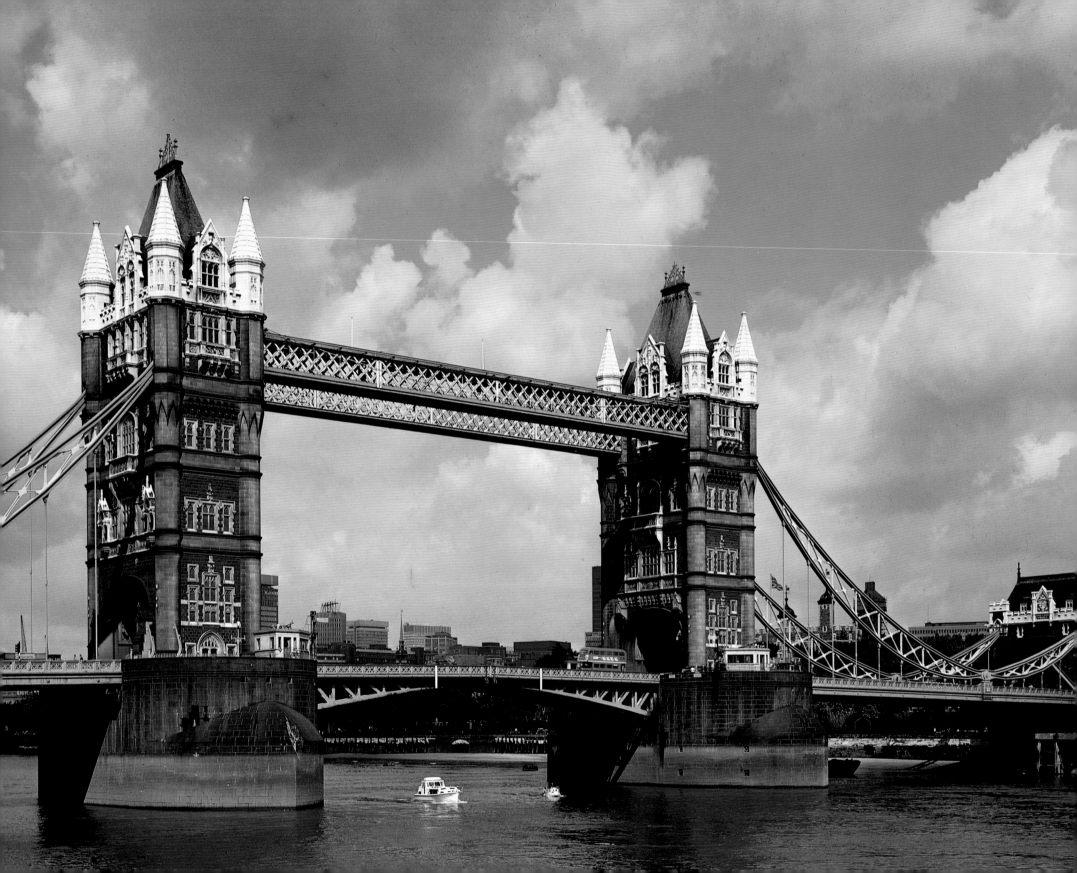

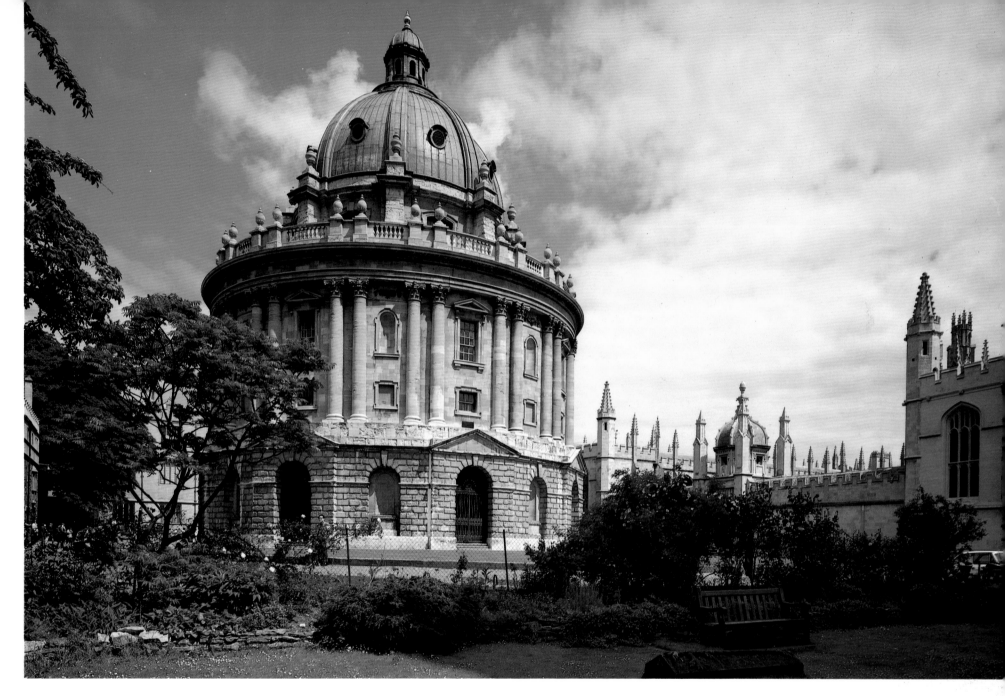

Tower Bridge, London, England

LEFT: At high tide when traffic on the River Thames is heaviest, it's possible to see the center section of Tower Bridge separate and each section fold back against its tower to allow passage of large ships. The high Gothic towers were designed to blend with that stern old fortress, the Tower of London, adjacent to it.

PHOTOGRAPHY DATA: Morning light, normal lens.

Radcliffe Camera, Oxford, England

ABOVE: Oxford University has been an educational center since its establishment during the 12th century. One of its famous buildings is the Radcliffe Camera (library), erected in 1737. The city of Oxford, on the Thames river, is only 50 miles from London.

PHOTOGRAPHY DATA: Midmorning light, wide-angle lens.

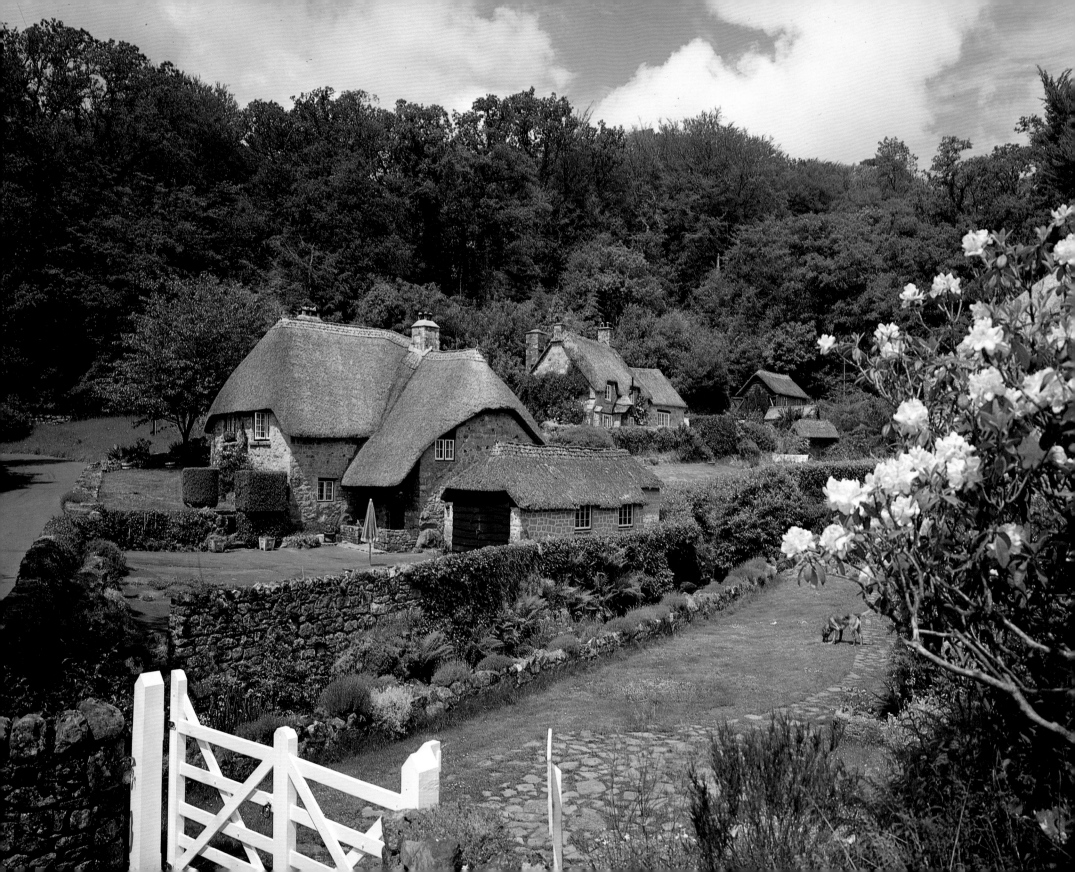

Buckland-in-the-Moor, England

LEFT: Of the many thatched-roof cottages to
be seen in England, Buckland-in-the-Moor (in
Devon, not far from Plymouth) is a rare gem. It
is an enchanting spot to see and to photograph—
a beautiful part of the English countryside.

*PHOTOGRAPHY DATA: Early afternoon,
intermittent sunlight, wide-angle lens.*

Salisbury Cathedral, England

RIGHT: Salisbury Cathedral is a magnificent example of
Early English Gothic architecture and the only one in
England constructed in one uninterrupted building phase;
only the lofty spire was added later. Other English
cathedrals were created piecemeal and often exhibit many
periods and styles.

Cathedrals were usually erected in the center of the
towns and were surrounded by other buildings, but
Salisbury was built at the edge of town. Standing in the
midst of a grassy park, there is sufficient expanse to
photograph the entire cathedral from its foundations to the
tip of its 404-foot high spire.

*PHOTOGRAPHY DATA: Near sunset, normal lens.
Direct sun reflection on the stained glass windows warms
the gray cathedral.*

15

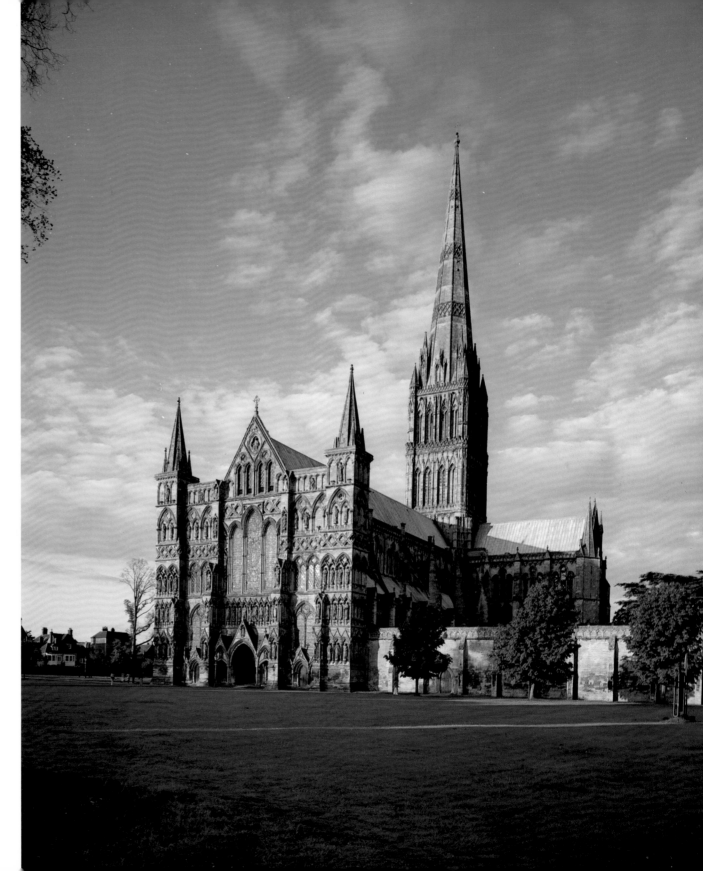

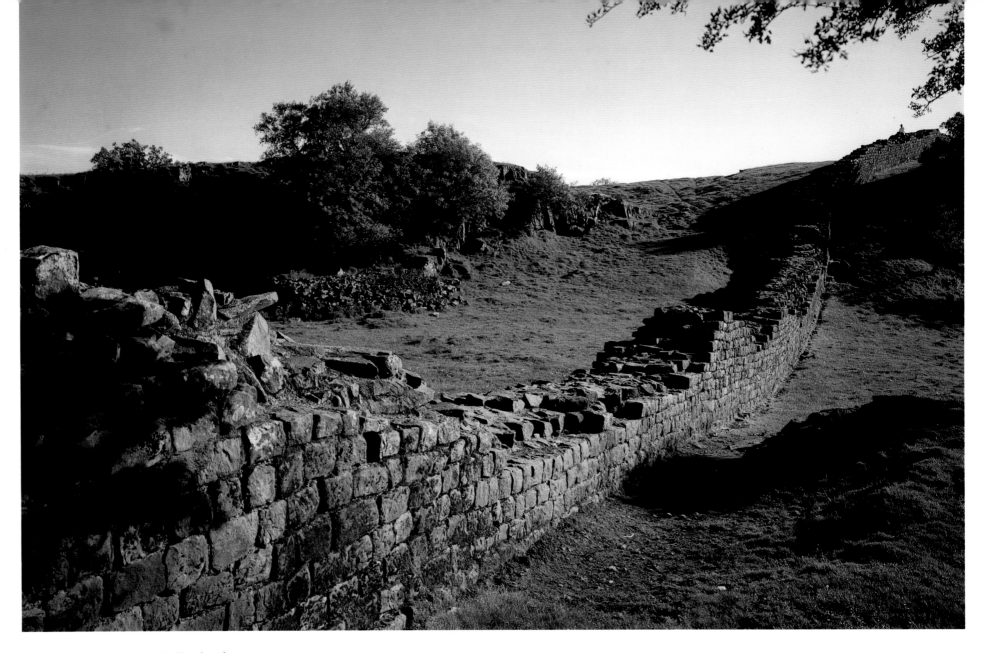

Hadrian's Roman Wall, England

ABOVE AND RIGHT: Hadrian's Wall was built in 122 A.D. under orders of the Roman Emperor to delineate and fortify the northern frontier of Roman-occupied territory in England. It was known as the "Fortified Sentry."

For over 73 miles (80 Roman miles) it stretched in an unbroken line acros the narrow neck of England. This was the farthest outpost of the Roman Empire. Here the garrison army kept vigil against attacks from the north and in more peaceful times regulated trade. About seven and a half feet thick by six to fifteen feet high, the Wall supported seventeen stone forts along its length. At intervals of 1,620 yards (one Roman mile) were mile-castles; equally spaced between them were two signal towers. The Romans held it until 400 A.D.

Long expanses of the Wall still remain, climbing up and over the Northumbrian hills, but parts are lost under the city of Newcastle and form a foundation of the military road. Elsewhere, the squared-up stones were used to build churches and farm houses. The finest stretch of Hadrian's Wall lies within Northumberland National Park between Gilsland and Chollerford.

PHOTOGRAPHY DATA: (Left) Late afternoon, wide-angle lens. (Right) Morning, normal lens.

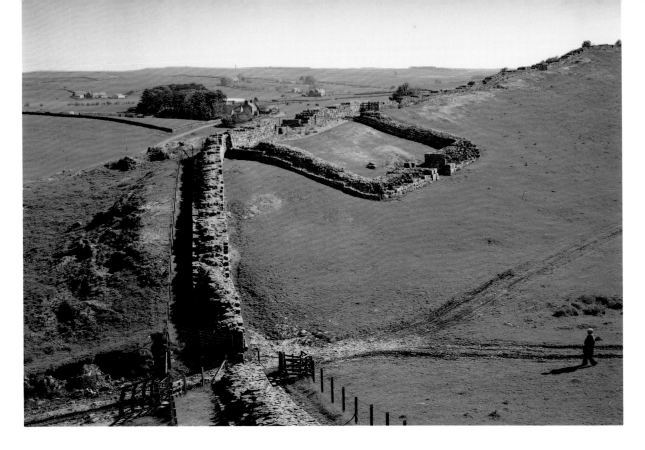

Anne Hathaway's Cottage, Stratford-on-Avon, England

BELOW: England has many charming thatched-roof cottages, but surely the most visited and publicized one is Anne Hathaway's Cottage in Stratford-on-Avon. Some furnishings of the Hathaway's—pewter plates, wooden trenchers, carved four-poster bed—have been preserved. An informal English garden of herbs, fruit trees and flowers lend an air of quiet decorum and grace to this half-timbered girlhood home of Anne Hathaway, who left in 1582 to become the wife of William Shakespeare.

PHOTOGRAPHY DATA: Early morning, wide-angle lens. Buses arrive from 9:00 a.m.

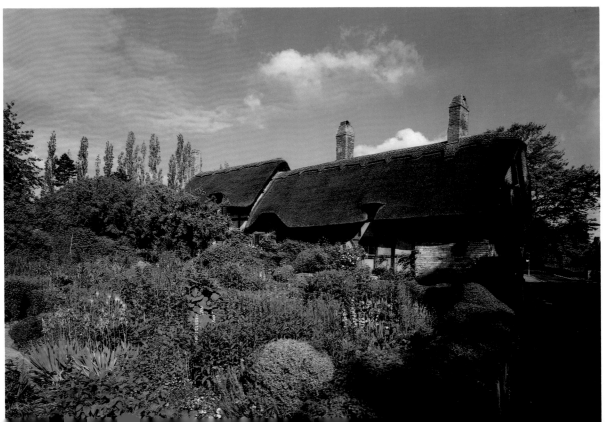

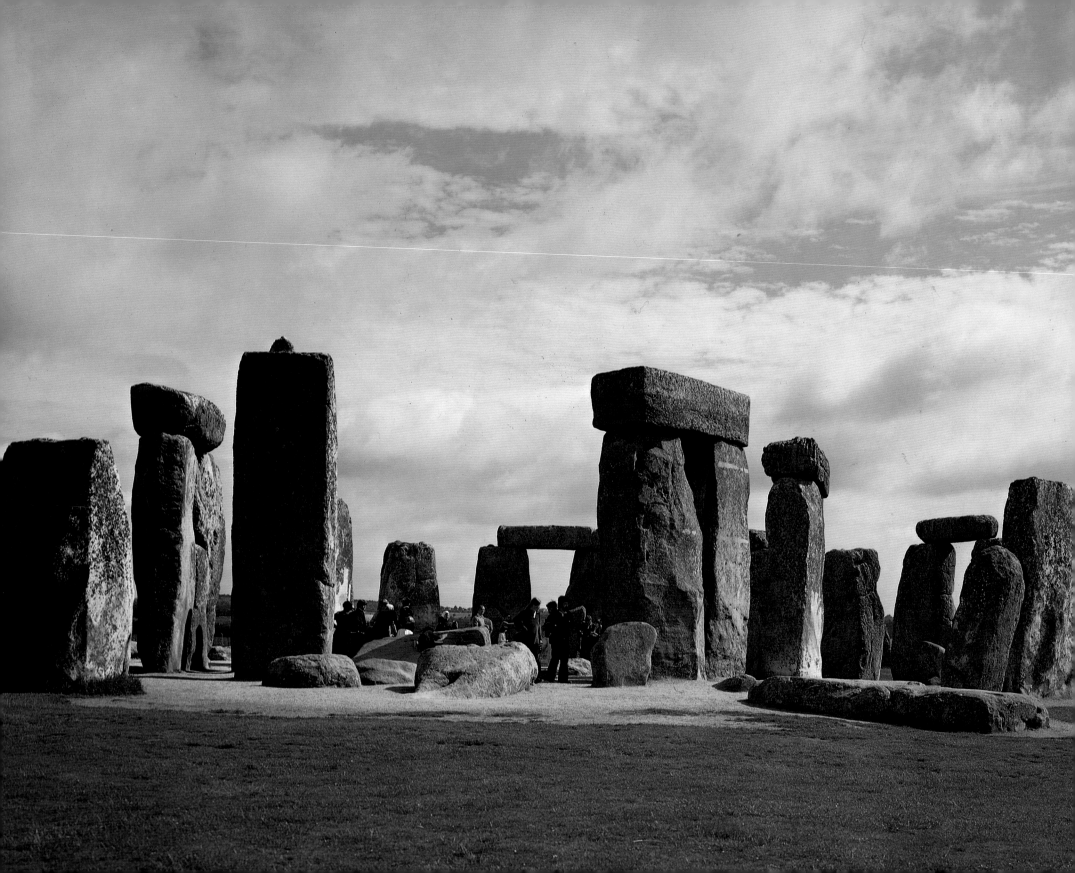

Stonehenge, England

LEFT: Stonehenge is in all likelihood the oldest and most noteworthy prehistoric monument in England. The massive stones are arranged in a series of rings with the upright stones of the outer circle connected by stone lintels. The purpose of this structure has long been a topic of conjecture by scholars and has not yet been adequately unraveled. There is speculation that it was once an astronomical observatory.

PHOTOGRAPHY DATA: Midday, normal lens. After several days of gray skies, we recorded this important monument. It could be much more dramatically photographed near sundown on a rare clear day.

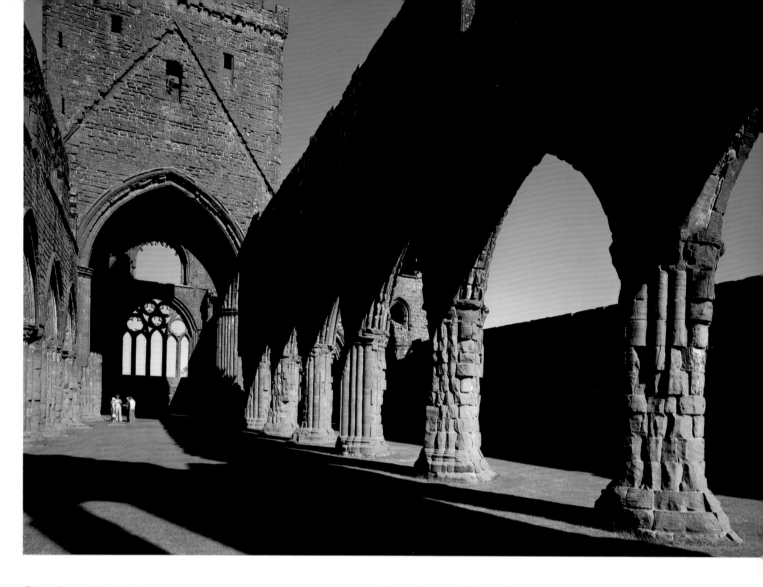

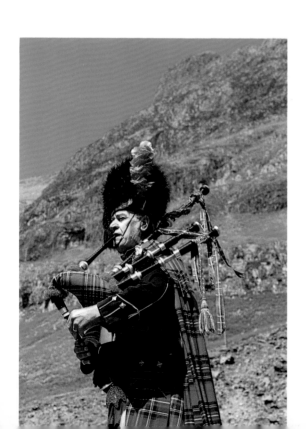

Bagpiper, Scotland

LEFT: The distinctive skirl of a bagpipe played by a kilted highlander immediately says Scotland to everybody. A reed musical instrument, the bagpipe has pipes protruding from a windbag held under the arm and filled by air blown from the mouth or a bellows.
Although always associated with Scotland, it is also used in Ireland and parts of rural Europe.

PHOTOGRAPHY DATA: Afternoon, normal lens.

Sweetheart Abbey, Scotland

ABOVE: Founded in 1273 by Devorgilla in memory of her husband John Balliol, Sweetheart Abbey is aptly named. This beautiful red stone ruin is not far from the City of Dumfries. Balliol College at Oxford University was established ten years earlier by Devorgilla.

PHOTOGRAPHY DATA: Afternoon, wide-angle lens.

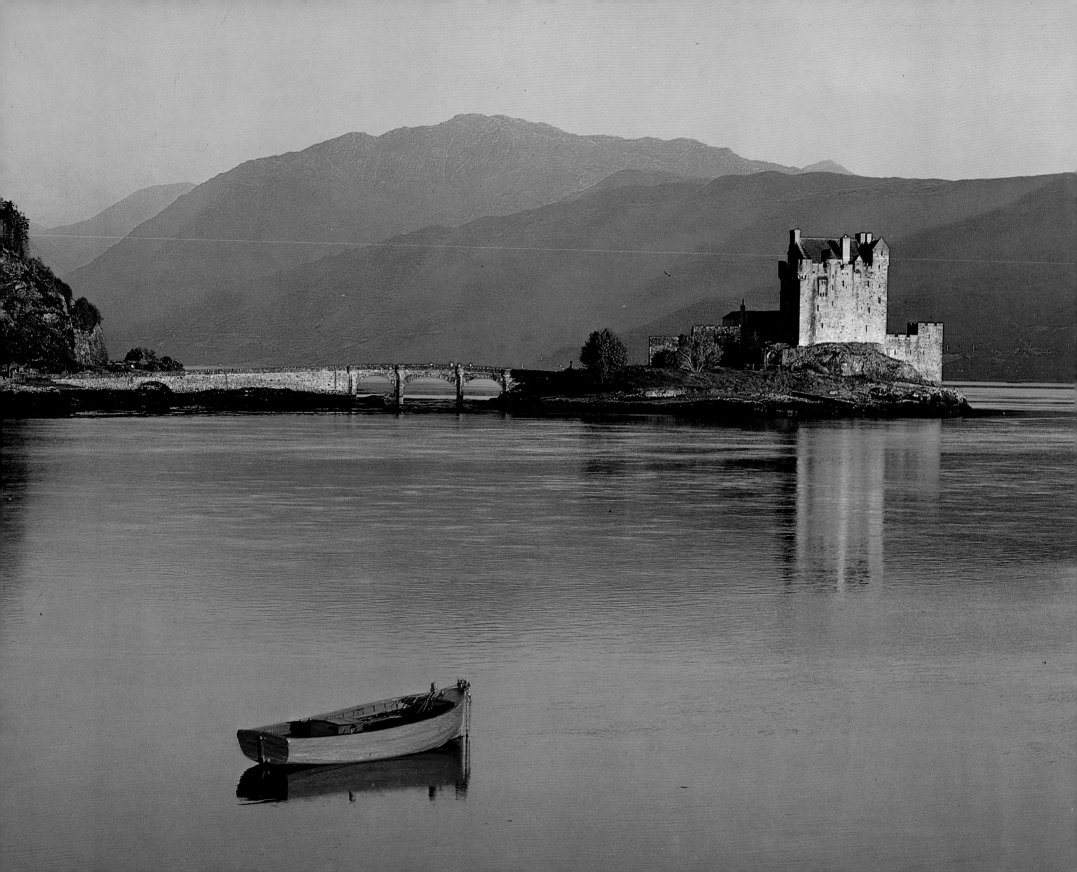

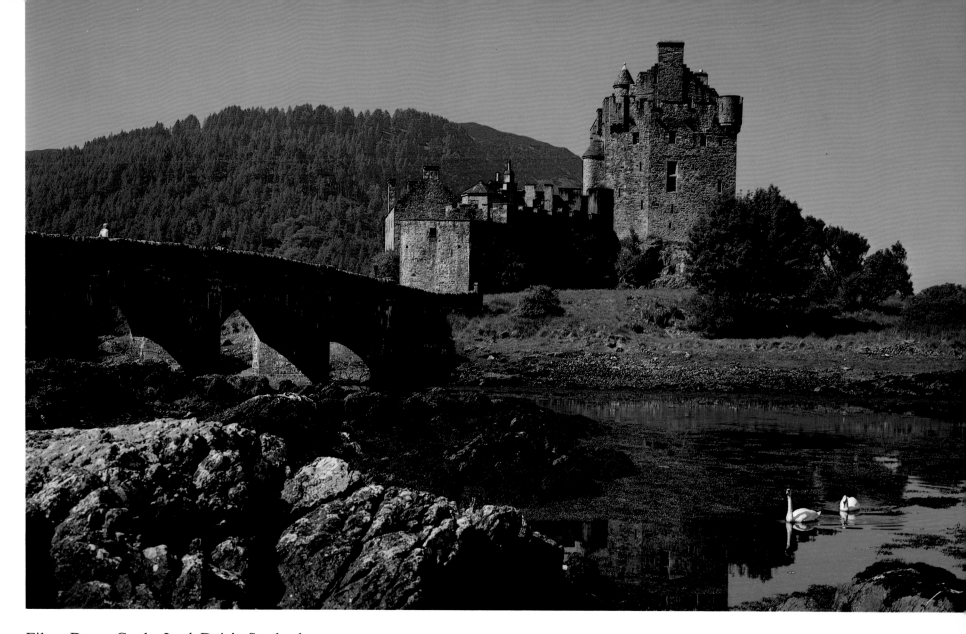

Eilean Donan Castle, Loch Duich, Scotland

ABOVE AND LEFT: Almost touching the rocky Scottish shore, within the embrace of an inlet or loch, is the small islet on which Eilean Donan Castle was built in 1220. The island is presently chained to the mainland by a causeway, making it accessible to tourists. In 1719, when it was manned by Scottish Jacobite troops, the castle was blown up by an English man o' war. Now wholly restored, it contains a small museum and memorial which are open from Easter to September. The powerful Clan Mackenzie and also Clan Macrae held ancient claims to this castle.

PHOTOGRAPHY DATA: (Left) Sundown, long lens. Late evening light makes a most dramatic time of day. Swan (above) morning, normal lens.

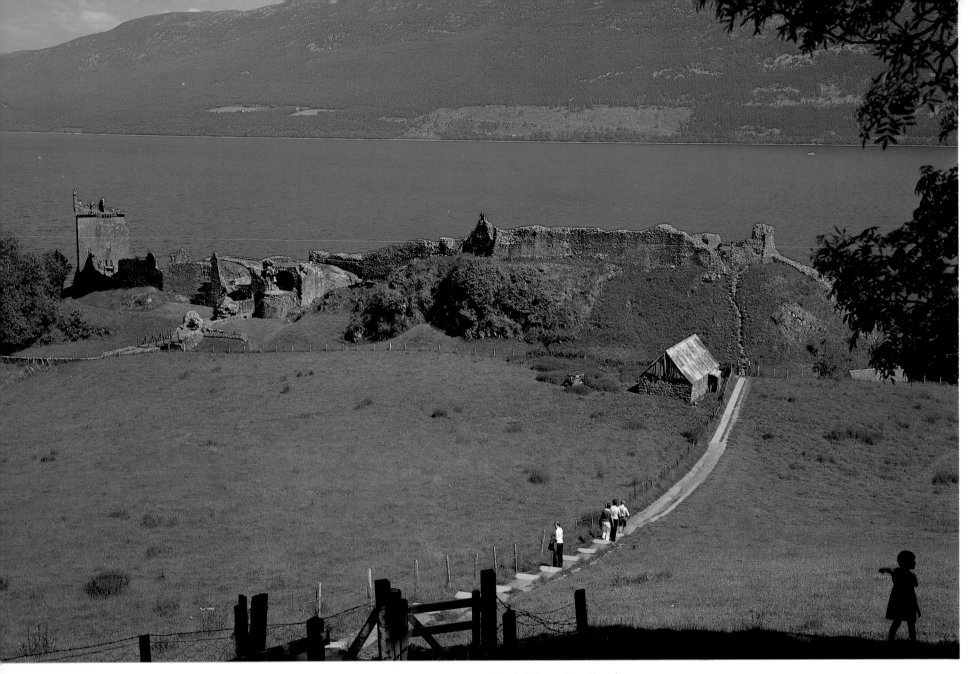

Loch Ness, Scotland

Fourteenth century Urquhart Castle, once one of the largest castles in Scotland, is situated on a promontory on the banks of Loch Ness. Appearances of the fabled ''Loch Ness Monster'' are most frequently reported from this site. Years of scientific soundings and investigations have not yet revealed any proof of its existence, though warm weather brings out hordes of ''monster watchers'' with their binoculars and cameras.

PHOTOGRAPHY DATA: Afternoon, normal lens.

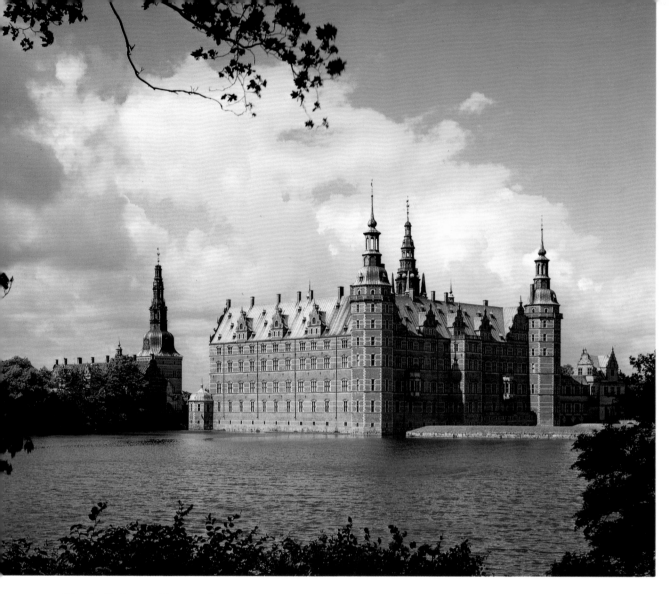

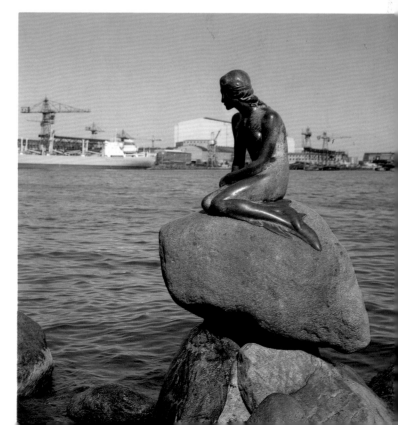

The Little Mermaid, Copenhagen, Denmark

BELOW: Sitting on some rocks on the harbor shore, The Little Mermaid has posed silently for unnumbered photographers. Half woman, half fish, she is a figure in a Hans Christian Anderson fairy tale. Among her legendary accomplishments she "reveals voluntarily or under compulsion, things about to happen," or "she can impart supernatural powers to a human being,"—a soothsayer of antiquity, it would seem.

PHOTOGRAPHY DATA: Afternoon, normal lens.

Frederiksborg, Denmark

ABOVE: One of the most outstanding Renaissance palaces in northern Europe, Frederiksborg stands on small islands in the palace lake. Built in the early 17th century, much of the existing structure is the result of restoration in accordance with the original plans after a major fire in 1859. Since that time it has been a National Historical Museum.

PHOTOGRAPHY DATA: Morning, normal lens.

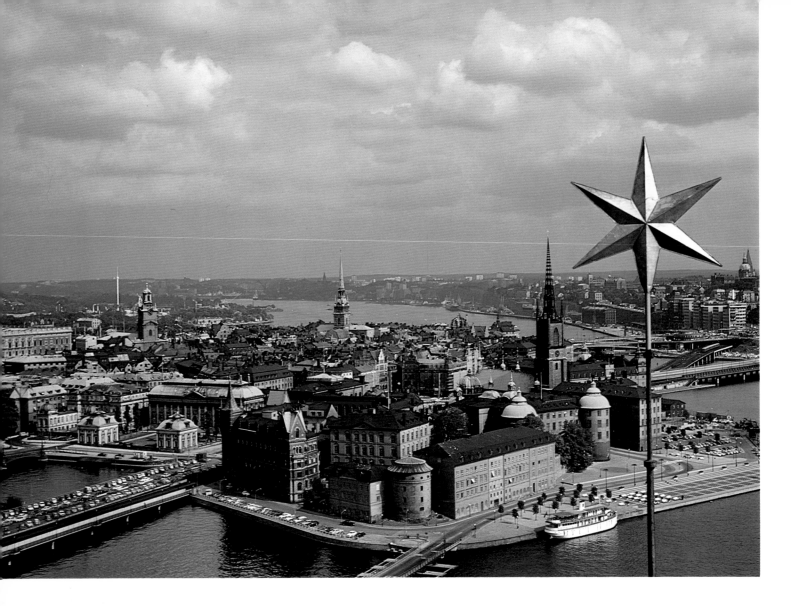

Briksdal, Norway

RIGHT: A waterfall, cascading from the foot of the beautiful blue Briksdal Glacier, sends its cooling spray over sightseers who venture close. You can walk up the narrow winding road or ride up in a little horse-drawn, two-wheeled "jkerre." Either way is a rewarding experience; the glacier and the falls are both magnificient.

PHOTOGRAPHY DATA: Afternoon, normal lens.

Stockholm, Sweden

Founded in 1252, Stockholm stands on the eastern side of Lake Mälar, where the waters flow into the Baltic Sea. At first, settlements were built and fortified only on islands, and not until much later did they gradually spread to the mainland.

This old and interesting section of Stockholm on the island of Riddarholm, as seen from the tower of the Town Hall, has been preserved as much as possible. Riddarholm Church, which contains the tombs of Sweden's monarchs, dates from the 13th century. The lacy cast iron spire was added in 1840.

PHOTOGRAPHY DATA: Midday, normal lens. The best view of the old city is from the city hall tower.

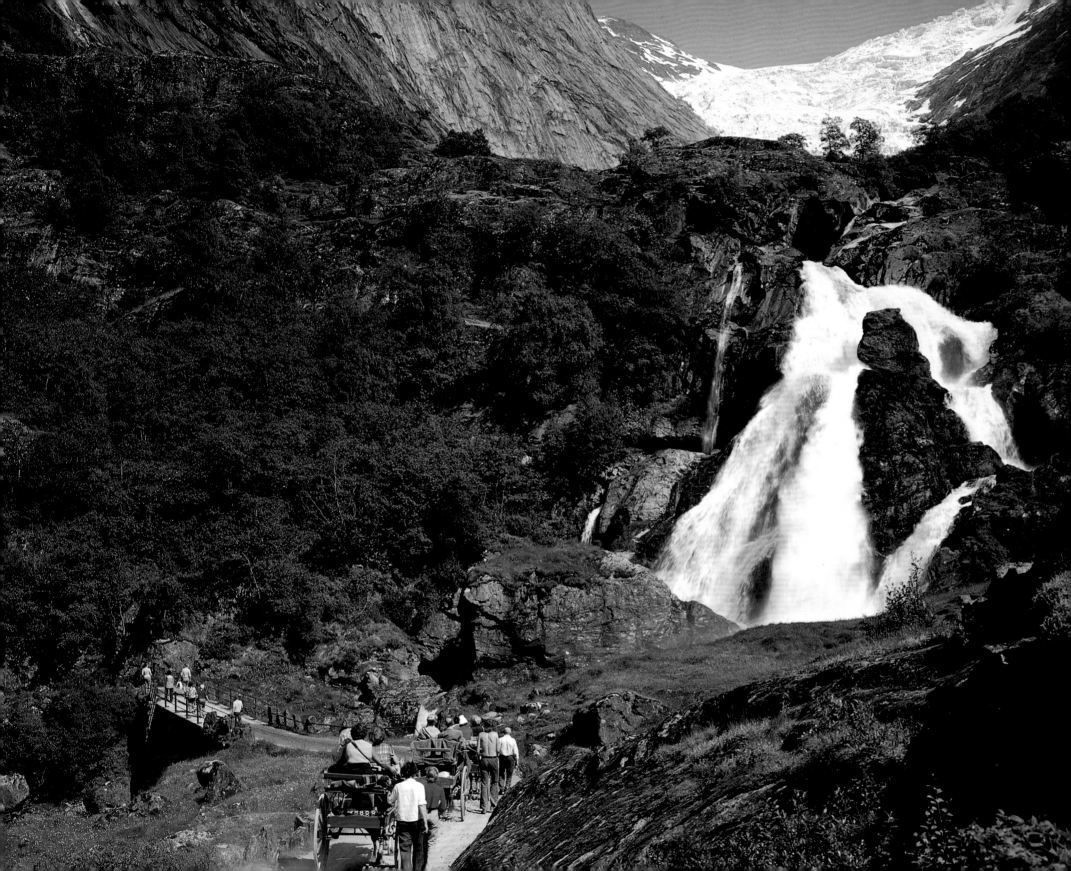

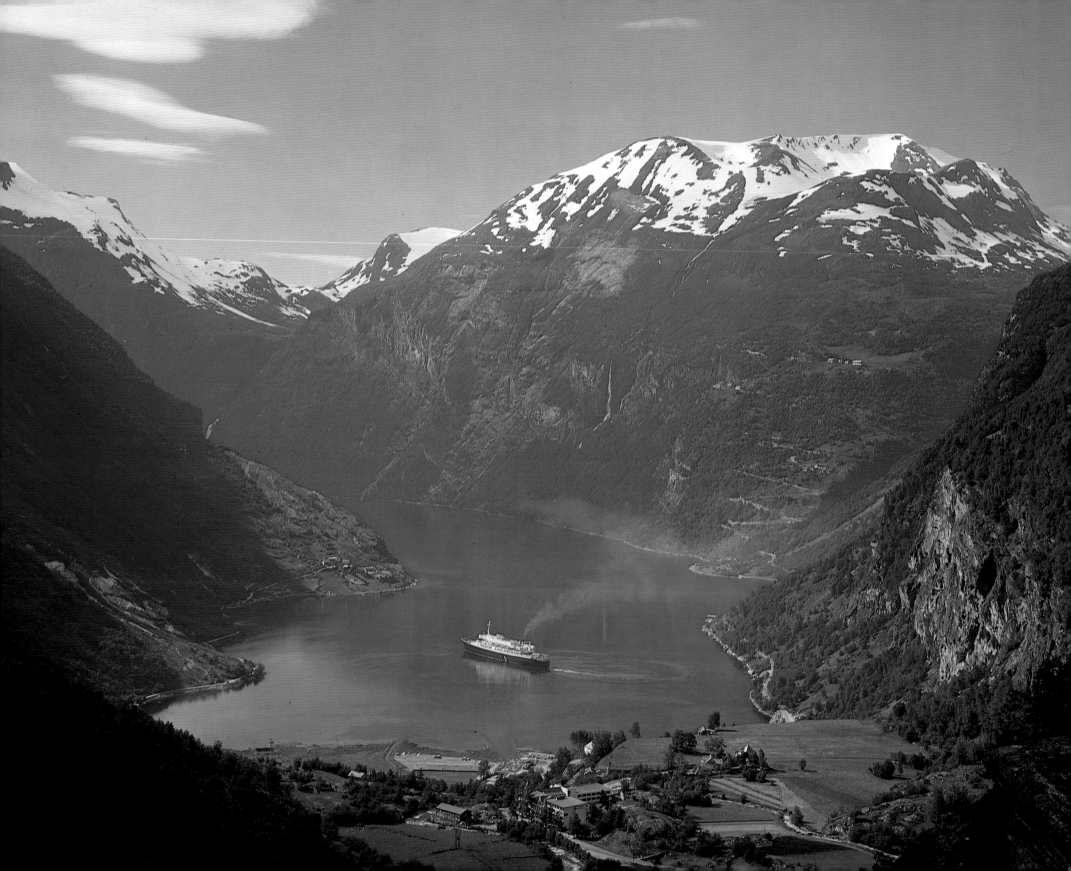

Andalsnes, Norway

RIGHT: A land of mountainous terrain and high plateaus, Norway's highways must of necessity zig-zag up and down the steep sides. The scenery along these twisting climbing roads is well worth any moments of uneasiness. Looking down on a fiord, or passing close to a waterfall, a herd of sheep, a stand of trees, or a hillside covered with snow and skiers (yes, in summer!) make Norway one of our favorite places—as do its warm, friendly and helpful people.

PHOTOGRAPHY DATA: Afternoon, wide-angle lens.

Geiranger Fiord, Norway

LEFT: Norway is deeply indented by numerous fiords (or fjords) which are long, relatively narrow arms of the sea bordered by precipitous mountains. Fiords or ''Viks'' have always been a vital force in the lives of Norwegians, for the sea is the prime source of their livelihood since farm land in mountainous Norway is at a minimum. From about 700 through 1100 A.D. Vikings ranged the seas in their wooden boats, plundering and annihilating coastal settlements and towns. Their name ''Vikings'' came from the ''Viks'' or fiords of their homeland.

Geiranger Fiord has a rugged beauty that is heightened by waterfalls, such as the Seven Sisters, which plunge from the high cliffs as individual falls. It's quite a thrill to see a great white cruise ship loaded with holiday crowds enjoying the scenic grandeur of Norway, negotiate one of the deep fiords.

PHOTOGRAPHY DATA: Morning, normal lens. One can check for ship arrivals and departure times at several local hotels.

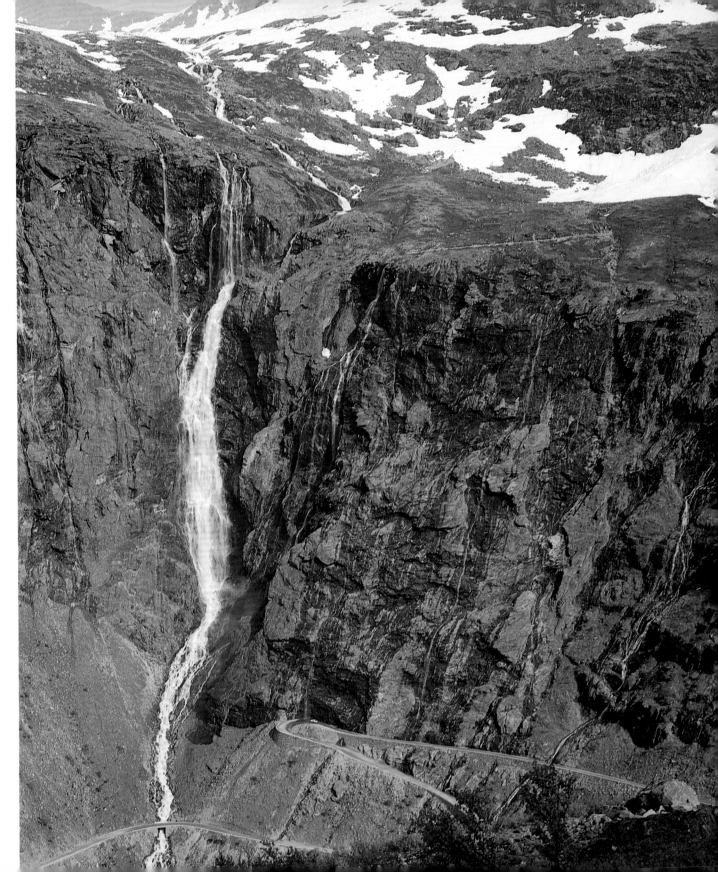

Stave Church, Borgund, Norway

BELOW: When King Olaf II made Christianity the official religion of Norway around the turn of the 11th century, seven or eight hundred of these towering wooden stave churches were constructed by Viking boat builders. Some of the people were not quite willing to accept this new religion, so many of the old myths persisted and are reflected in the ornamental carvings and decorations. About twenty of these stave churches are still standing in Norway; one of the best preserved is this one at Borgund, dating from the 12th century.

PHOTOGRAPHY DATA: Afternoon, wide-angle lens. Sometimes composition is compromised by various elements that are present. Flowering shrubs are not always in the best location.

Stryn, Norway

BELOW: Norway occupies a mountainous strip in western Scandanavia with a seacoast deeply scored by numerous fiords. While Norway measures only a little over 1,000 miles from north to south, its coastline is over 2,000 miles long. Beside its deep inland fiords there is often only a narrow ribbon of habitable land. Stryn is a typical village built on the edge of a fiord on Norway's western coast.

PHOTOGRAPHY DATA: Afternoon, normal lens.

28

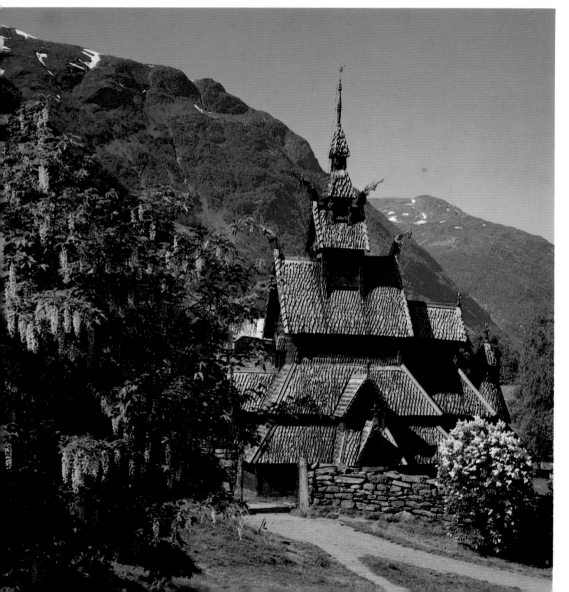

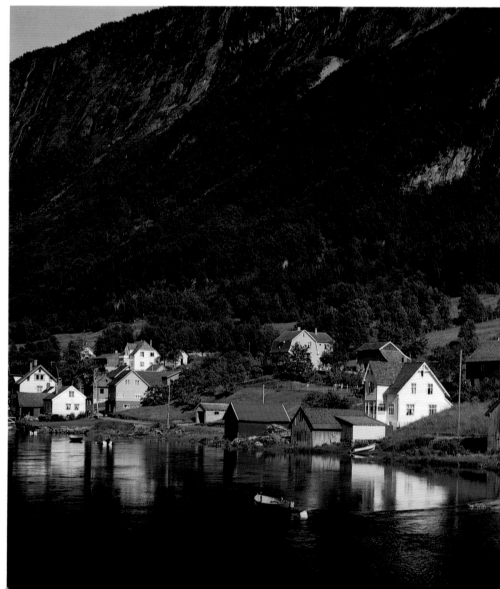

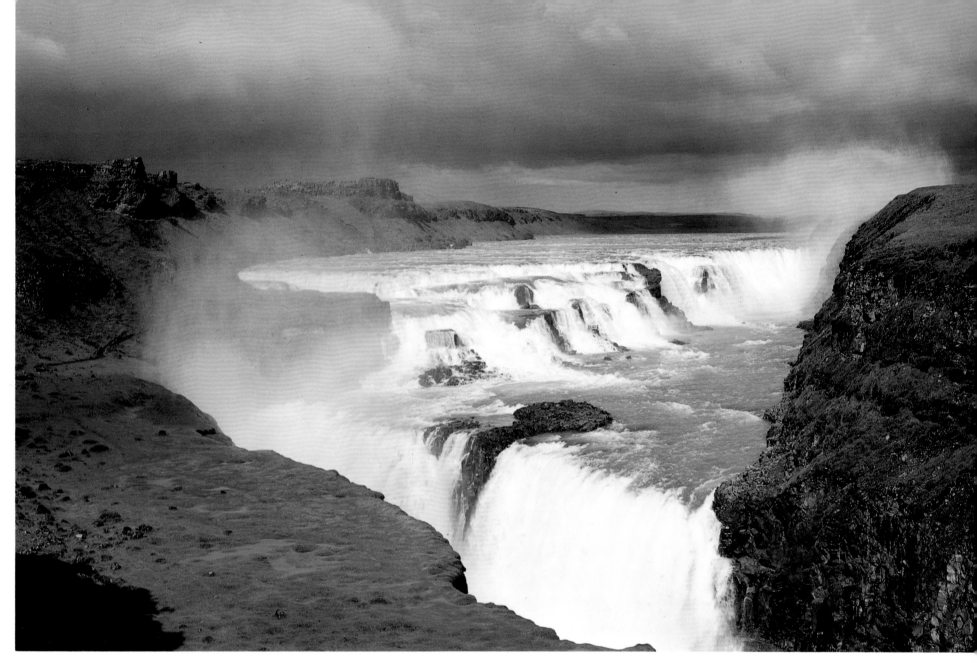

Golden Falls, Iceland

An independent island nation in the North Atlantic, Iceland touches the Arctic Circle in the north. It is remarkable for the largest glaciers and the most volcanic activity in Europe. Iceland's surprisingly mild climate (average of 30° in January, 52° in July) is due to the Gulf Stream that warms the coastal areas of the south and southwest. The population of the island is most dense in this area. To a couple of warm-blooded desert dwellers from Arizona it felt cold, not mild! A distinctive feature is the numerous waterfalls dropping over sheer walls of basalt. Golden Falls (Gullfoss) usually has twin rainbows in its spray.

PHOTOGRAPHY DATA: Afternoon, normal lens.
A little sunlight appeared after a long wait.

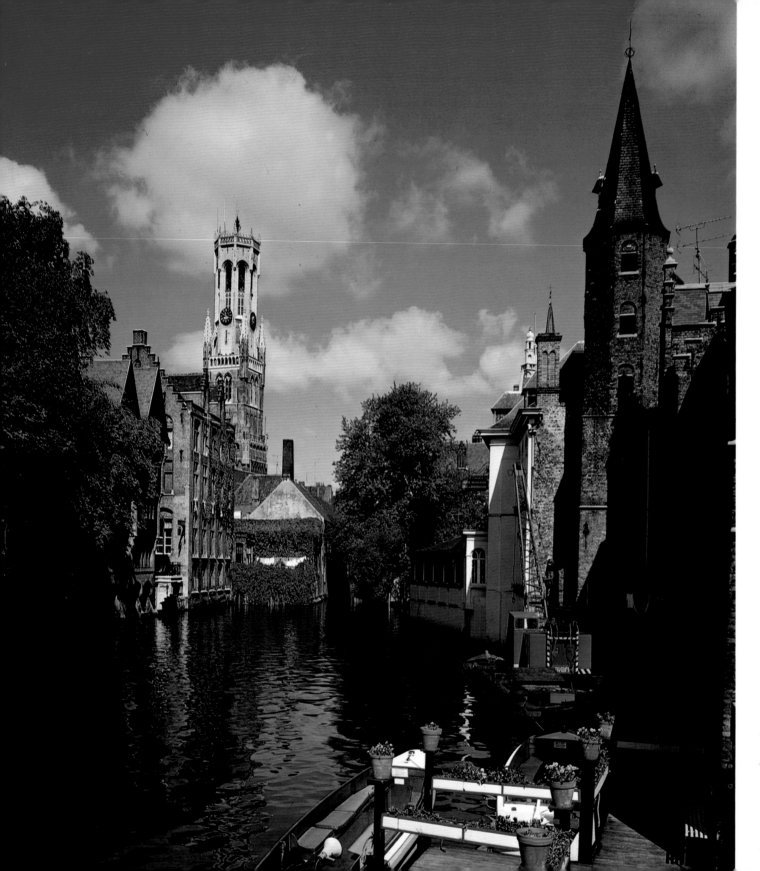

Bruges, Belgium

LEFT: Built on a network of canals, Bruges is the capital of the province of West Flanders. Its name is Flemish for bridges, which cross the canals in profusion. In the 14th-century medieval city, the monuments of Bruges' past are many, but the most noteworthy is the great, square belfry on the market square. Its 47-bell carillon is famous throughout the world. Also on the square is the 19th-century Government Palace which serves as a background for a medieval pageant of knights in a jousting tournament. At one time combat ceased only with the injury or death of a knight. The church condemned these jousts continuously until in the 15th century victory was finally reduced to the unhorsing of an armed adversary.

PHOTOGRAPHY DATA: (Right) Afternoon, wide-angle lens. This photograph by Naurice Koonce (Ray Manley's partner). (Left) Morning light, wide-angle lens. Yes—the tower leans.

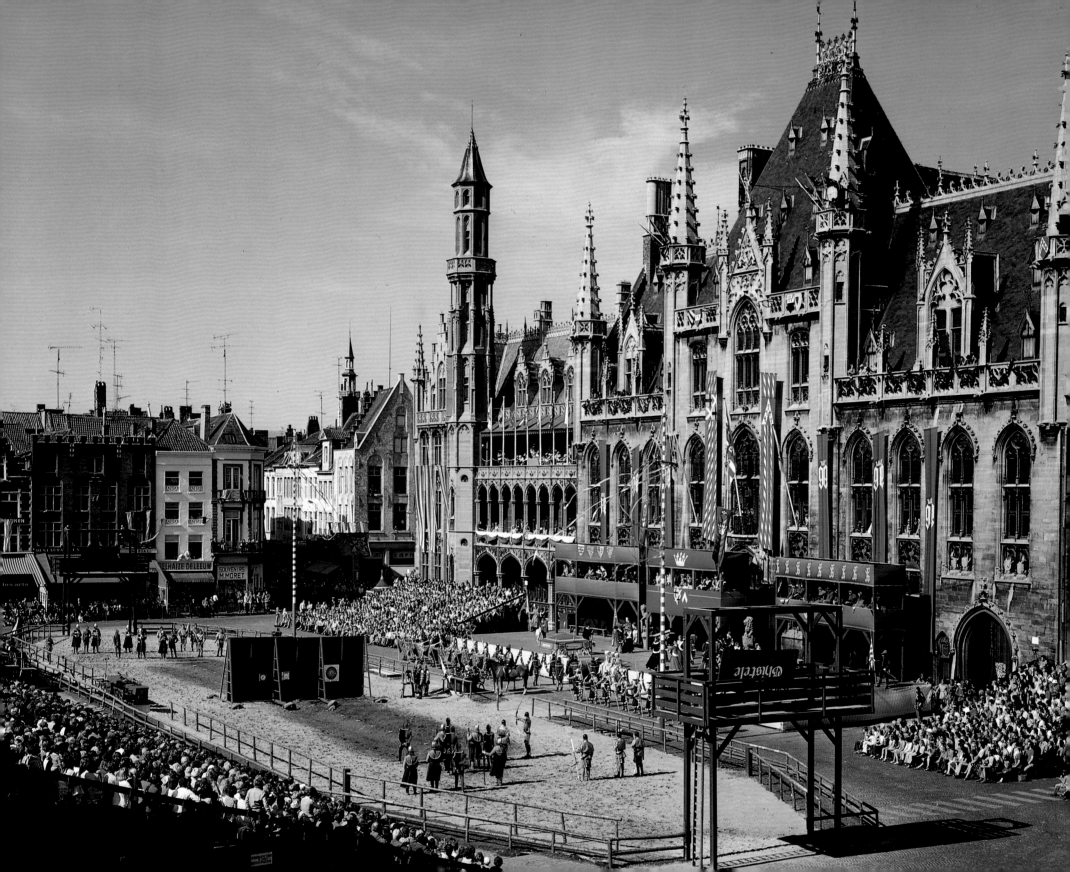

Volendam, Holland (Netherlands)

RIGHT: Typically Dutch in its stern architecture and the costume of its people, Volendam is a popular tourist attraction. On a paved dike on the shores of the Zuider Zee, it's not far from Edam, of cheese fame. Here men still wear baggy black breeches of heavy wool and wooden shoes. Women in their embroidered black wool dresses and starched white winged caps appear to have just stepped out of the past or the pages of an old geography book.

PHOTOGRAPHY DATA: Afternoon, normal lens.

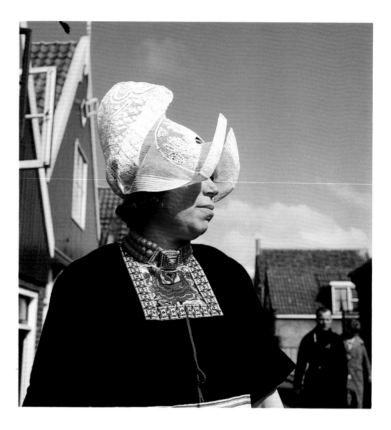

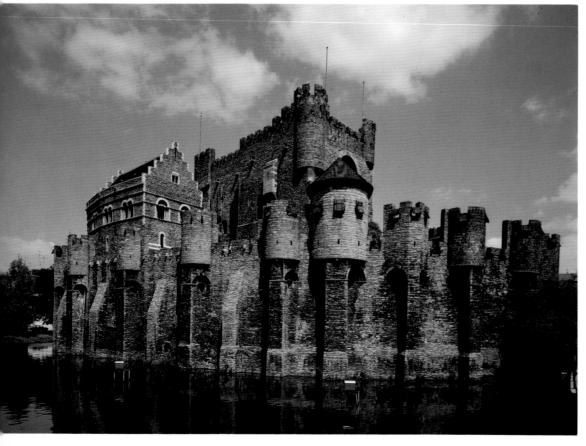

Ghent, Belguim

ABOVE: A flourishing inland port because of its many canals, Ghent is an ancient city built on the site of two 7th-century monasteries. It contains many and varied buildings and art works of historical significance. The stately restored Chateau of the Count of Flanders dates back to 1180.

PHOTOGRAPHY DATA: Afternoon, wide-angle lens.

Kinderdijk, Netherlands

RIGHT: Known popularly as Holland, the Netherlands is a flat, marshy land that has been turned into a pleasing, pastoral landscape interspersed with windmills, canals, draw-bridges, picture-book villages and bustling cities. Much of the land has been reclaimed from the sea and, since it lies below sea level, has to be protected from flooding by a system of dikes, windmills and pumping stations.

Not far from Rotterdam, the small town of Kinderdijk boasts more of Holland's famous windmills in one photogenic location than any other area. School children on an afternoon excursion are delighting in a glorious day and a boat ride on the canal.

PHOTOGRAPHY DATA: Afternoon, long lens.

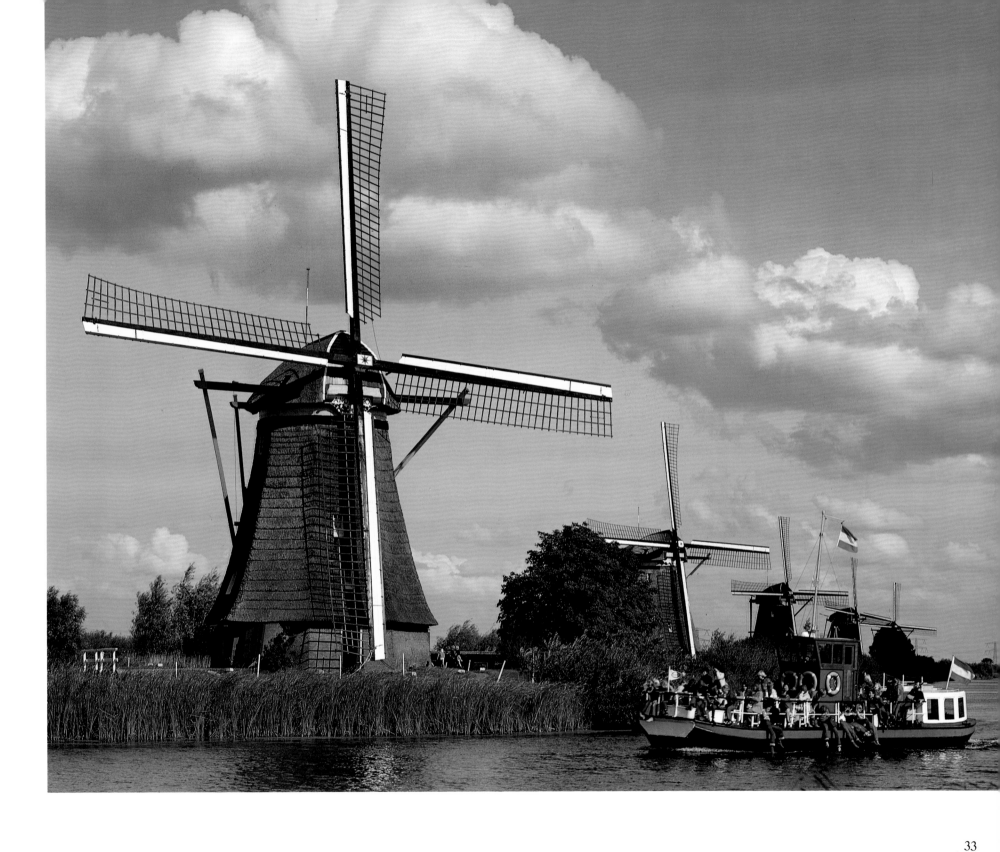

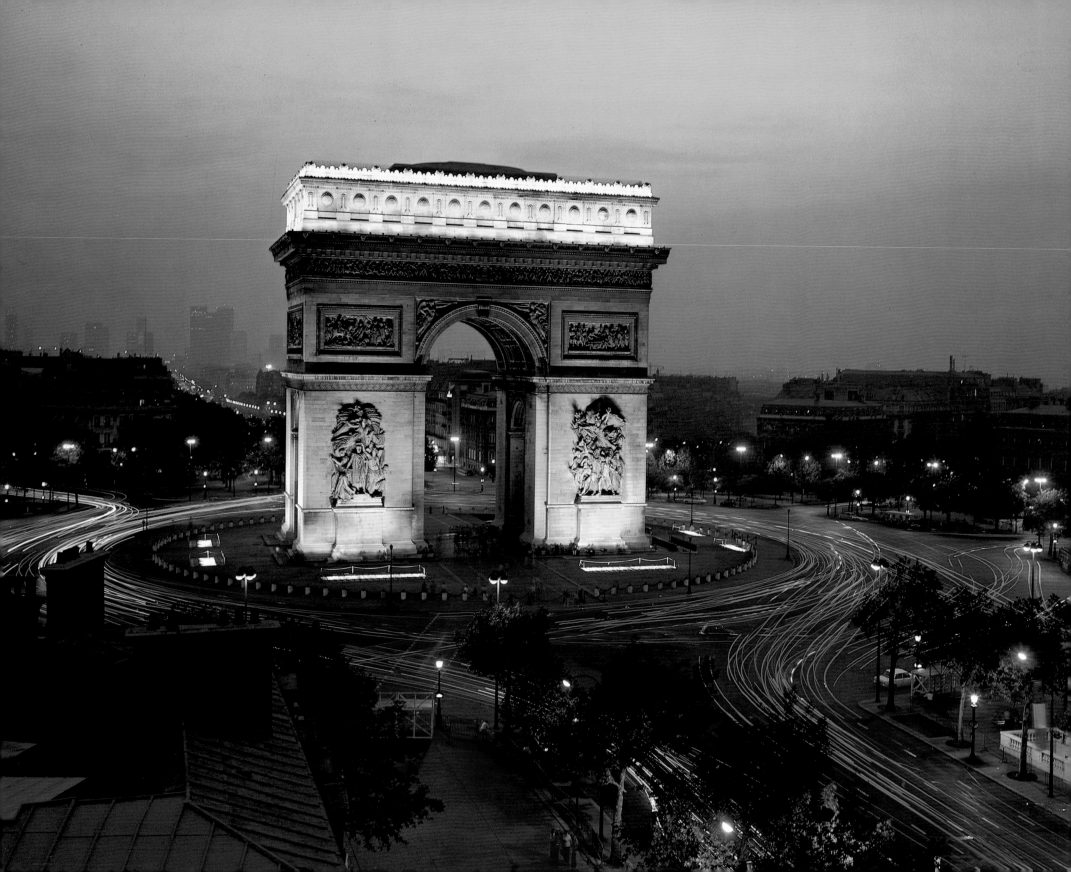

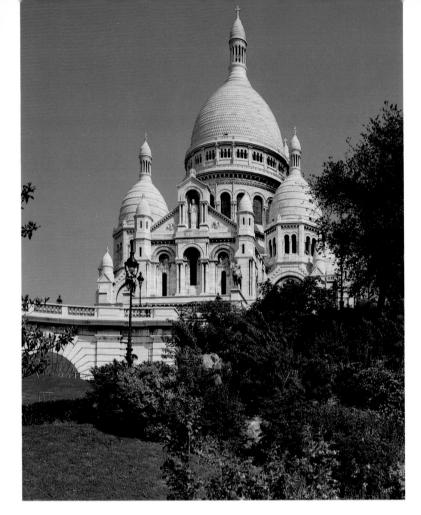

Sacre-Coeur, Paris, France

LEFT: The dazzling white domes of the Basilica of the Sacre-Coeur rise from the high Montmartre section in the north of Paris. This area has long been a popular quarter for many famous and not-so-famous artists. It is possible to see these craftsmen at their painting in the nearby Place du Tertre. A superior panorama of Paris can be seen from the high steps of the Sacre-Coeur.

PHOTOGRAPHY DATA: Midmorning, normal lens.

Moulin Rouge, Paris, France

LOWER RIGHT: An old and popular cabaret near Place Pigalle, the Moulin Rouge sparkles at night with myriad lights. Few tourists would miss an opportunity for a glimpse of its leggy showgirls and musical variety show.

PHOTOGRAPHY DATA: Night, normal lens, time exposure.

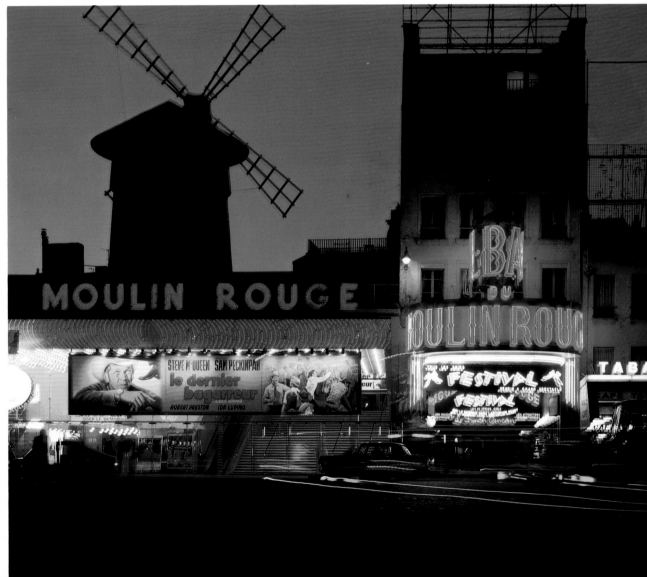

Arch of Triumph, Paris, France

LEFT: France is larger than any other European country—with the exception of Russia—although it's much smaller than the state of Texas. Paris, on the Seine River, is its capital and largest city and the target of millions of tourists who come to view its monuments, museums, art treasures, boutiques, sidewalk cafes and night clubs.

Planned on a grand scale, the Arc de Triomphe was begun in 1806 by Napoleon and was completed thirty years later by King Louis Philippe. A full dozen radiating avenues converge with the Arch on the Place de l'Étoile. Elaborately adorned with sculptures, the Arch is often the site of national ceremonies. Beneath the Arch is the Tomb of the Unknown Soldier with its eternal flame.

For a magnificent view of the city, including the very famous avenue, the Champs-Élysées, ride the elevator 160 feet to the top of the Arch.

PHOTOGRAPHY DATA: Sunset, normal lens. A double exposure made this picture possible, first recording the faint sunset and a time exposure two hours later when the lights were turned on. Special permission can be obtained to use the penthouse above the American drugstore.

35

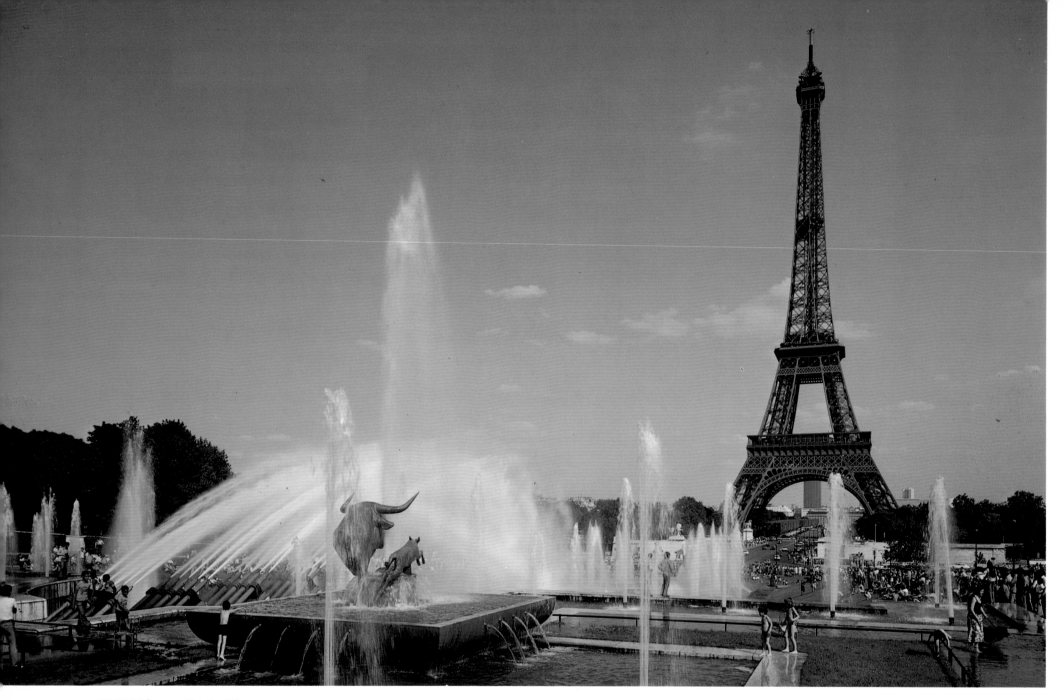

Eiffel Tower, Paris, France

LEFT: Erected for the Paris Exhibition of 1889, the Eiffel Tower is approximately 1,000 feet high.
This monumental engineering feat—once disdainfully called ''Eiffel's Folly''—since that time has
become one of Paris' most-visited tourist attractions. Its maker, Gustave Eiffel, was a bridge
builder and his talent is revealed in this lofty tower built of steel and iron. A superb view can be
enjoyed from its height—with all of Paris at your feet!

*PHOTOGRAPHY DATA: Afternoon, wide-angle lens. Using a large camera on a Saturday
afternoon can be a bit hazardous. The fountains are turned on for special holidays, weekends and
evenings after sundown.*

Etretat, France

RIGHT: Etretat, near Le Havre, is a small resort village with a beach flanked by towering white limestone cliffs. The action of the ocean's perpetual waves has sculpted the limestone into interesting shapes.

France has a multitude of scenic attractions in addition to monuments and antiquities, although the latter are the more famous. Some of the sea coast is especially picturesque in northern France along the English Channel.

PHOTOGRAPHY DATA: Afternoon, normal lens.

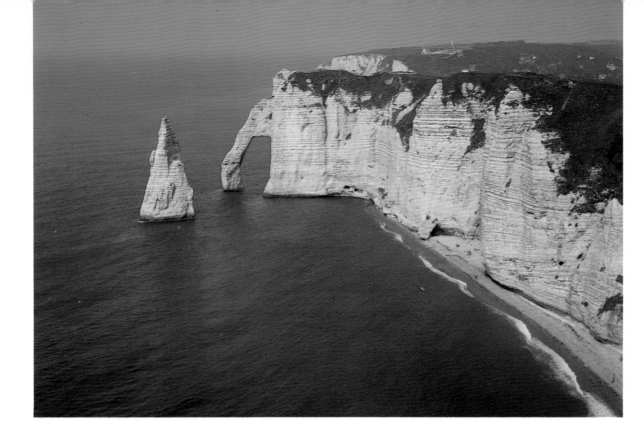

The Pont du Gard, Nimes, France

RIGHT: Amazingingly well-constructed even though *no* mortar was used, the Pont du Gard is a Roman aqueduct near Nimes. It has been standing over the River Gard for an almost unbelievable 2,000 years. From Uzes—39 miles distant—fresh water passed through interlinking channels and over this bridge enroute to Nimes. Over 800 feet long and 155 feet high, the Pont du Gard has three tiers of gracefully proportioned stone arches of varying sizes. The huge building blocks were cut from nearby quarries.

PHOTOGRAPHY DATA: Afternoon, wide-angle lens.

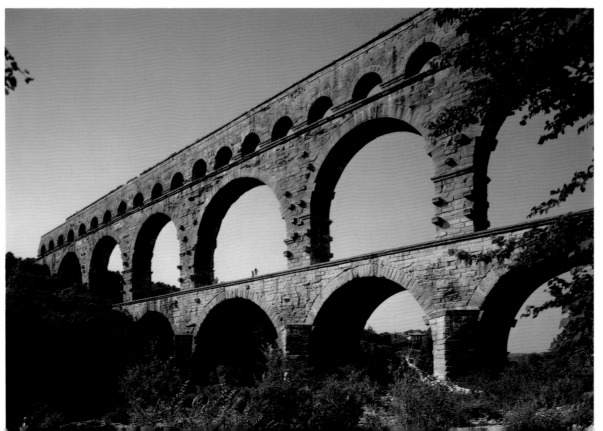

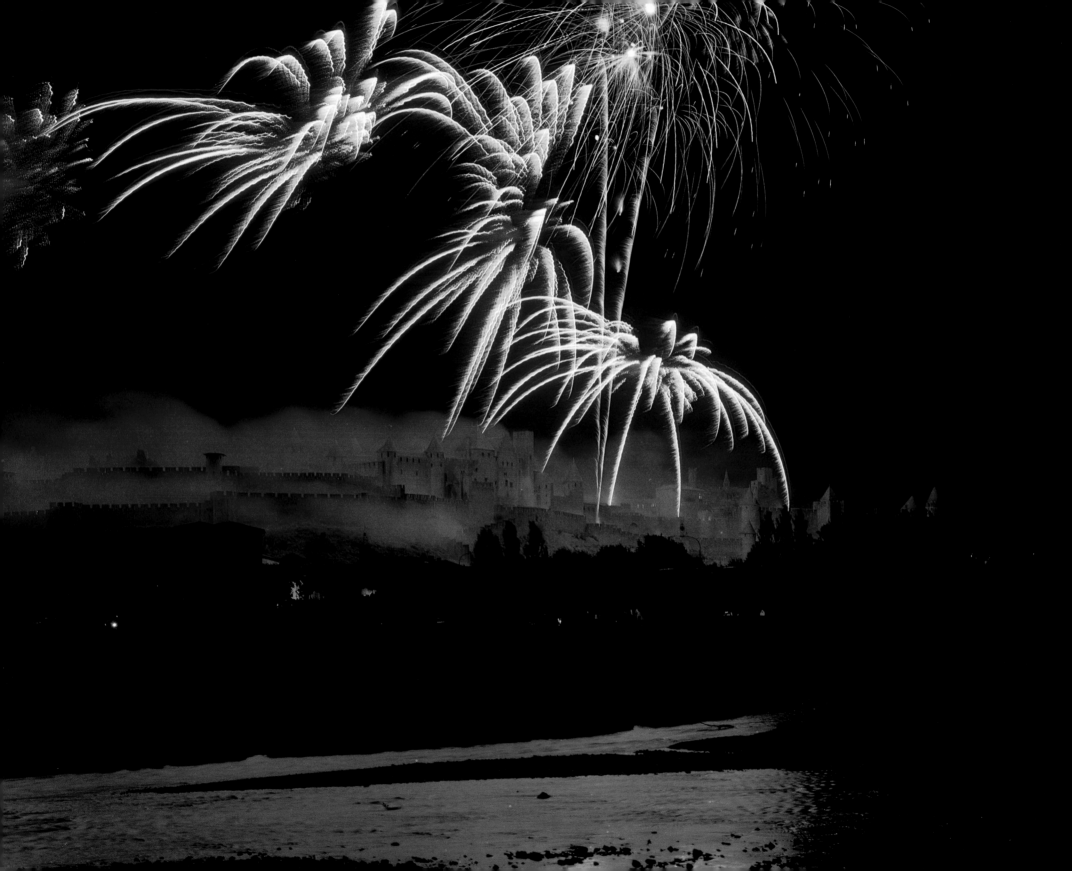

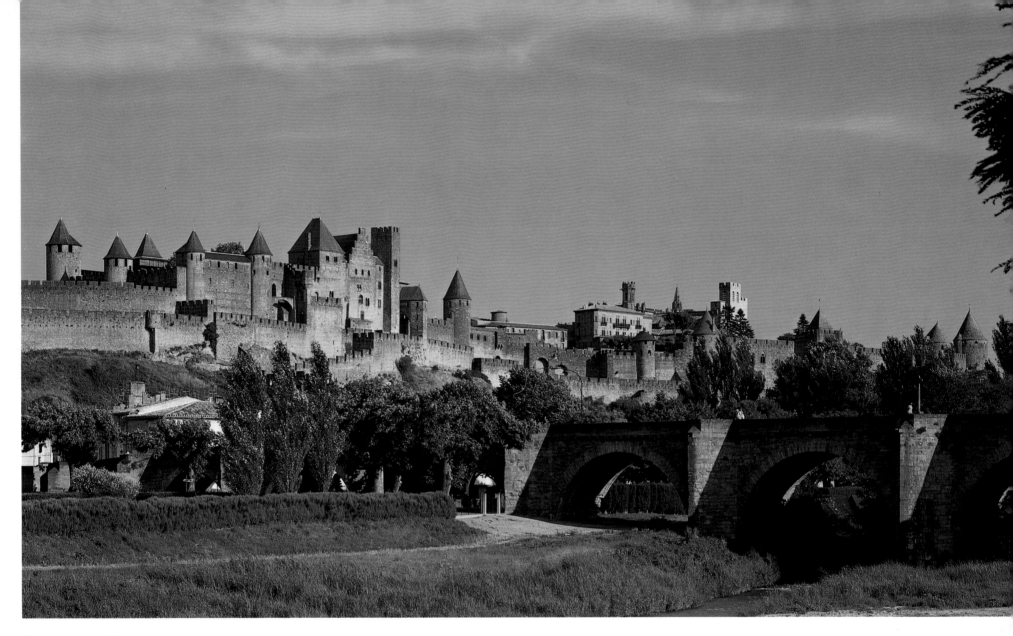

Carcassonne, France

LEFT AND ABOVE: One of the most perfectly restored medieval fortresses in southern France—and probably the world—is Carcassonne, with its castle, double walls, towers and battlements. La Cité was developed during four different periods, each using distinct methods of stone construction on the walls. A visitor can readily see and identify remnants of the earliest building during the Gallo-Roman era (from the 2nd century B.C. to the 4th century A.D.) by the huge blocks of stone fitted together without mortar. Most of the construction was done during the 13th century and the restoration during the 19th century.

In recent history, 300 German officers were held prisoner in the castle within La Cité during World War I. In March 1944 during World War II, all the residents had to move out and all but one of the gates were blocked when Carcassonne became the site of a German headquarters.

After liberation in 1944, the inhabitants moved back to their homes.

Each July 14, Carcassonne has a celebration with a dazzling display of fireworks which culminates when the entire city and its walls appear to be in flames. Seen from one of the bridges in lower town, the pageant is a marvel to behold and well worth a visit on that special day.

PHOTOGRAPHY DATA: Night, 10:30 p.m., medium long lens. An aperture of f:11 records fireworks nicely. A time exposure of 30 seconds was necessary to record the glow of red flares illuminating the gray stone walls. (Care must be taken not to record too many rocket bursts.)

Day, afternoon, long lens.

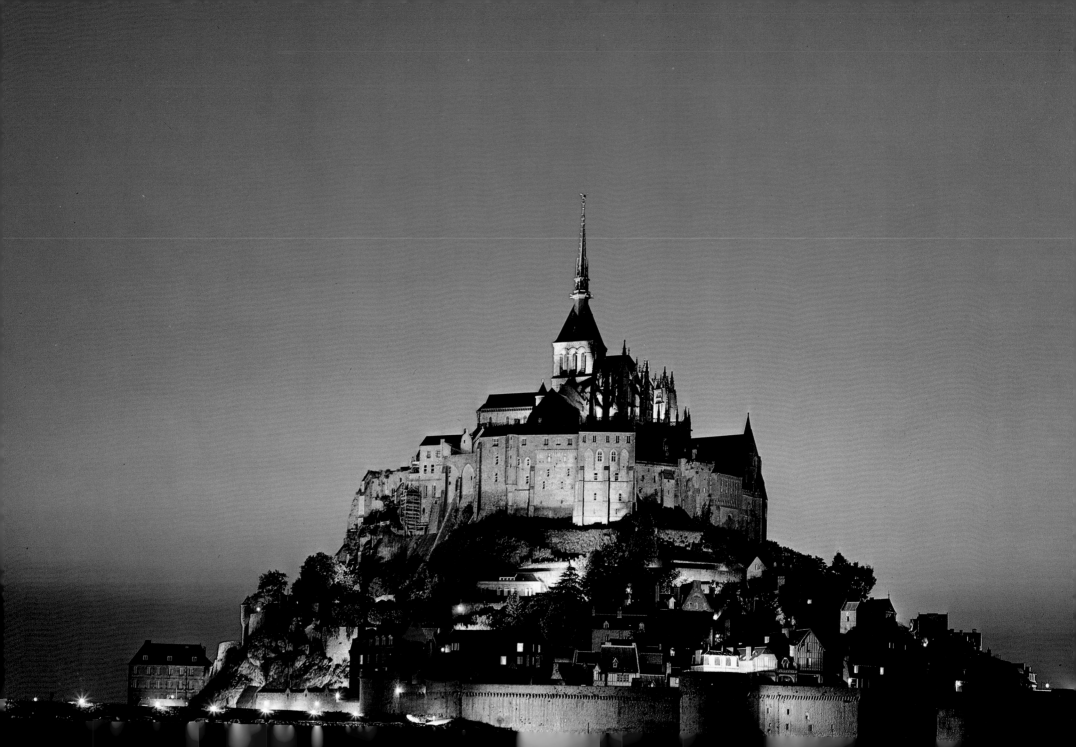

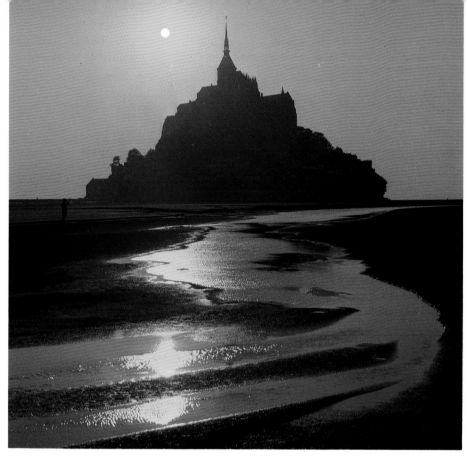

Mont St. Michel, France

LEFT AND ABOVE: Mont St. Michel, on a rocky islet off the Normandy coast of France, was built as a fortified Benedictine abbey. At low tide it rises from the sandy tidal flats. At flood tide, when the tide advances at up to eight miles per hour, the fortress is surrounded by the sea. A man-made causeway is its only connection to the mainland a mile away. The base of the island has encircling walls and towers protecting the abbey and village. During especially high and rushing tides the walkways abound with spectators observing this spectacular phenomenon.

PHOTOGRAPHY DATA (2 photos): Sunset (above), long lens, orange filter.

Dusk and night (left), normal lens. First exposure was made of sky; second, two hours later, one minute time exposure. The lights are turned off at 11:45 p.m.

Angers, France

RIGHT: A portion of the once water-filled moat of the 13th-century Angers Château has been transformed into a precise and beautiful formal garden, which adds color and liveliness to the grim stone walls of the castle. In another section tame deer graze in the long dry moat. King Louis IX was the builder of this hulking fortress. Henry II ordered it to be razed but the governor of Angers, by stalling, managed to save all but the upper portions of the seventeen stone towers.

Noted for its sparkling wines, Angers is an enterprising city in the Anjou region of France. It also has a 12th-century Gothic cathedral and a tapestry museum that are of interest.

PHOTOGRAPHY DATA: Overcast sky, wide-angle lens.

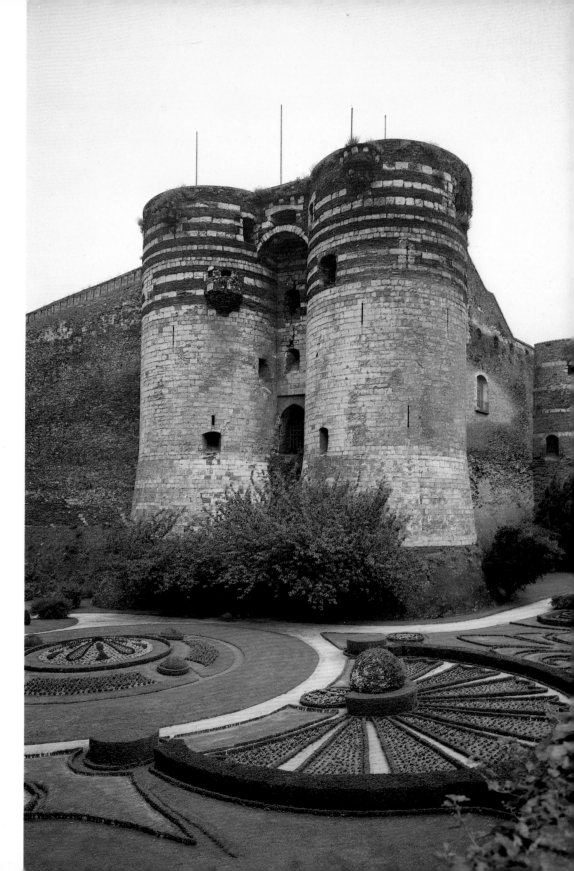

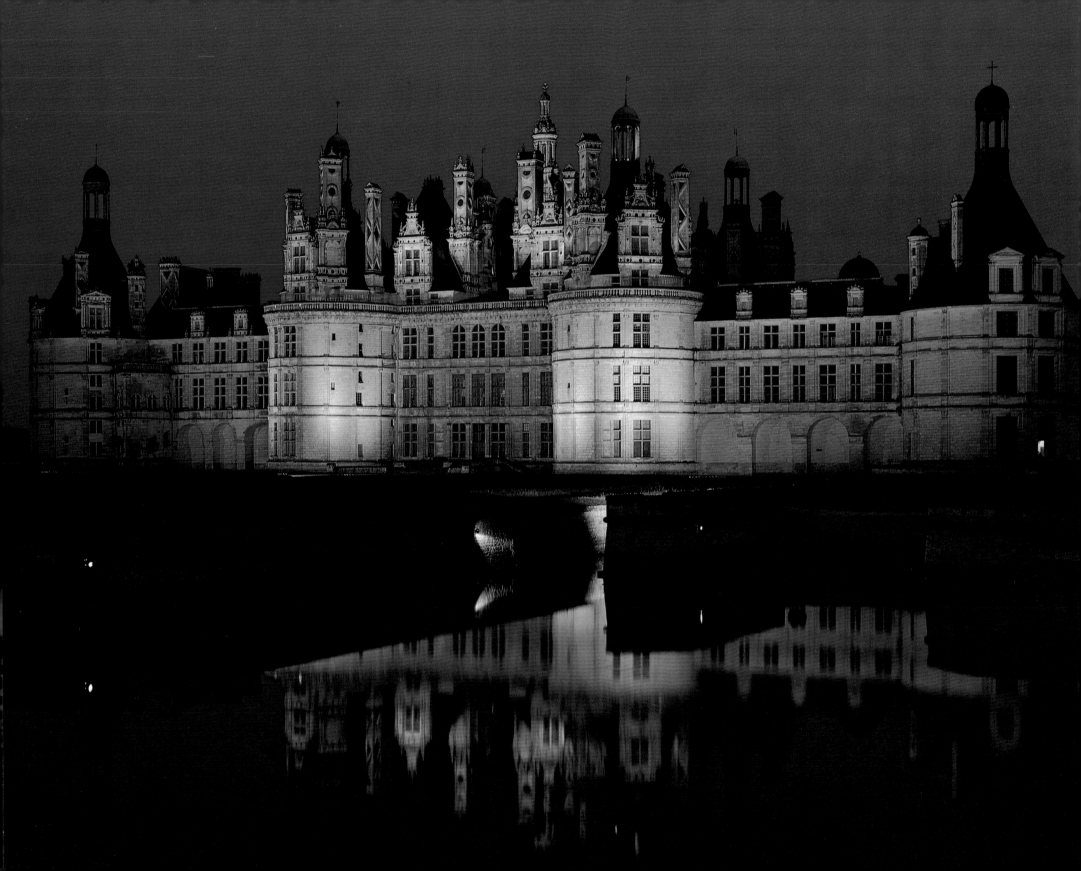

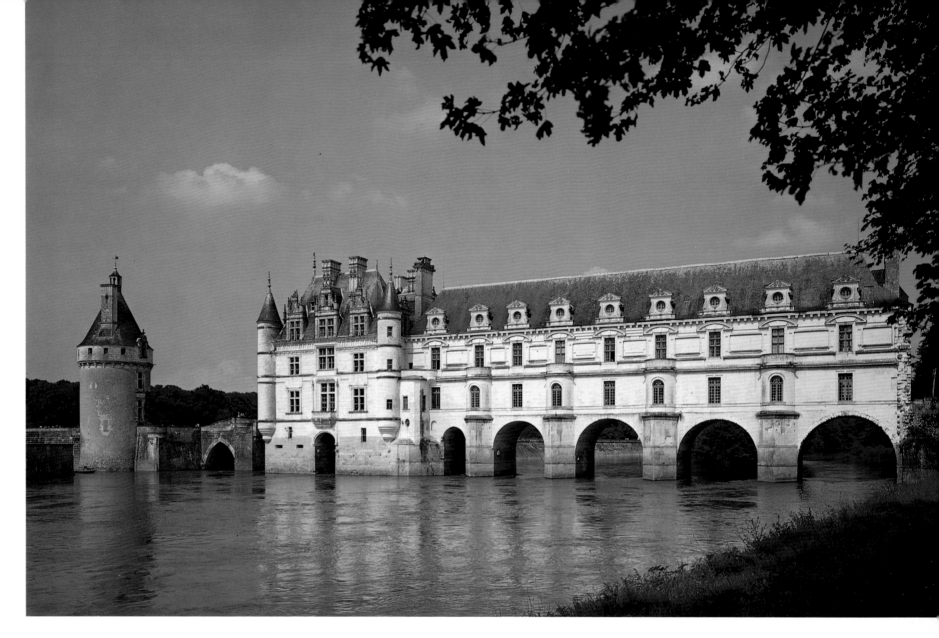

Château de Chambord, Loire Valley, France

LEFT: The beautiful Loire Valley was the playground of French kings who built magnificent châteaux to satisfy their whims for weekend hunting parties or to gain the favors of their mistresses. In a day of stark modern architecture, it is difficult to imagine the years of expert craftsmanship required to fashion this masterpiece—Chambord. This hunting lodge was owned by Francis I, King of France (1515–47) and boasts 400 rooms.

PHOTOGRAPHY DATA: Night, normal lens, time exposure. Daylight film used with standard light bulbs records a pleasing, warm illumination.

Chenonceaux Château, Loire Valley, France

ABOVE: An outstanding setting and handsome gardens make the Renaissance style Chenonceaux Château unique. On the Cher River in the Loire Valley plain, the original building was erected in 1516, with a bridge spanning the Cher added some years later. A long gallery was later built above the bridge, forming an almost separate wing different in character from the main part of the château.

PHOTOGRAPHY DATA: Afternoon, normal lens.

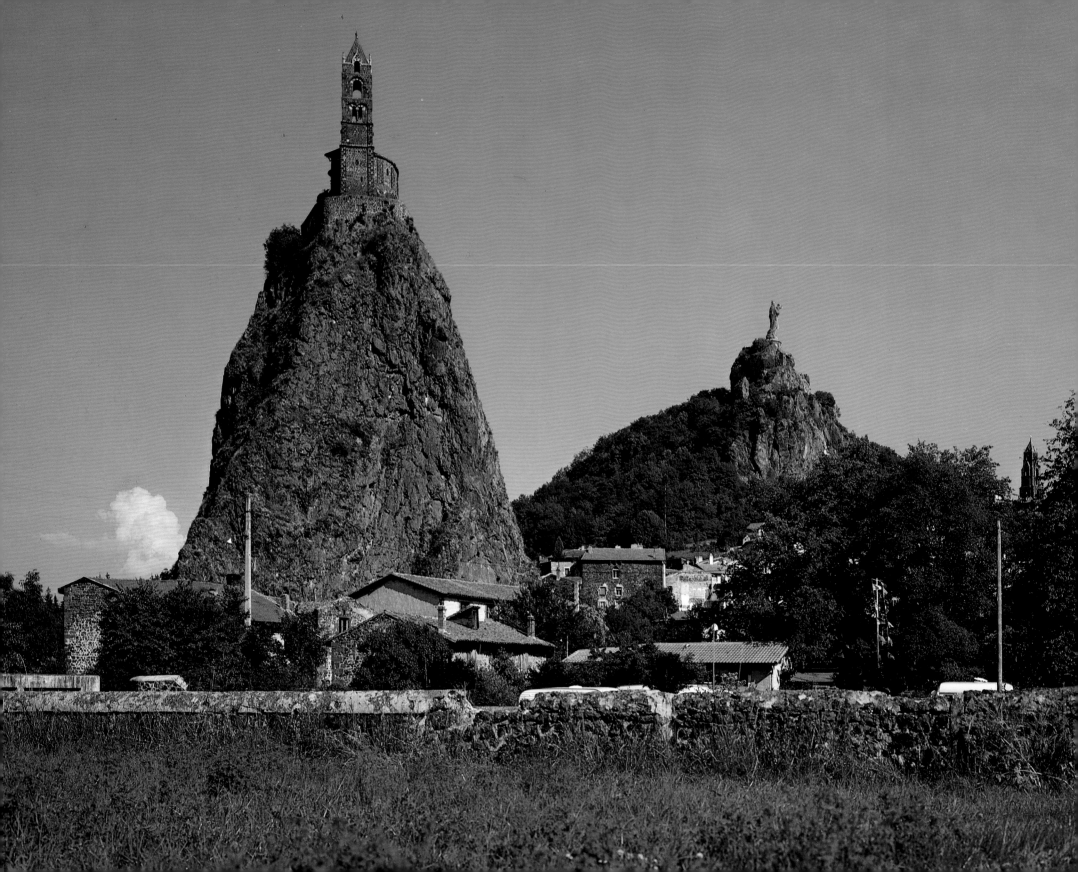

Le Puy-En-Velay, France

LEFT: Standing like great stalagmites, the massive volcanic plugs of Le Puy (The Peak) startle the curious tourist. Rising 280 feet, one lava cone is crowned with the 11th-century Chappelle St. Michel d'Aiguille. Precipitous stairs can be climbed by the faithful and energetic to reach the chapel.

Noted for exquisite handmade lace, Le Puy women, with their knee pillows studded with pins, make threads fly in the making of this dainty and artistic specialty. Factories are currently usurping this art and fewer and fewer lacemakers are seen.

PHOTOGRAPHY DATA: Afternoon, normal lens.

Amiens, France

RIGHT: Miraculously, Amiens' noble cathedral survived two World War bombings. It was undamaged during World War II even though 60 percent of the city around it was destroyed. One of the finest examples of Gothic architecture and the largest church in France, it was built during the 13th century.

PHOTOGRAPHY DATA: Afternoon, wide-angle.

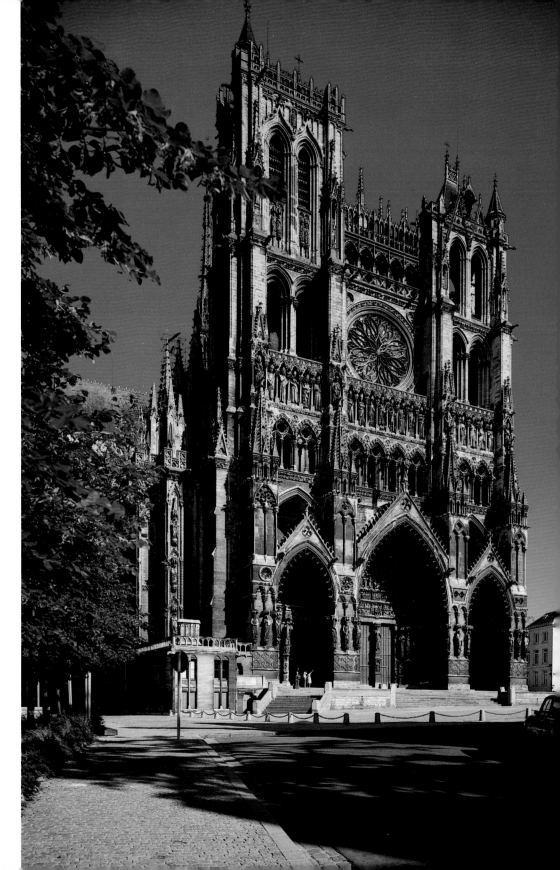

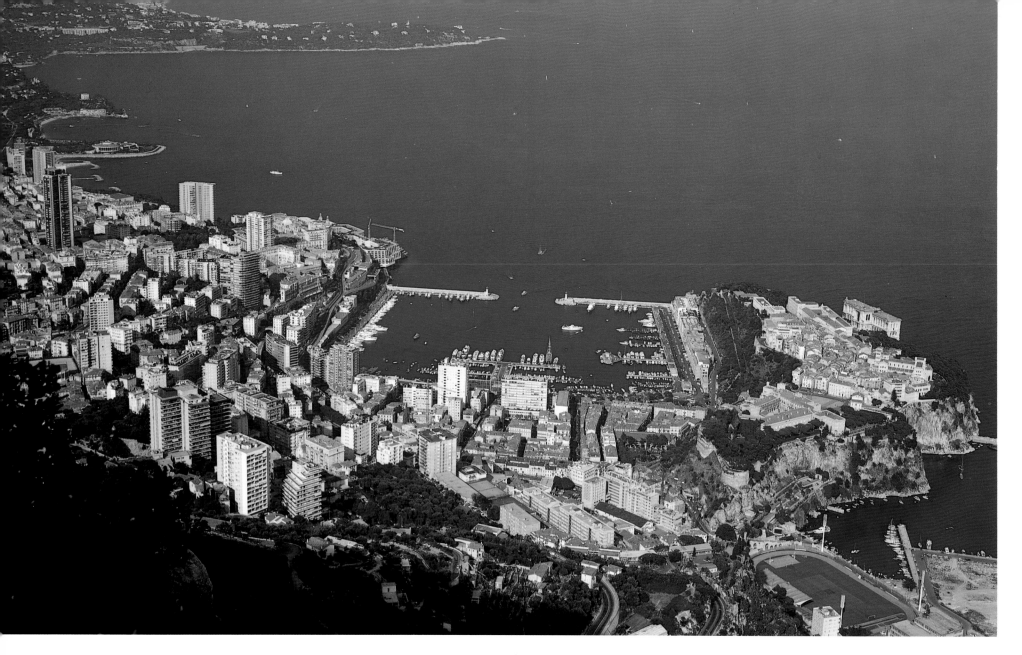

Monaco

ABOVE: A sun-splashed sovereign principality on the Mediterranean Sea, Monaco is bounded on all other sides by France. It covers a small area of about 370 acres, much of it on steep hillsides. The high rocky promontory that extends into the sea forms one side of the harbor. On this projection (called "The Rock") is the palace of Princess Grace and Prince Ranier and an outstanding oceanographic museum.

PHOTOGRAPHY DATA: Afternoon, normal lens, haze filter.

Coca Castle, Spain

RIGHT: Not far from Segovia, a Spanish castle, the pink-walled Villa de Coca, has been restored to some of its former glory. A military-type fortress, the inner high-walled and turreted castle is surrounded by a moat and outer towered walls—a very stern and forbidding castle. Built in a dry and desolate area, enemy invasion would be difficult.

PHOTOGRAPHY DATA: Morning, normal lens.

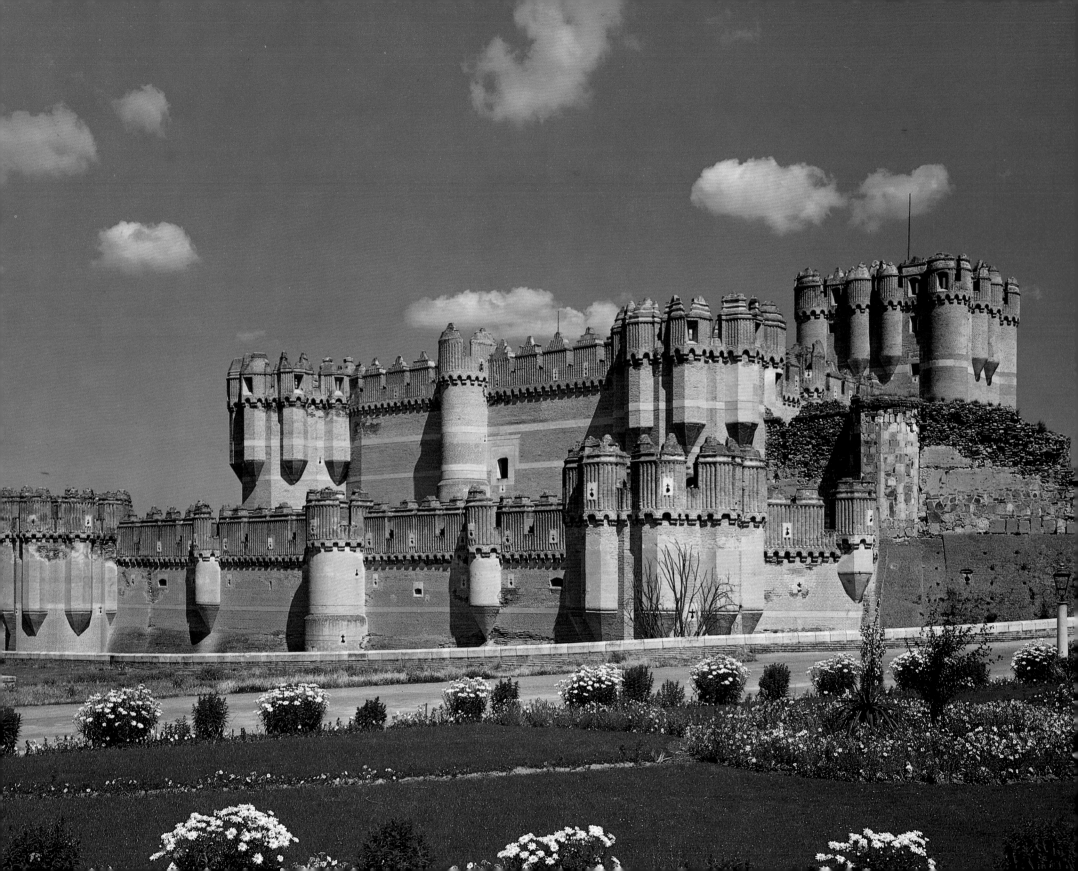

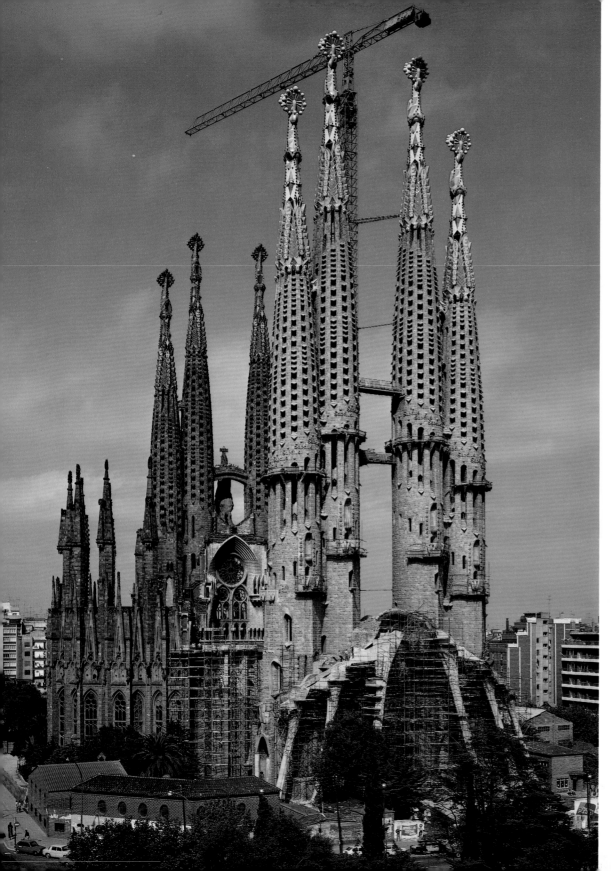

Expiatory Temple of the Holy Family, Barcelona, Spain

LEFT: Founded in the 3rd century B.C., Barcelona is a large seaport and industrial city on the Mediterranean coast of Spain. Soaring high in its skyline are the spires of the Expiatory Temple of the Holy Family. Begun in 1882 (a very recent date for a cathedral), it is still under construction and won't be completed during our lifetime. Erection of the temple was instigated by Jose Bocabella, a bookseller. Architect Francisco del Villar sketched the plan. After his resignation the work was turned over to architect Antonio Gaudí who spent all his life on it. Building has continued spasmodically since that time, depending on funds available and settling of disputes over its design.

PHOTOGRAPHY DATA: Late afternoon, wide-angle lens. While it is possible to photograph these spires from a park to the west, a balcony several floors above the streets is advantageous.

Toledo, Spain

RIGHT: Situated on a high granite hill, surrounded on three sides by the Tagus River, Toledo is only forty miles from Madrid. Steep, narrow and winding streets inside the city impart a medieval look. Of special interest to visitors is the painting called the "Burial of Count Orgas" in the Santo Tomé Church, painted by El Greco, the famous Spanish artist. Having been born in Crete, he was afflicted with a long Greek name, mercifully reduced to El Greco (The Greek) by his compatriots. The former home of this great artist is now a museum containing more of his paintings.

Of further interest are the Toledo or Damascene etched steel knives and ornaments which originated long ago in Persia.

PHOTOGRAPHY DATA: Morning, wide-angle lens.

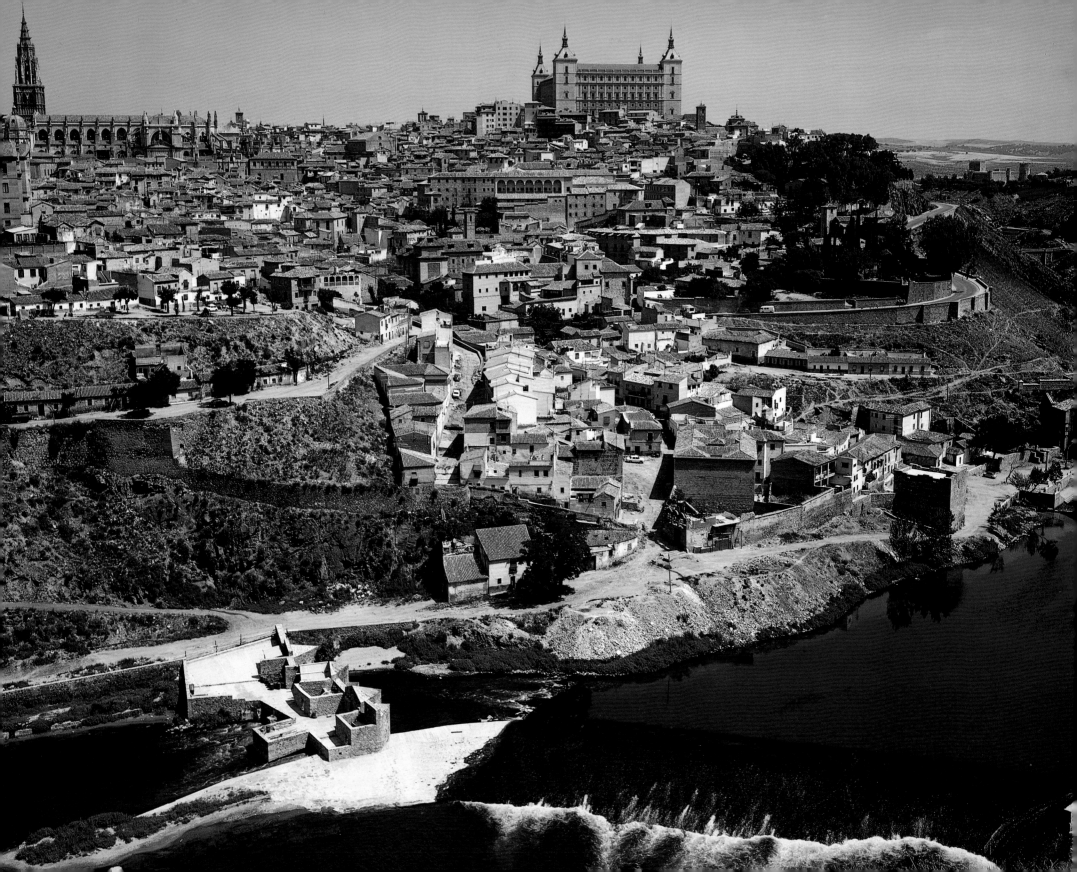

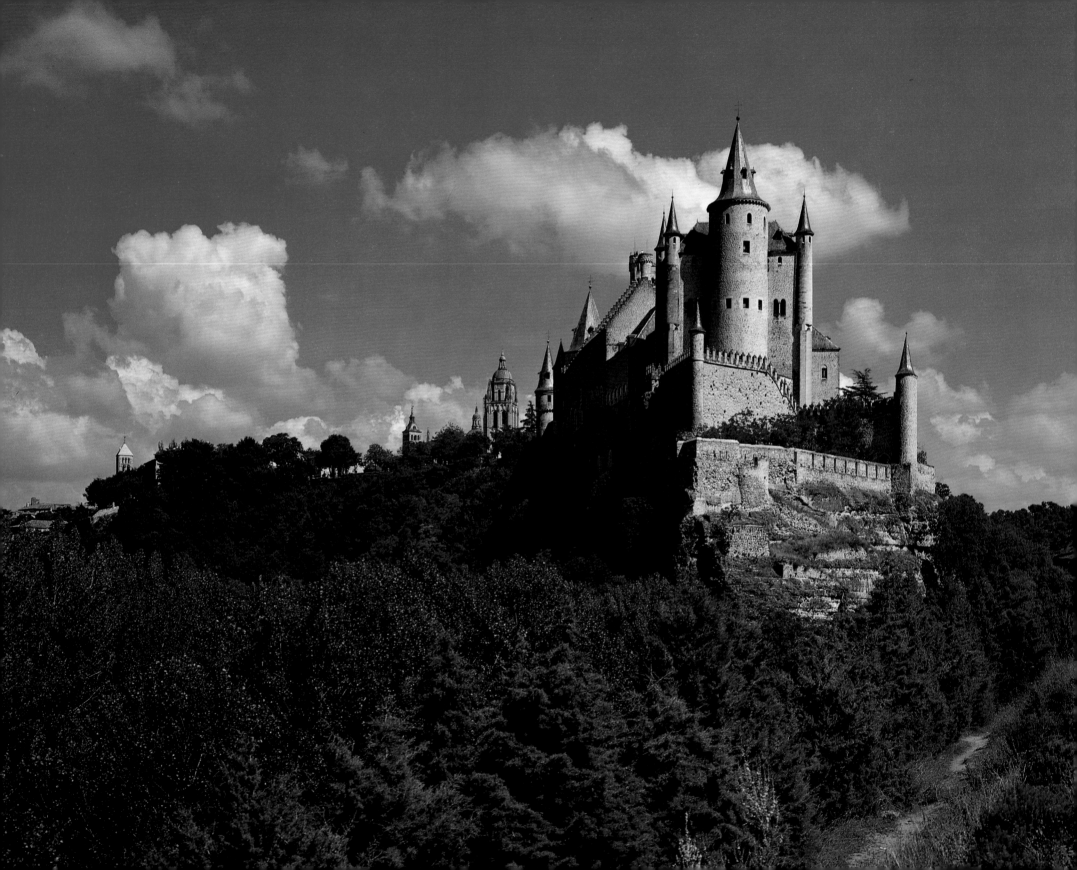

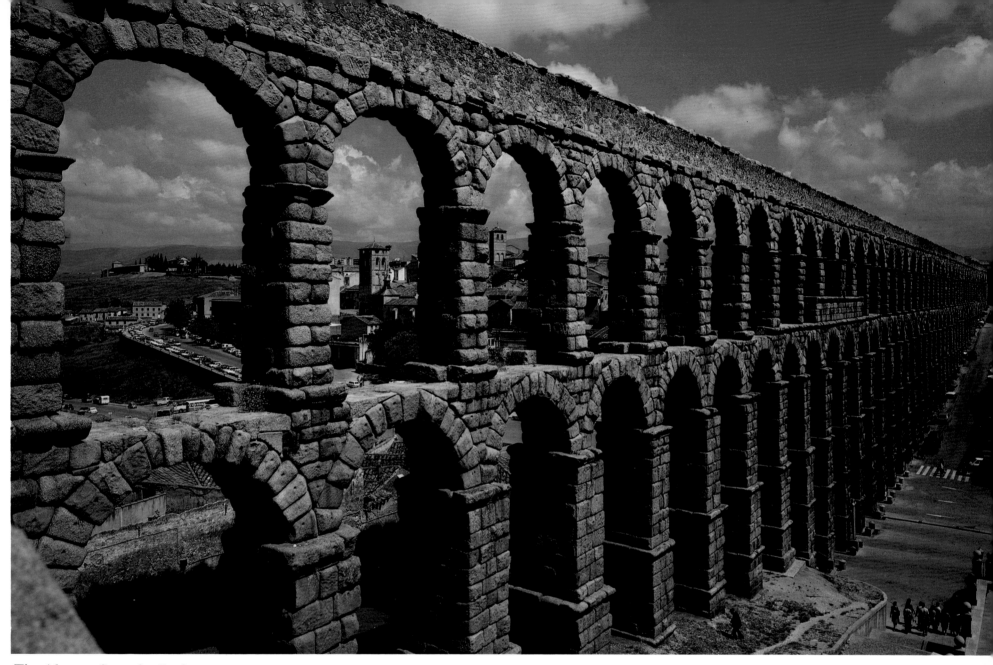

The Alcazar, Segovia, Spain

LEFT: A morning's drive from Madrid will take you to Segovia and a visit to a story-book castle, the great and mighty Alcazar. Dramatically perched on a craggy precipice, it was begun during the 11th century, rebuilt in the 14th, and is an outstanding example of an old Castillian Castle. It was here that Isabella I, who was to finance Christopher Columbus' trip in 1492, was crowned Queen of Castile.

PHOTOGRAPHY DATA: Late afternoon, normal lens. Normally very late evening light gives a warm glow, yet dissipating clouds necessitated earlier photography.

Roman Aqueduct, Segovia, Spain

ABOVE: Over 90 feet high, the arched Roman Aqueduct at Segovia is an impressive landmark that still supplies the city with water. Standing since the 2nd century, it was built of huge white granite stones fitted together without cement. The Romans' technological accomplishments in engineering remain after all these centuries for us to study and admire.

PHOTOGRAPHY DATA: Early afternoon, wide-angle lens. A precise timing hid many cars in shadows and emphasized the stonework.

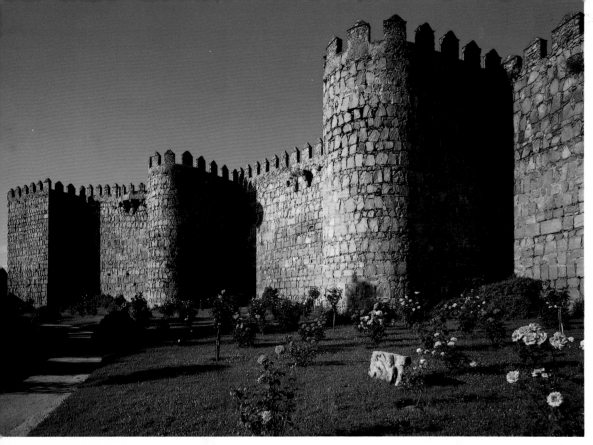

Avila, Spain

LEFT: Avila's 40-foot-high dark granite walls, built during the 11th century, have over eighty turrets and nine gateways, though they are only a little more than a mile and a half in length. It is hard to picture this charming walled city as a bastion of defense against invaders, but Avila stands in a heavily trafficked pass and in an earlier day the fighting was almost constant.

PHOTOGRAPHY DATA: Morning, wide-angle lens.

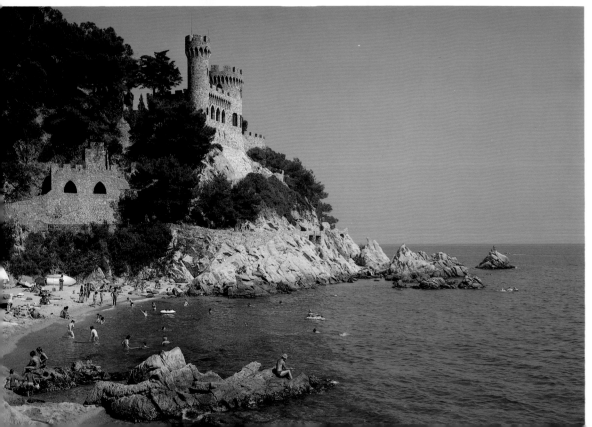

Llorett de Mar, Costa Brava, Spain

LEFT: All along the Costa Brava seacoast of Spain are beach resorts that have sprouted up since European travel has increased in popularity. Spain not only has sun and sand along the warm Mediterranean Sea but also is much less expensive than most of the rest of Europe. Spain's roads and resorts are particularly crowded during the months of July and August which is holiday time for most Europeans. Llorett de Mar is a small seaside village that has grown into a vast resort area.

PHOTOGRAPHY DATA: Morning, normal lens.

Tossa de Mar, Costa Brava, Spain

RIGHT: The rough and rugged seacoast of Spain extending from Barcelona to the French border, known as the Costa Brava, has many warm, sun-kissed beaches. Holiday crowds from the cooler and damper climates of Europe converge here in enormous numbers to swim in the warm Mediterranean Sea and acquire a suntan (or sunburn). Once a small fishing village, Tossa de Mar is now a popular beach resort.

PHOTOGRAPHY DATA: Midmorning, normal lens.

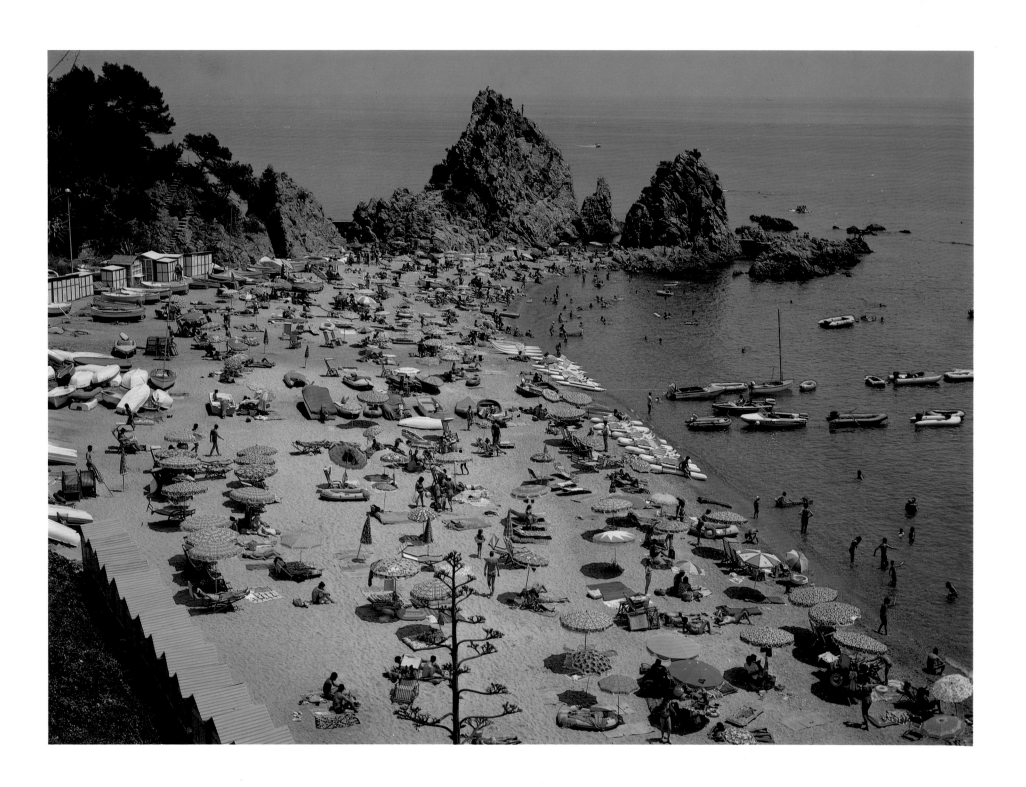

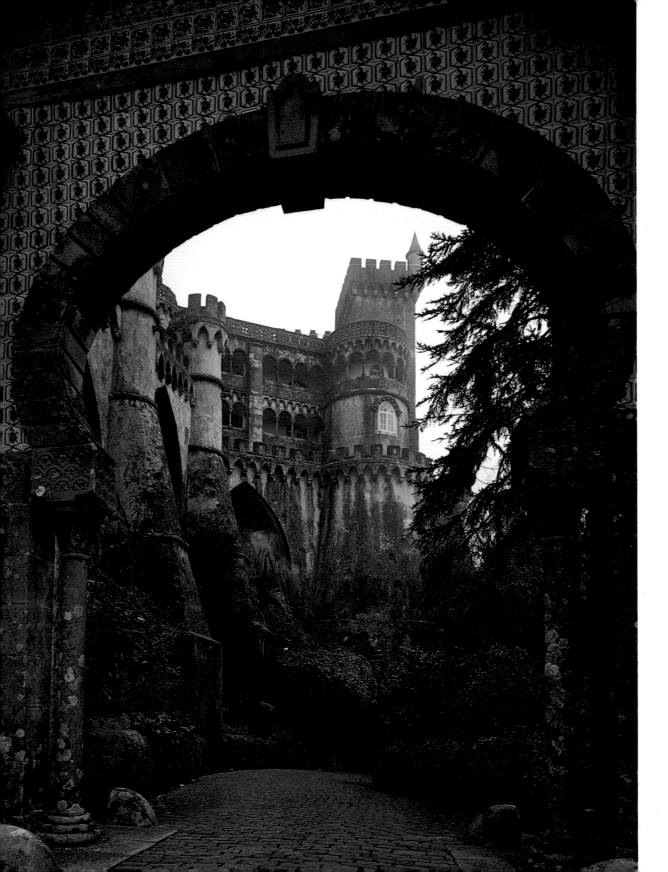

Sintra, Portugál

LEFT: Sintra is a resort village in the cool mountains that ascend above the Costa del Sol (Coast of the Sun) west of Lisbon. Near Sintra on a wooded green hill, the King-consort of Portugal's Queen Maria II built a fairy-tale castle in 1840. Its lofty towers, cupolas and walls are reminiscent of castles in his native Germany. The gateway to this citadel is particularly ornate and unusual.

PHOTOGRAPHY DATA: Morning; wide angle lens; cloudy. Photo by Naurice Koonce (See credit page).

Navigation Monument, Lisbon, Portugal

BELOW: Before Columbus discovered America, the Portuguese Prince Henry the Navigator had sent ships to explore the uncharted coast of west Africa. Although he himself never traveled, he established an observatory and a school and designed navigational instruments which gave great impetus to the foundation of the Portuguese empire overseas. This interesting modern monument on the Tagus River honors Henry the Navigator.

PHOTOGRAPHY DATA: Morning, long lens. Photo by Naurice Koonce (See credit page).

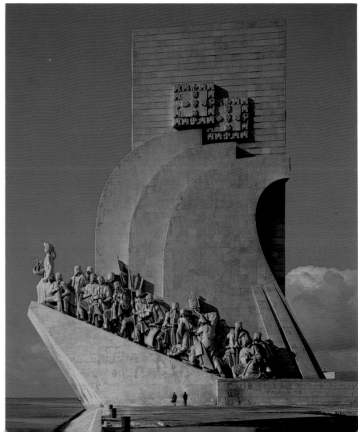

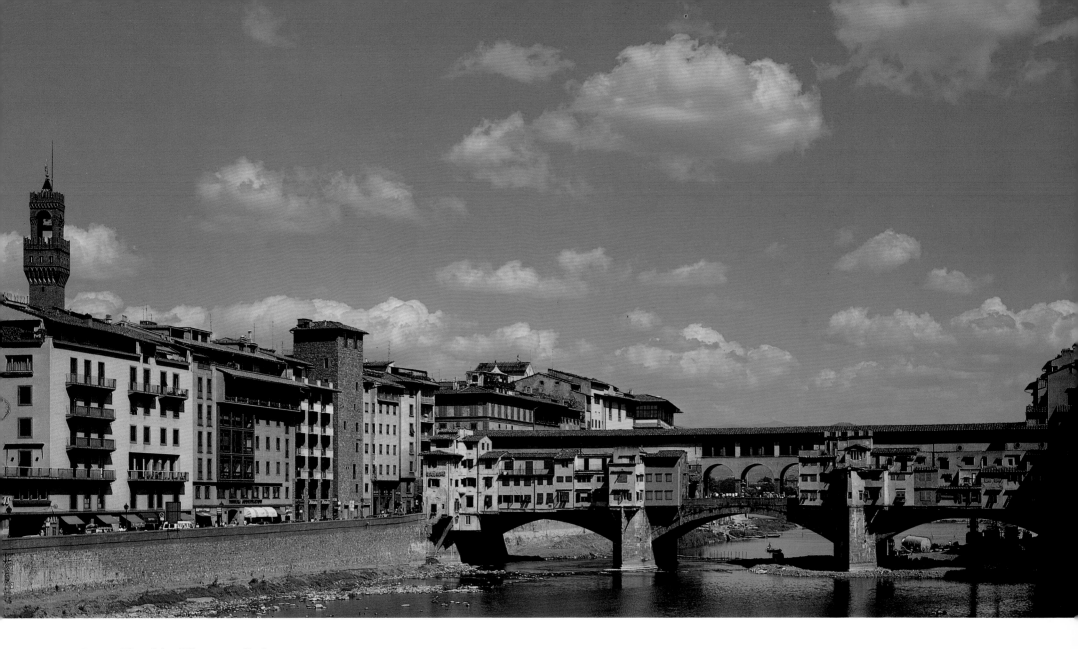

Ponte Vecchio, Florence, Italy

ABOVE: Rebuilt in 1345, Ponte Vecchio (Old Bridge) first spanned the Arno River when Florence (Firenze) was still a Roman military colony. Since that time, the Arno has risen several times above the arches of the bridge, with the flood of 1844 being one of the worst. Some repair work was necessary after World War II when, fortunately, the Ponte Vecchio escaped total demolition—the only bridge in Florence spared by the retreating Germans. But the catastrophe which struck Florence in 1966, when a dam controlling the Arno burst, was the most disastrous of all. Water and mud gushed into this city of treasures, and the world was grief-stricken. The Ponte Vecchio was badly battered but continued to stand. After cleaning and restoration it has today resumed its function as a bridge of shops.

PHOTOGRAPHY DATA: Afternoon, normal lens.

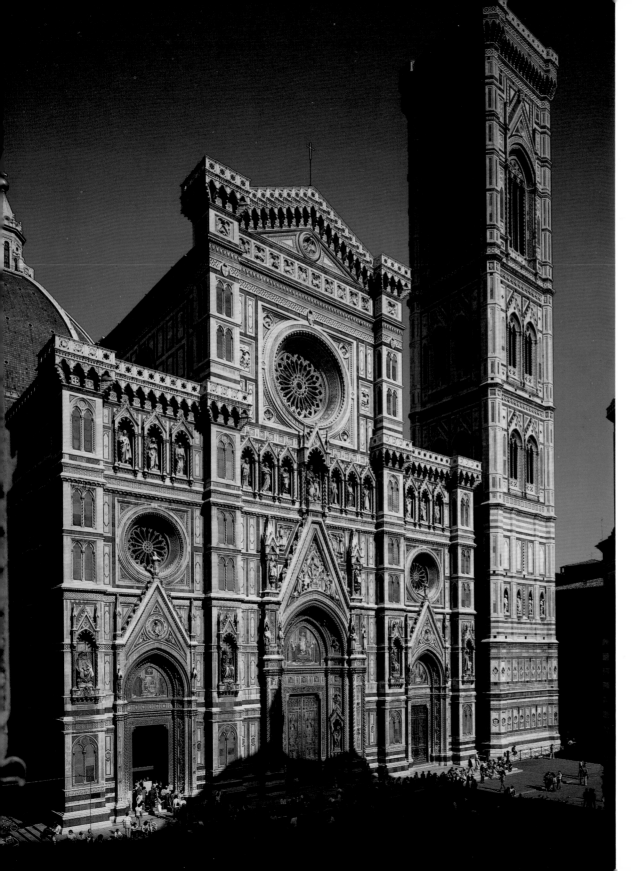

Duomo, Florence, Italy

LEFT AND RIGHT: Italy is a country of delightful beaches, lovely lake resorts and wonderful mountains, as well as incomparable riches in art and archeology.

Florence, or Firenze, is particularly saturated with history and culture. The building of the Cathedral of Santa Maria del Fiore, in the Piazza del Duomo, covered a period of about 165 years. Architecturally, it included styles which stretch from Gothic to Renaissance. One of the more colorful cathedrals, it is faced with white, green and red marble, the colors of the Italian flag.

PHOTOGRAPHY DATA: Afternoon, wide-angle lens.

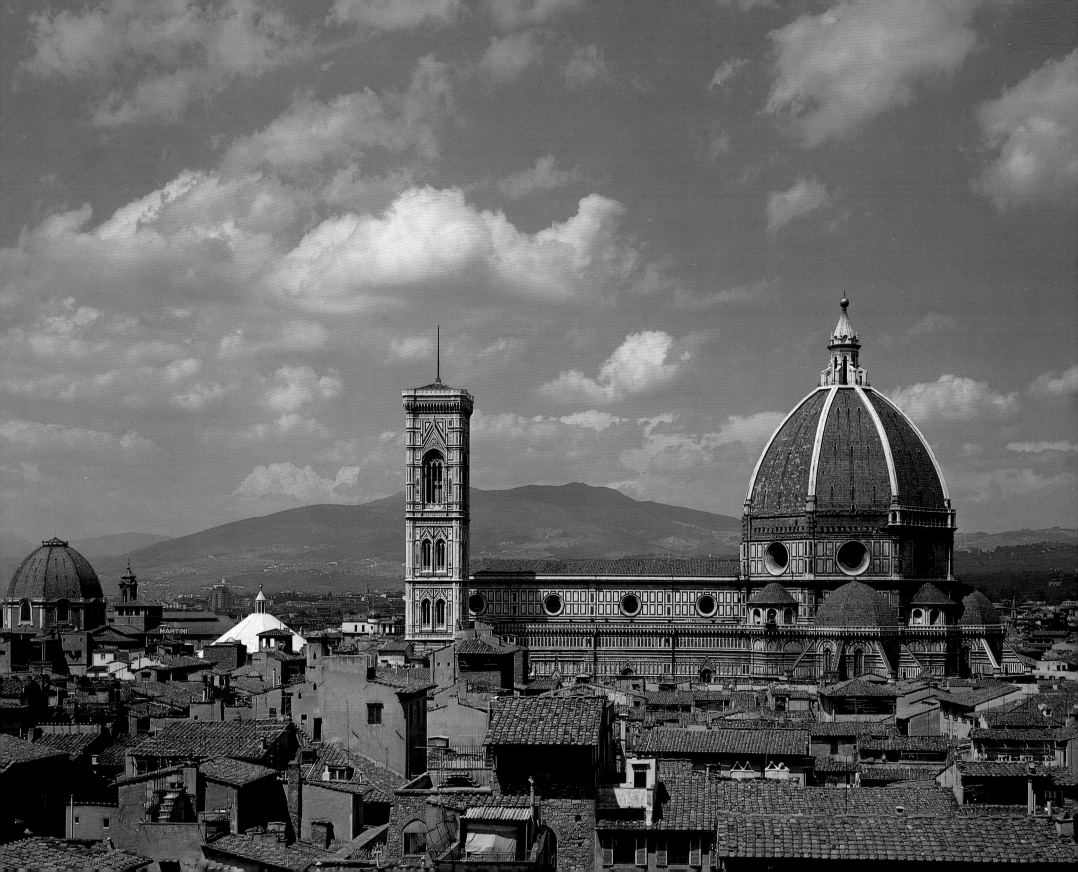

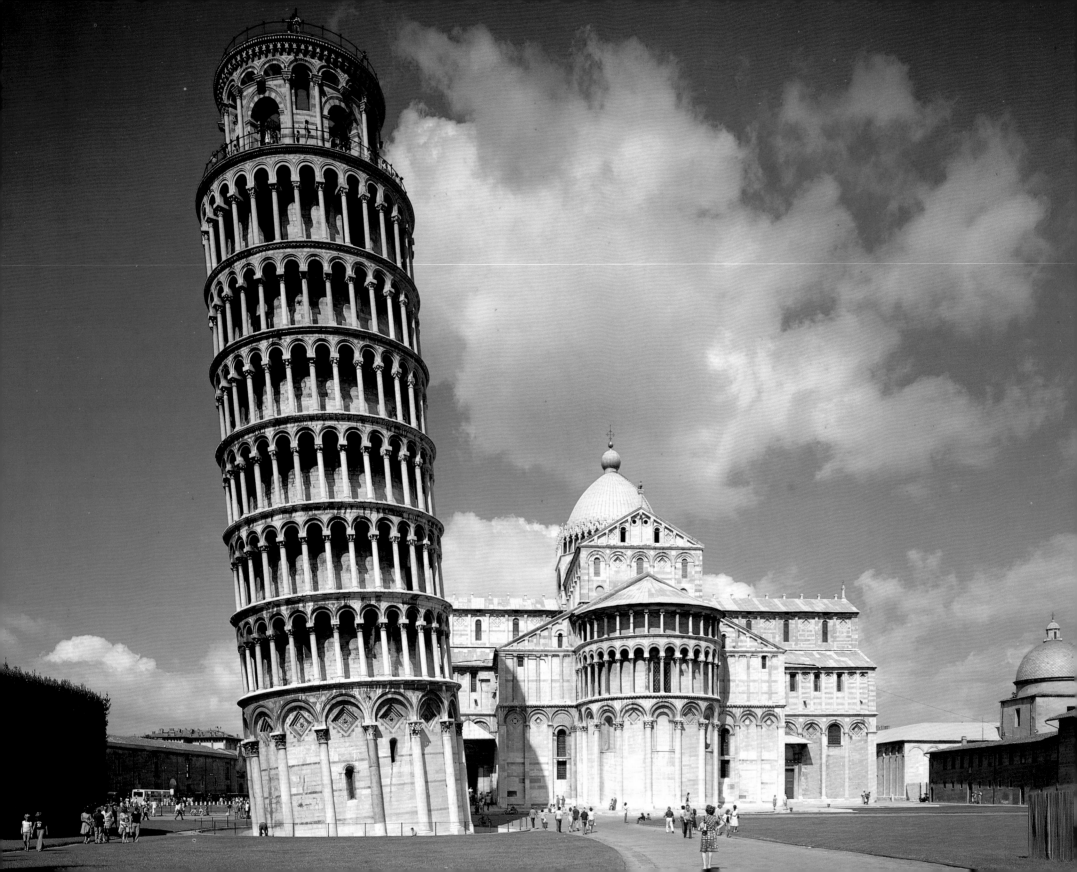

The Leaning Tower of Pisa, Italy

LEFT: Galileo (1564–1642) was born in Pisa. The swinging lamp in the Cathedral of Pisa brought forth his observation of the perfect timing of the pendulum. Later he demonstrated to scientists from the Leaning Tower of Pisa how bodies of different weights fall with the same velocity. The Tower was not conceived as a leaning campanile, but through the years its ''angle of repose'' has increased. Early in its tilting, the builders decided to omit the gold spire originally planned. You may climb the interior circular staircase to the belltower (almost 300 steps lead dizzily to the top) but it's a very strange sensation as the angle of the stairs is the same as the Tower.

PHOTOGRAPHY DATA: Morning, wide-angle lens.

Siena, Italy

RIGHT: An artist's yellowish-brown pigment is called raw sienna. After roasting the raw clay in a furnace it turns a reddish-brown and is then called burnt sienna. This color is named for the Italian city of Siena which is built on the yellowish-brown hills, in the center of a rich agricultural region.
It is noted for its wine and marble and the celebrated festival of the Palio, an annual summer horse race held on the main town square. Townspeople dress in ancient costumes, heraldic flags are flown, bells toll and excitement fills the air.

The horizontally striped cathedral is made of brick with marble facings. The interior is remarkable for the elaborate striping of light and dark marble covering the walls and columns and for the intricately inlaid floor. Marble is used bountifully all over the city—our small hotel had marvelous pink marble floors.

PHOTOGRAPHY DATA: Past noon, wide-angle.

59

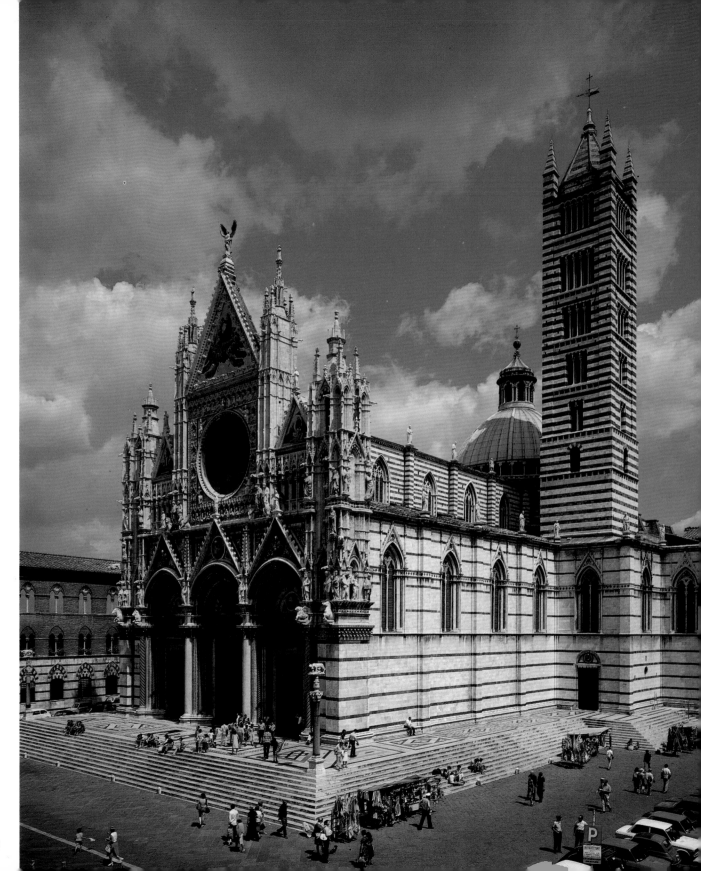

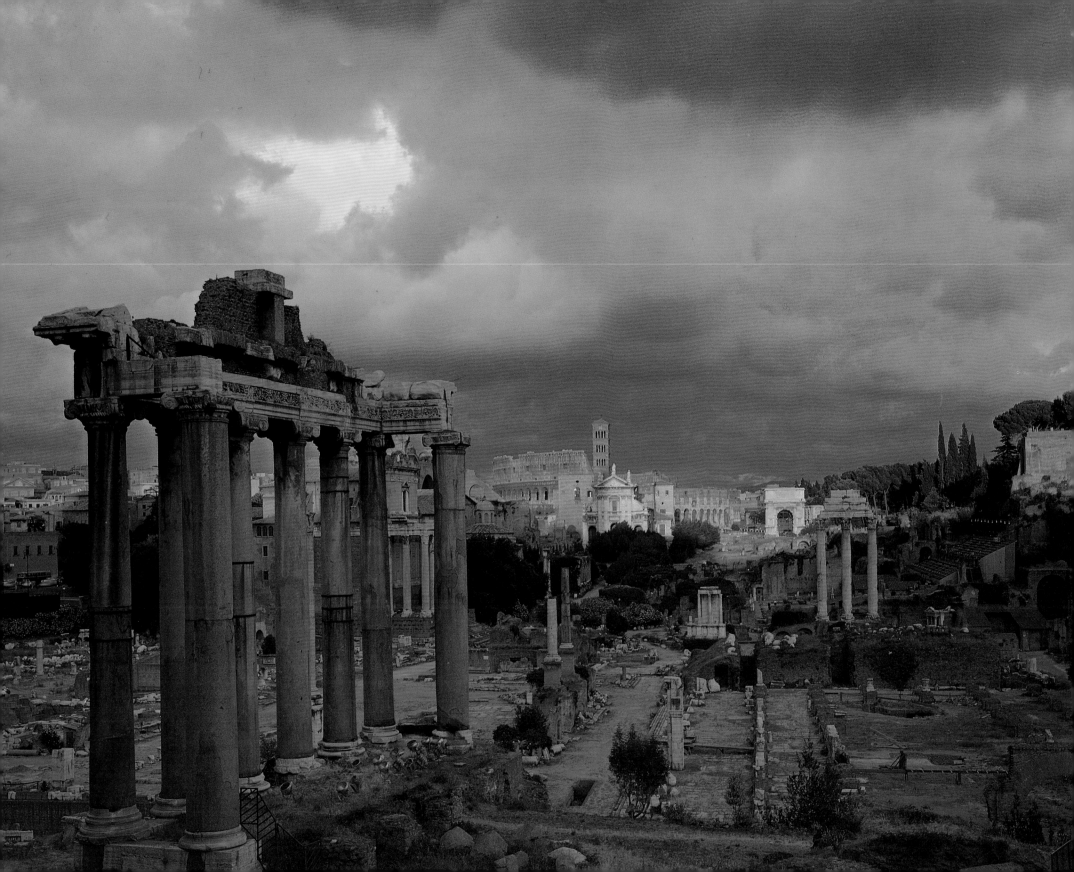

The Roman Forum, Rome, Italy

LEFT: Romulus and Remus, according to a traditional historical account, founded a settlement on the Palatine Hill of Rome in 753 B.C. This date is substantiated by archeological evidence. This community joined with others in the early 6th century B.C. to establish a city around a site that later became the Roman Forum.

The Roman Forum (Forum Romanum), the oldest and largest of the forums, expanded many times in its history, moving some of its secondary functions to other locations. Even so, lack of space made necessary the building of new forums by emperors who wished to immortalize themselves.

A focal point of Roman government of the empire, the Forum was in the center of the ancient city. The erection of its triumphal arches, temples, monuments and state buildings accompanied the rise of Rome to world power; the ruins show its fall during the Middle Ages when war was waged against paganism.

PHOTOGRAPHY DATA: Late afternoon, normal lens.

St. Peter's, Vatican City, Italy

RIGHT: Vatican City, the tiniest sovereign state in the world, is the official home of the Pope and the center of the Roman Catholic Church with its own passports, stamps, newspaper, radio and railroad system. Covering only 109 acres within the city of Rome, Vatican City has the world's largest Christian church, St. Peter's. Michelangelo's plans for the church and Bernini's colonnades, as well as the work of many other designers, make it one of the most impressive buildings in the world. Begun in 1506 above the tomb of St. Peter, it was finally crowned with the dome designed by Michelangelo in 1570. Much later, in 1667, Bernini's entrance piazza surrounded by graceful columns was added.

Tourists of all faiths never fail to visit this famous basilica.

PHOTOGRAPHY DATA: Sundown, normal lens.

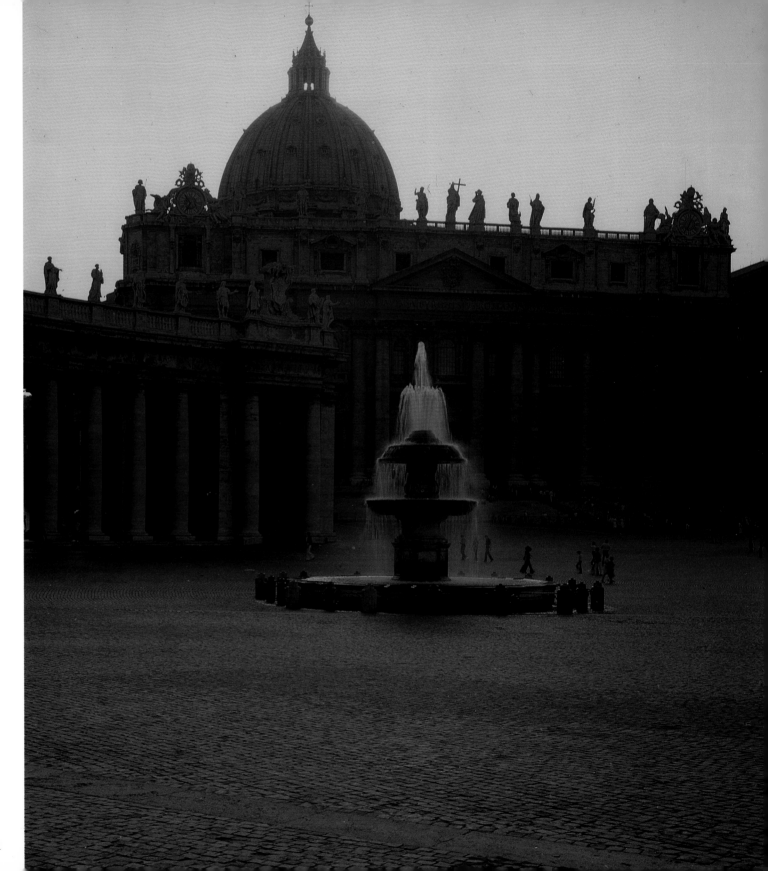

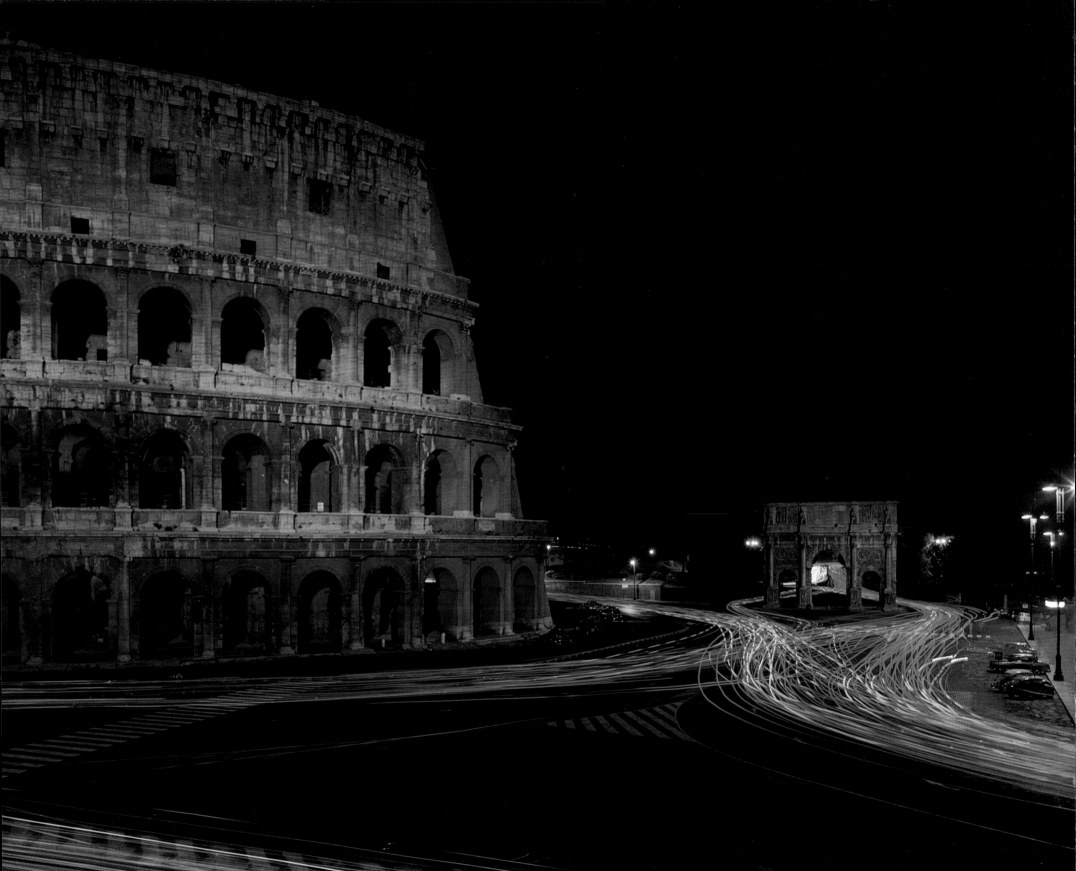

The Colosseum, Rome, Italy

LEFT: Part of the glory that was Rome, built 72–80 A.D. by the Emperor Vespasian and his sons Titus and Domitian, the Colosseum was a large amphitheater. In the tiers of seats which encircled the structure, almost 50,000 Romans could be seated according to their status, with the emperor and his nobles on the lowest level, protected from the dangers of the arena by a 15-foot wall. Gladiators fought wild animals and Christians were sacrified mercilessly to hungry lions. For almost three centuries the ghastly crimes in the Colosseum amused the decadent Romans.

Much of the structure remains, despite partial dismantling during the Middle Ages, when its stones were broken up to be used in new buildings. Damage also was suffered by the Colosseum through fire, earthquake and vandalism. Although stripped of the marble and the travertine coating it once had, the Roman Colosseum is still a wondrous sight.

PHOTOGRAPHY DATA: Night, wide-angle lens, time exposure.

Venice, Italy

RIGHT: Venice has inspired poets and painters for many hundreds of years with its elegant old palaces, majestic churches and dwellings lining the canals. Their original rich hues have been muted by centuries of time to soft pastel tones.

Traversed by more than 150 canals, Venice is divided into two distinct parts by the beautiful Grand Canal. Transportation is by motorboats, barges, ferries and, of course, by the graceful gondolas. These traditional Venetian boats are manned by gondoliers in their colorful costumes of straw hats, striped shirts, red sash and black trousers. When not in use, the gondolas are tied to wooden posts (many resemble barber poles) along the canals.

The magnificent 17th Century church, Santa Maria della Salute, lends its imposing silhouette to further enhance the evening sky.

PHOTO DATA: Sunset, long lens.
Exposure for a sunset photograph while the sun is above the horizon can be metered by shading the meter from the direct sun rays. If a colored filter is used, place it over the meter for its compensating factor.

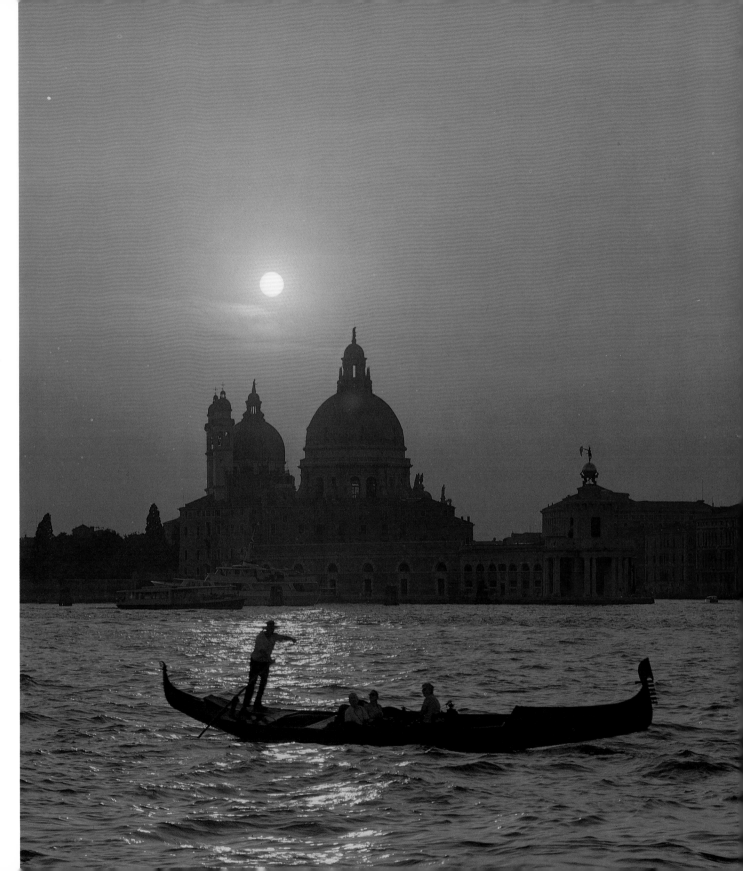

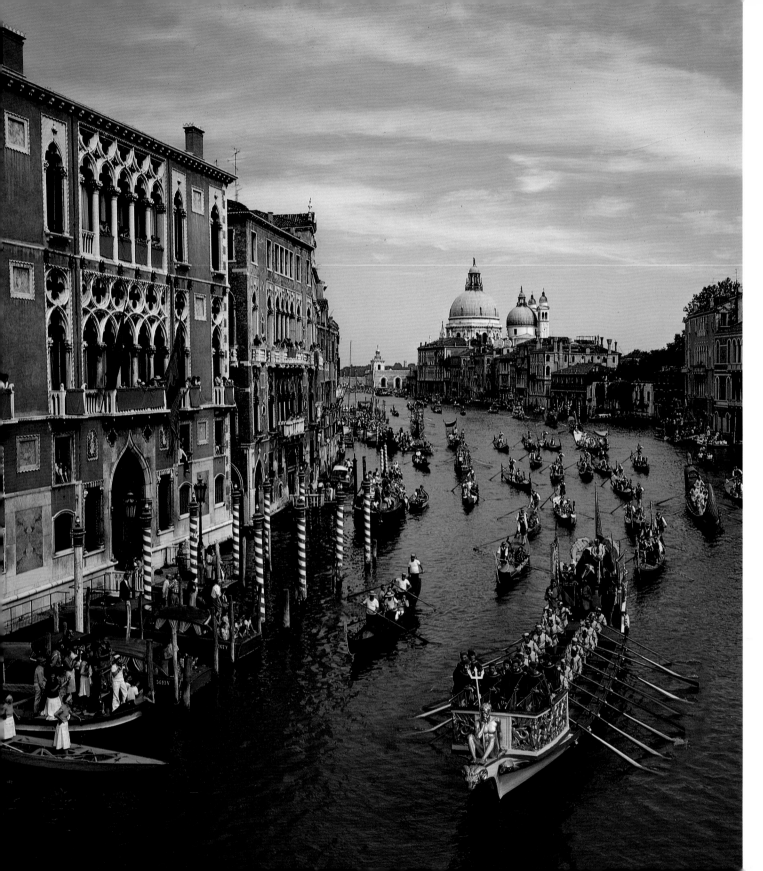

The Historical Regatta (La Regata Storica) Venice, Italy

Venice, home of the gondala, has given great importance to regattas through the centuries. The most significant and competitive event of them all is La Regata Storica. It recaptures the beautiful traditions and historical episodes of the Venetian Republic with an incredible visual delight. The competitive race is preceded by a fantastic water parade; antique gondolas with oarsmen in period costumes, richly furnished boats and the graceful, swift crafts of the rowing societies which still thrive in Venice today. Countless other large, small, lavish and simple gondolas complete the extra-ordinary scene. Colorful cheering onlookers on the bridges, the ferry landings, at the windows and balconies of the palaces and on boats and barges, all relish the wondrous spectacle unfolding on the Grand Canal. With such a profusion of gondolas, people and costumes to see, I found myself wishing it could all be done in slow motion so I wouldn't miss anything! And then the races started—with events for different sized gondolas, with varying numbers of rowers, including events for women. Each team with their matching colors and brilliant sashes is urged on by the crowd as their gondola rows out and around the bend. Anticipation builds until the exhausted contestants reappear and head for the finish line.

It is like this every year on the first Sunday in September on the Grand Canal. We've seen this Venice regatta twice and find its fascination and colorful beauty unforgettable.

PHOTOGRAPHY DATA: LEFT: Afternoon, wide-angle lens. RIGHT: Afternoon, normal lens.

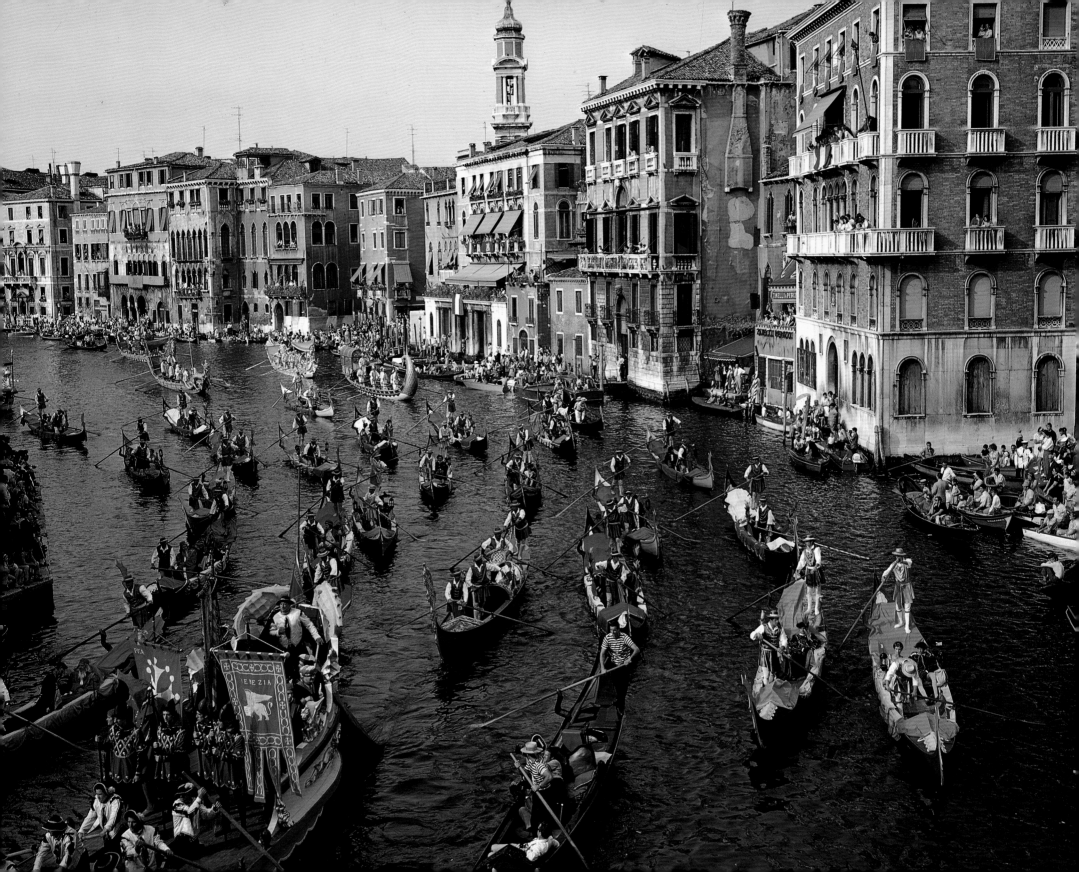

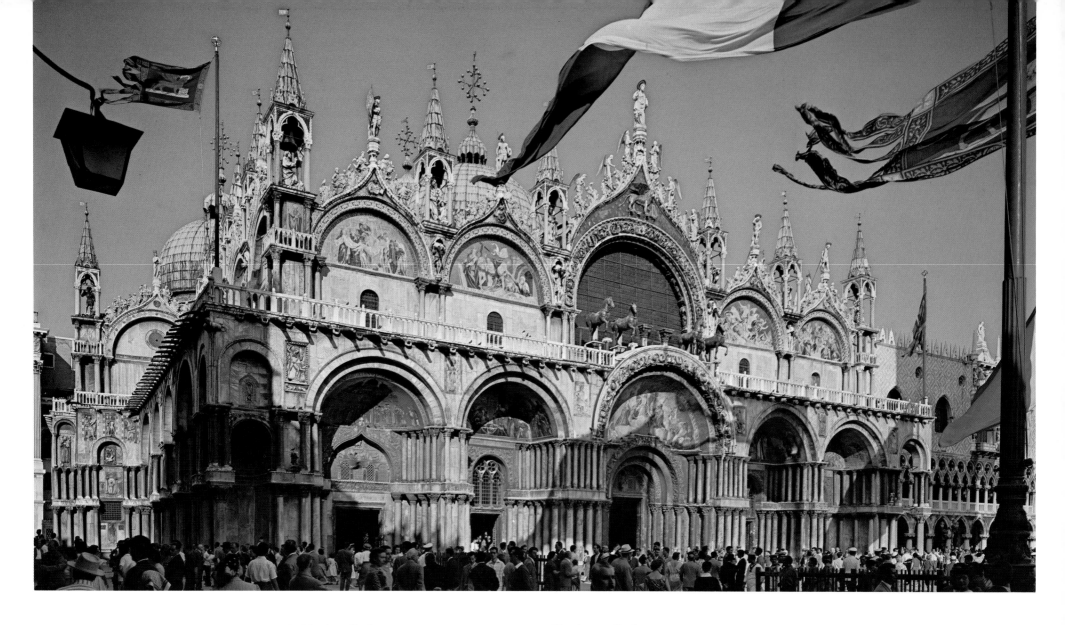

St. Mark's (San Marco) Cathedral, Venice, Italy

ABOVE: The Cathedral of San Marco is dedicated to the patron saint of Venice. Built in the form of a cross, the basilica is topped by four large domes of equal size, with a fifth more massive dome in the center. One of the finest remaining examples of Byzantine architecture, St. Mark's has an ornate facade with five arched portals facing St. Mark's Square. The handsome Greek-sculptured quartet of horses over the main portal are well-traveled—from Alexandria to Rome to Constantinople. Taken as booty during the 4th Crusade they were transported from Constantinople to Venice. Napoleon later commandeered them to be used on his triumphal arch in Paris. After Napoleon's fall, the prized bronze steeds were returned to Venice. Now an endangered species because of modern air pollution, they are being transported to the interior of St. Mark's for public viewing in sealed glass cases.

PHOTOGRAPHY DATA: Afternoon, wide-angle lens.

Positano, Italy

RIGHT: A narrow winding road on the precipitous cliffs along the Mediterranean, the Amalfi Drive passes through many villages that cling to the steep hillsides like vines.

Positano was once a small, quiet village but has become a bustling resort. On a small curving bay with cerulian blue water, the green and yellow tiled dome of the church dominates the view of the town.

PHOTOGRAPHY DATA: Morning, wide-angle lens.

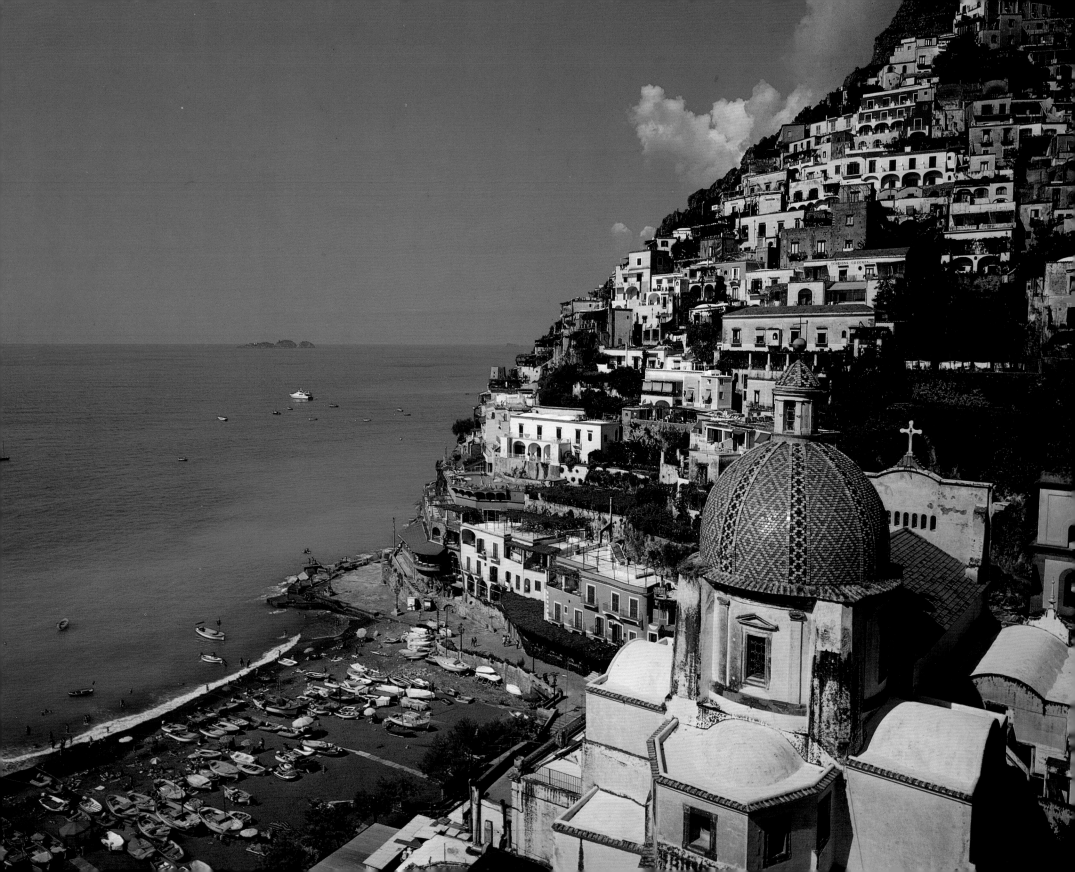

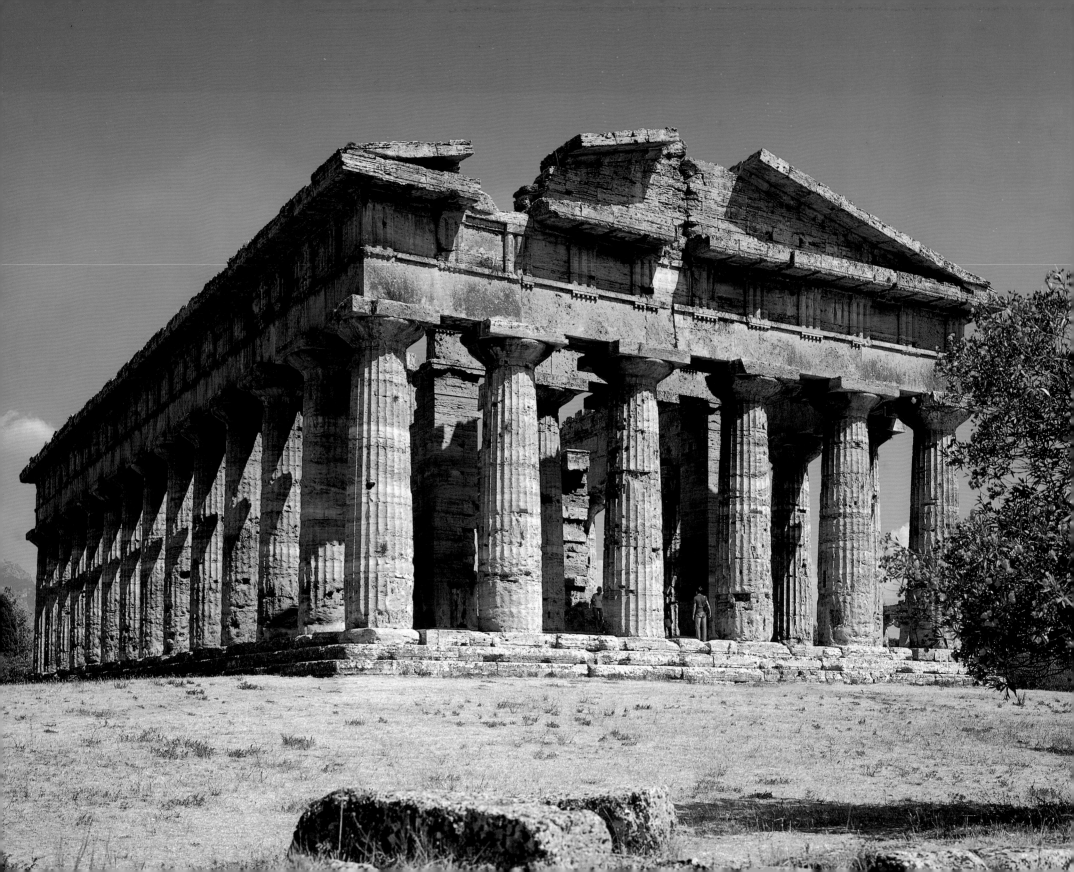

Temple of Poseidon (Neptune), Paestum, Italy

LEFT: Buried for many years in the malarial swamps on the Bay of Salerno, Paestum is a reminder that the Greeks once inhabited this part of southern Italy. These imposing ruins, now excavated from the silt which engulfed them, are still masterpieces of Greek Doric Architecture. The 5th century B.C. Temple of Poseidon is the only one that has retained its cornices and the two gables.

PHOTOGRAPHY DATA: Afternoon, normal lens.

Amalfi, Italy

RIGHT: Amalfi, on the north coast of the Gulf of Salerno, was at one time a great naval power. It was an independent Republic and an important trade center in the 9th century. It has no real harbor today; a long tunnel through the rock is the dramatic entrance to this ancient town founded by the Romans. Amalfi is one of Italy's most beautiful seacoast towns with terraced gardens on the steep hillsides. Grapevines, lemon trees and flowers—particularly the bright-blossomed bougainvillea—create a colorful vista against the predominantly white buildings.

PHOTOGRAPHY DATA: Midday, wide-angle lens.

Atrani, Italy

PAGE 70: There seems to be a similar pattern to the towns built along the narrow and winding Amalfi Drive. At Atrani the tiny bay is usually crowded with fishing and pleasure craft. And, as usual, a colorfully tiled church dome surmounts the village scene.

PHOTOGRAPHY DATA: Morning, normal lens.

Dolomites, Italy

PAGE 71: Part of the Italian Alps, the spectacular saw-tooth pinnacles called the Dolomites are a magnesium limestone formation and are streaked with colorful veins. Named for the French geologist Dolomieu, the Dolomites were shaped by erosion. In 1956 the Winter Olympics were held in Cortina d'Ampezzo, a town in the heart of these mountains. Our view shows Misurina Lake with the serrated Cadini Peaks in the background, a short mountain drive from Cortina.

PHOTOGRAPHY DATA: Midday, normal lens.

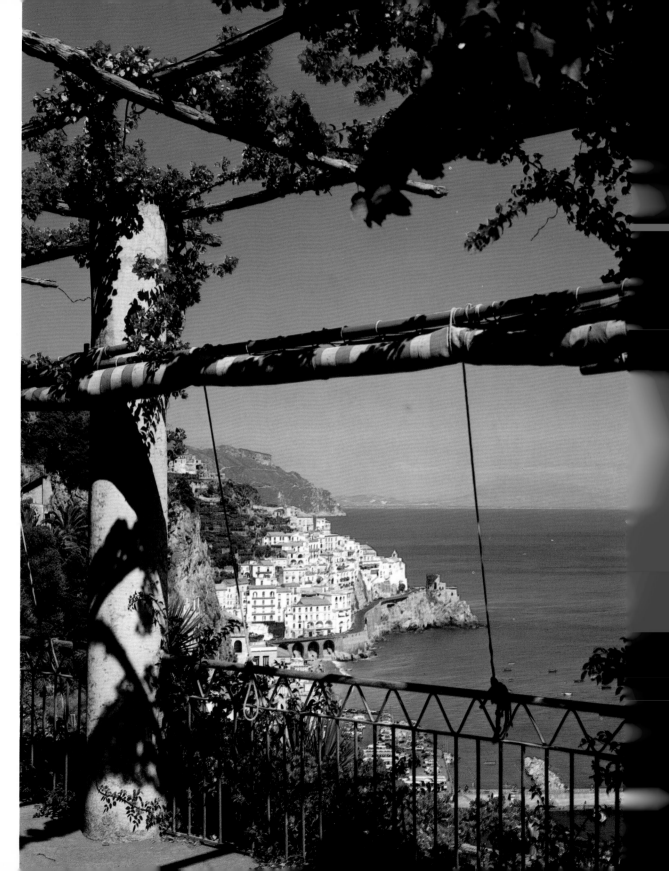

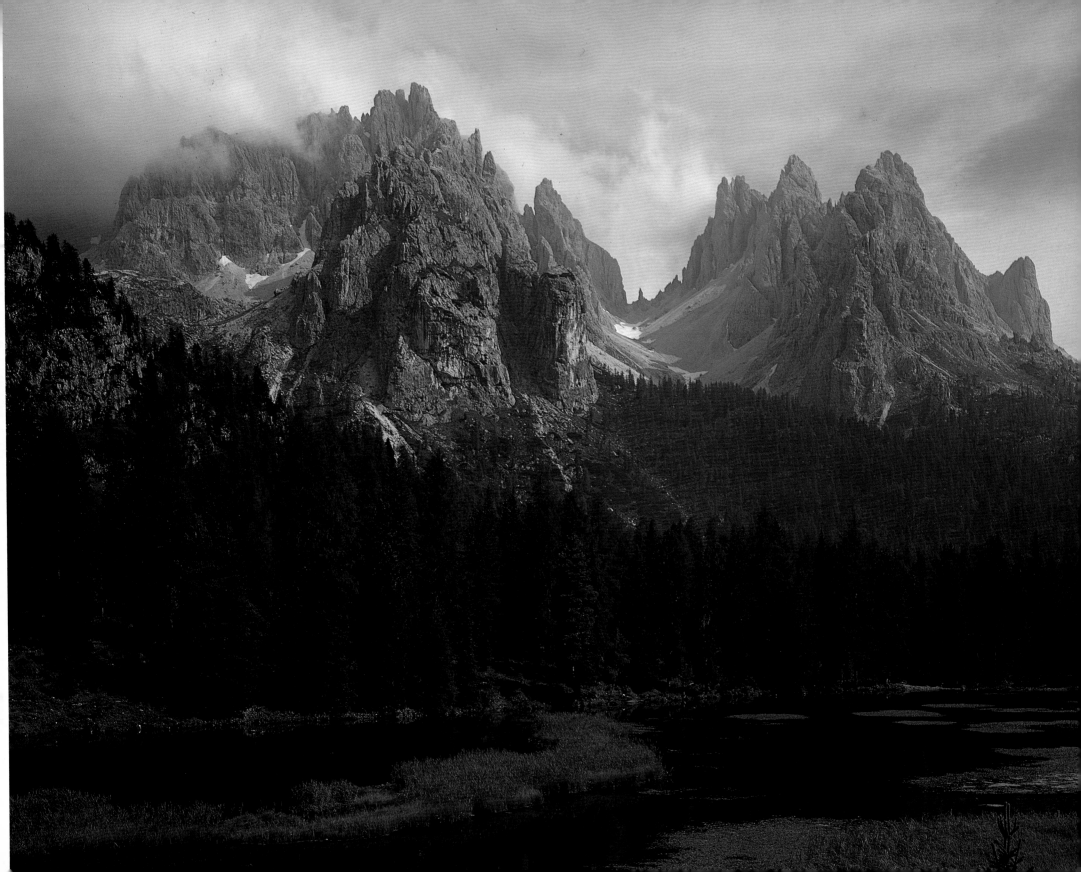

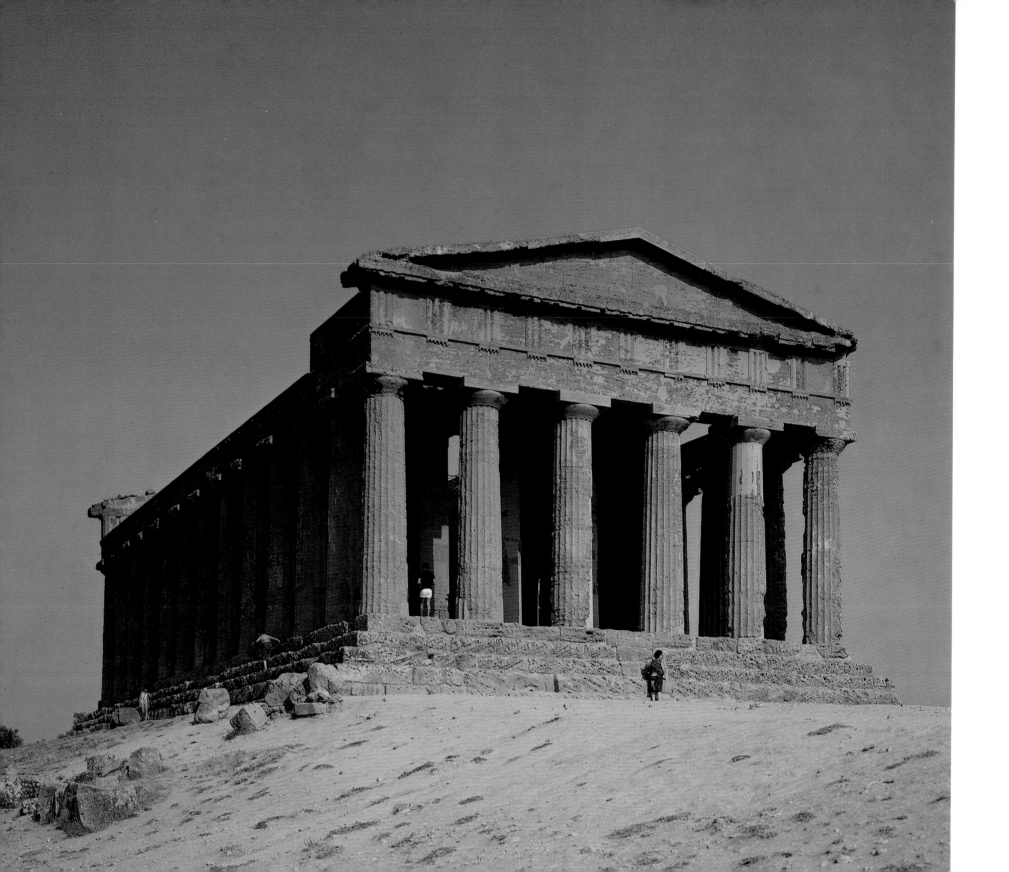

Temple of Concord, Agrigento, Sicily

LEFT: Sicily is the Mediterranean's largest island, a short ferry boat ride across the narrow Straits of Messina, from the toe of Italy's boot. A mountainous rocky land, Sicily is a dramatic island saturated with ancient history.

Agrigento, on the southern seacoast, is distinguished for its ancient Greek temples, particularly the Temple of Concord. Its great dimensions astounded even the ancients. This classic Doric Temple was converted into a Christian Church during the 6th century and the ruins are better preserved than other Greek temples in Sicily and Italy.

PHOTOGRAPHY DATA: Late afternoon. Normal lens.

Michelstadt, Germany

RIGHT: You must leave the autobahn (freeway) to find some of the lesser known but picturesque villages in Germany. In these places you will find the curious timber-frame houses—houses with wood skeletons, their interstices packed with fragments of broken brick and stone.

Michelstadt's quaint little Rathaus (town hall) with many spires and a clock tower helps to identify this as a medieval village and one of the most charming towns in Germany.

PHOTOGRAPHY DATA: Midday, normal lens.

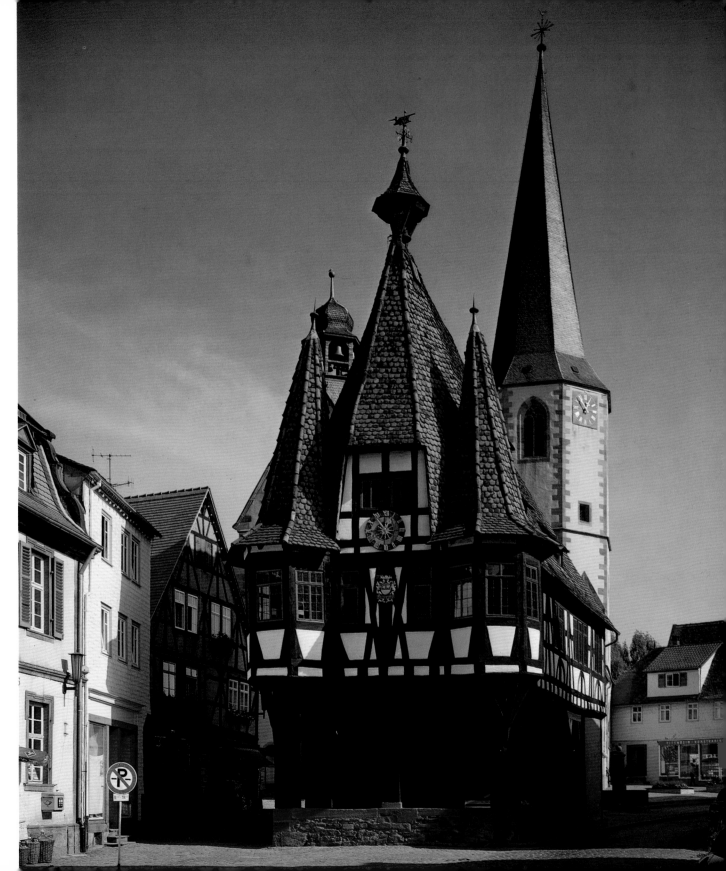

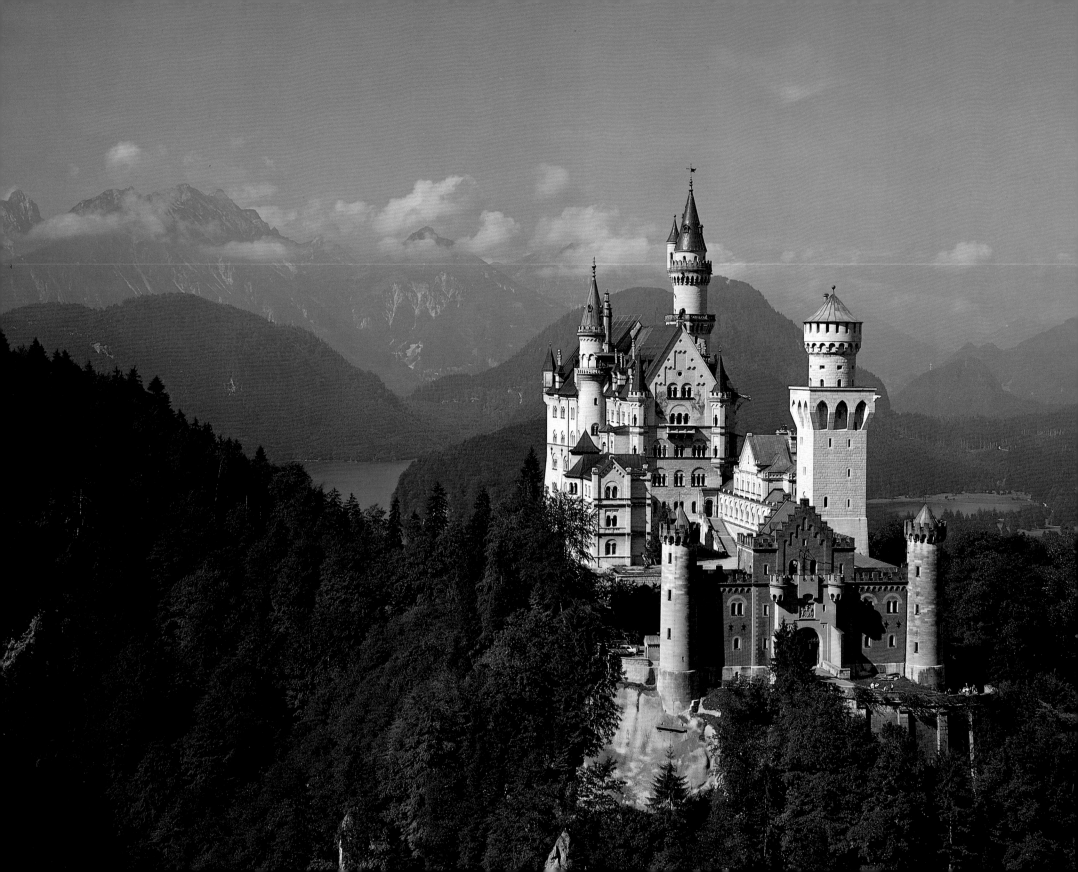

Neuschwanstein, Bavaria, Germany

LEFT: In an alpine setting near the town of Füssen, Neuschwanstein embodies all the attributes of a mythical castle from our childhood fairy tales. With its many turrets, great halls, stained glass windows and opulent furnishings, you might expect to see knights in armor or a richly costumed king emerge from the arched gateway.

One of three lavish castles created by Ludwig II, King of Bavaria from 1864 to 1886, Neuschwanstein took seventeen years to build. It was completed shortly before the so-called "Mad King" died by drowning in a nearby lake.

Even though he bankrupted his country and died unloved by his people, Ludwig left them three exceptional castles. Visitors to all three, Neuschwanstein, Linderhof and Herrenchiemsee, bring substantial revenues into Germany's coffers. He also gave composer Richard Wagner, who was impoverished and rejected, protective and caring sponsorship. Without Ludwig's support of this great composer, the world might have been deprived of glorious Wagnerian music.

PHOTOGRAPHY DATA: Morning, normal lens. A hillside climb is required to obtain this classic viewpoint. During the summer, sunlight strikes at front entrance from mid-morning until noon. I have made this climb eight times since 1958 and have waited over eighteen days for sunshine.

Linderhof Castle, Bavaria, Germany

RIGHT: Near Oberammergau in a pleasant wooded setting, King Ludwig II constructed his extravagant Linderhof Castle. Diminuitive in size, it is a potpourri of rich and detailed craftsmanship. Gilt, mirrors, porcelain, mother-of-pearl, ivory and other materials are used lavishly in its interior to ornament this luxurious castle of French design.

There are several gardens, pools, statuary and a great fountain which is usually displayed on the hour for about ten minutes.

Linderhof was built over a period of five years while Neuschwanstein was also in the process of construction. It is not a home, but a showpiece patterned to some extent after France's Petite Trianon.

PHOTOGRAPHY DATA: Afternoon, normal lens.

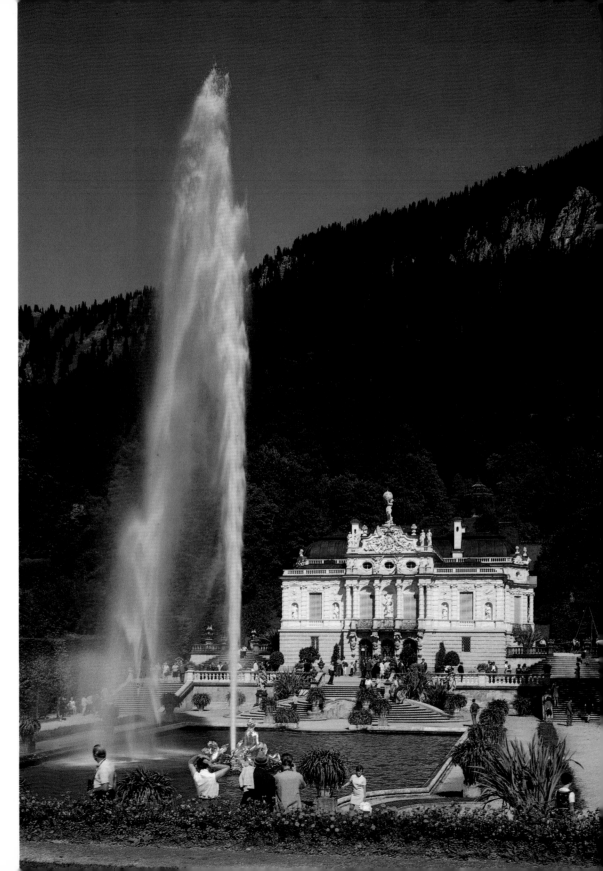

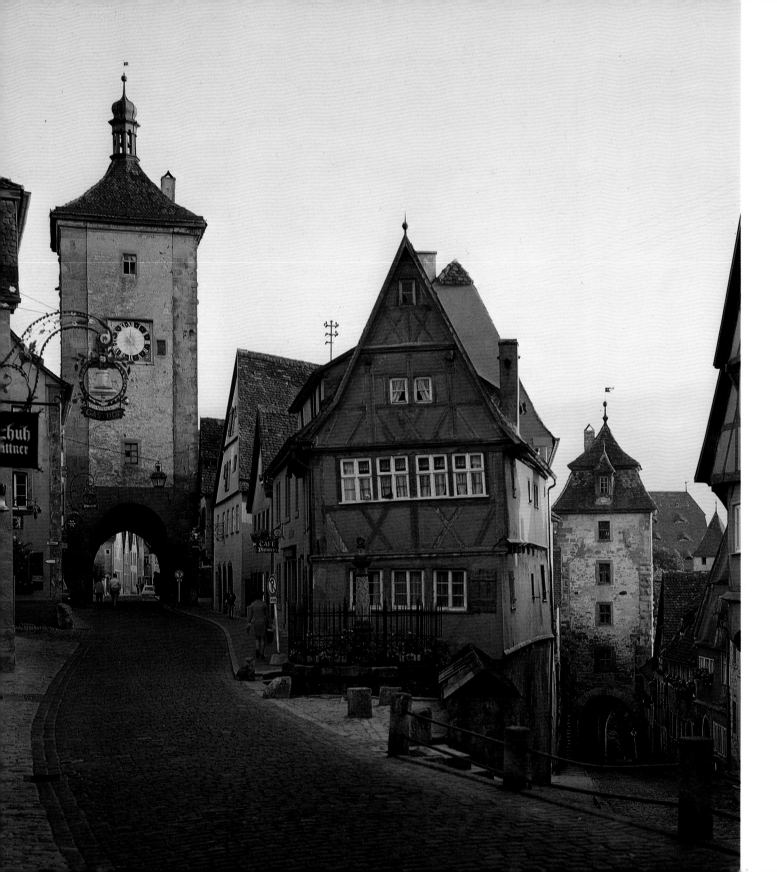

Rothenburg, Germany

LEFT: Encircled by sturdy stone walls, Rothenburg is a medieval town of gabled stone and half-timber houses, churches, shops and a townhall (rathaus). A walking tour through its narrow cobblestone streets transports you back to the 14th century, if you can close your mind to the ever-present automobile and other modern distractions. Bright geraniums overflow their window boxes. Identifying signs hang over the doorways of storekeepers indicating their merchandise, as has been done in old European towns for centuries.

PHOTOGRAPHY DATA: Sundown, wide-angle lens. Meter should read a neutral area such as a roadway, avoiding sky.

Cat Castle (Burg Katz), Rhine River, Germany

RIGHT: Between Koblenz and Bingen, 35 miles of the busy Rhine River winds through the Rhine Gorge, a mountainous section of castles, terraced vineyards and riverside towns to which many legends are attached.

Medieval knights fighting between themselves and exacting tolls from ships traveling the Rhine, fortified the overlooks with their castles. Cat Castle or Burg Katz is a 14th-century stronghold on the cliffs above St. Goarshausen. Most of the Rhine castles today are museums, restaurants, hotels or youth hostels and as such, welcome millions of visitors.

PHOTOGRAPHY DATA: Morning, long lens.

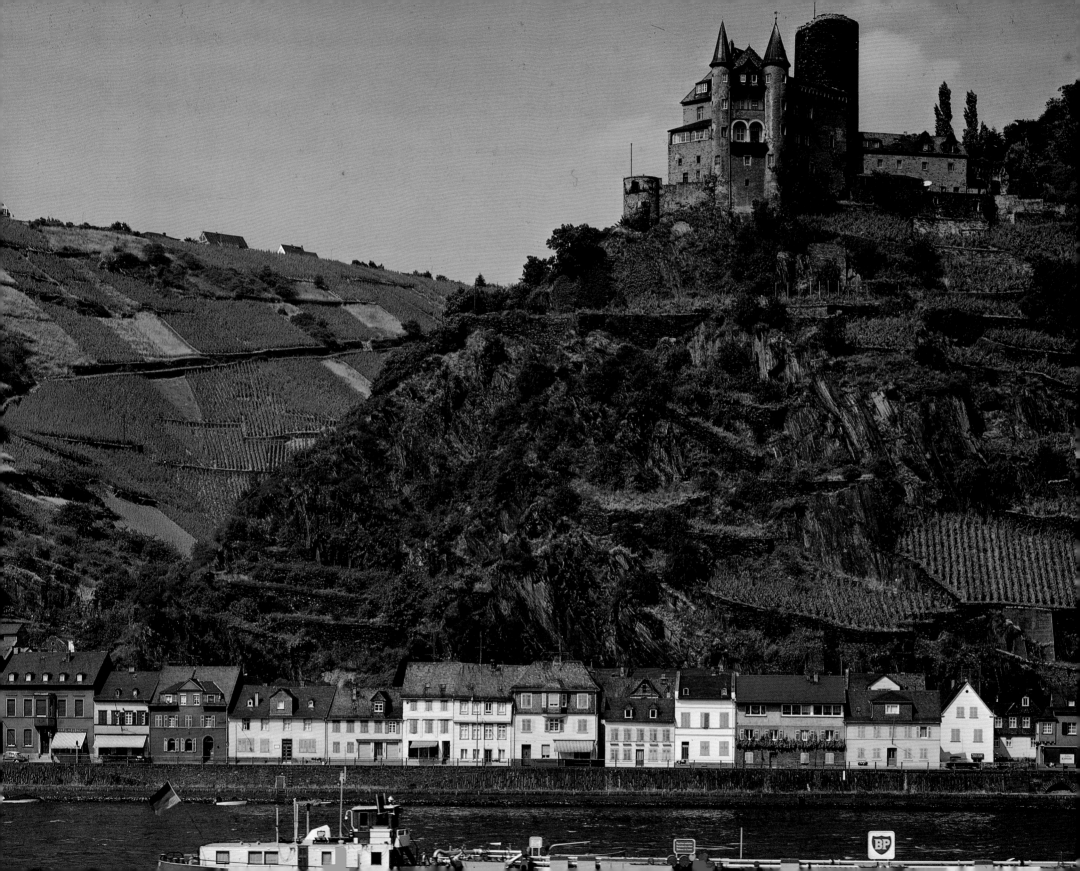

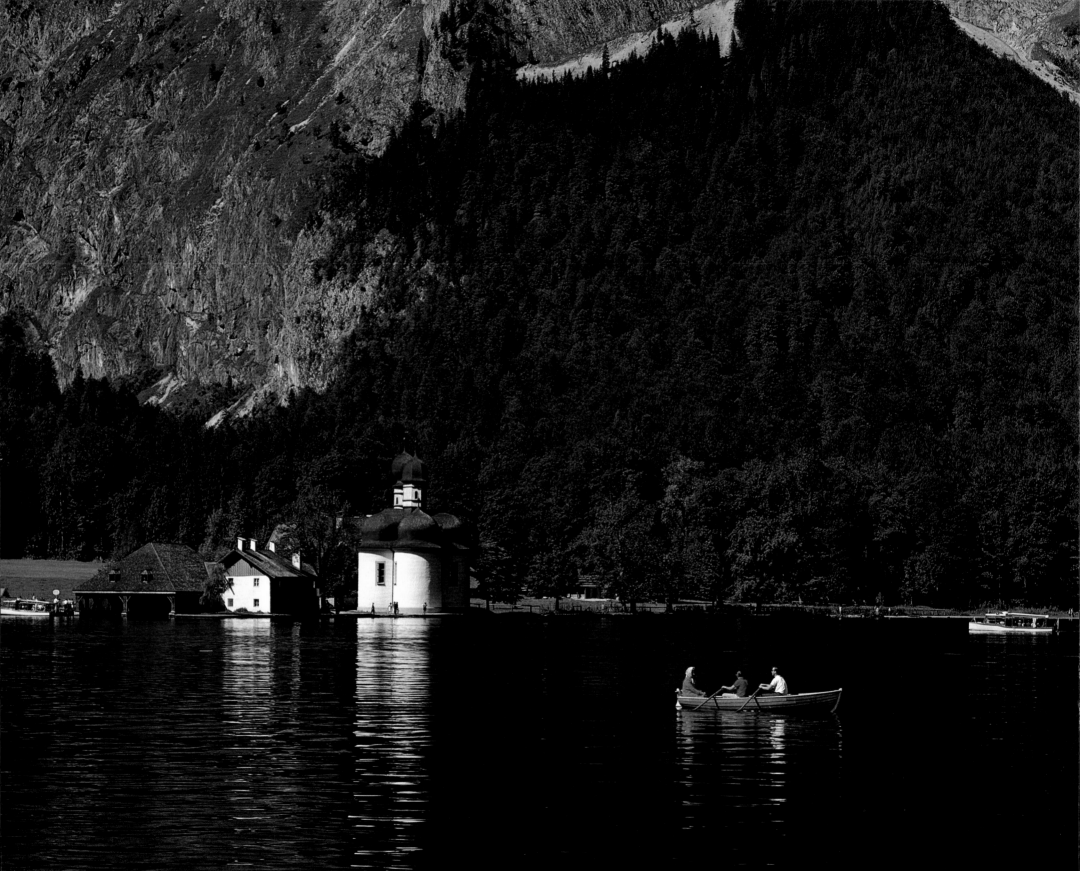

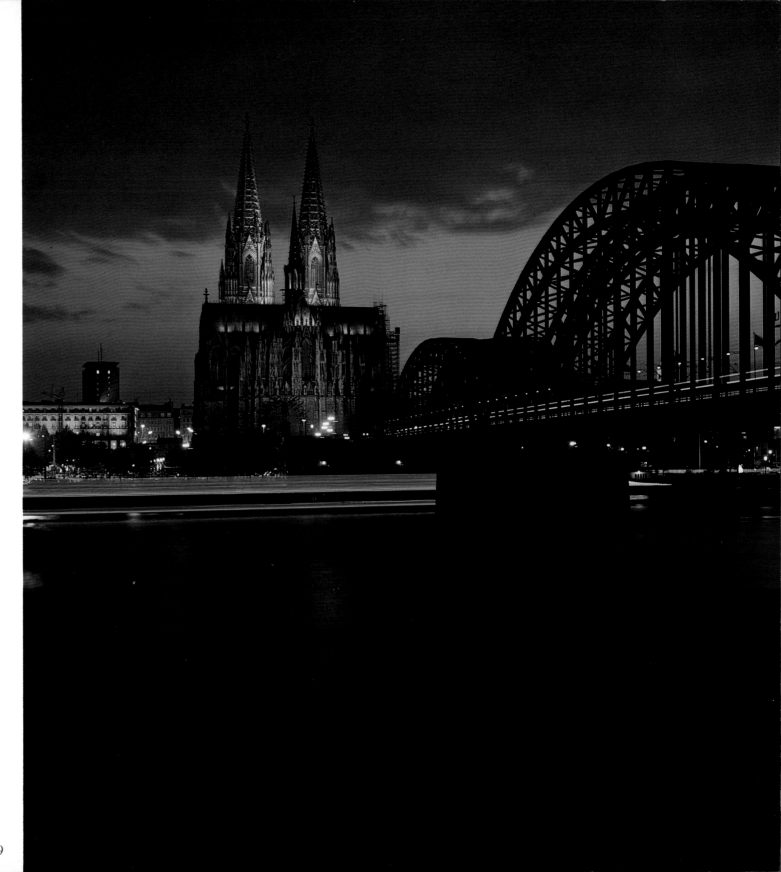

Königsee, Germany

LEFT: In the Bavarian Alps, not far from Berchtesgaden, Königsee is a crystal clear lake 2,000 feet above sea level. It lies between precipitous mountains which rise 6,500 feet.

No loud motorboats mar its quiet beauty. We glided over the deep Alpine lake in a noiseless electric tour boat. In the middle of the lake we stopped and listened to the great silence. Then one of the boatmen blew a horn which echoed and re-echoed from one mountain to the other.

The trip ends at the picturesque Chapel of St. Bartholomew, white with onion-shape domes, set against a striking backdrop of deep green trees and rocky cliffs.

PHOTOGRAPHY DATA: Morning, long lens.

Cologne (Köln) Cathedral, Germany

RIGHT: Beside the Rhine River the Cologne Cathedral's 525-foot twin towers soar majestically in the night sky. The original Cathedral was ruined by the Normans; rebuilt, it was again destroyed by fire. In piecemeal fashion it was rebuilt to its present status. Although the city surrounding it was virtually leveled by allied bombing during World War II, Cologne Cathedral—The Dom—escaped extensive damage.

PHOTOGRAPHY DATA: Dusk, long lens. There is a short period when evening light and artificial lighting are in balance. Usually the best time occurs when the sky becomes darker than the supplimentary light.

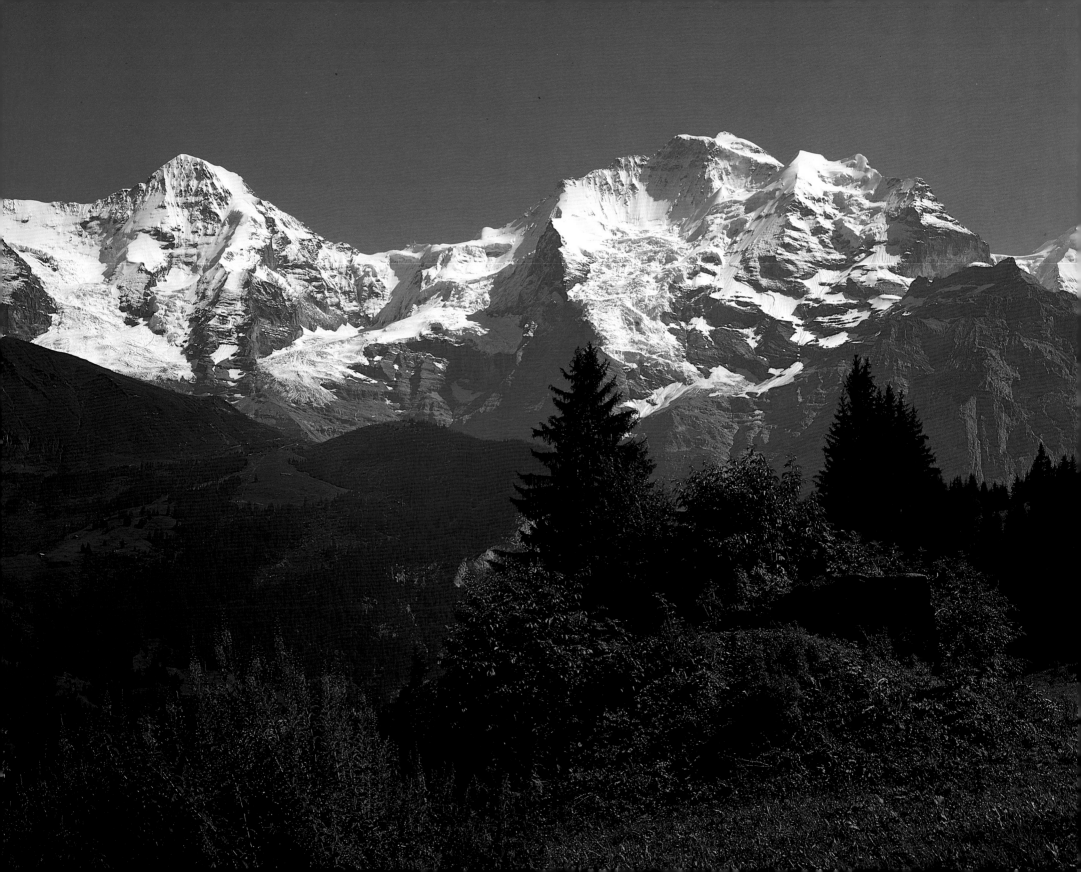

Jungfrau, Switzerland

LEFT: Covering over half of the country, Switzerland's Alps have great variety and scenic magnificence. The majestic Alpine landscape of mountains, glaciers, green meadows and valleys attracts travelers from all over the world.

The mighty Jungfrau with her head in the clouds at 13,642 feet, is one of its celebrated peaks. For sightseers not willing to admire this monarch just from afar, Europe's highest railway climbs more than 11,000 feet up the Jungfrau for a closer look. A tunnel over four miles long takes the cog-wheel trains through both Mt. Eiger and Mt. Mönch, its neighboring peaks. An exciting trip with an icy, fantastic view from the top.

PHOTOGRAPHY DATA: Afternoon, long lens. A haze filter will cut the ultraviolet rays and protect your lens from dust.

Mt. Eiger from Grindelwald, Switzerland

RIGHT: It would be harder, I believe, to find a window in Switzerland without a window-box full of gayly blooming flowers (mostly geraniums) than to find the proverbial needle in a haystack! And how they brighten and enhance any view!

The resort village of Grindelwald, reached by either automobile or cog-train from Lauterbrunnen in the valley below, has a tremendous and ever-changing view of Mt. Eiger (13,025 ft.).

PHOTOGRAPHY DATA: Early morning, wide-angle lens.

81

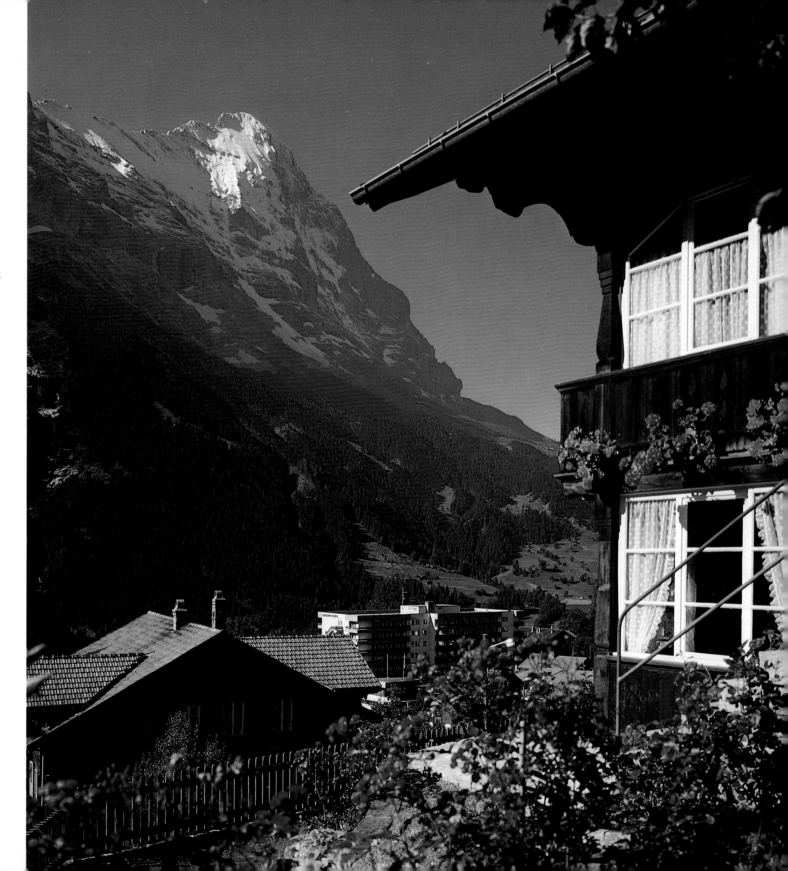

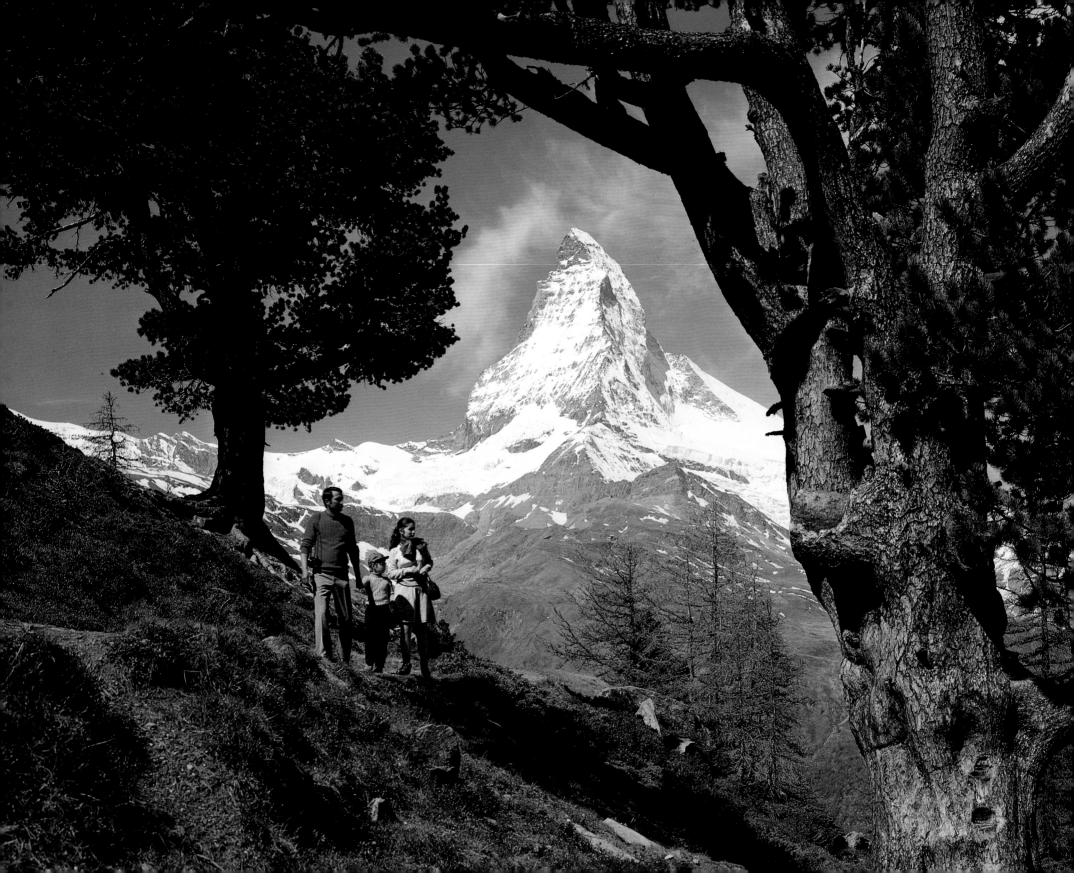

The Matterhorn, Zermatt, Switzerland

LEFT: Pointing supremely heavenward, the magnificent Matterhorn, from its height of 14,700 feet looks down on the lesser heights near Zermatt. While the snow season has skiers on every slope, the trails during summer are filled with hikers. Each path offers new and different vistas of this matchless mountain. The Arolla pines, which grow at high elevations in the Alps, make a pleasant stopping place to admire the view while catching your breath.

PHOTOGRAPHY DATA: Mid-morning, normal lens.

Karlskirche, Vienna, Austria

RIGHT: Karlskirche is a Baroque style church built to carry out a vow by Charles VI (last of the male Hapsburg line), that if Vienna were saved from the plague, he would erect a church. It was built outside the city walls and combines classic Roman columns with tall spiraled pillars depicting scenes in the life of St. Borromea, to whom it was dedicated.

PHOTOGRAPHY DATA: Dusk exposure to record the sky. After a wait of approximately one hour, a second exposure was made to record the lighting effect on the building. Normal lens.

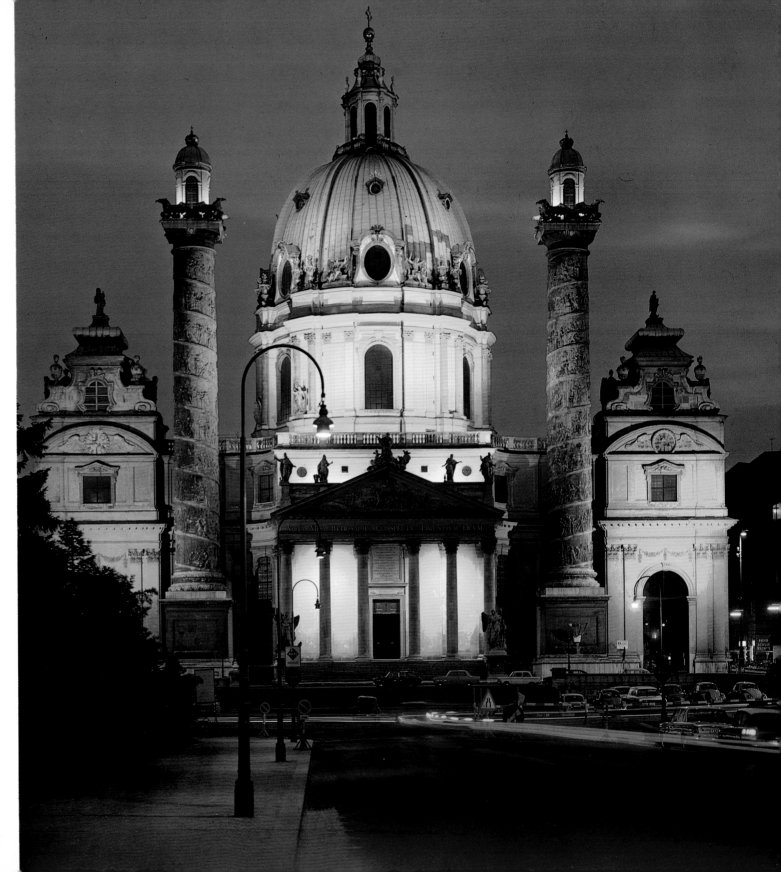

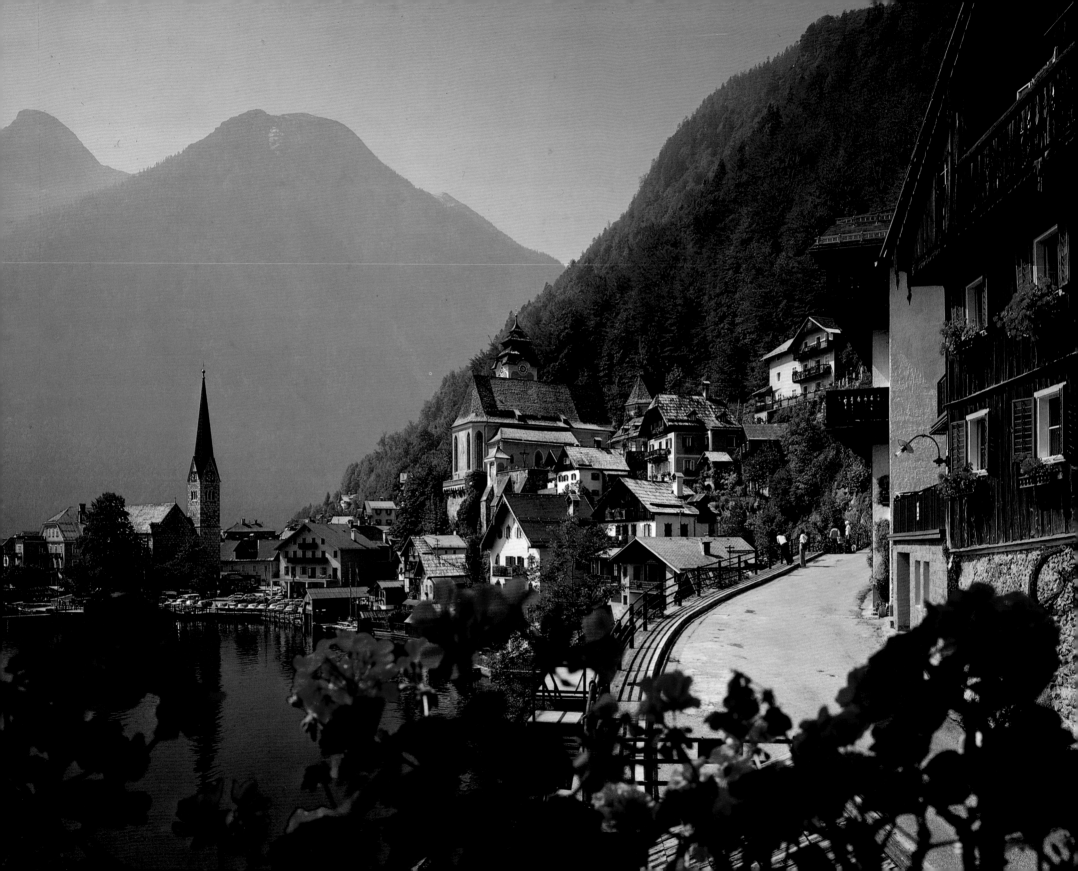

Hallstatt, Austria

LEFT: Clinging to the side of the mountain at the edge of the Hallstättersee, Hallstatt was an area of great importance in the early iron age. Many of its artifacts of pottery and iron have been found. High above the town on the Salzburg Mountain are salt deposits which have been mined for thousands of years. They are still important to Hallstatt's economy, not only for the salt, but also as a tourist attraction. An excursion down a shaft of the salt mine draws many visitors.

PHOTOGRAPHY DATA: Morning light, wide-angle lens. Often a good camera position requires a little friendly persuasion to the owner of a second story window.

Vienna, Austria

BELOW: For centuries Vienna has epitomized culture, music, beauty and gaiety to the world. At one time it was the intersection of European trade routes. It is still a beautiful city of handsome buildings and parks and churches. In the distance one sees the great gothic spire of St. Stephens Cathedral which was many years in restoration after World War II. Tourists to Vienna put the opera and the Lippizan horses high on their priority lists.

PHOTOGRAPHY DATA: Afternoon light, normal lens.

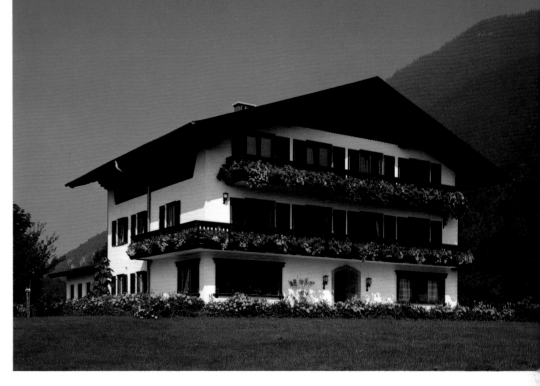

Chalet near Wolfgangsee, Austria

ABOVE: In the middle of a hay field not far from the shores of Wolfgangsee, a new chalet is already displaying a brilliant crop of flowers. Many homes in Switzerland and Austria, who are neat and tidy neighbors, conform to the Tyrolean chalet type of construction.

A chalet's simple beauty is often as admirable as a palace or a splendid cathedral.

PHOTOGRAPHY DATA: Morning light, normal lens.

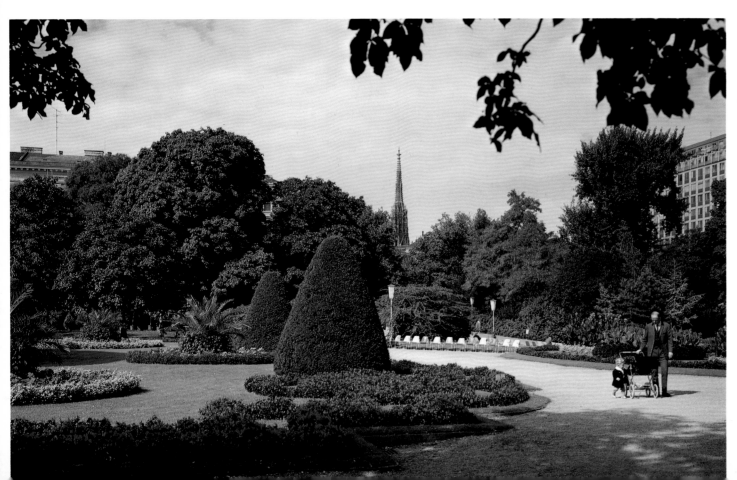

85

Mostar, Yugoslavia

LEFT: Entirely different from Dubrovnik is Mostar (most old city) about a hundred miles distant. On the Naretva River, this old town seems to fit no specific niche since such a conglomeration of peoples and religions have trodden it for centuries. The Turks are credited with having built this simple arched bridge during their 400 years of occupation of this area, then called Hercegovina. Many people visit Mostar specifically to photograph this beautiful scene. In summer, fearless youths can be seen diving from the top of the bridge to the cool depths of the river below.

PHOTOGRAPHY DATA: Midday, normal lens.

Old Dubrovnik, Yugoslavia

RIGHT: *Old* Dubrovnik not only refers to the antiquity of this intriguing medieval city on an arm of land in the Adriatic Sea, but due to the fact of expansion beyond its sturdy walls, a *new* Dubrovnik is creeping up the adjoining hillside.

Founded by Greeks in the 7th century, it has had a history of jurisdiction by various powers. Dubrovnik became an international trade center with a great merchant fleet between the 13th and 18th centuries.

Although the city suffered severely in a 1667 earthquake, its ramparts are as complete as those at Carcassone in France, even though they haven't had such extreme restoration.

PHOTOGRAPHY DATA: Morning light, long-lens.

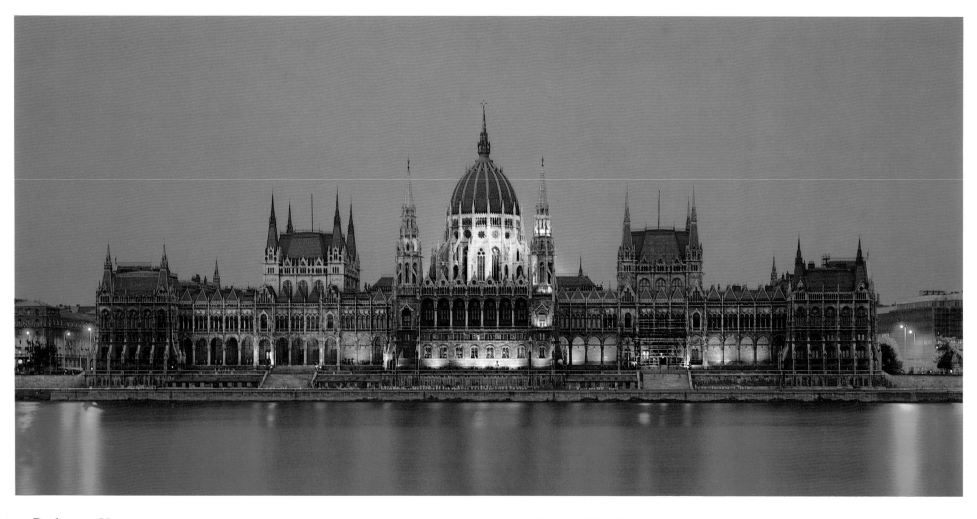

Budapest, Hungary

ABOVE: Budapest, the largest city and capital of Hungary, is divided by the Danube River. Buda is on the right bank and Pest on the left. Connecting them are many bridges across Europe's longest river, the Danube, which flows from Germany's Black Forest region to the Black Sea.

Facing Pest, the impressive dome and sharp spires of the floodlighted Parliament are reflected in the waters of the "Blue" Danube.

PHOTOGRAPHY DATA: Dusk exposure and time exposure after dark. Long lens.

Prague, Czechoslovakia

RIGHT: Frequently called the "the city of 100 spires," Prague is the capital of Czechoslovakia. It has a wealth of structures built in Romanesque, Gothic, Italian Renaissance and especially Baroque style.

The Gothic 14th-century Town Hall in Old Town Square displays an astronomical clock which attracts visitors. On the twelfth hour a cock crows, a door opens and a parade of figures appear representing the Twelve Apostles.

In 1945, during the Prague uprising against the Nazis, (just before the arrival of the Soviet Army), the Nazis shot hundreds of Prague citizens and destroyed most of the Old Town Hall. The ancient clock was damaged by fire but has been repaired and the remnants of the Old Town Hall stand as a monument to those who lost their lives in the revolt.

PHOTOGRAPHY DATA: Morning, hazy sunlight, wide-angle lens.

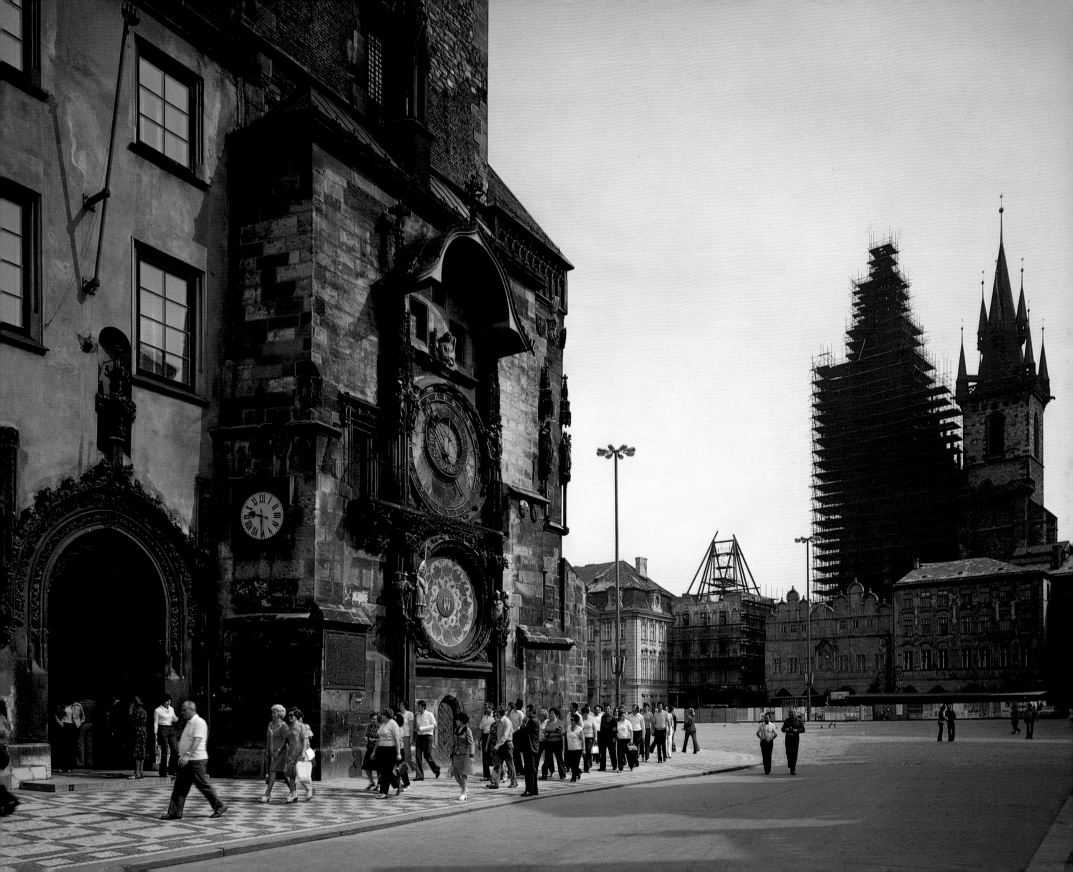

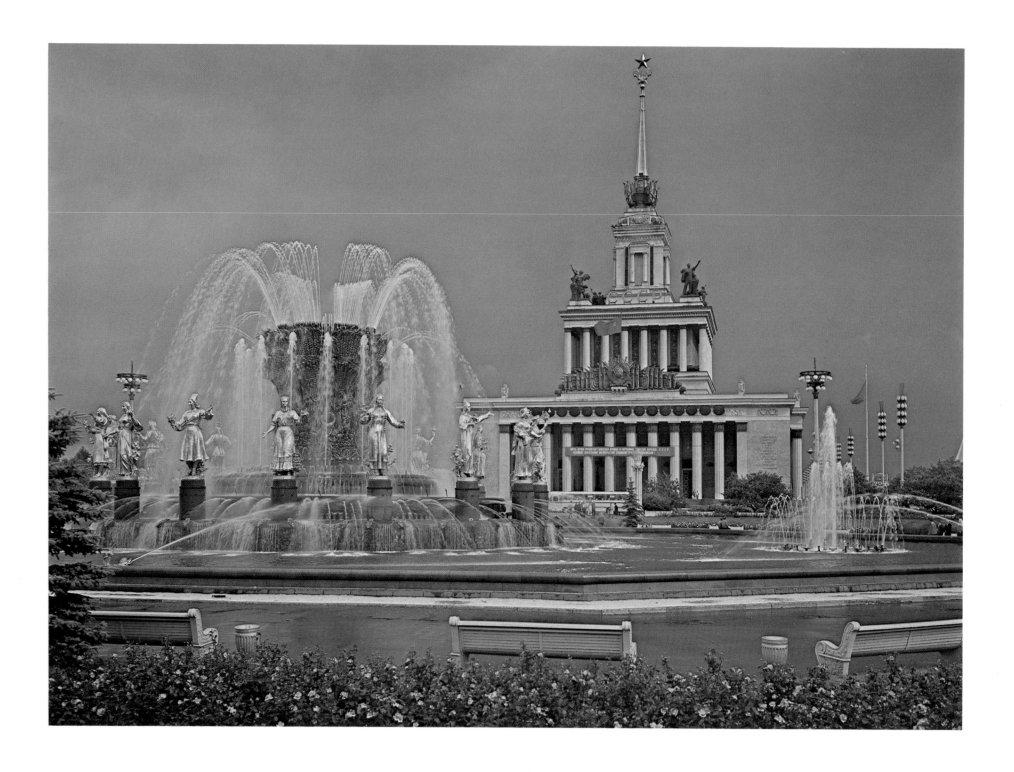

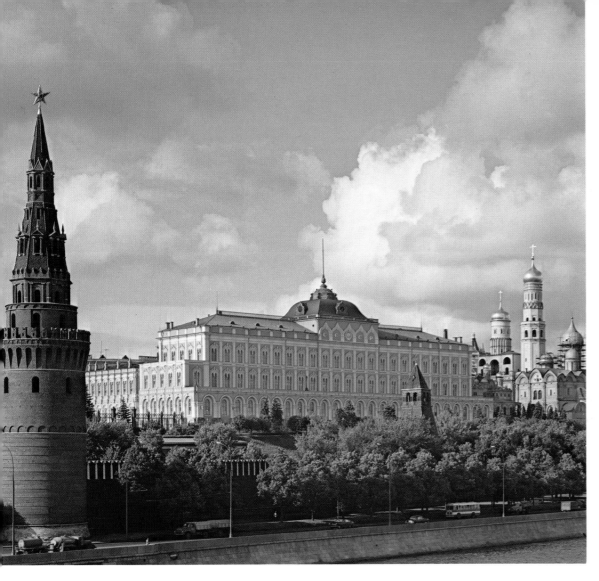

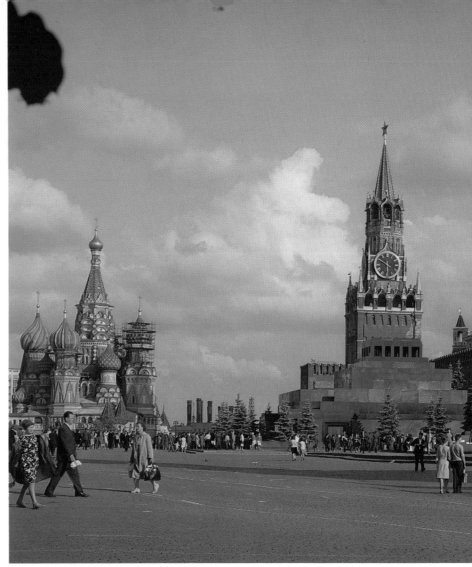

Moscow, Russia

ABOVE: Moscow's heart is the 90-acre Kremlin, first opened to the public in 1955. The 15th-century red brick wall, which encloses the compound of palaces and churches, replaced an old wooden stockade. "Kremlin" is a medieval word meaning the walled central section of a town.

ABOVE RIGHT: Adjoining the towered walls, Red Square is a huge cobblestoned expanse; the scene of major demonstrations in Russia. On one side of the Square, with an incongruous mixture of Oriental and Renaissance features, stands 16th-century St. Basil's Cathedral. Built by Ivan the Terrible, it now houses a museum.

LEFT: A permanent display of Russian history, accomplishments, plans and hopes for the future, the Exhibition of Economic Achievements is housed in some fifty buildings. The gold-leafed figures in the impressive fountain represent each state of the Soviet Union.

PHOTOGRAPHY DATA: Red Square—Morning light, normal lens; The Kremlin across Moscow River—late evening, normal lens; Fountain—afternoon storm, normal lens.

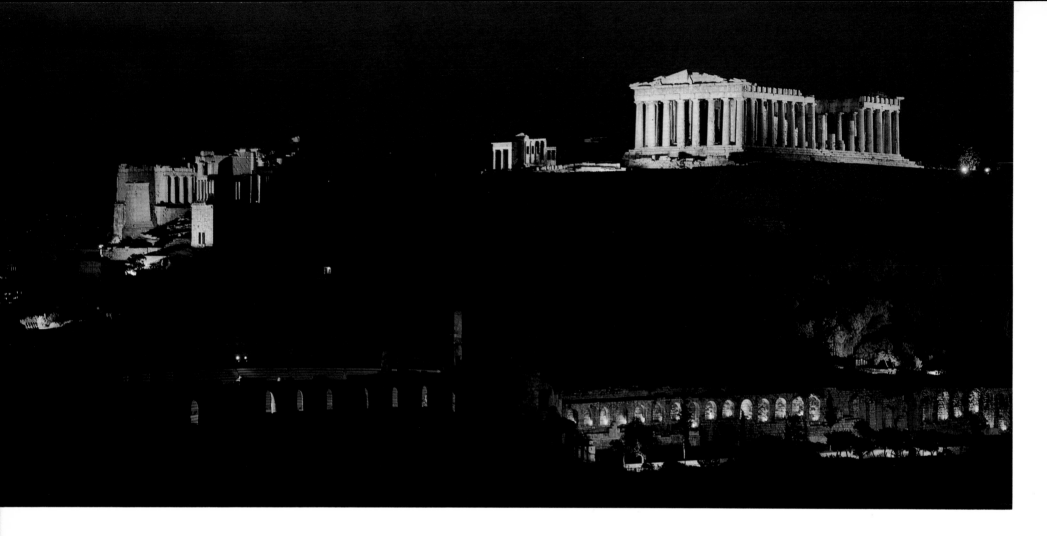

The Acropolis, Athens, Greece

ABOVE: Acropolis means but one place to the world, the sacred high city (acro-polis) of Athens, Greece. Marble quarried from the nearby mountain, Pentelicus, was used to build several magnificent buildings overlooking Athens. The Parthenon, which dominates the Acropolis, was built as a temple to Athena, Greek goddess of war, crafts and peace. Most of the outer Doric columns of the Parthenon still stand surrounding the empty shell of the structure which once housed the golden statue of Venus. Although damaged many times by vandals, one still senses the majesty and beauty, the flawless design and workmanship of the sanctuaries on the Acropolis.

PHOTOGRAPHY DATA: Late evening, long lens. Time exposure from a nearby hill.

Mykonos (Mikonos), Greece

RIGHT: A very popular Greek isle in the blue Aegean Sea, Mykonos is visited by tour boats from Athens. The dazzling whiteness of the town contrasts with the brilliant colored paint used on the little fishing boats bouncing gently in the shallow harbor.

Powered by the wind, the barley mill's sails have been turning for countless years. It has become an identifying symbol for the whitewashed island of Mykonos, while it continues to grind grain for the islanders.

PHOTOGRAPHY DATA: Sunset, normal lens; morning view, normal lens.

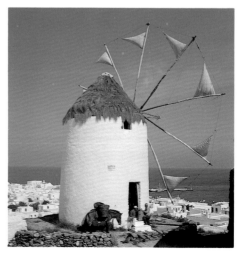

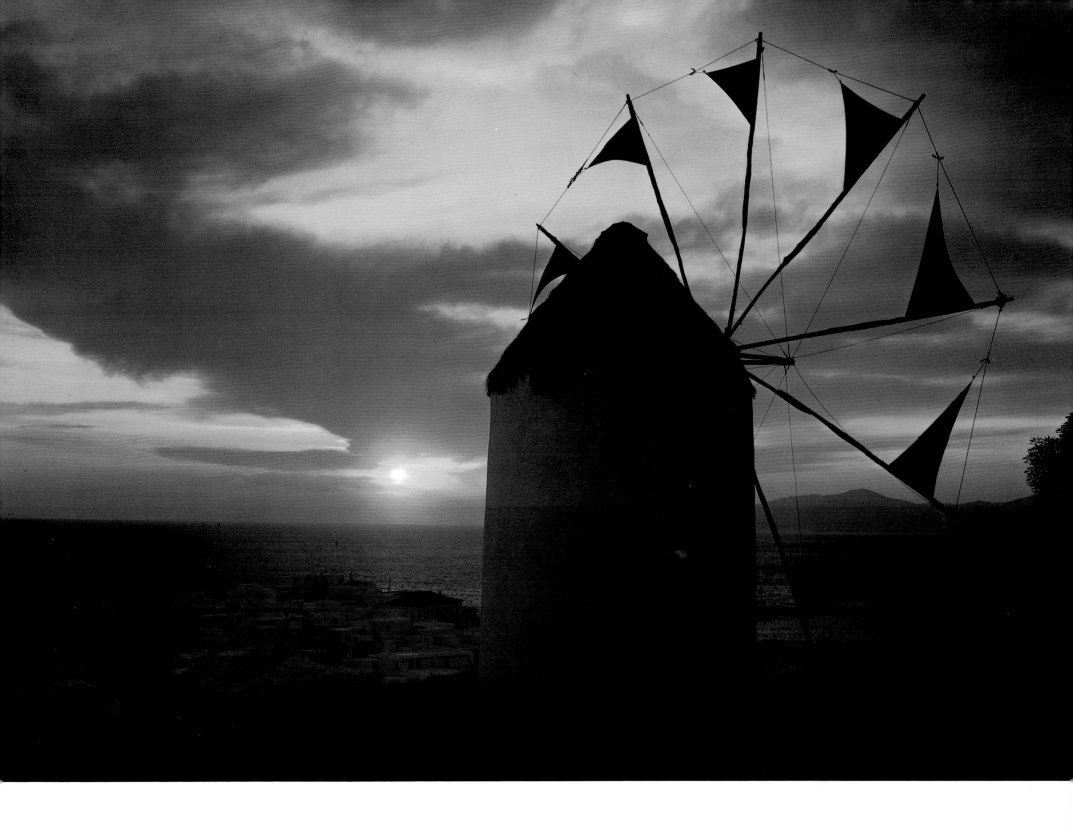

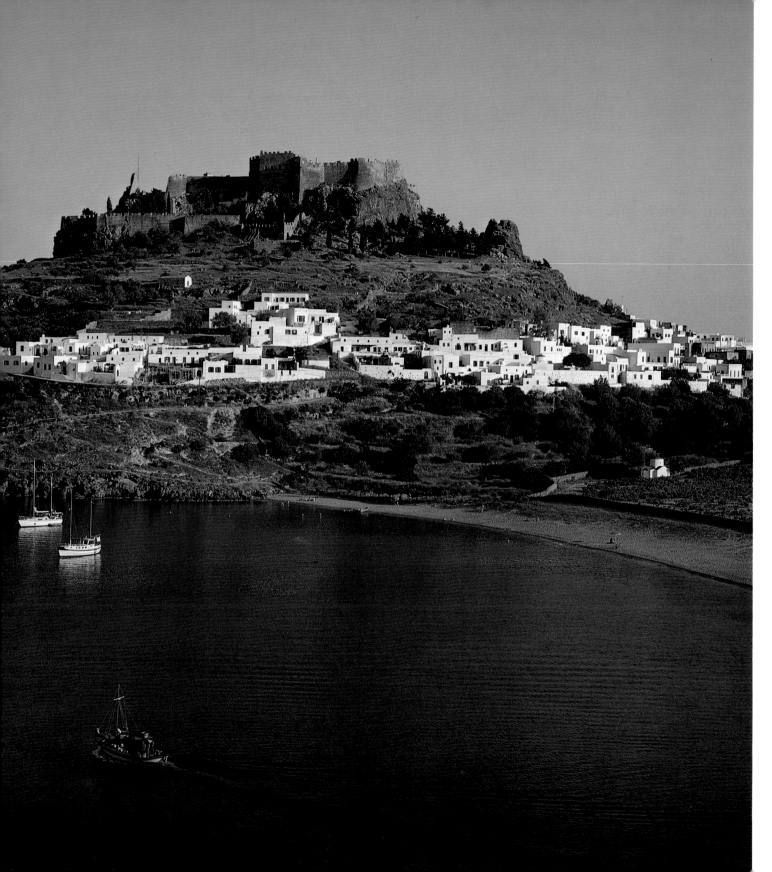

Lindos, Rhodes

LEFT: Greeks first settled in the warm climate of the Island of Rhodes in 1,000 B.C. Two noteworthy towns, Rhodes and Lindos, are at opposite ends of the island.

Approaching by road from the town of Rhodes, the village is hidden until the last hill is topped; then the small protected harbor and the sparkling white houses of fishermen and their families come into view. Towering above is the Acropolis with the remaining Doric columns of the Temple of Athena, fragments of a Byzantine Church and some crusader ruins.

The Acropolis is reached by riding donkeys, led by the village men, up the steep, winding lane past the simple white-washed dwellings.

PHOTOGRAPHY DATA: Afternoon, normal lens.

Delphi, Greece

RIGHT: Sacred to the ancient Greeks, Delphi, the sanctuary of the god Apollo, was the destination of pilgrims for more than a thousand years seeking advice and counsel from the Oracle of Delphi. Apollo was thought to speak through the Oracle, believed to be a young virgin who uttered ambiguous vaporings which were interpreted by the priests as they saw fit.

Ruins of a temple, a theater and the treasuries, used to house the many offerings made to Apollo, are here, as are the famous inscriptions ''Know Thyself'' and ''Nothing in Excess.''

A short distance from the main ruins one can see the remaining graceful columns of the Temple to Athena, a small circular temple surrounded by olive trees.

PHOTOGRAPHY DATA: Mid morning, normal lens.

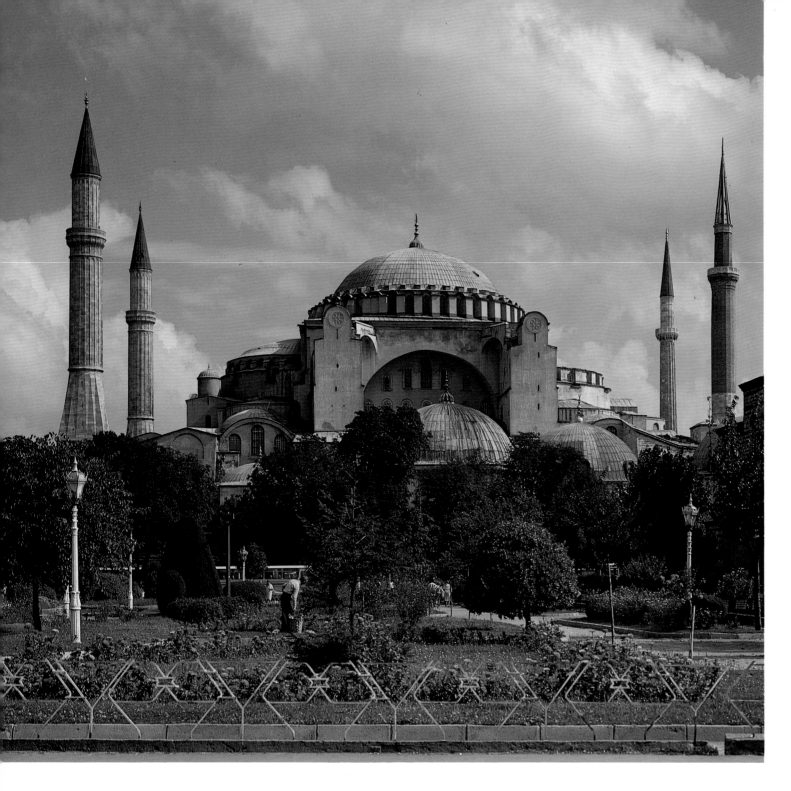

Hagia Sophia, Istanbul, Turkey

LEFT: The skyline of the old section of Istanbul is studded with minarets and domes which are inherent in Byzantine architecture. The Mosque of Hagia Sophia (meaning divine wisdom) was built as a Christian church (St. Sophia) by Constantine in 325 A.D. In 1453 it was converted into a mosque, the minarets were added and the fine Christian mosaics were obliterated in accordance with the tenets of Islam.

Atatürk, founder of modern Turkey, restored these mosaics and in 1935 Hagia Sophia was made into a museum.

PHOTOGRAPHY DATA: Morning, normal lens.

The Blue Mosque, Istanbul, Turkey

RIGHT: Popularly known as the Blue Mosque because of the blue interior tile, the six minarets on this Mohammedan temple caused deep consternation when built by Sultan Ahmed I in the 17th century. Its minarets were equal in number to those of the Kaaba in Mecca, holiest city of the Islamic faith and the birthplace of Mohammed. Enraged disciples of the religion hurriedly increased the minarets to seven on their sacred Great Mosque in Mecca.

The Blue Mosque is the most spectacular of Istanbul's many mosques.

PHOTOGRAPHY DATA: Morning light, normal lens.

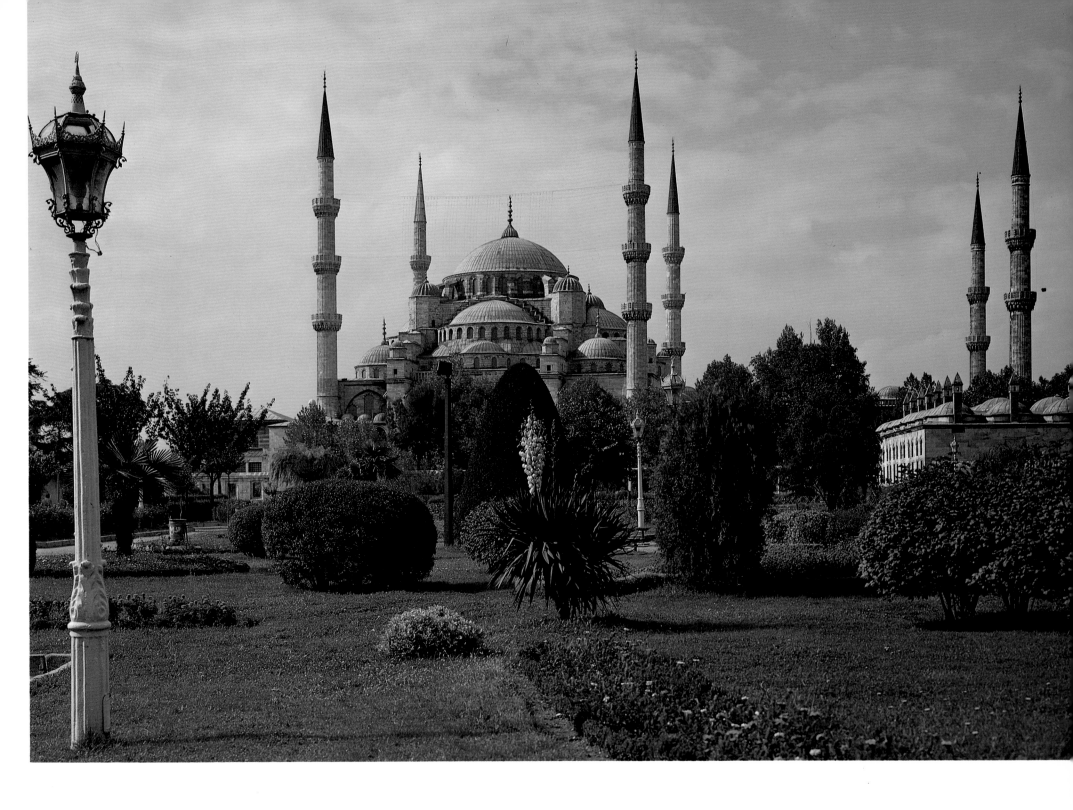

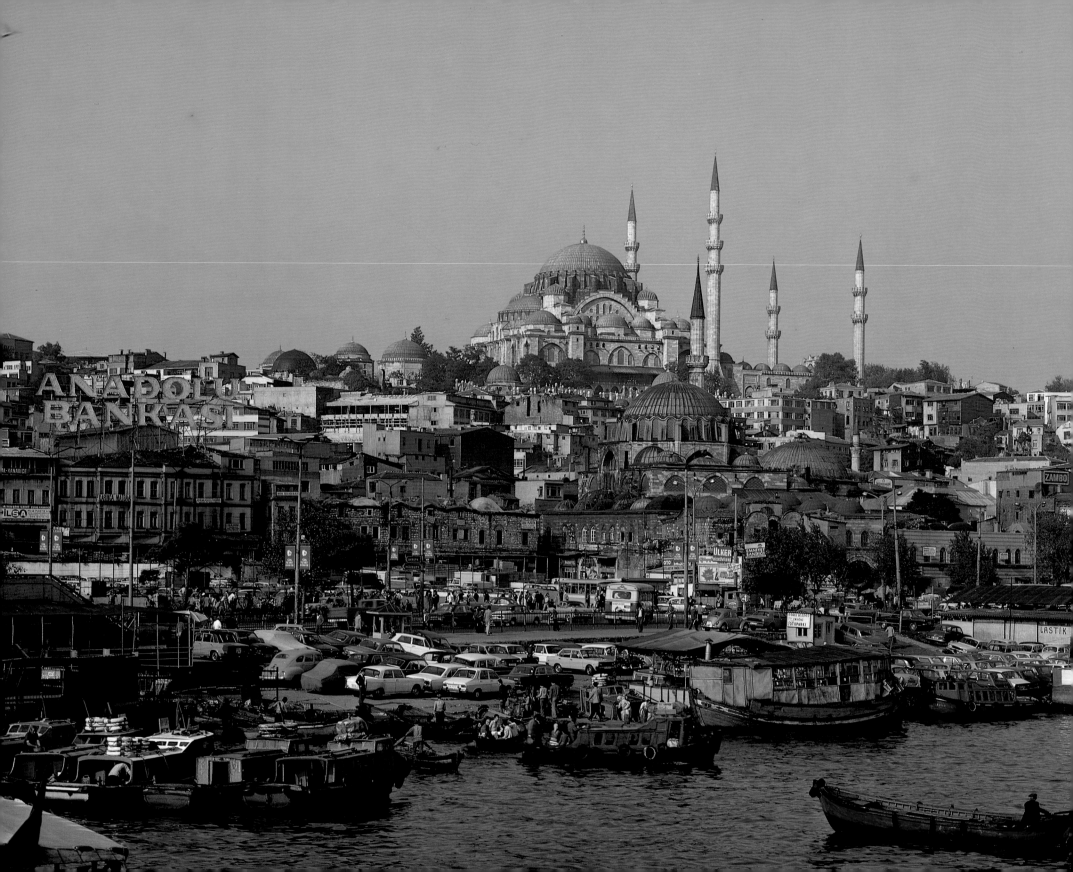

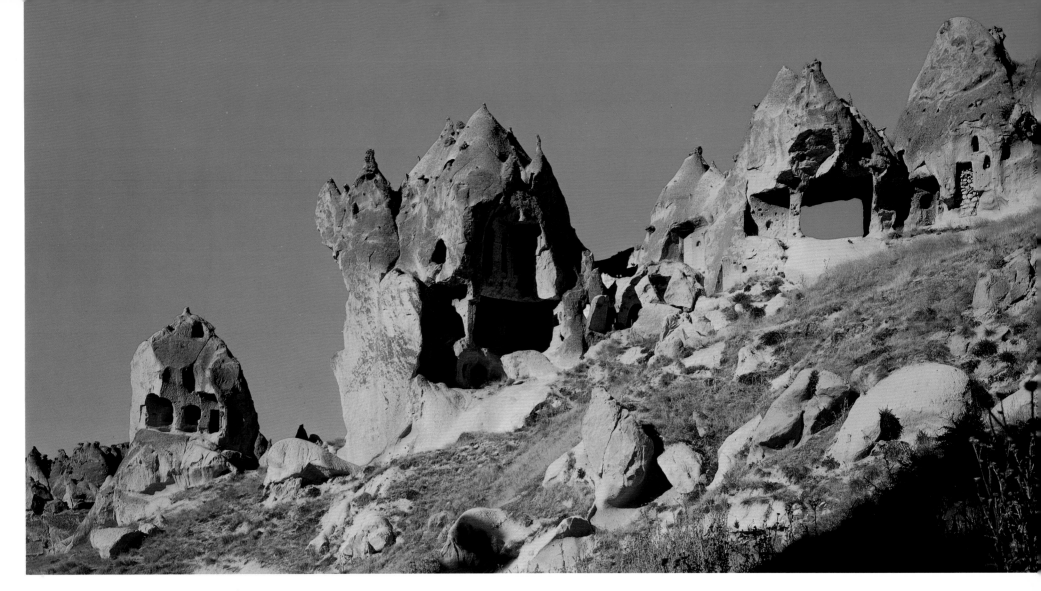

Süleyman Mosque, Istanbul, Turkey

LEFT: The Bosphorous, a narrow 17-mile strait, separates Turkey in Europe from Turkey in Asia. At this point, the city of Istanbul, first called Constantinople, then Byzantium, is a thriving and crowded city in Europe. From the Gálata Bridge in Istanbul, it is exciting to watch the bridge traffic and water traffic, both on and over the Golden Horn, an inlet of the Bosphorous in Europe. Over it all, the magnificent mosque of Sultan Süleyman the Magnificent dominates.

PHOTOGRAPHY DATA: Early morning, long lens.

Göreme Valley, Cappadocia, Turkey

ABOVE AND PAGE 100: Göreme Valley in Turkey's Anatolian highlands is studded with rock cones that have been hollowed out, first by early Christians into chapels and cells, and later for dwellings by Turkish farmers of Moslem (Muslim) faith. Few travelers have penetrated this valley in central Turkey, about 200 miles from Ankara.

Countless ages ago Mt. Erciyas erupted and spread an extensive layer of lava and ash. As the ash cooled and cracked, melting snows and rain eroded caves and chimneys in this tuff. A harder stone cap crowns the cones and protects the softer stone beneath from erosion. Early settlers in this ancient Cappadocia area of Asia Minor found it more reasonable, in a land where wood was scarce, to hollow out their homes in the soft rock. Some contain as many as ten floors and the front door is sometimes reached by a ladder or rope.

PHOTOGRAPHY DATA: Late afternoon, normal lens (both photos).

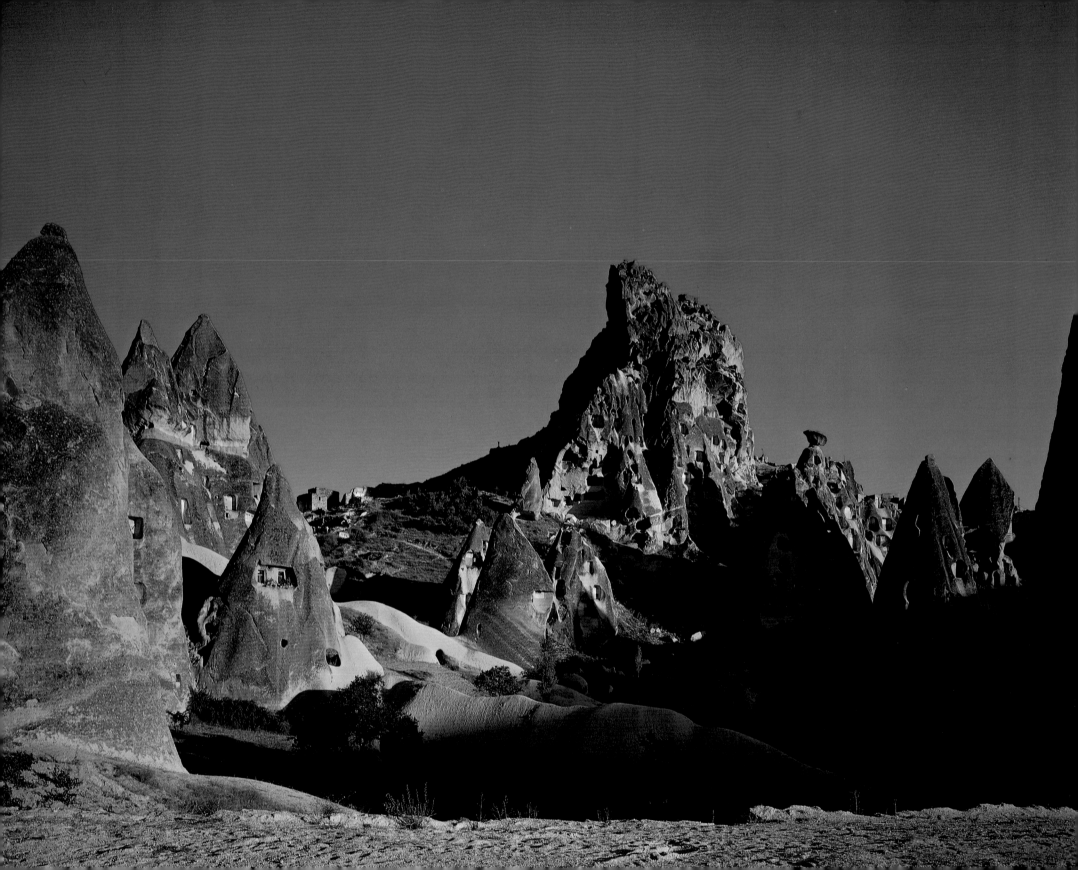

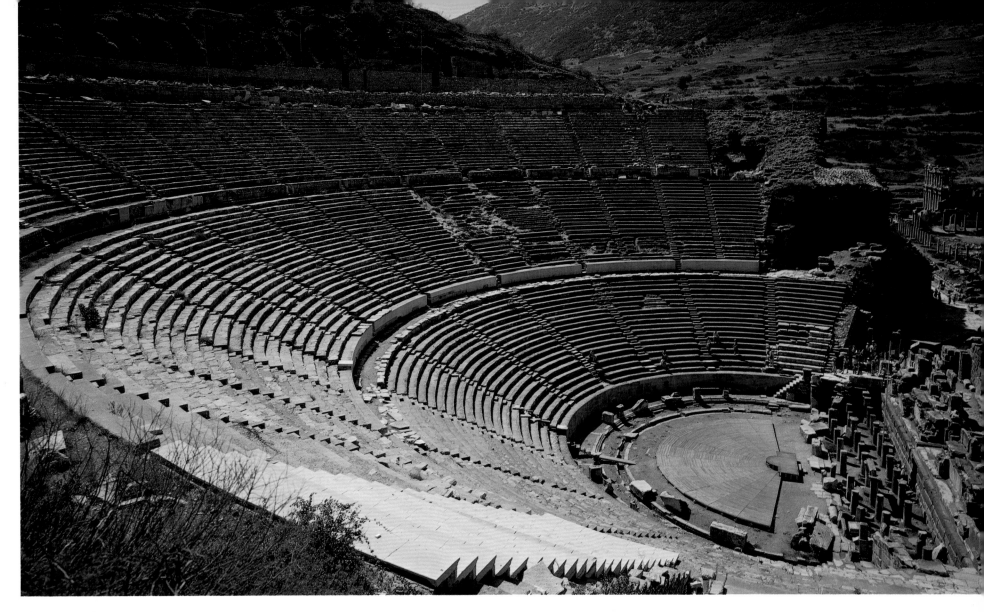

Theater, Ephesus, Turkey

In the Great Theater of Ephesus 25,000 townspeople could sit in the rows of seats
that terraced the hillside and watch the dances, plays and rites honoring their pagan
goddess, Diana.

St.Paul, who stayed in Ephesus for some time preaching the new Christian faith, precipitated
a riot among the worshipers of Diana. Vehemently intoning ''Great is Diana of the
Ephesians'' they tried to sieze Paul. Friends were able to conceal him until the clamor died
and he was able to steal away.

For centuries the city had attracted pilgrims to its great Temple of Artemis (Diana to the
Romans). Although this fabulous marble temple no longer survives, it was considered to be
one of the ancient Seven Wonders of the World.

PHOTOGRAPHY DATA: Morning, wide-angle lens.

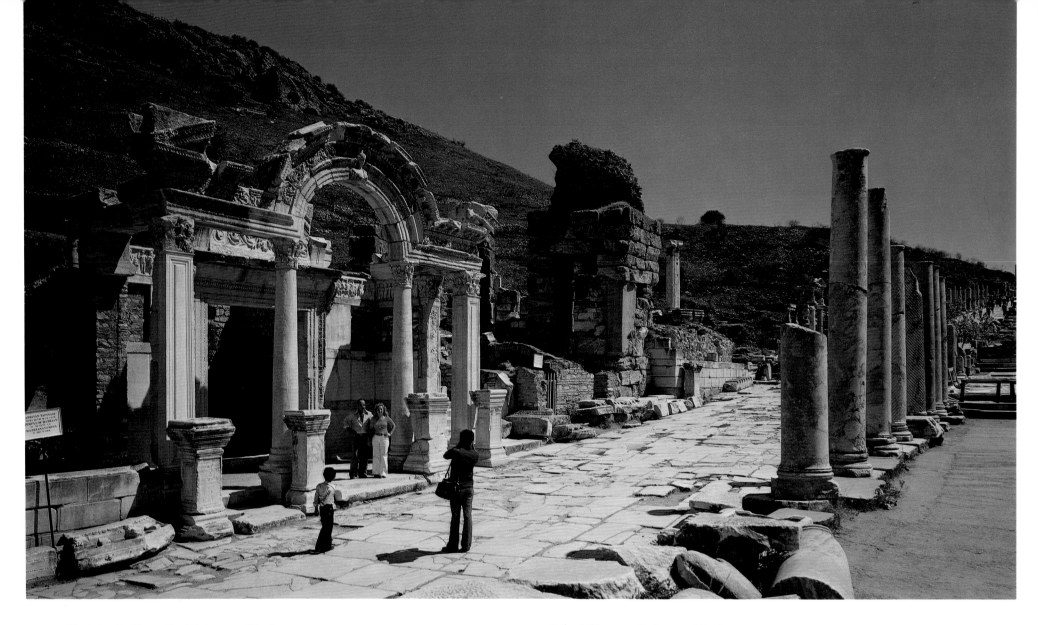

Hadrian's Temple, Ephesus, Turkey

ABOVE: World trade made the city of Ephesus a rich seaport which rivaled the splendor of Rome. The Roman Emperor Hadrian traveled extensively and as patron of many Roman cities, spread much of the culture of Rome to its far-flung outposts. Ephesus erected a Temple to Hadrian; a beautiful building with marble columns facing the street.

Once Ephesus overlooked the Aegean Sea but river silt filled and clogged its harbor and the once-proud city began to die. The long marble avenue that stretched from the center of Ephesus to the harbor now ends in a marshy silted area far from the sea.

PHOTOGRAPHY DATA: Afternoon, wide-angle lens.

The Library, Ephesus, Turkey

RIGHT: Fragments and ruins are all that remain of the ancient city of Ephesus, once a Roman provincial capital.

However, an Austrian construction company, along with archeologists, are reconstructing the Ephesus Library, originally built in 115 A.D. Although the transformation is far from complete, the building is beginning to look as it did during the golden age of Ephesus. Partially sunken in the sloping ground so that the main facade is accentuated, it is a two-story building with graceful columns, niches for statues and richly detailed ornamentation.

PHOTOGRAPHY DATA: Late morning, wide-angle lens.

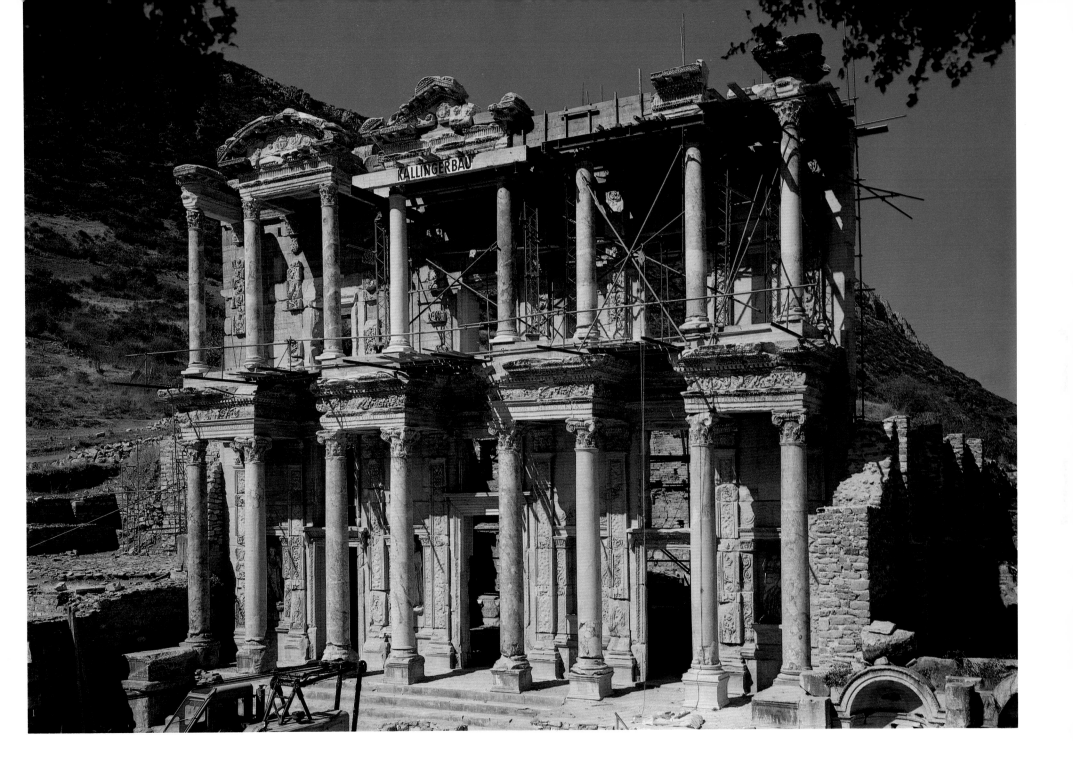

103

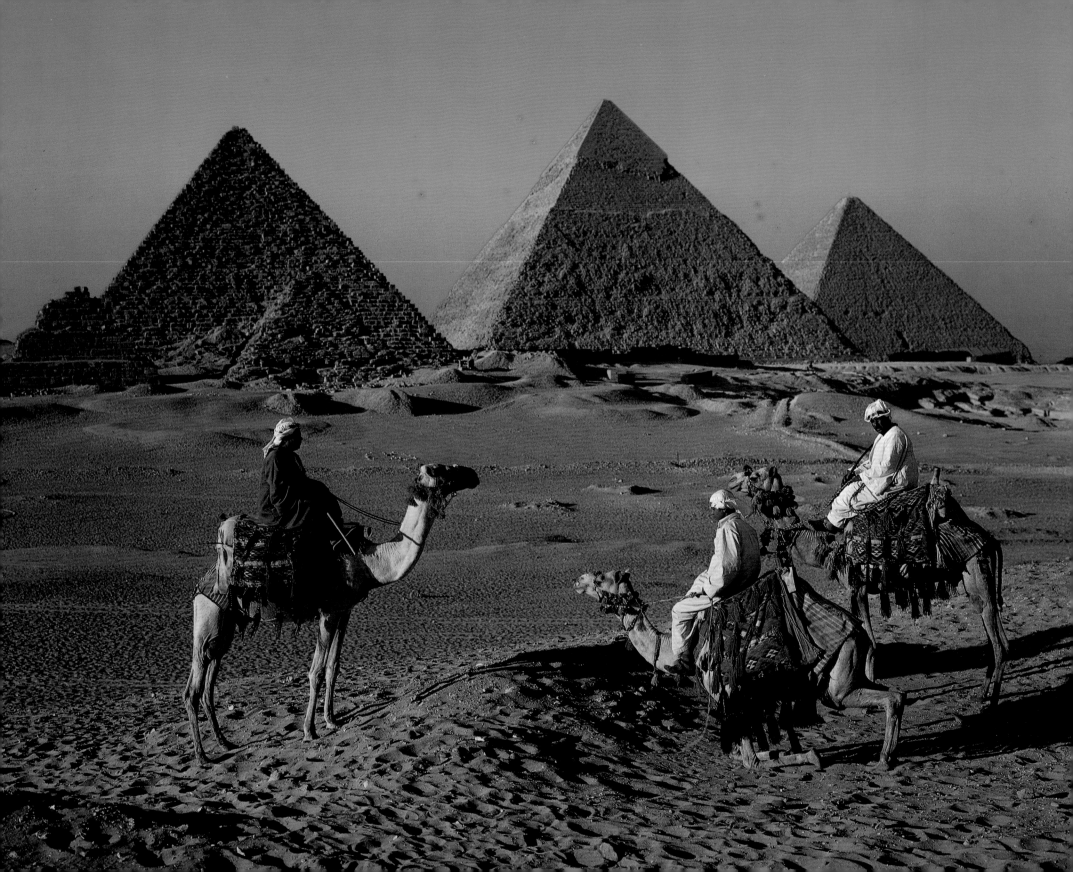

Pyramids of Giza, Egypt

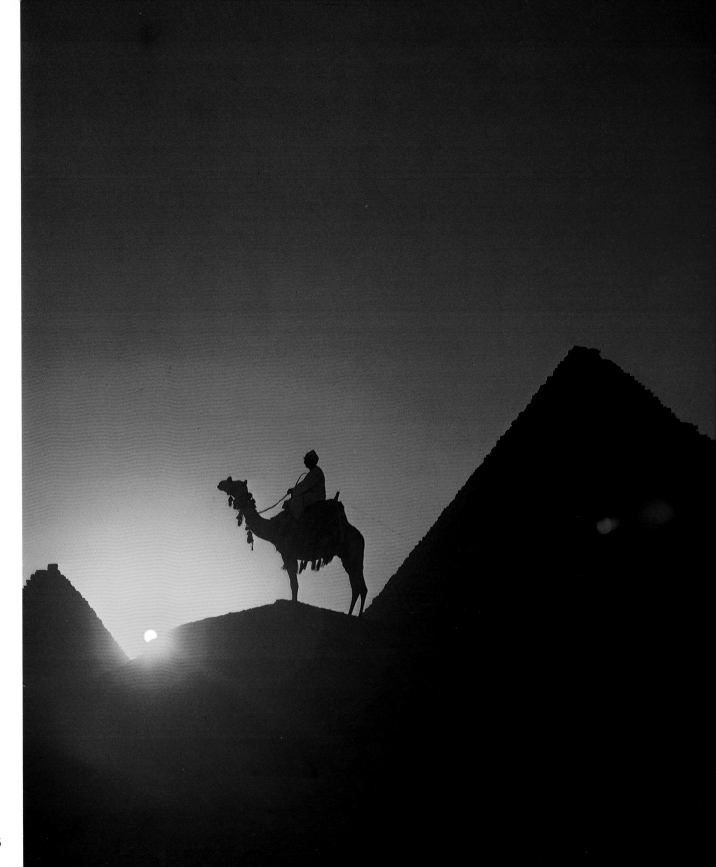

LEFT: Able to survive on minimum amounts of water and food and yet carry heavy loads, the camel (dromedary) is an indispensable beast of burden in desert regions. Their broad, padded two-toed feet move easily across the deep sand.

Desert dwellers breed camels not only for riding and transporting cargo, but use the hair for carpets and tents, the skin for leather, the dung for fuel, and also drink dromedary milk.

An integral part of your visit to the Pyramids is a ride on a camel. You climb aboard while it is lying on the sand. It rises up rear end first, throwing you forward almost over its head and then, on its feet, lurches along with a swaying gait not unlike a wallowing ship. Front legs first, the camel kneels down, with complaining grunts and groans, and almost tosses you over its head again when you dismount. Flaunting such a nose-in-the-air supercilious air, the camel is a strange and intriguing creature.

PHOTOGRAPHY DATA: Late afternoon, normal lens.

RIGHT: Almost 2.5 million limestone blocks, each weighing 2½ tons, form the tomb of Pharaoh Khufu. This is the largest of the Pyramids of Giza. The "how" of its construction has not been proven even 5,000 years later. The prevalent opinion is that all three Pyramids of Giza, not far from Cairo, were built by manpower using ropes, levers, rollers and sand ramps. No written specifications have been found to corroborate this theory. Researchers lately are of the opinion that this Herculean task was performed by conscripted laborers and farmers idled when the Nile River was in flood.

The tomb of Khufu or Cheops was the first one built and has, like the others, been stripped of its fine limestone outer facing.

PHOTOGRAPHY DATA: Sunset, normal lens. Exposure was determined by metering sky area near sun.

105

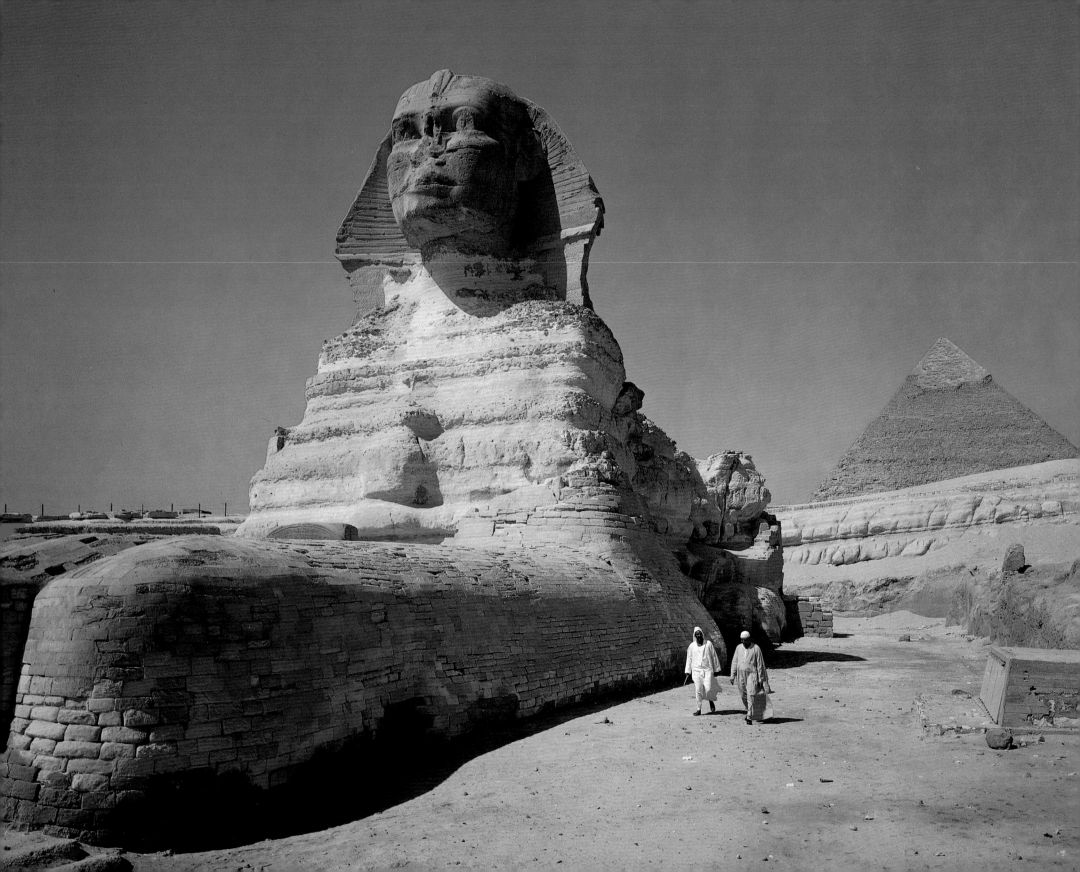

Sphinx, Egypt

LEFT: An ancient mysterious figure, the Great Sphinx of Giza has a lion-shaped body symbolizing strength. Carved from a rock outcropping during the reign of King Khafre (Kafra), who built the second pyramid, it probably bears his features. Mameluke riflemen scarred the face with their bullets, taking off the nose, beard and part of the neck.

Two guides in their flowing robes (jellabas) walk near the Sphinx giving it scale. Photographs often give it the appearance of being as high as the Pyramids but it is actually much smaller.

PHOTOGRAPHY DATA: Morning, wide-angle lens.

Temple of Rameses, Abu-Simbel, Egypt

RIGHT AND PAGE 108: Rameses II ruled Egypt for 67 years and spent much of his reign building monuments to himself. Four colossal 65-foot high statues of Rameses were carved from the sandstone cliffs on the west bank of the Nile River. When the new Aswan Dam was projected 50 nations supported the heroic task of lifting these colossi to higher ground above the level of Lake Nasser which was formed by the dam. Rameses II, in his majesty and his wife and family in diminished proportions, overlook the lake impassively. Queen Nefertari was honored with her own temple nearby with four standing colossi of her husband Rameses and two of herself.

PHOTOGRAPHY DATA: Morning, normal lens.

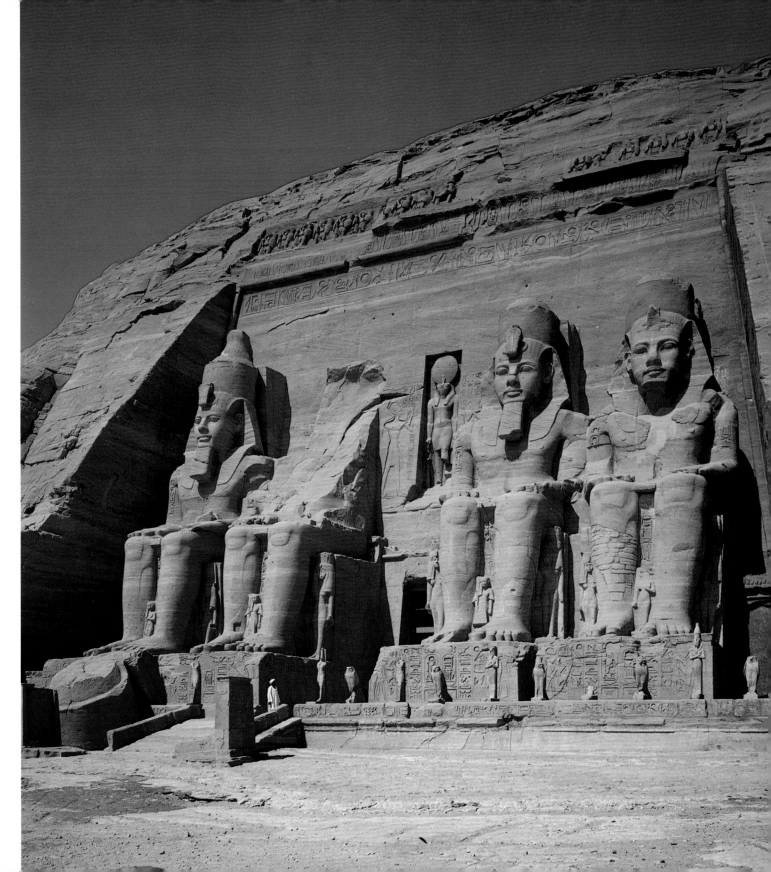

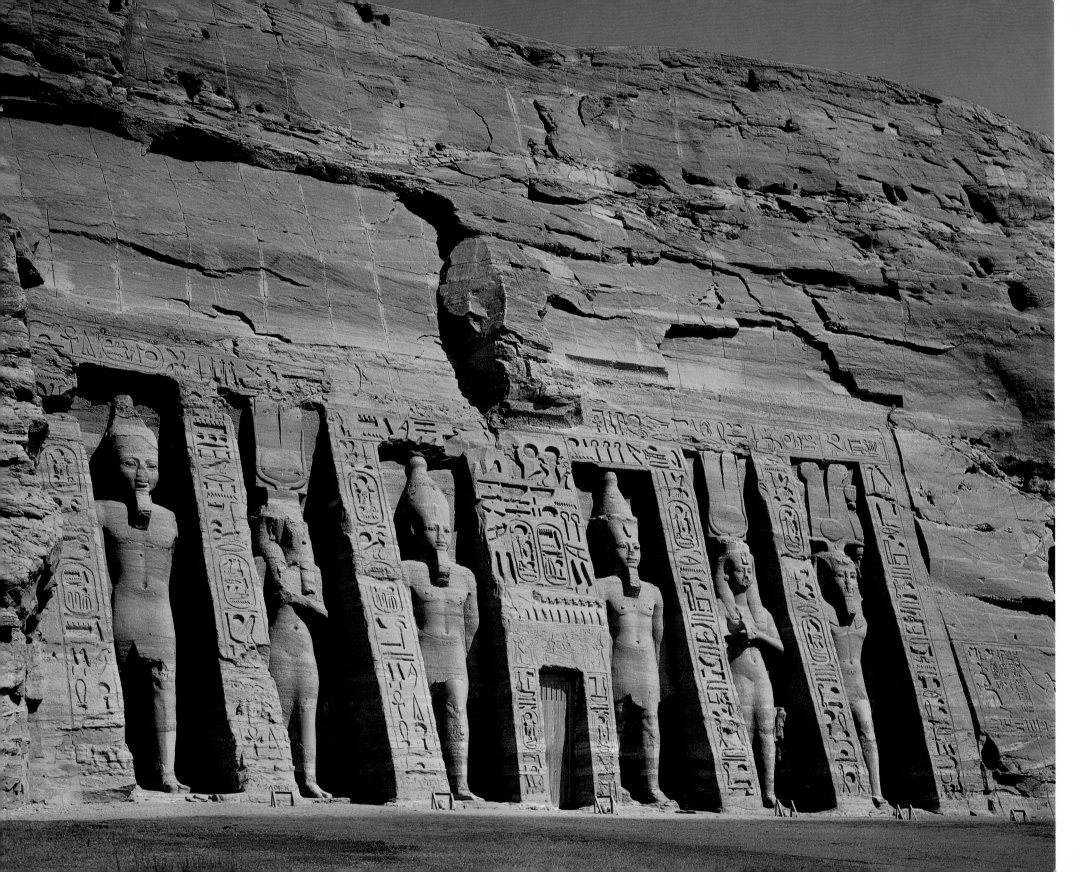

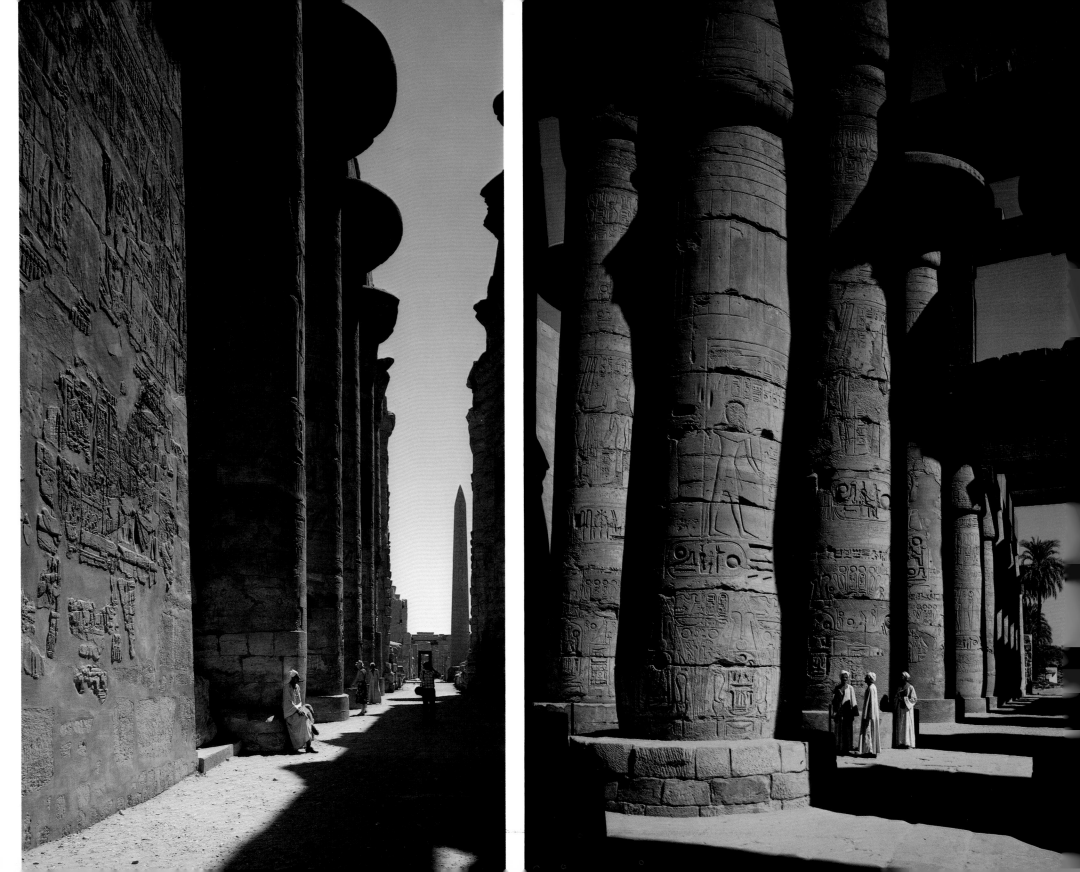

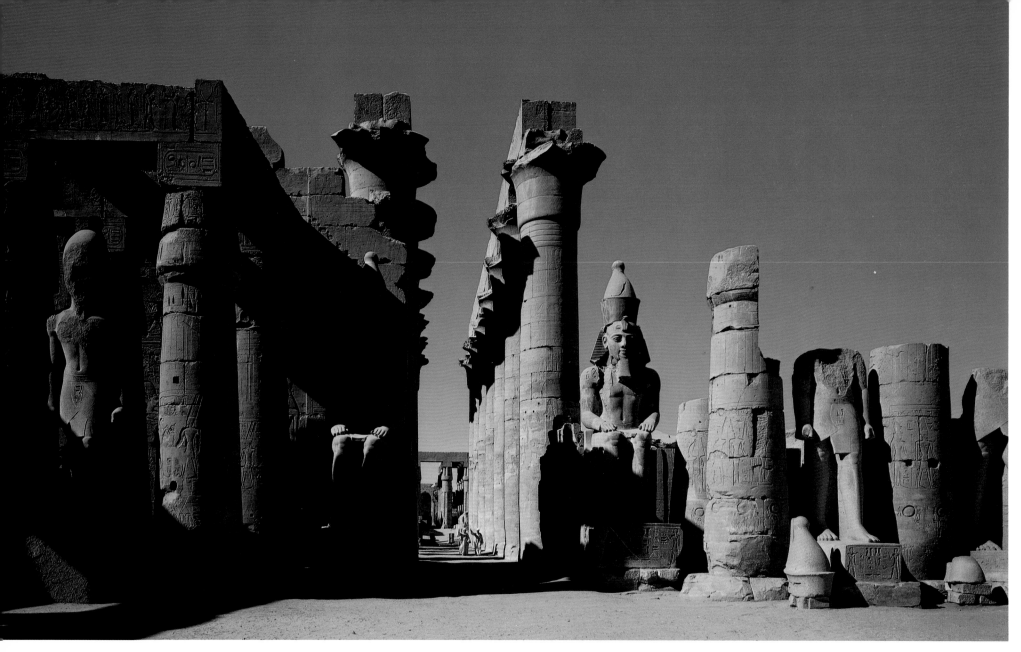

Temple of Karnak, Egypt

PAGE 109: The Temple of Karnak was once dignified by 140 monumental columns, 69 feet high and 33 feet in circumference. Built partially during the reign of Rameses II, the hall has sixteen rows of splendidly carved columns. Four great obelisks were introduced by Queen Hatshepsut but only one of these monoliths remains today. The others have become rooted in various large cities of the world.

PHOTOGRAPHY DATA: Morning, wide-angle lens.

Temple of Luxor, Egypt

ABOVE: The Temples of Luxor and Karnak are located to the south and north, respectively, of the ancient city of Thebes, once the world's greatest city.

Capitals on the columns of the Temple of Luxor are designed to resemble papyrus buds; a reed-like plant that used to grow profusely in Egypt and was used for making a paperlike writing material used by aristocrats and nobility.

PHOTOGRAPHY DATA: Morning, normal lens.

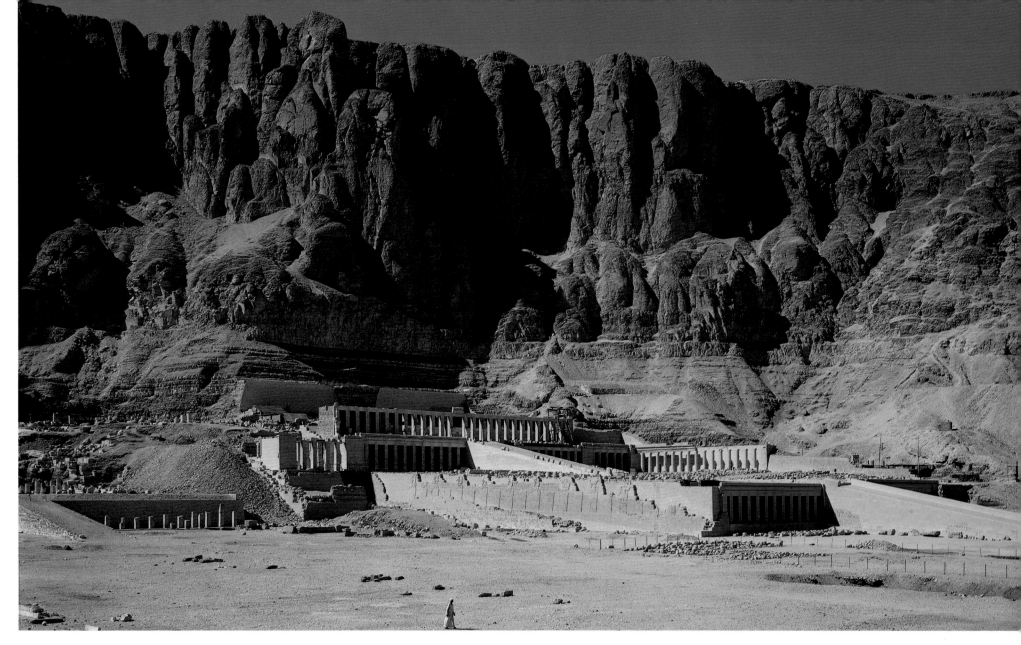

Queen Hatshepsut's Temple, Egypt

ABOVE: Queen Hatshepsut first ruled as the young King's regent, but soon assumed the full rights of a Pharaoh, even to the false beard worn by many Pharaohs. During the 21 years of her rule she built this great funerary temple to honor herself and her father. At this period of history the Pharaohs worshiped the sun god and above the three beautiful terraces and processional ramps, is an altar for worship.

PHOTOGRAPHY DATA: Afternoon, normal lens.

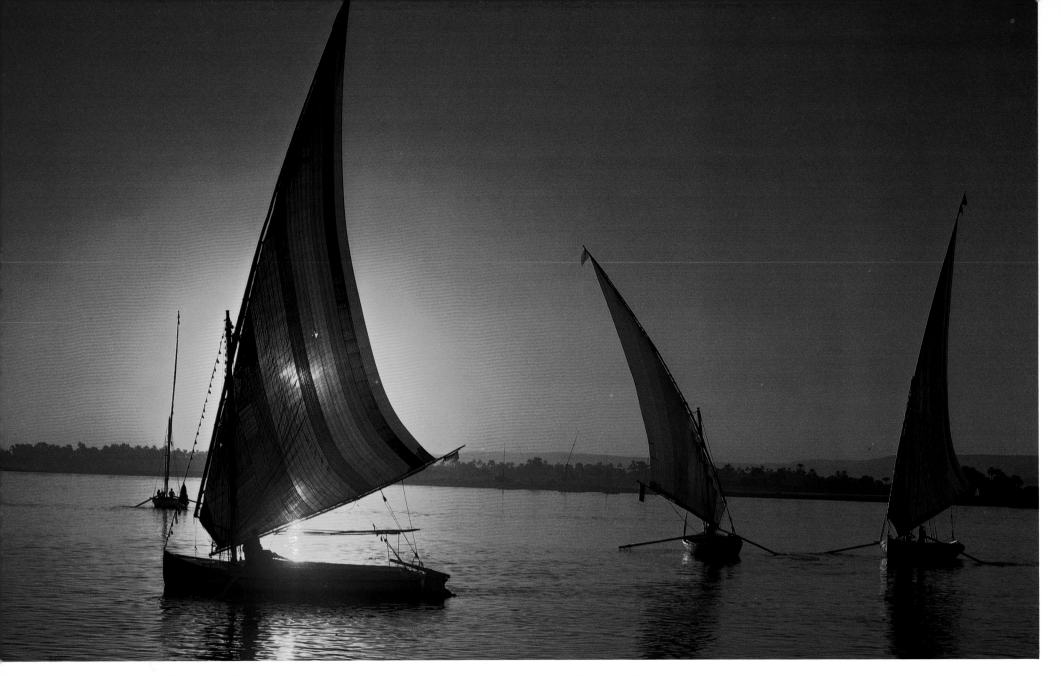

Feluccas, Nile River, Egypt

ABOVE: Triangular-sailed boats called Feluccas have sailed on the Nile River for thousands of years. Carrying cargo or passengers, their large lateen sail can capture the slightest breath of wind. When the breeze fails, oars are manned. At evening their sails reflect the warm color of the setting sun.

PHOTOGRAPHY DATA: Sundown, normal lens.

Leptus Magna, Libya

RIGHT: Leptus Magna was the largest city of ancient Libya. The Phoenicians, master sea traders of the world, established Leptus Magna as a trading post for their shipping. With a complex history of conquerors, credit is given to the Italians for uncovering the statues of former Roman emperors and clearing the sand from the buried city. Visual proof of the strong Roman power in North Africa, the mighty amphitheater of Leptus Magna was constructed around 200 A.D.

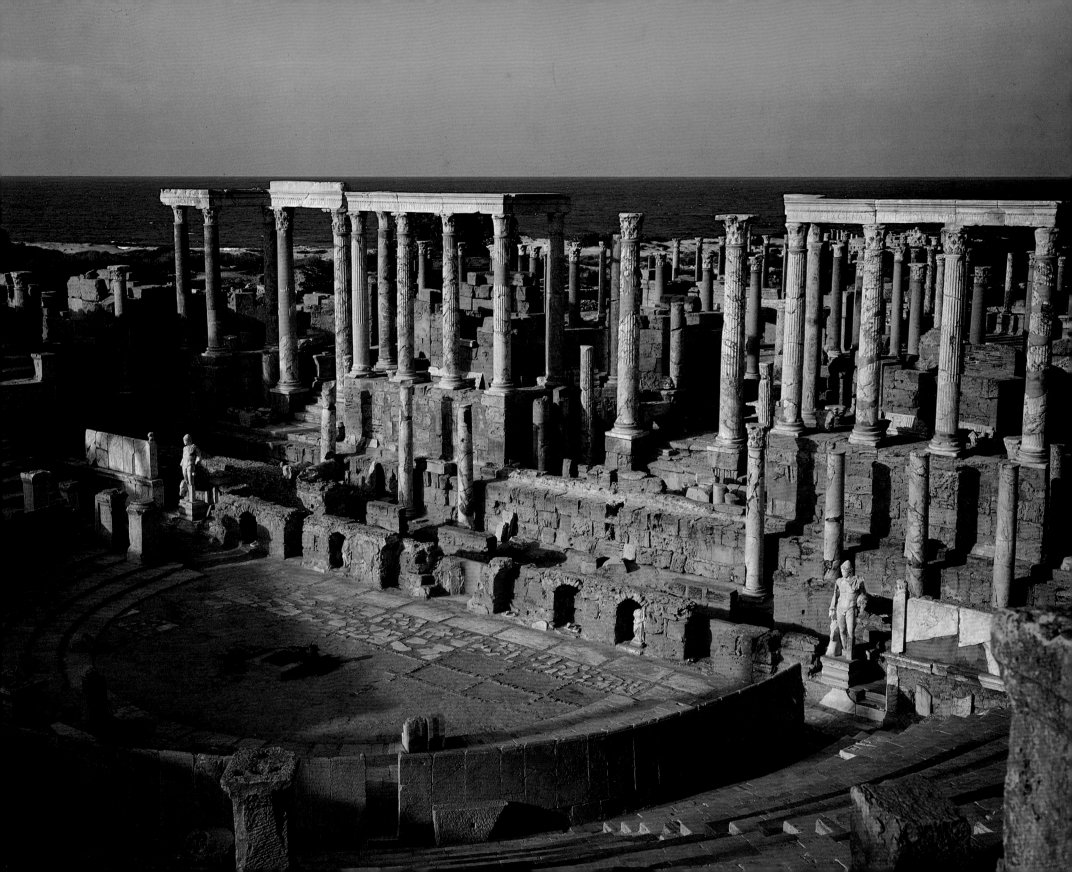

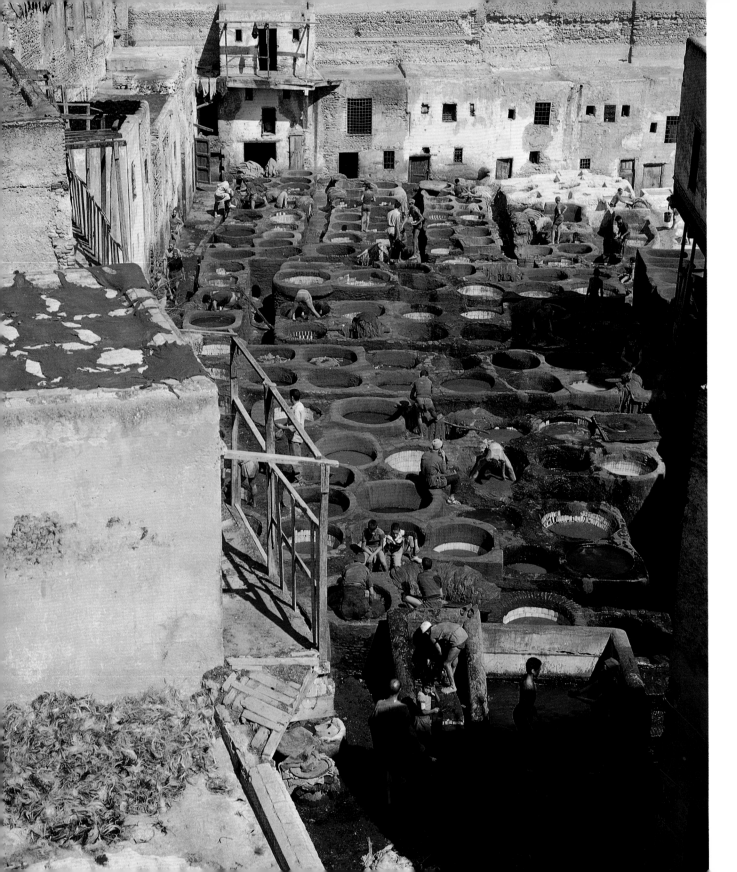

Tannery, Fez, Morocco

LEFT: Much Moroccan leather used commercially is dyed in this Easter egg array of foul smelling vats in Fez. The hair is removed from dried skins which are vigorously scraped by hand before they are placed in the vats to be dyed and seasoned. They are then stretched out on nearby roof tops to dry. These same dyeing vats have been used for centuries.

PHOTOGRAPHY DATA: Afternoon, wide angle lens. A guide would be required to help find this unusual sight.

114

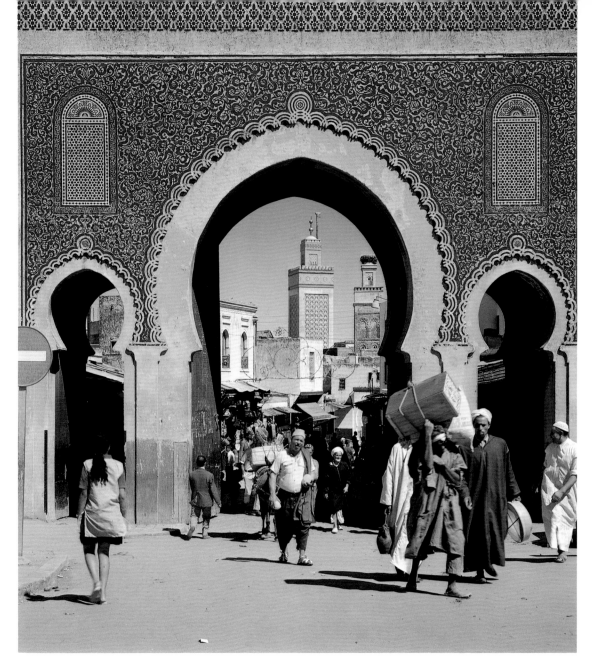

Gateway, Fez (Fés), Morocco

ABOVE: One of the sacred Islamic cities, Fez has over a hundred mosques. There were reportedly 785 of them during the Middle Ages when Fez was in its prime. The gateway to the ''casbah'' or old inner city looks much the same now as it must have centuries ago. A ''no entry'' sign and 20th century clothes on a young lady are the only modern adjuncts. Inside the portal narrow streets twist between open-front shops and walled courtyards.

PHOTOGRAPHY DATA: Midday, normal lens.

Koutoubia Minaret, Marrakech (Marrakesh) Morocco

Morocco has been an independent nation since 1956. It had been a French protectorate since 1912. But it's City of Marrakech is over 900 years old. Arab invaders displaced the Berbers who lived here and Islam prevailed. One evidence is the tall red square minaret of the Koutoubia Mosque, where countless generations of Marrakech citizens have heard the muezzin's (priest's) call from this minaret, reminding Muslims of the obedience they owe Allah.

PHOTOGRAPHY DATA: Afternoon, normal lens.

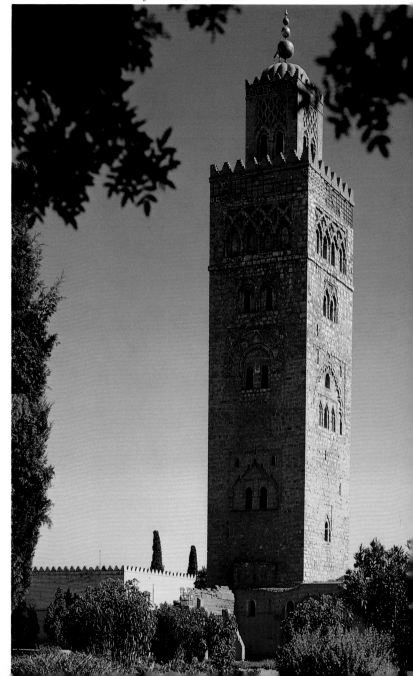

115

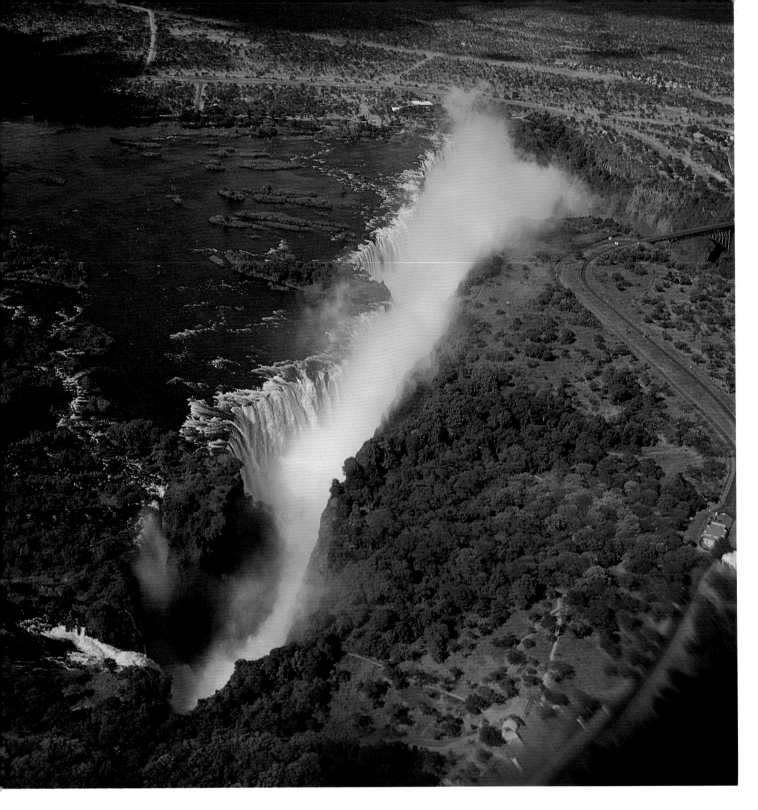

Victoria Falls, Rhodesia

LEFT: The smooth flowing Zambezi River is a mile wide as it approaches the border of Rhodesia. Suddenly as though the hand of a giant holding a huge knife had made a slash completely across the river, it drops noisily into a narrow trench, 355 feet deep. The water and spray for centuries have been called by the natives "the smoke that thunders". All of the water confined in the trench exits through one narrow canyon. The rainbows and the magnitude of the falls are overwhelming. Discovered by David Livingstone in 1855, they were named Victoria Falls in honor of his queen.

PHOTOGRAPHY DATA: Midday; Normal lens. Numerous viewpoints present a ground level opportunity for photography—but only an aerial view explains the unusual falls geological character. Photo by Mickey Prim (See credit page).

The Wailing Wall, Jerusalem

RIGHT: One of Judaism's most sacred places, the Western or Wailing Wall is a remnant of the wall which surrounded Herod's temple. Solomon had built the first temple. It was destroyed by Nebuchadnezzar, rebuilt about 70 years later after which it was desecrated and in such bad repair that Herod restored it. Destroyed again in A.D. 70, Jewish pilgrims for centuries have mourned the temple's loss at the Wailing Wall except during the period it was held by Jordan.

PHOTOGRAPHY DATA: Late morning, normal lens.

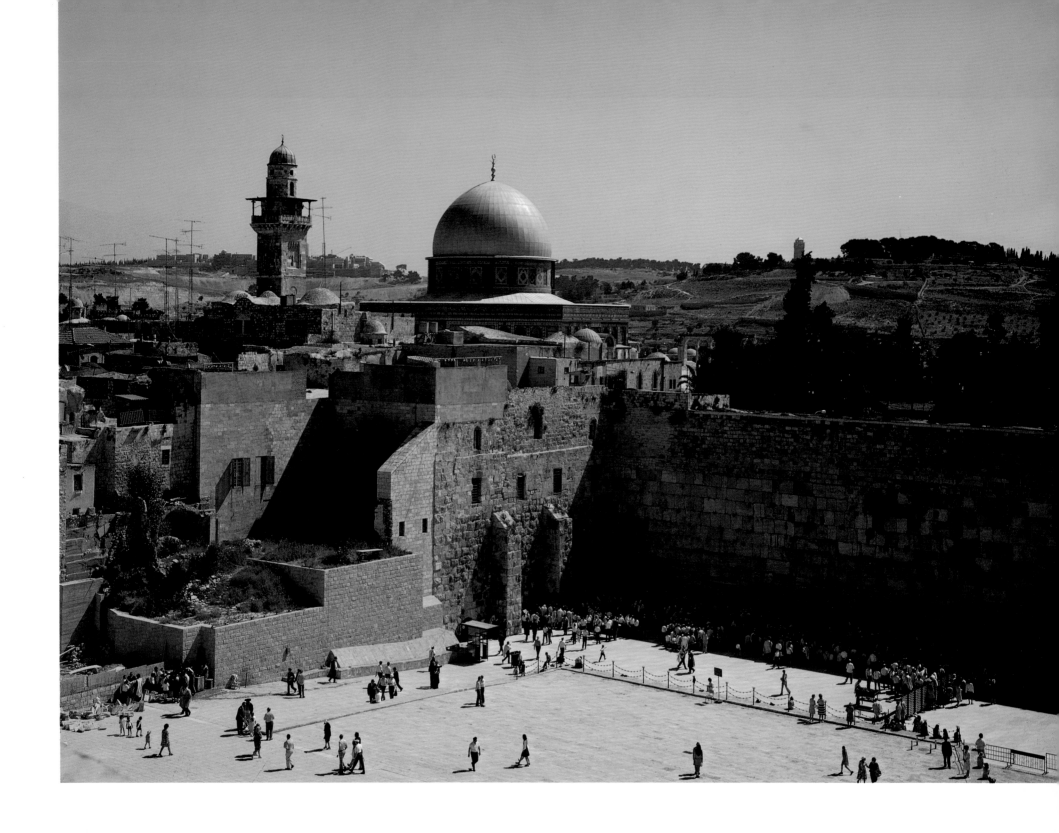

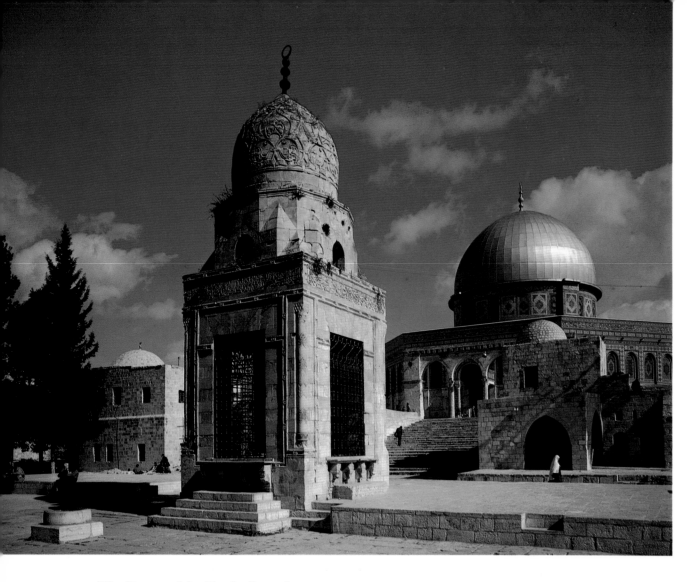

Jerusalem

RIGHT: An ancient city held in equal reverence by Jew, Muslim and Christian, Jerusalem is a fine example of a completely walled town of the late Middle Ages. Here tribes have clashed with tribes, nations with nations. The massive wall which survives today is said to be located above an early settlement of 1800 B.C. A viewpoint on the Mount of Olives shows much of Jerusalem's old city wall and the glistening Dome of the Rock is a prominent feature.

PHOTOGRAPHY DATA: Early afternoon; normal lens.

BELOW: Silhouette of the Russian Orthodox Church on the Mount of Olives.

PHOTOGRAPHY DATA: Sunset; normal lens.

The Dome of the Rock, Jerusalem

ABOVE: Standing on a site sacred to Moslem, Christian and Jew, the Dome of the Rock is built over the Rock of Abraham. This bleak stone is the traditional spot where Abraham, claimed as an ancestor by both Arab and Jew, was going to sacrifice his son at God's command. From here Mohammed, according to Moslem belief, rode up to heaven. The Dome of the Rock has been a holy shrine for Moslems since the 7th century.

PHOTOGRAPHY DATA: Morning, wide angle photograph by Naurice Koonce

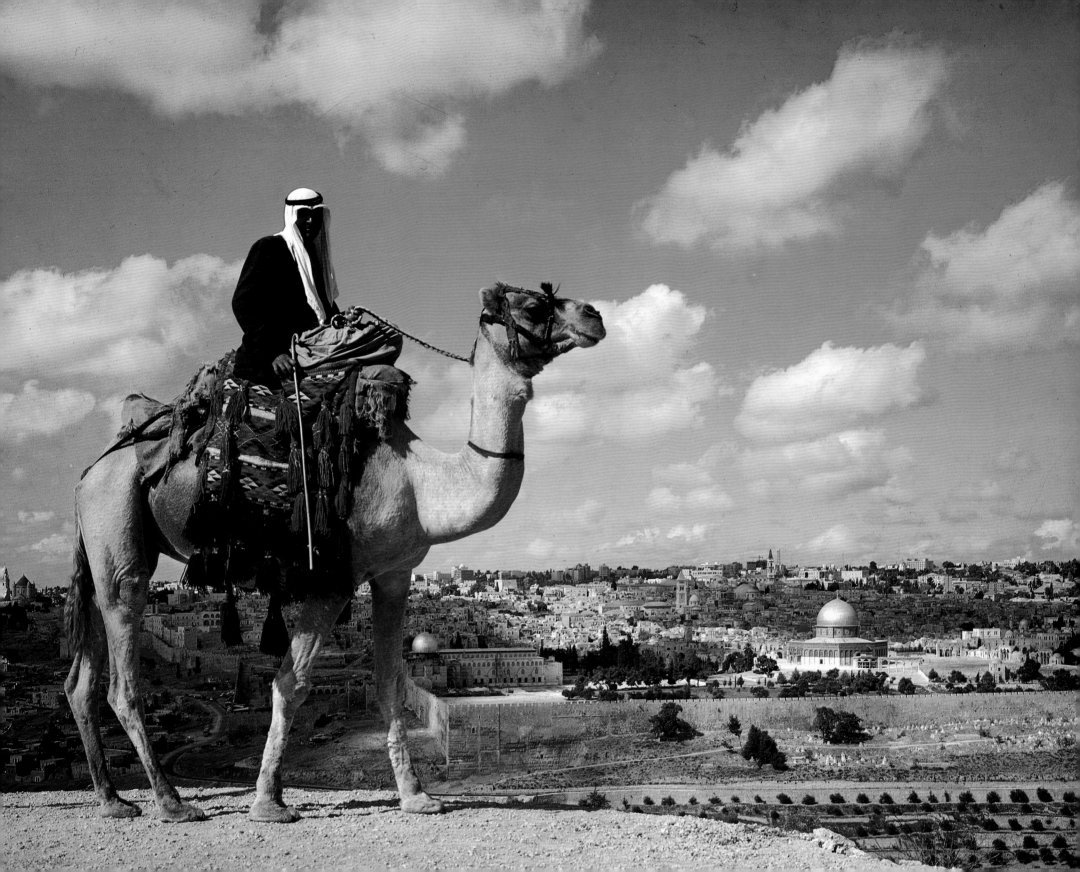

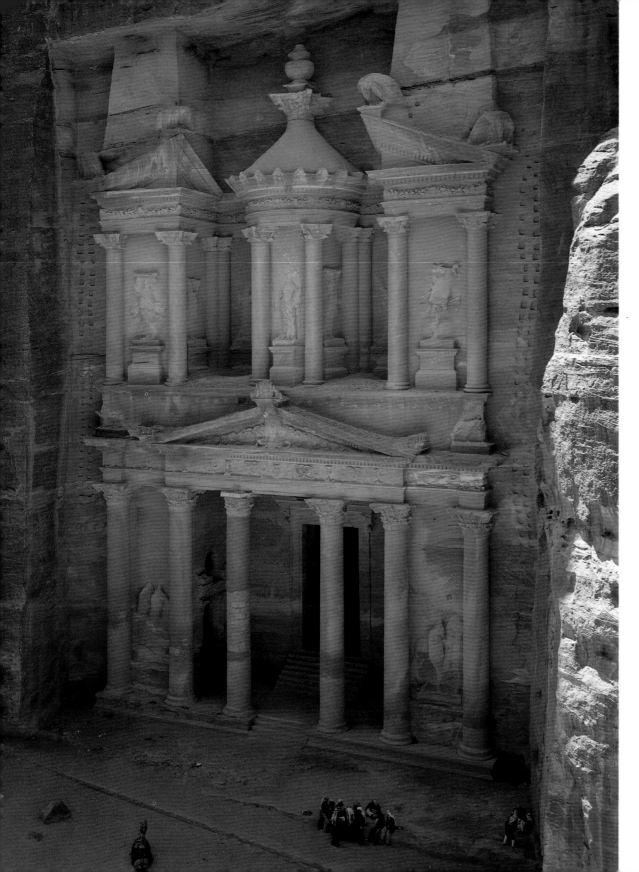

The Treasury, Petra, Jordan

LEFT AND RIGHT: Temples, palaces, homes, theaters and tombs are carved from the pink sandstone cliffs in Petra, the ''Rose Red City of the Desert.'' Petra was the depot for merchants and caravans bringing goods from the East to the Red Sea and the Mediterranean until the change in trade routes caused its decline.

Reached through a mile-long cleft with sheer walls 300 feet high, the pass narrows at places to a few yards wide. Rounding a bend in the deep chasm, the startlingly beautiful and ornately carved facade of the Treasury comes abruptly into sight, framed as though through a tunnel. Then the chasm opens to give a wider view. Hewn from a varicolored stratified cliff, the 130-foot high Treasury was probably a tomb. The sculptured urn at the top was damaged by Arab riflemen who tried to shatter it to obtain the treasure they believed was hidden there. It was Arabs who first called it The Treasury.

Lost to the world for centuries, it was rediscovered in 1812 by a Swiss explorer.

PHOTOGRAPHY DATA: Right, morning sunlight, wide-angle lens. Left, afternoon shade, normal lens.

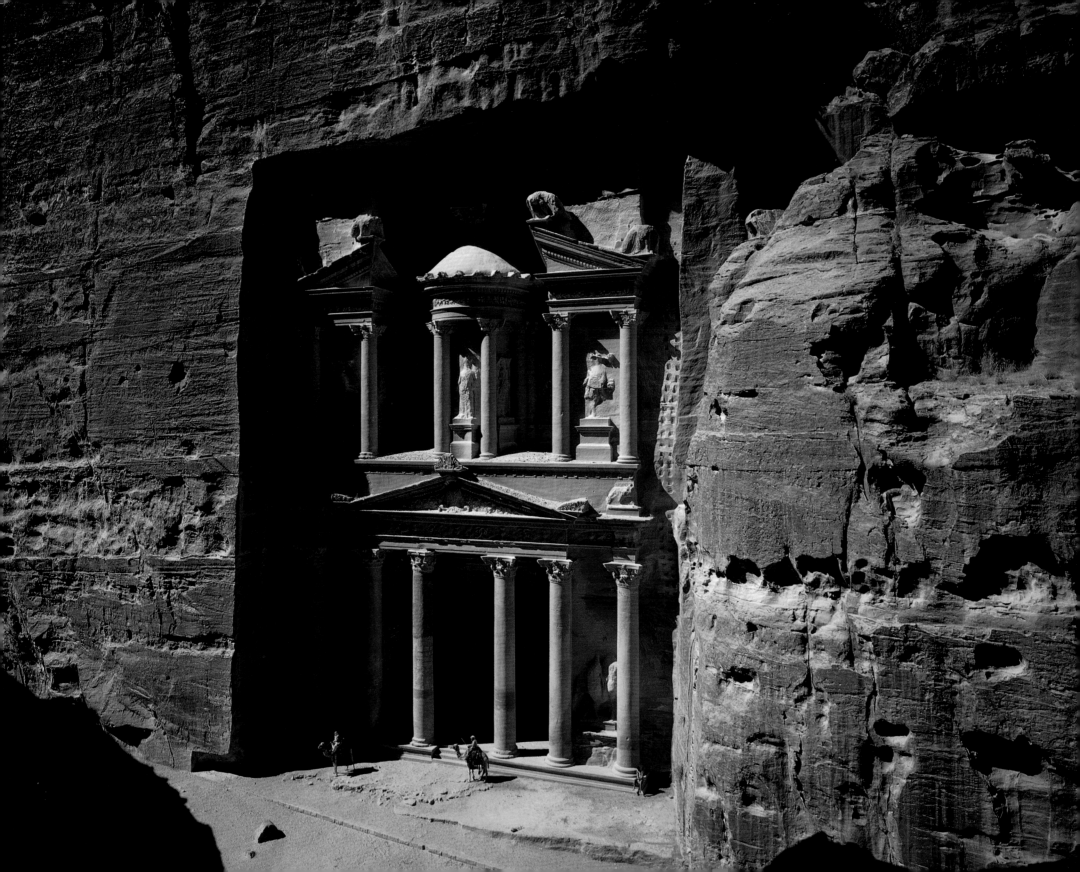

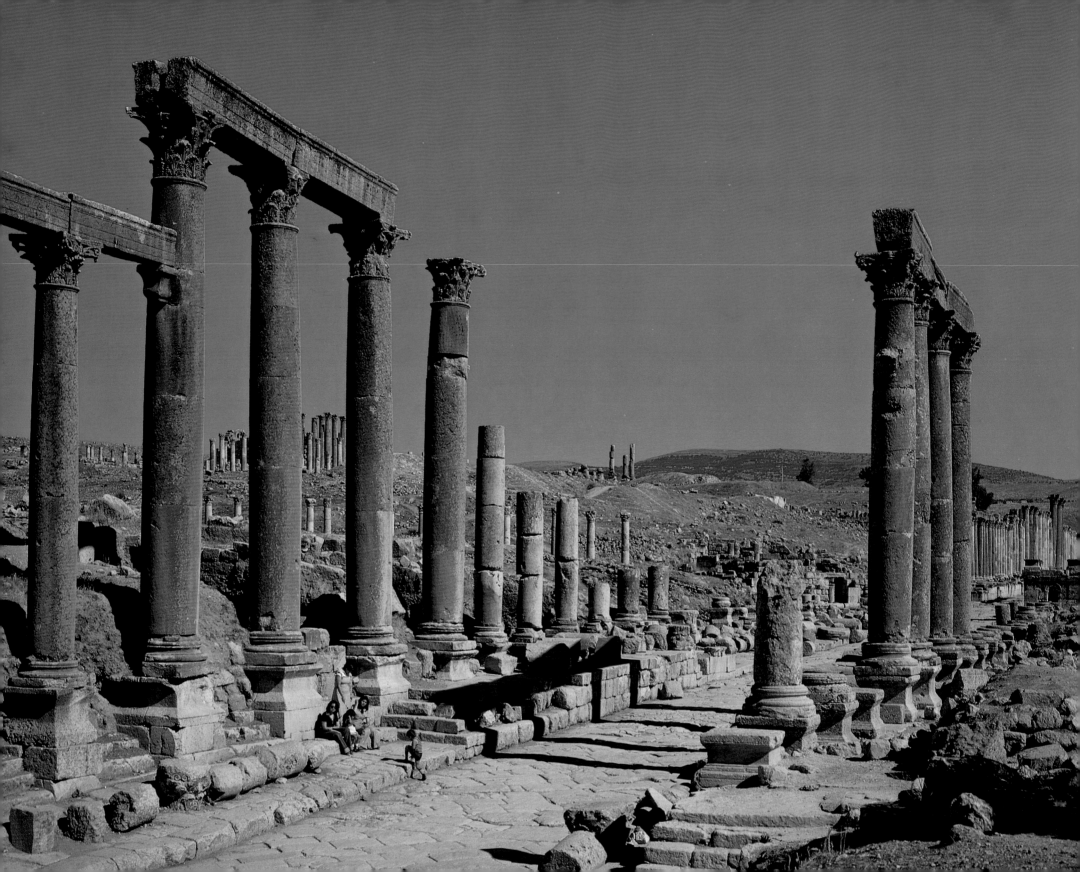

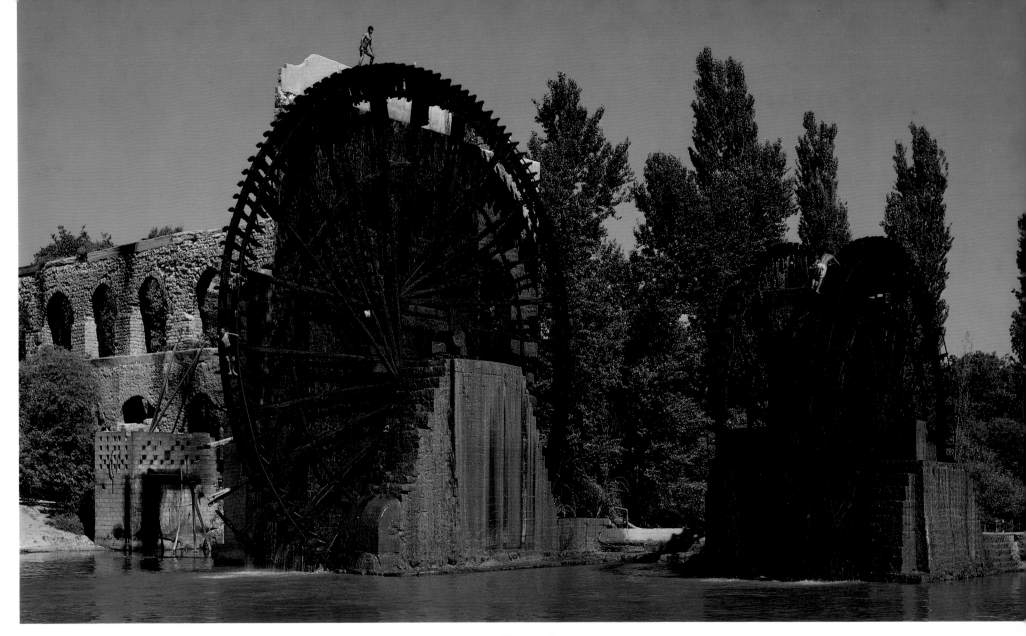

Hama, Syria

ABOVE: Believed to have been built by Persians long before the birth of Christ, the giant norias (waterwheels) of Hama have been turning continuously since then, except when yearly repairs are in progress. Wooden partitions are part of the wheels and as they rotate upward pushed by the force of the Orontes River, the water is lifted and dumped into the aqueduct and thence to the fields.

Wearily creaking and groaning, the wonderful noise the ancient norias make is increased by the shouts of boys riding the waterwheels and diving into the river.

PHOTOGRAPHY DATA: Midday, normal lens. When the norias are dry they are a light brown, but when wet the moss is nearly black and requires more exposure.

Jerash, Jordon

LEFT: Although the golden age of Jerash was after the 4th century B.C., its inception goes back much farther. Little is known of this once vital city of Old Testament times, but excellent city planning is revealed in its ruins. An impressive colonnaded street, which runs the entire length of the town, still shows deep ruts worn in the stone paving by chariot wheels. Though many of the columns have fallen, some still retain their ornate Corinthian capitals.

PHOTOGRAPHY DATA: Morning, wide angle lens.

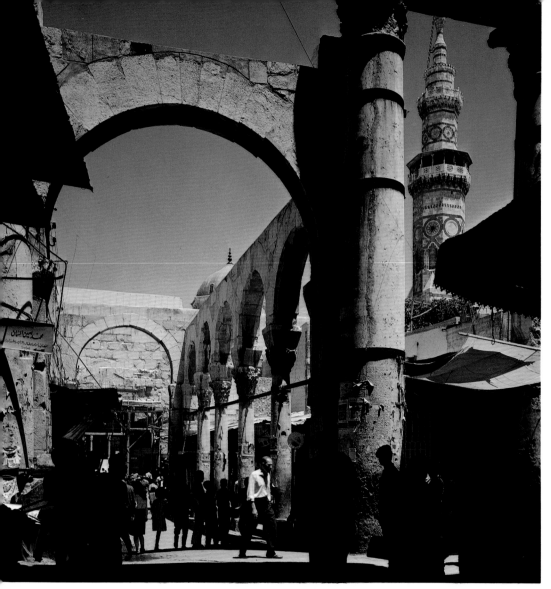

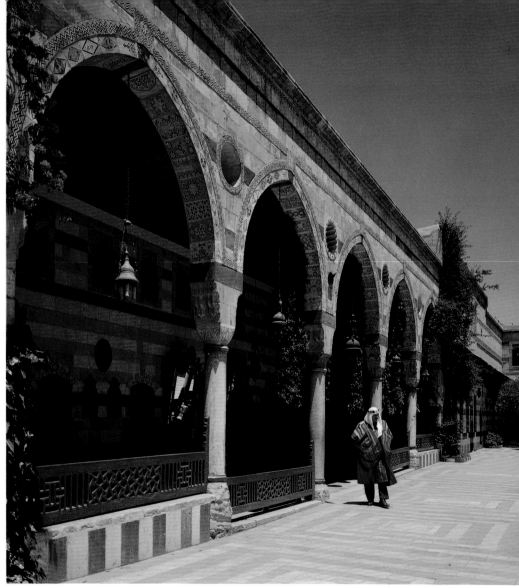

Omayyad Mosque, Damascus, Syria

ABOVE: Inhabited since prehistoric times, Damascus is believed to be the oldest continuously inhabited city in the world. Syria's busy capital has grown far beyond the ruined walls that once surrounded it. A fertile oasis in the desert, Damascus was the end of an ancient caravan route. The Omayyad Mosque is built on the site of an ancient Roman temple that was later enlarged and made into a church dedicated to John the Baptist. This was razed and the Great Mosque was built in its place. Inside the Omayyad Mosque is a small building with a cupola which, reportedly was erected over the head of John the Baptist.

PHOTOGRAPHY DATA: Afternoon, wide angle lens.

Azem Palace, Damascus, Syria

ABOVE: Damascus was a prosperous city with its bazaars selling silk, wool, furniture and articles inlaid with mother-of-pearl. Of intense hardness and keenness, the famous sword of Damascus steel was its most important product. When Tamerlane sacked the city in the 14th century, however, he captured all the sword makers and the fine craft was suspended. Though the oldest continually inhabited city in the world, Damascus has few ancient buildings other than a mosque and the Azem Palace. Now a museum, the palace was once a medieval citadel.

PHOTOGRAPHY DATA: Afternoon, wide angle lens.

124

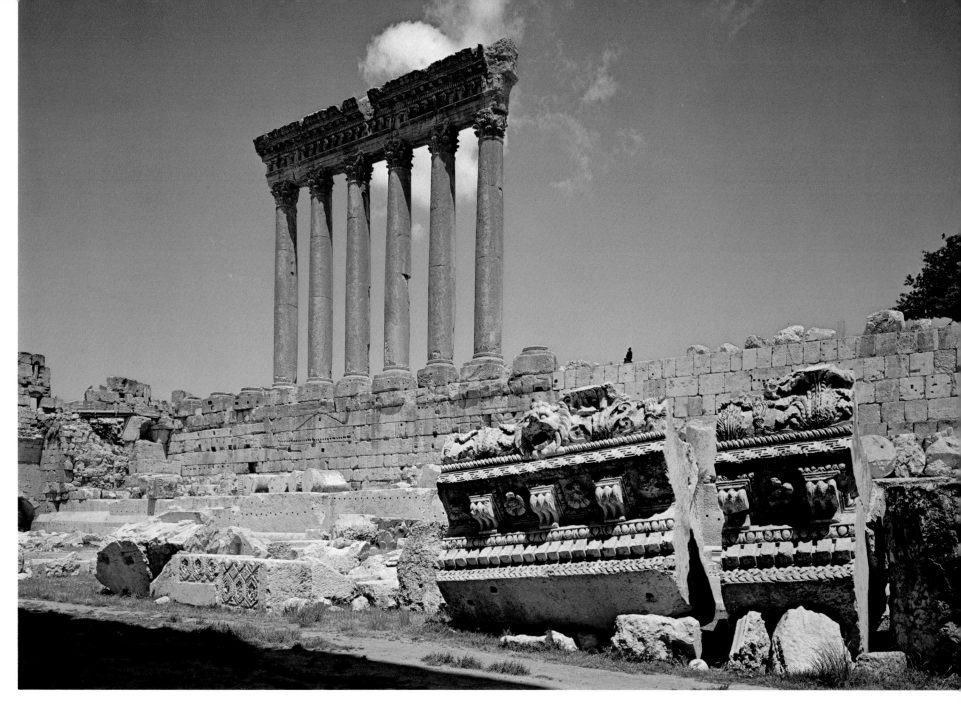

Temple of Jupiter, Baalbek, Lebanon

ABOVE: Built during Nero's reign, the Temple of Jupiter is an imposing Roman ruin with 65-foot high pillars. The temple was badly battered and plundered by both Arabs and Turks.

PHOTOGRAPHY DATA: Morning, wide angle lens.

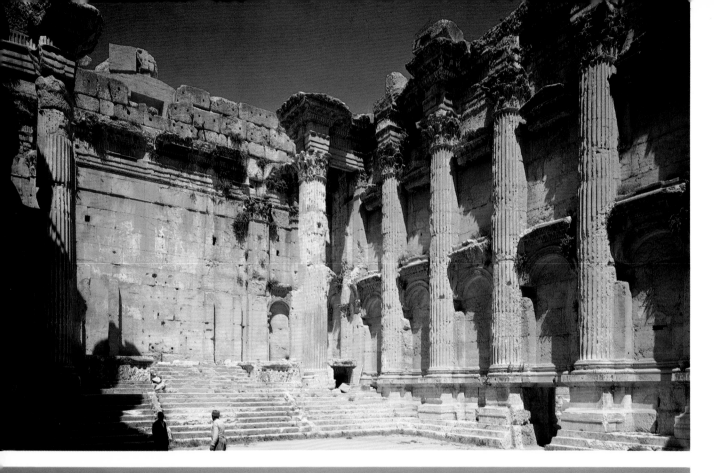

Temple of Bacchus, Baalbek, Lebanon

LEFT: Bacchus was the Roman god of wine, whose worship led to riotous drunken revelry and debauchery in this elaborately decorated temple dedicated to him. Amidst the ruins modern audiences can now enjoy the pageants and festivals held where once priests awed the crowds with blood sacrifices to the pagan gods.

PHOTOGRAPHY DATA: Morning, wide angle lens.

Shah's Mosque, Isfahan (Esfehan), Iran

RIGHT: "Isfahan is half the world" went the saying when the village, almost overnight, had become one of the most beautiful cities of the 16th century and the capital of the remarkable Shah Abbas the Great. Shah Abbas, familiarly called "Shabis" by the Persians, built this matchless Royal Mosque in 1592. The intricate floral and geometric patterns in the blue and gold mosaics are in observance with the Islamic doctine which forbids representing human or animal forms.

PHOTOGRAPHY DATA: Night, normal lens. A time exposure was made after an earlier exposure for the sky. With the energy shortage the mosque is no longer illuminated every night. I paid $20 for fifteen minutes of light.

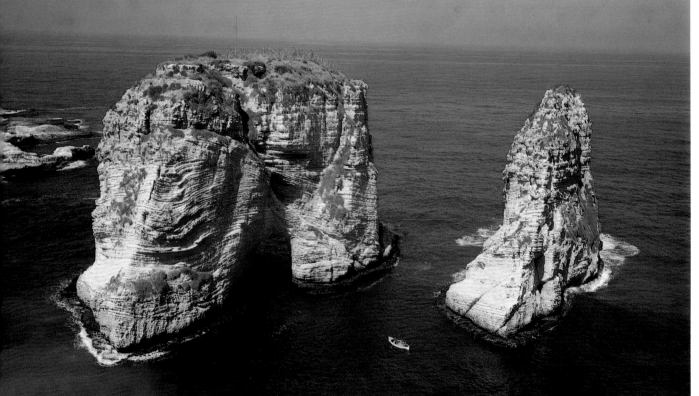

Pigeon Rocks, Beirut, Lebanon

LEFT: Interaction of sea and wind carved the limestone formations known as Pigeon Rocks. These beautiful white cliffs are a prominent landmark jutting out of the Mediterranean Sea near Lebanon's capital city of Beirut.

PHOTOGRAPHY DATA: Morning, normal lens.

126

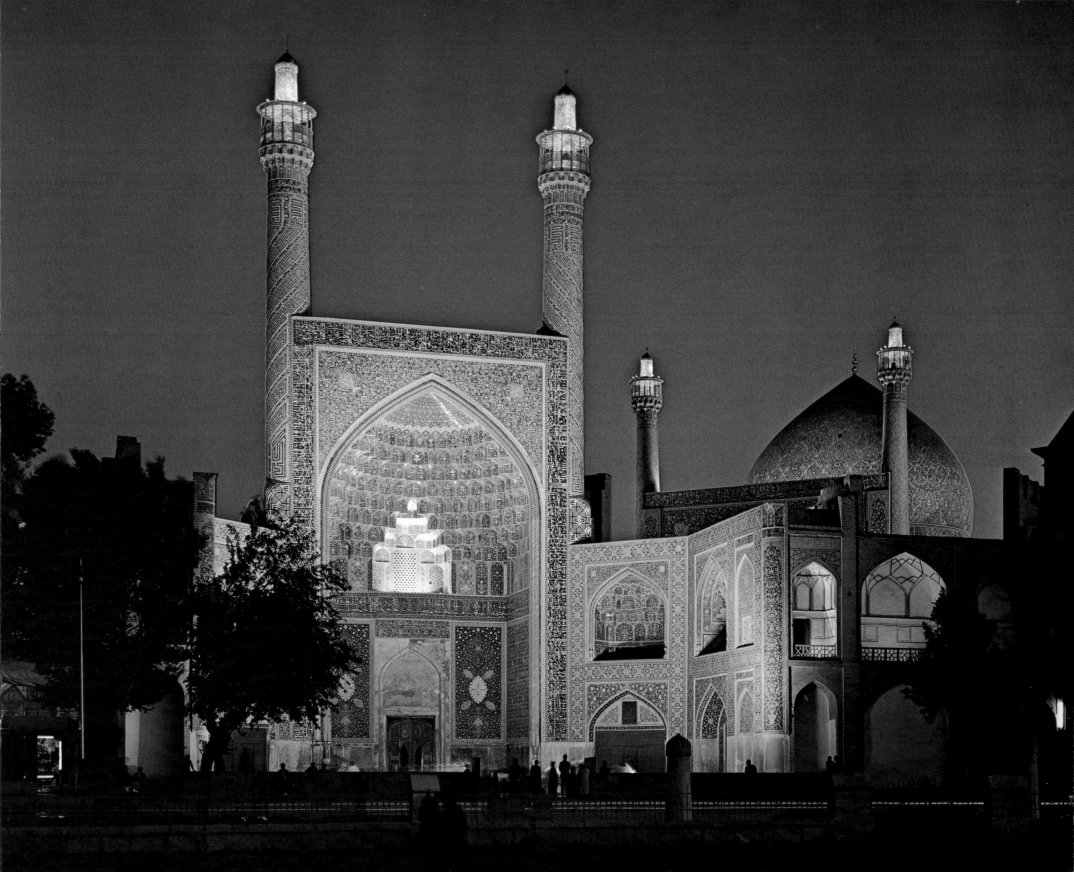

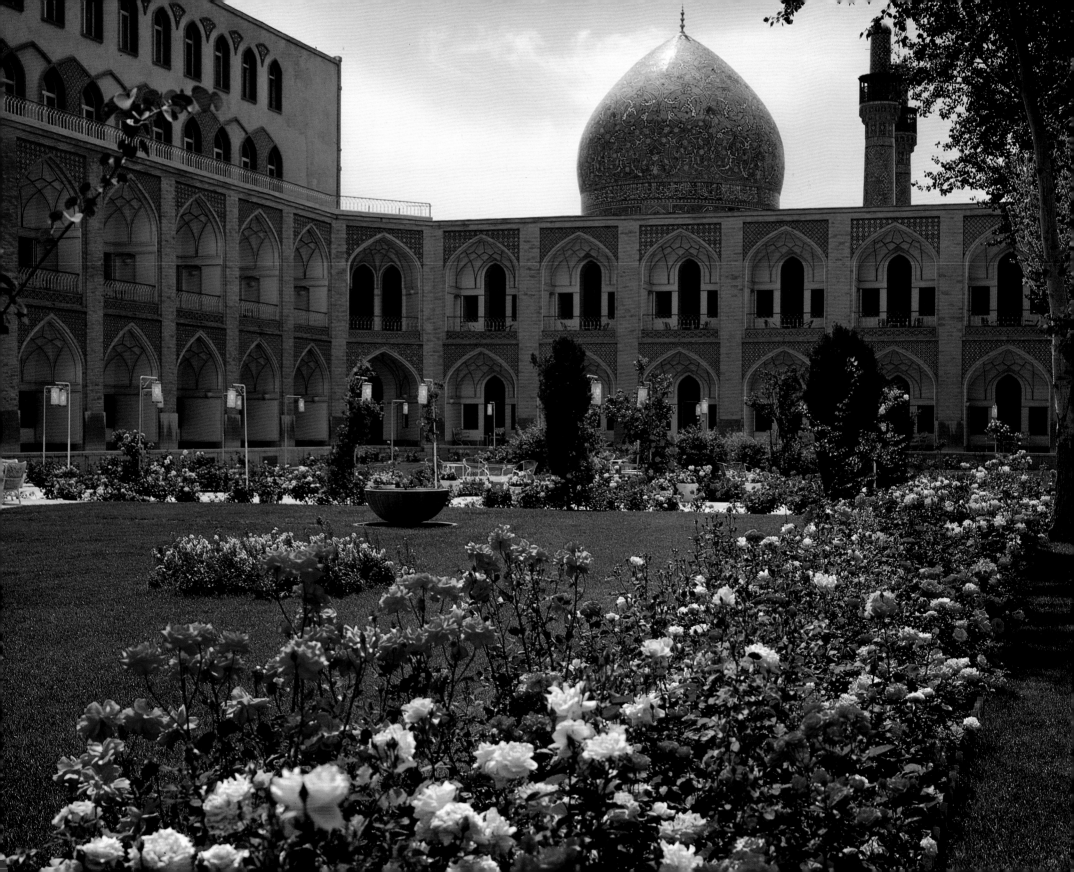

Shah Abbas Hotel, Isfahan, Iran

LEFT: The Shah Abbas Hotel in Isfahan, of recent construction, is a show place of Persian artistry in perfect harmony with the rare mosques and palaces built in the days of Shah Abbas. Tiles, mosaics, inlays and marble are all part of the luxurious ornamentation used on the interior. A marvelous rose garden embellishes the patio while the tiled dome of a nearby mosque appears to be a part of the inimitable decor.

PHOTOGRAPHY DATA: Morning, wide-angle lens.

Isfahan, Iran

RIGHT: The bazaars in Isfahan, a city of craftsmen, have a bewildering array of objects for sale. Much of the fabrication is done right in the shops where you can watch a silversmith tap out his delicate scrollwork, or a coppersmith hammering out trays and pitchers with noisy skill. Shopkeepers vie for the shopper's attention and invite them to examine their wares of carpets, hand-printed cloth, turquoise and other semi-precious stones, hand-painted miniatures on ivory, antiques, and glass decorated with gold and silver designs, as well as jewelry and countless other souvenirs.

PHOTOGRAPHY DATA: Morning, wide-angle lens.

129

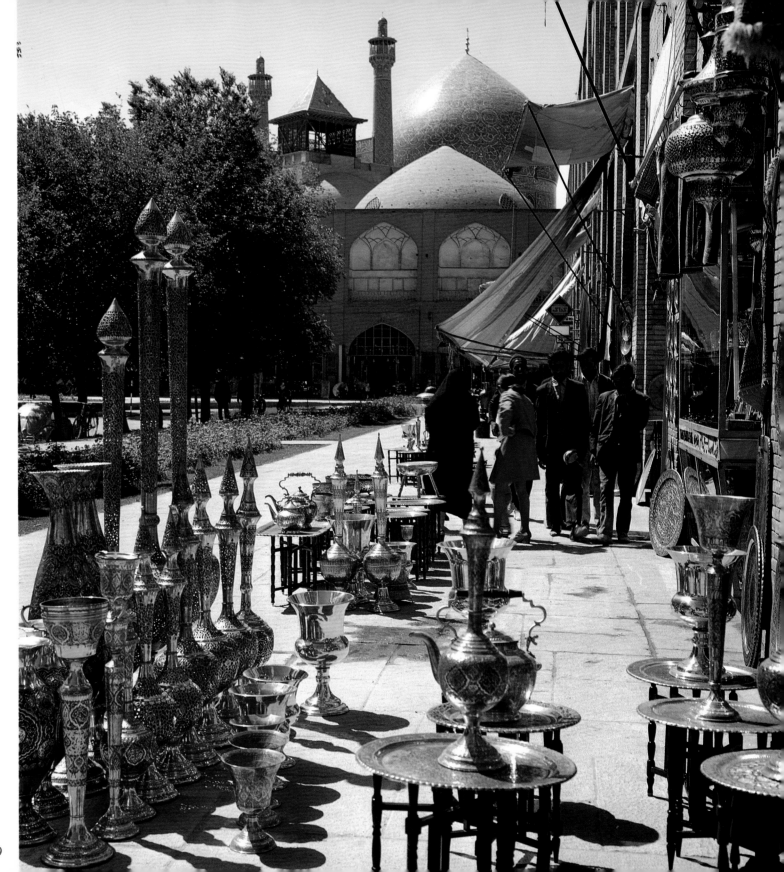

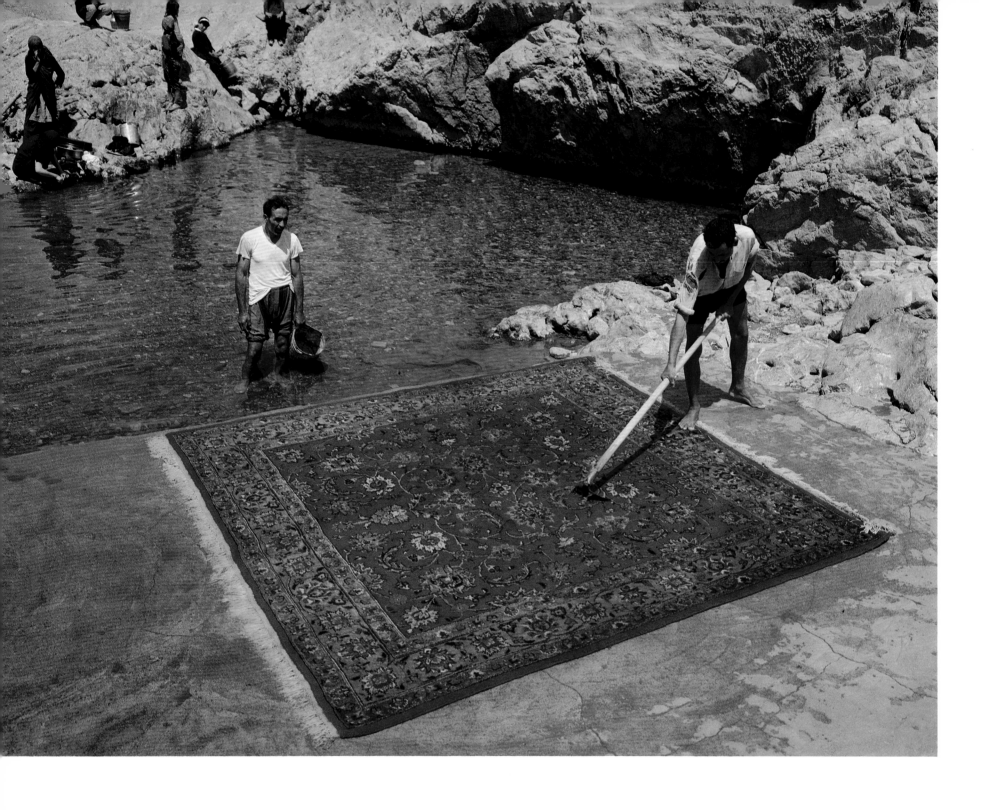

Rey, Iran

LEFT: In Rey, south of Tehran, there is a rock-rimmed spring whose waters are believed to brighten and sustain the colors of Persian rugs. Soaped and scrubbed with a rake-like tool, rinsed with buckets of spring water, these masterpieces are then draped to dry on the side of the massive rock above the spring. Fine rugs are sent here from Europe to be restored in the mineral-rich water.

PHOTOGRAPHY DATA: Morning, normal lens.

Mt. Demavend, Iran

RIGHT: A dormant volcano, Mt. Demavend soars skyward almost 19,000 feet. Snow-streaked even in summer, the rocky slopes are grazed by the sheep and goats of the nomads who pitch their black goatshair tents around the base.

PHOTOGRAPHY DATA: Late afternoon, normal lens.

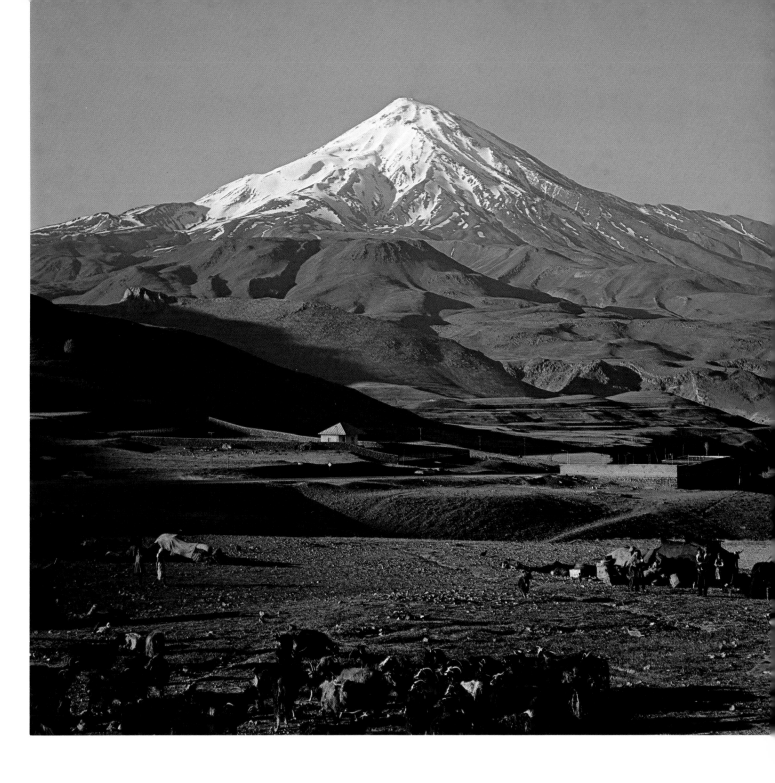

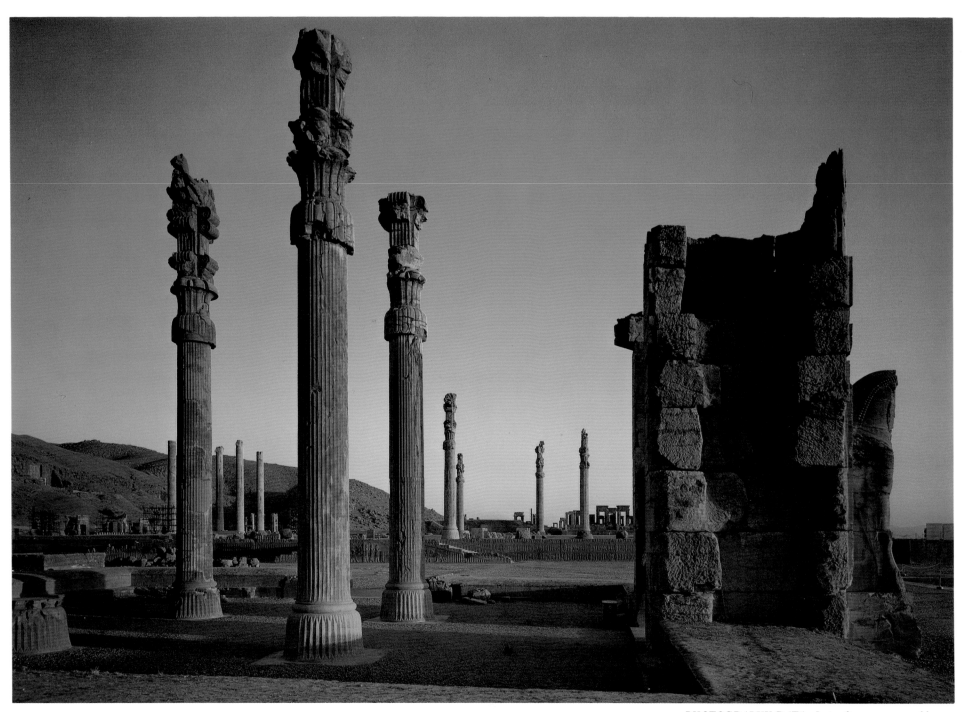

PHOTOGRAPHY DATA: Late afternoon, normal lens.

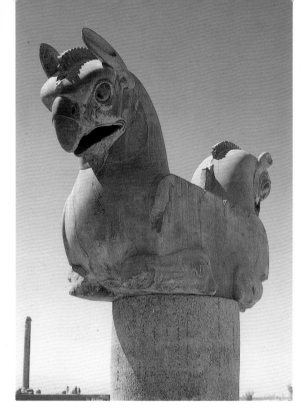

PHOTOGRAPHY DATA: Late morning, normal lens.

Persepolis, Iran

Beautiful fluted columns supported the roof of the Apadana (audience hall) which was timbered with Lebanon cedars. Built over 25 centuries ago by Darius I and his son Xerxes, the palaces and halls covered a wide terrace and abounded in architectural sculpture. All the stairways and most of the terraces were lined with relief carving which decorated only the outside facades of buildings. Persepolis was the ceremonial capital of Persia (Iran) until Alexander the Great destroyed it in 330 B.C. Fortunately many of the exquisite relief carvings are still whole; meticulously detailed, the Persians seem to have had a particularly rare aptitude for portraying animals.

Many of the capitals or upper portion of a column were decorated with animal scuptures. The double image rested directly on the shaft of a column. These double images were made in the shapes of men, dragons, bulls or bulls with men's heads. (See page 134 for additional relief carvings)

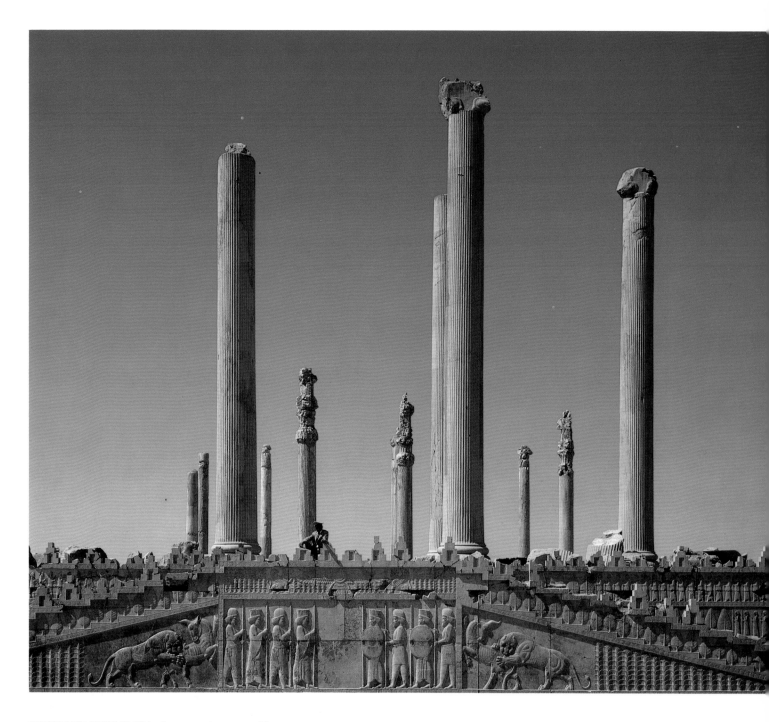

PHOTOGRAPHY DATA: Late morning, normal lens.

133

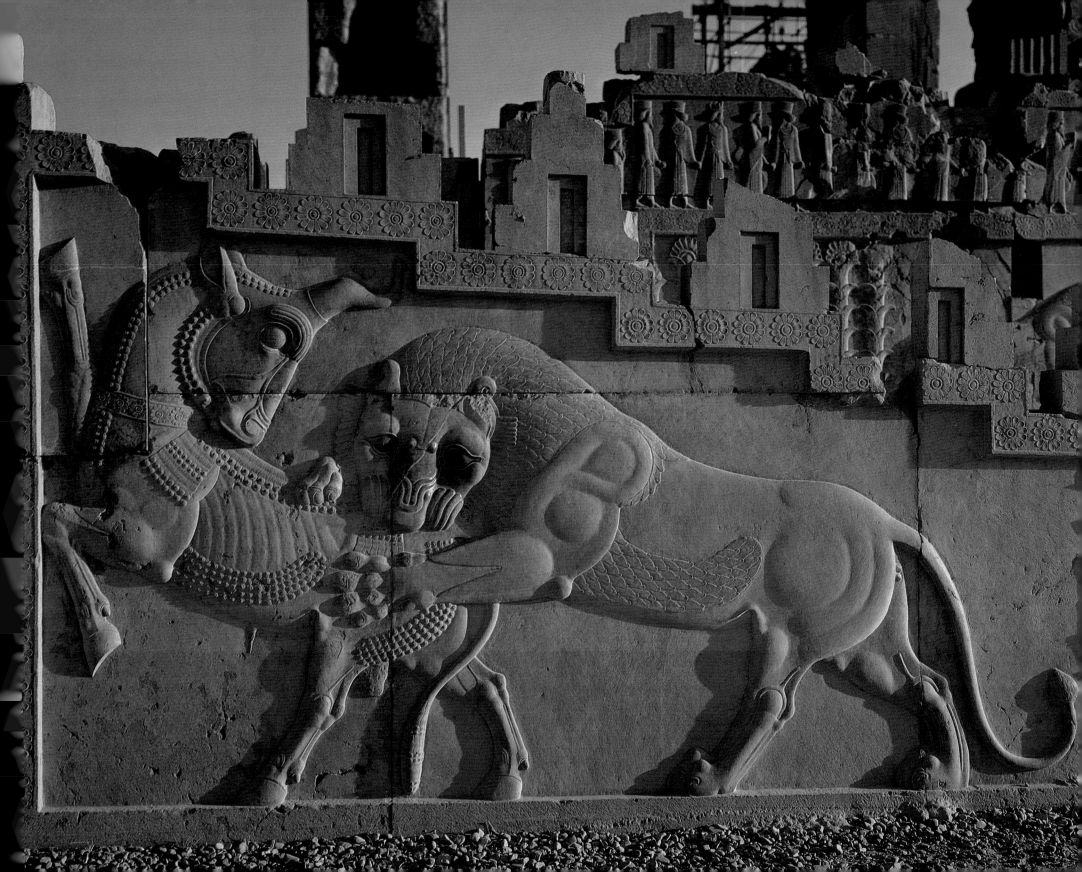

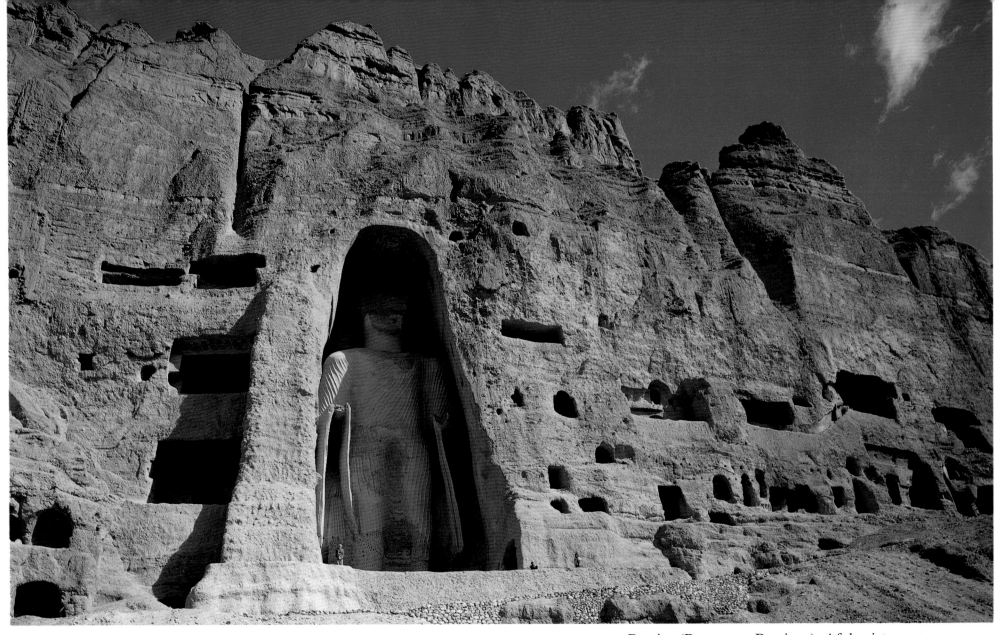

Bamian (Bamyan or Bamiyan), Afghanistan

ABOVE AND PAGE 136: Bamian, one of Afghanistan's foremost attractions, lies in a high rugged mountain valley that is reached by a fascinating seven hour drive from the capital city of Kabul. The narrow, dusty road winds along rivers and through villages that are little changed since Alexander visited them over 2,300 years ago. Bamian was invaded by Genghis Khan in 1221. Two immense Buddhas (135 and 175 feet high) are carved in the steep sandstone cliff, which is also honeycombed with caves. Muslims invading the valley drove out the Buddhist monks and battered the images, which are believed to be around 1800 years old.

PHOTOGRAPHY DATA: Morning, normal lens (both photographs).

LEFT: *PHOTOGRAPHY DATA: Afternoon, normal lens.*

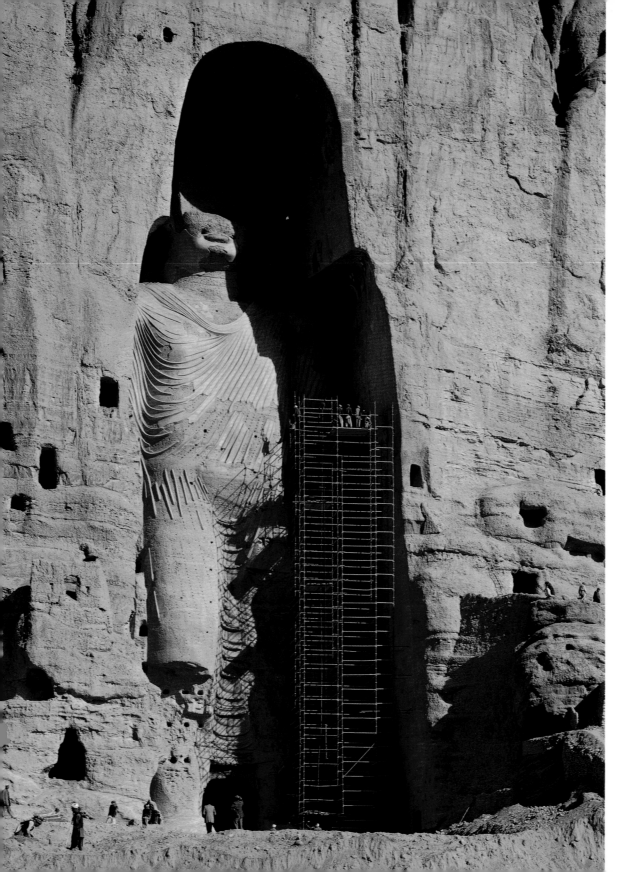

Badshahi Mosque, Lahore, Pakistan

RIGHT AND PAGE 138: The most exquisite architecture of the ancient world is found in cathedrals, temples and mosques. Pakistan is a Muslim country and in Lahore, near India's western border, is one of the largest mosques in the world. Aurumgzeb, a Mogul emperor (1658–1707), built Badshahi Mosque. A two-storied gateway opens onto a courtyard with a towering minaret at each of its four corners. The marble and red sandstone building is accentuated by its three white domes.

PHOTOGRAPHY DATA: Midmorning, wide-angle lens.

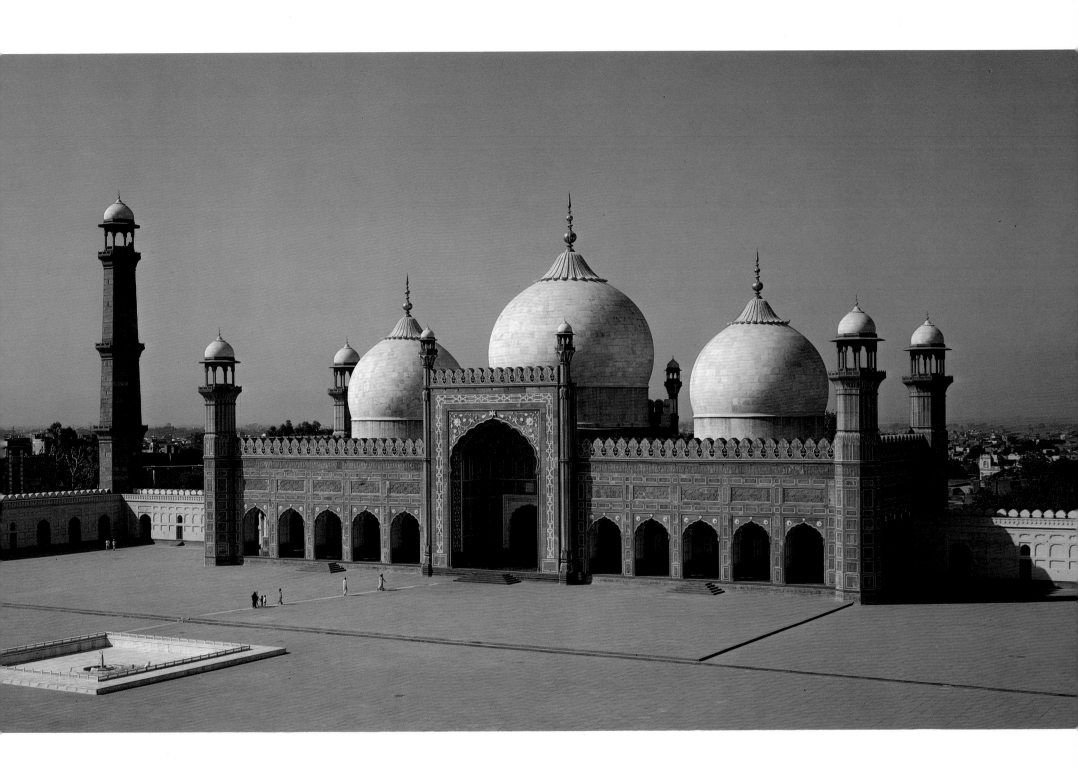

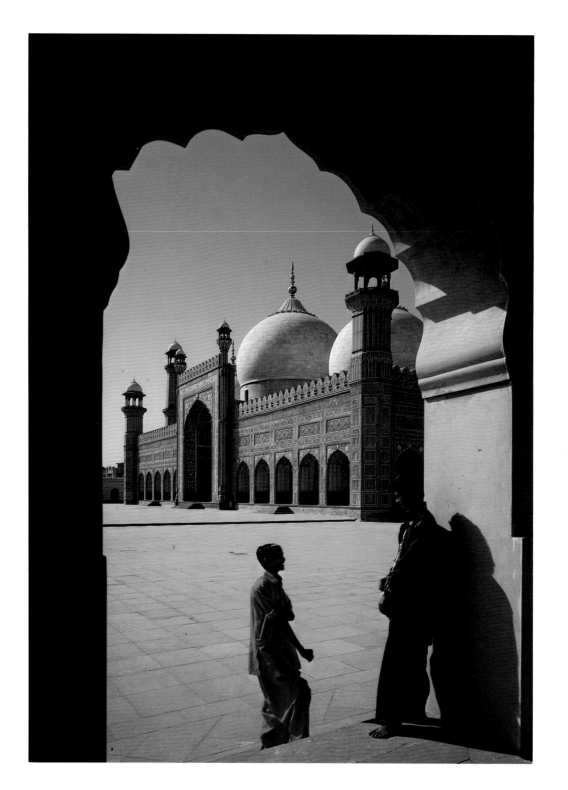

Golden Temple, Amritsar, India

RIGHT: Amritsar is the religious center of the Sikhs, whose religion blends Hindu and Muslim beliefs. Famed for their valor and strength, they are distinguished by the five k's: kes, long hair; kangha, comb; kacha, short pants; kara, iron bracelet; and kirpan, sword. Their most sacred shrine is the Golden Temple which was erected on an isle in the Amrit Saras, or Pool of Immortality, from which Amritsar takes its name. The Granth, the sacred book of Sikh scriptures, is kept in the gleaming Golden Temple, which is approached by a causeway of white marble.

PHOTOGRAPHY DATA: Afternoon, normal lens.

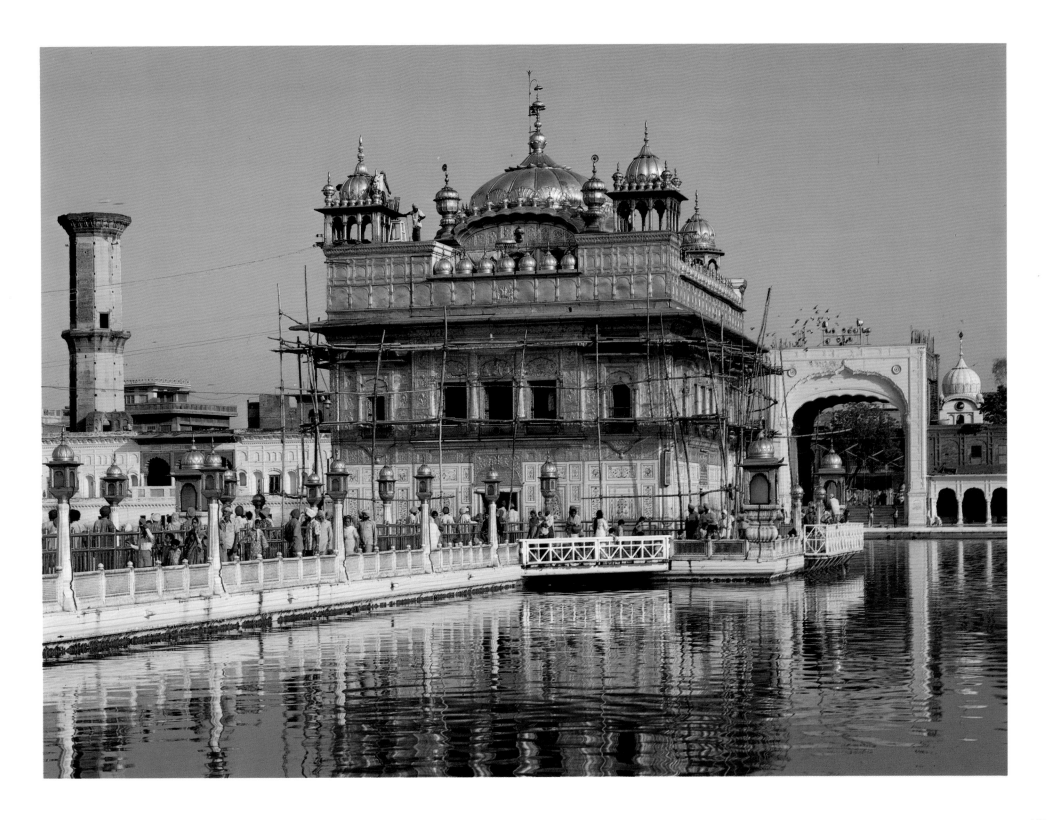

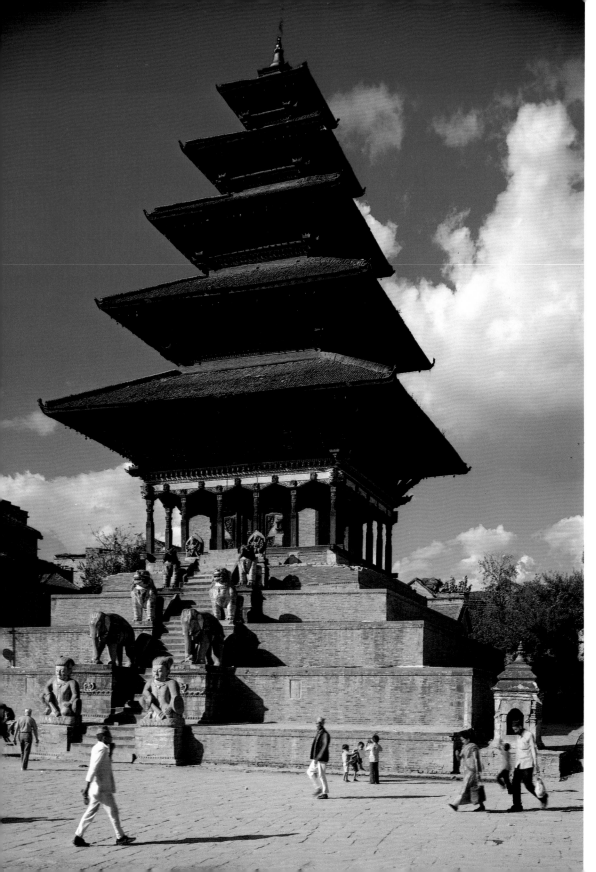

Bhadgaon, Nepal

LEFT AND RIGHT: Nepal, a small kingdom wedged between China and India, for 100 years was shut away from the rest of the world when it was controlled by the ruling Rana family. Now visited by many tourists, Nepal's three main cities, Kathmandu, Patan and Bhadgaon are clustered in the Nepal Valley. In Bhadgaon the Nyatopola Temple has statues lining the stairs with man, the weakest, at the bottom and stronger animals in ascending order to the top. In the same temple complex, Durbar Square boasts the glittering Golden Door Palace as well as the Palace of 55 Windows, which is built of ornately carved wood.

PHOTOGRAPHY DATA: Both pictures: Afternoon, wide-angle lens.

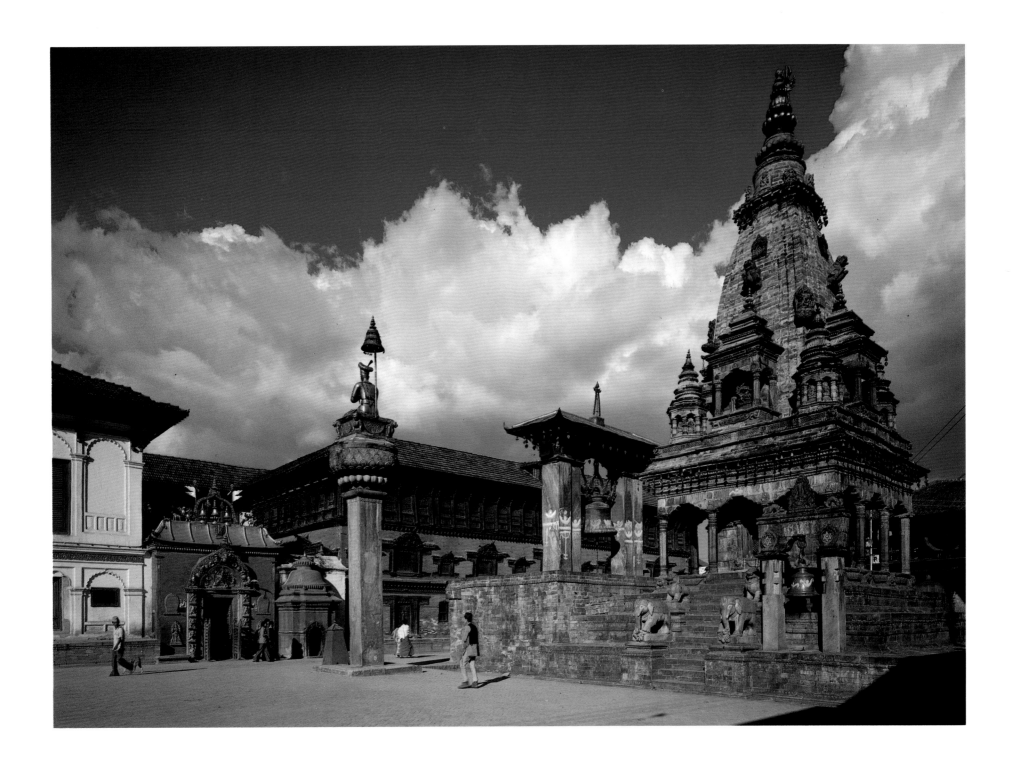

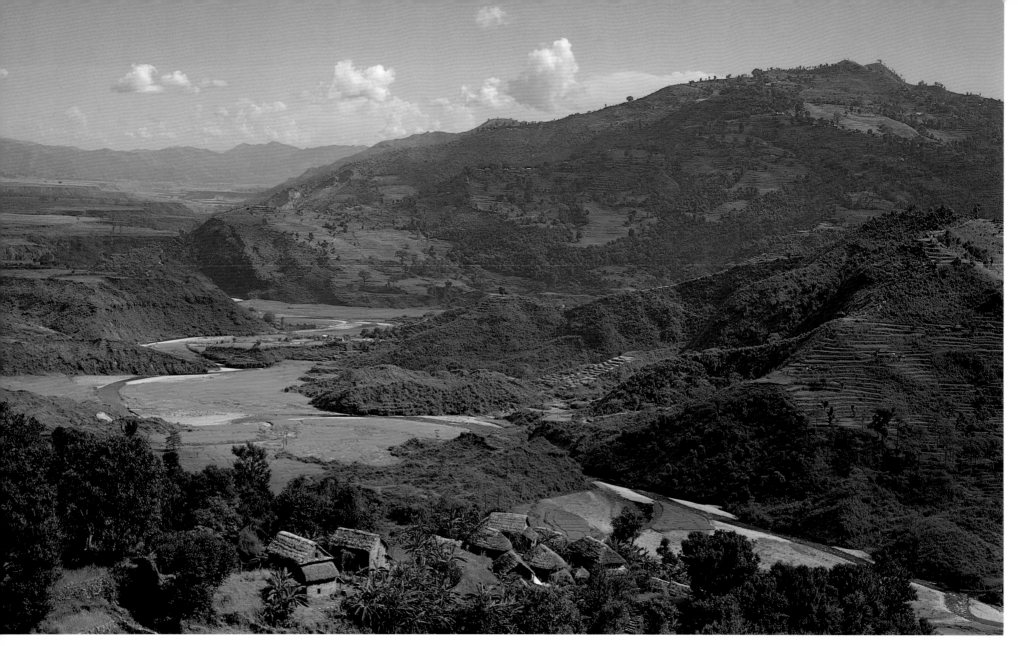

Rice Terraces, Pokhara, Nepal

ABOVE: Rice is the main crop of Nepal and is grown on terraced fields on the fertile slopes of the mountains. Most of the rice is grown here instead of in the valleys which are often subject to floods. Not far from Pokhara, a picturesque remote mountain village was built on a relatively flat area of the steep hillside.

PHOTOGRAPHY DATA: Morning, normal lens.

Machhapuchhare (Fish Tail Mountain) Pokhara, Nepal

RIGHT: The Matterhorn of Nepal is an awe-inspiring peak called Machhapuchhare, meaning Fish Tail, in the Annapurna Group of the Himalayas. Its isolation from other mountains and bold pyramidal shape make it a dominant and breathtaking presence in the Pokhara Valley. Almost 23,000 feet high, the beautiful peak draws visitors to Pokhara (3,000 ft.) by plane and car. Many are trekkers who follow trails to find ever more magnificent views of the snow-capped mountains. This is one of the most beautiful short scheduled flights in the world. It is only 35 minutes from Kathmandu along the flanks of the mighty Himalayas.

PHOTOGRAPHY DATA: Early morning, normal lens.

Note: Similar vertical view in front of book (page ii) early morning, long lens.

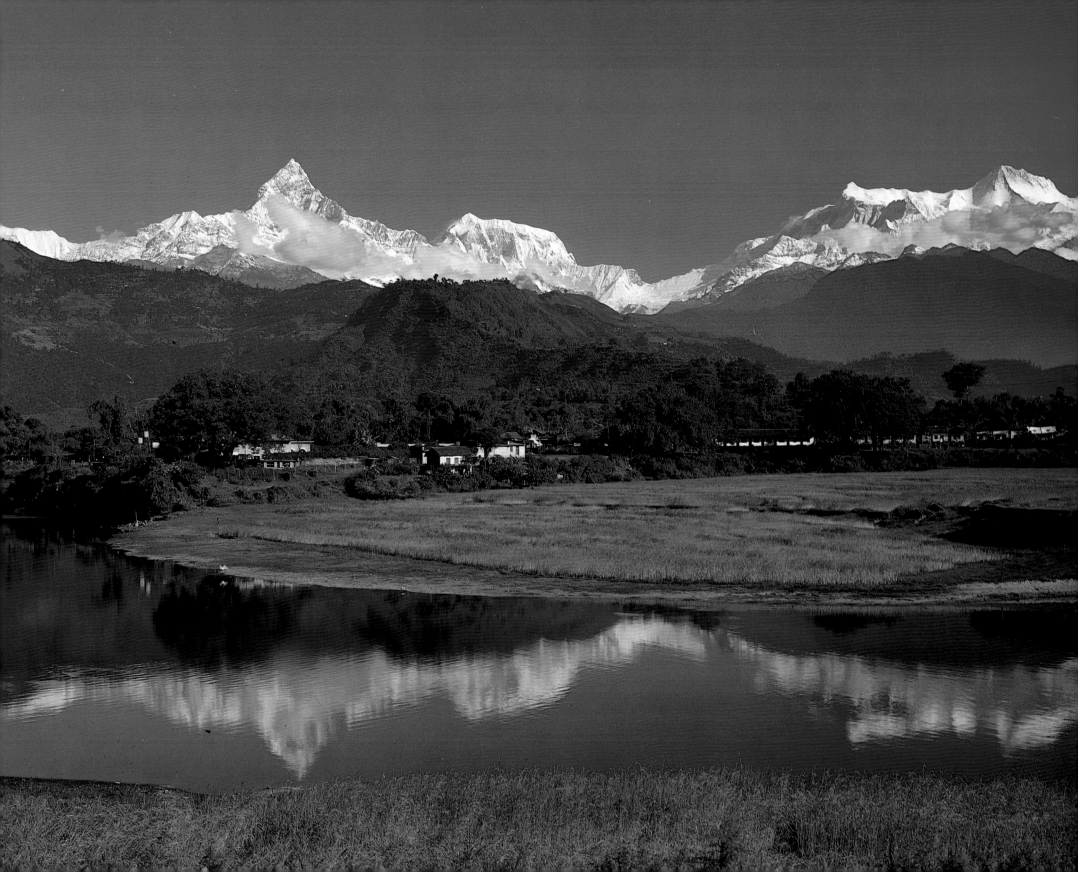

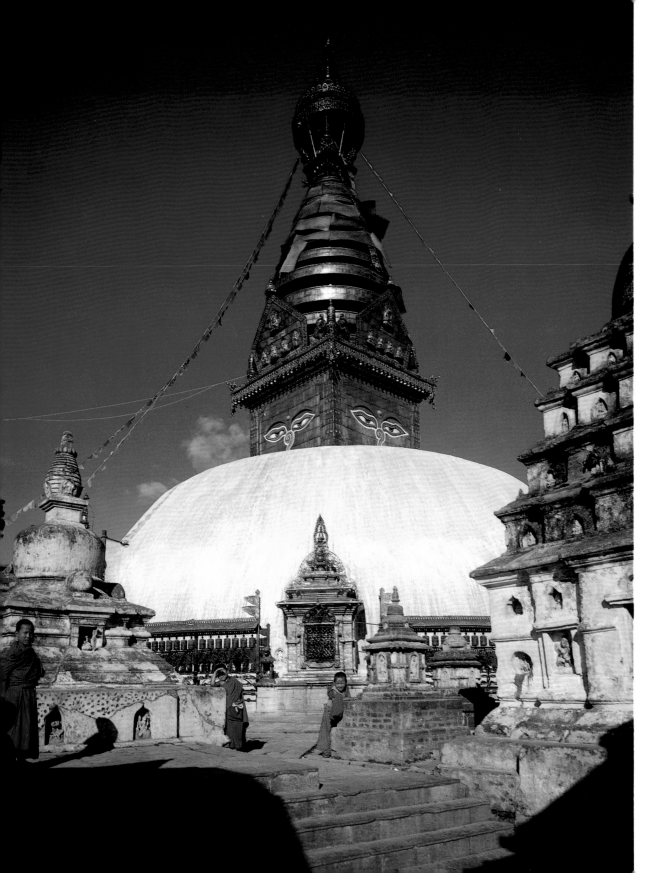

Swayambhunath Stupa, Kathmandu, Nepal

LEFT: Kathmandu, Nepal's capital city, is said to have more temples and shrines than any other city. On a hill overlooking the city, Swayambhunath Stupa has four pairs of all-seeing eyes and is surrounded by hundreds of covered images of Buddha. Prayer wheels at the base of the Stupa are whirled by worshippers as a mechanical aid to continual prayer, each revolution of the wheel counting as an uttered prayer.

PHOTOGRAPHY DATA: Afternoon, wide-angle lens.

The Goddess Kali, Kathmandu, Nepal

BELOW: Kali is a death-dealing Hindu goddess who exults in animal sacrifice. Worshipped as the black goddess of death and destruction, Buddhists also consider her a divine being who wears a threatening manner in defense of the faith. A six-armed goddess, Kali wears bracelets, anklets and earrings of snakes, a crown decorated with skulls and a necklace of human heads.

PHOTOGRAPHY DATA: Open shade, normal lens.

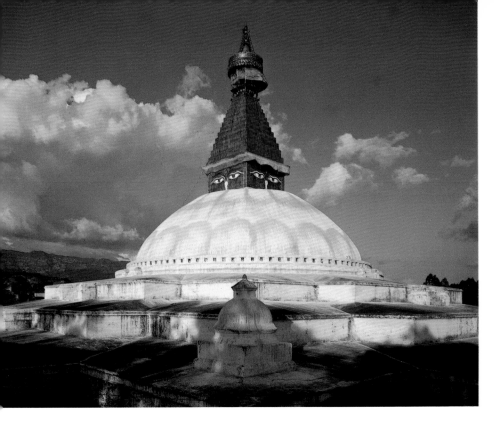

Bodnath (Bouddhanath) Stupa, Kathmandu, Nepal

ABOVE: Both Nepalese and Tibetan pilgrims visit Nepal's largest Buddhist shrine, Bodnath Stupa. Stupas are distinguished from temples by their spherical shape and were built to enshrine a "relic" fragment of Buddha's earthly body. In the 3rd century B.C. the Indian King Asoka is said to have divided Buddha's ashes into 84,000 parts for stupas throughout the Buddhist countries.

PHOTOGRAPHY DATA: Late afternoon, wide-angle lens.

Mount Everest

RIGHT: Mount Everest on the Nepal-Tibet border means but one thing, the highest mountain on earth; 29,028 feet. Great mountain climbers have scaled its wilderness of snow and ice, but now for the ordinary traveler there is a daily "Mountain Flight" from Kathmandu which enables a tourist to see with his own eyes Everest's wind-blown crest. From a distance of about 14 miles, an hour's flight along the eastern Himalayas is a unique experience.

PHOTOGRAPHY DATA: Morning "Mountain Flight", normal lens. Try to sit back of the wing and check for a clean window.

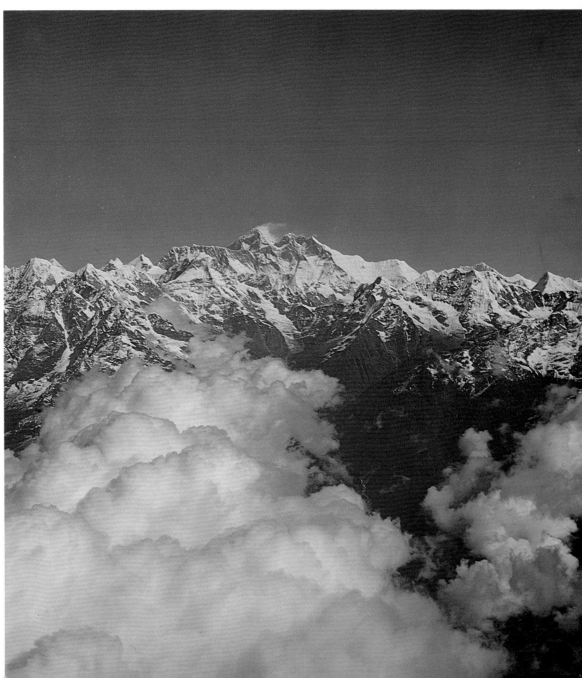

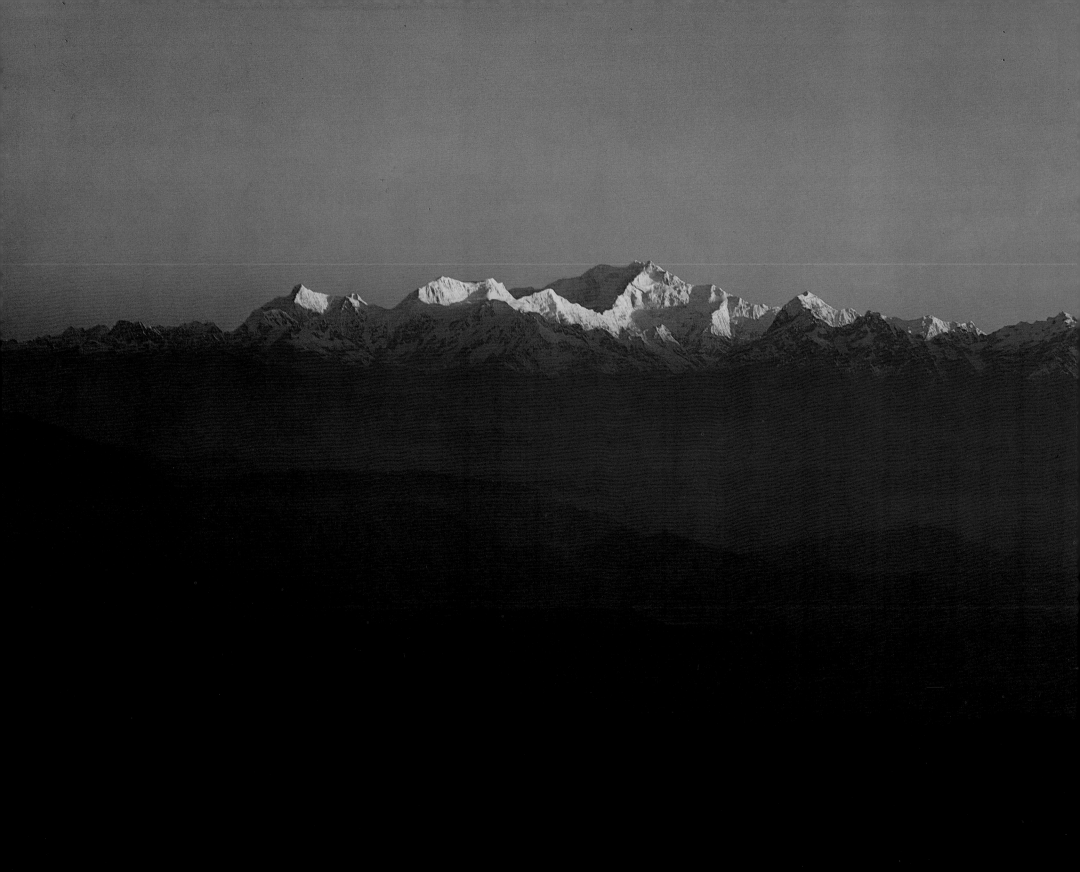

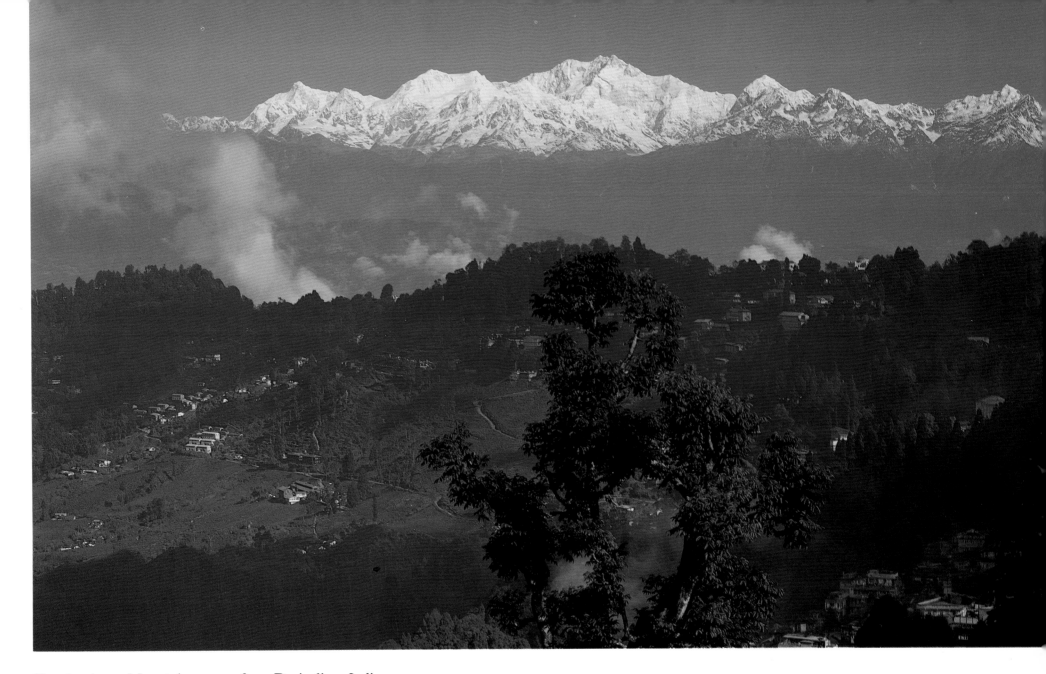

Kanchenjunga Mountain as seen from Darjeeling, India

LEFT AND ABOVE: Kanchenjunga is the third highest mountain in the world, topped only by Mt. Everest and K2. In the center of the Himalayan Range, it straddles the border of Sikkim and Nepal. This imposing mountain is over 28,000 feet high and is revered as the abode of gods by the people of Sikkim.

In the darkness just before dawn, the steep, narrow road to Tiger Hill (8,482 feet), in Darjeeling, is glutted with jeeps laden with people anticipating a sunrise view of Kanchenjunga. The dramatic spectacle, when the first rays of the sun touch the snow-clad mountain and turn it to gold, brings a rapturous ''ah'' from the multitude.

An entirely different mood and beauty is perceptible in Kanchenjunga a little later in the day. Less than fifty miles away, it towers over the choice tea-growing center of Darjeeling, a hill resort famous for its spectacular views of the awesome Himalayan Range.

PHOTOGRAPHY DATA: Sunrise, long lens. Morning, long lens.

BELOW: Mogul kings built pleasure gardens in Kashmir at one end of Lake Dal in Srinagar several hundred years ago, utilizing the natural springs that feed the lake. One of the best known, Shalimar, has been well-preserved and is visited by crowds of people in the summer. Here a lone priest was enjoying the tranquil beauty and solitude on a quiet afternoon.

PHOTOGRAPHY DATA: Afternoon, normal lens.

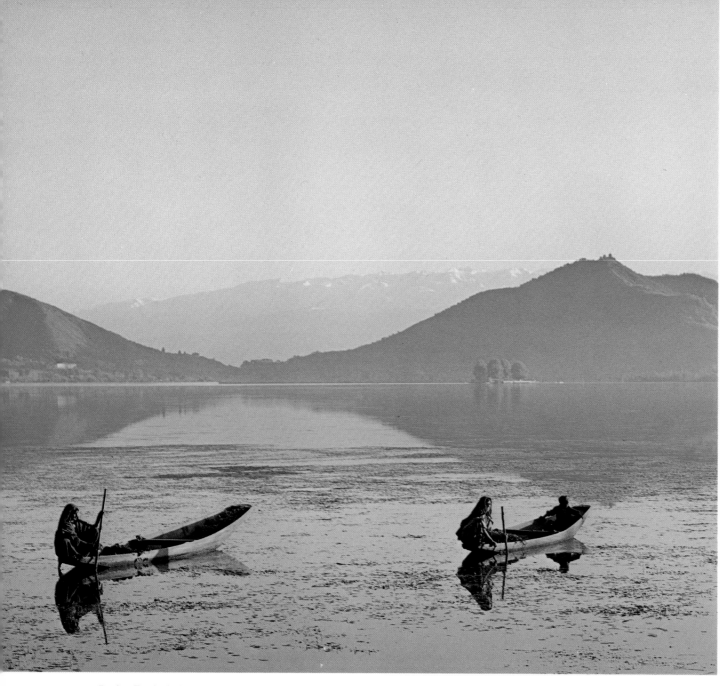

Lake Dal, Srinagar, Kashmir, India

ABOVE: In Kashmir's soft twilight, women seeking fodder for their animals, pole the bottom of Lake Dal. Twisting the poles to wrap the vegetation around them, the lotus roots and weeds are then piled high on the shikaras (small boats) until they appear close to foundering. Were it not for this continual harvesting, the shallow spring-fed lake would soon be clogged.

PHOTOGRAPHY DATA: Late afternoon, long lens.

Srinagar, Kashmir, India

RIGHT: The most unusual sight in Srinagar is the colorful houseboats anchored along the banks of Lake Dal. The popular houseboats were initiated by the British seeking a cool retreat from India's sweltering summer heat. In shikaras overflowing with enticing merchandise and bouquets of flowers, the merchants arrive as floating markets to reach those who dwell in the houseboats, where much subtle bargaining transpires.

PHOTOGRAPHY DATA: Morning, normal lens.

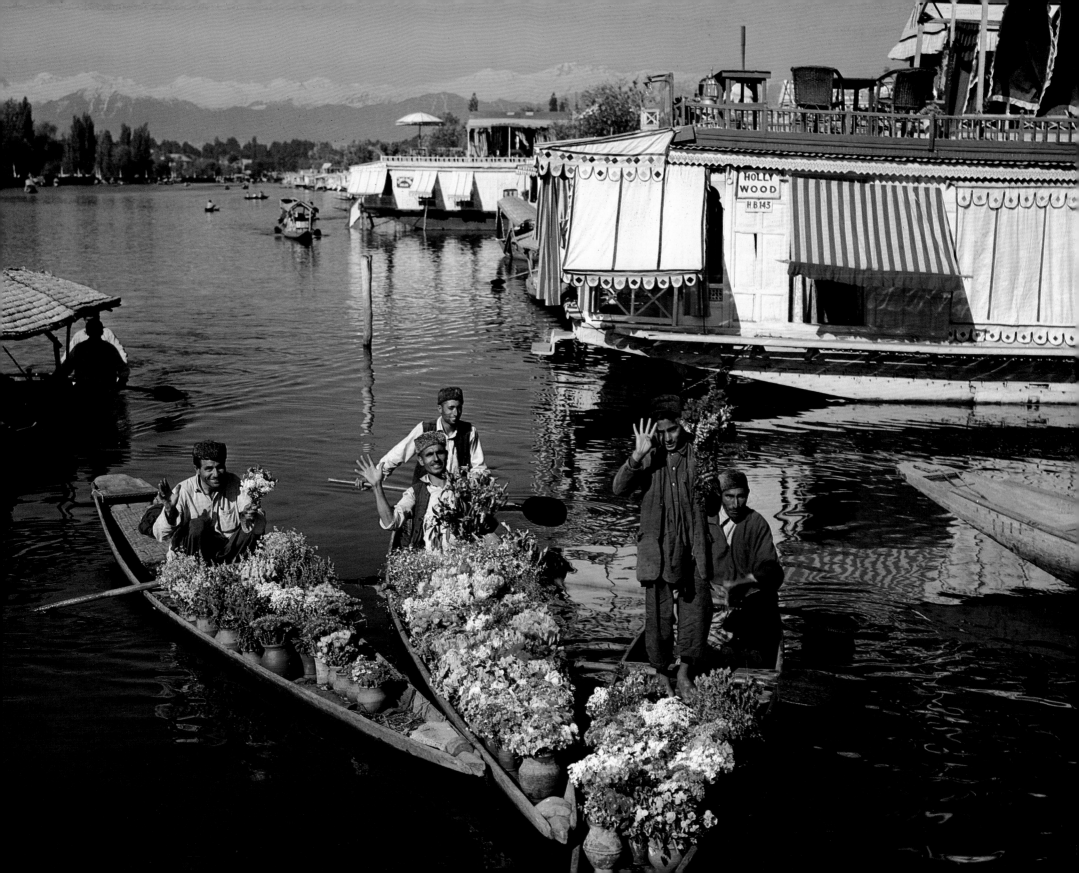

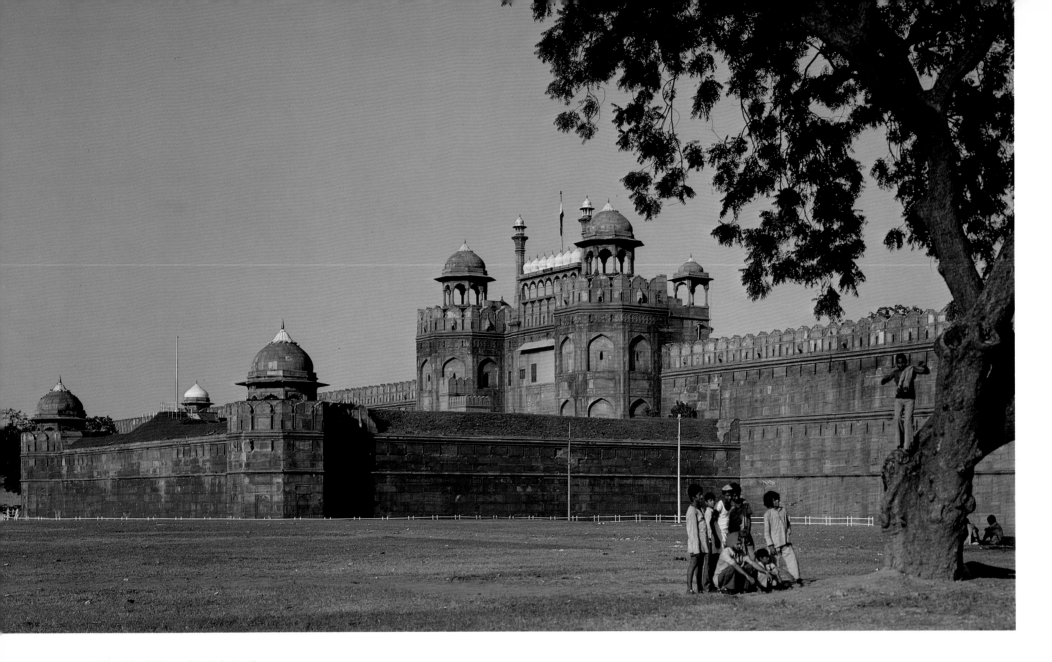

The Red Fort, Delhi, India

ABOVE: Shah Jahan, builder of the Taj Mahal and the most famous Mogul Emperor of India, built the Red Fort and changed his capital from Agra to Delhi. The high, red walls with their minarets and bulbous domes sheltered a city of grandeur containing a magnificent palace with jeweled marble walls, gardens, royal baths and military barracks. Invaders, earthquakes and time have marred much of their elegance but the delicately inlaid stonework remains. Even today one feels the power and strength of Shah Jahan in these formidable walls.

PHOTOGRAPHY DATA: Afternoon, long lens.

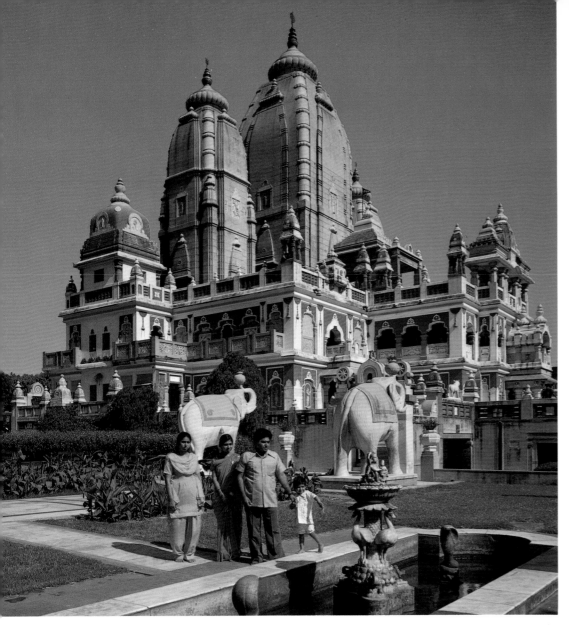

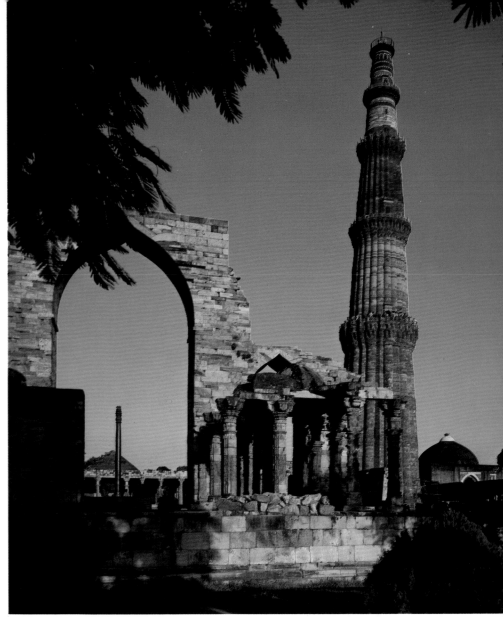

Birla Temple, Delhi, India

ABOVE: Birla Temple is named for the donor of this very modern Hindu temple built in 1938. All religions are free to participate in the daily worship within its doors where all are welcome. The carefully sculptured animals in the courtyard, including huge elephants, emphasize their doctrine of transmigration of the soul.

PHOTOGRAPHY DATA: Morning, wide-angle lens.

Qutb Minar, Delhi, India

ABOVE: One of the earlist surviving Islamic buildings, 13th century Qutb Minar was a tower of victory begun by Qutb-ud-Din Aiback, the first Moslem ruler of Delhi. The 238-foot high tapering tower was actually the free-standing minaret of a mosque. Constructed of red sandstone and marble, its beauty is in the gracefully fluted balconies and the bands of elaborately cut relief ornamentation.

PHOTOGRAPHY DATA: Late afternoon, wide-angle lens.

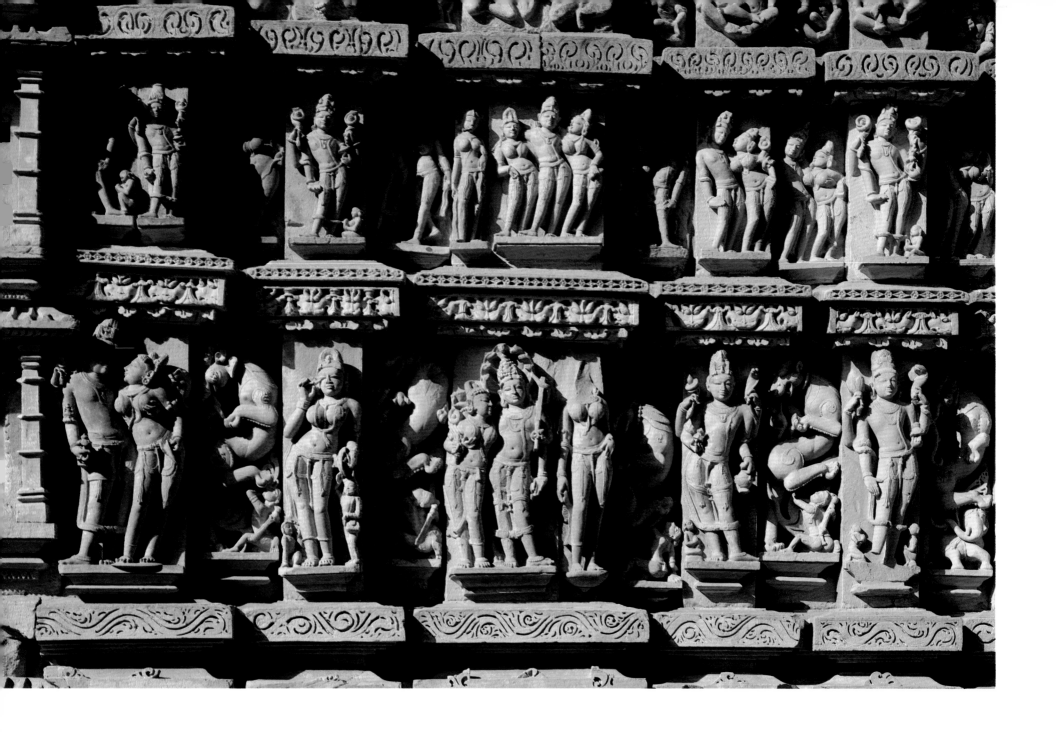

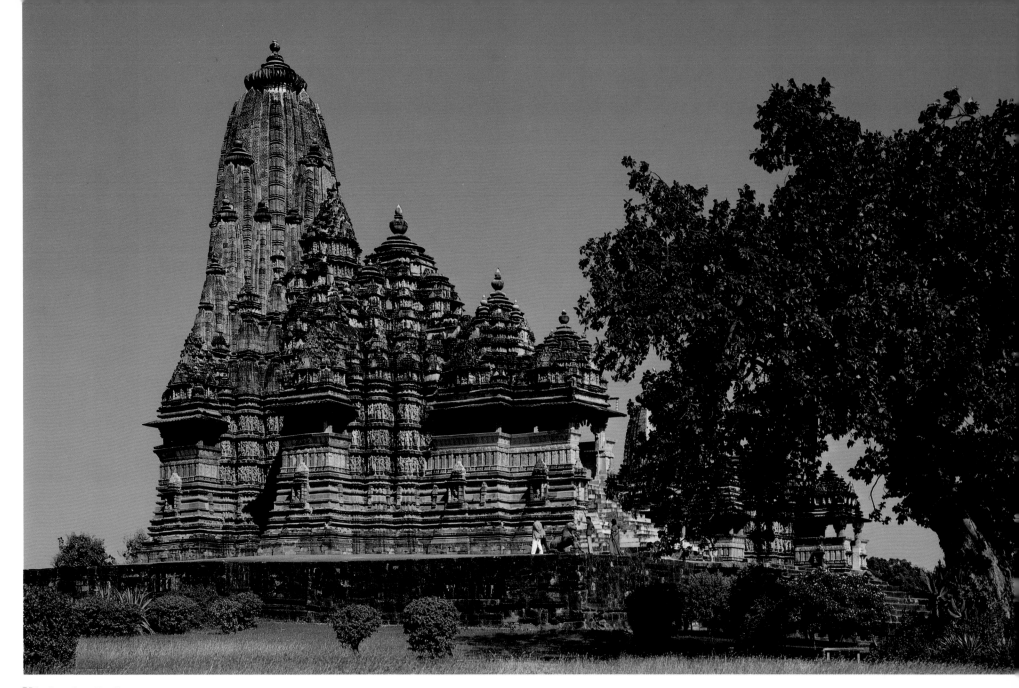

Khajuraho, India

LEFT AND ABOVE: The Temple of Khandariya-Mahadeva is the largest of many similar Hindu Temples
built between the 10th and 12th centuries in Khajuraho. The complex god Siva (Shiva) is
worshipped in this temple that is ornamented both inside and outside with exotic ritual
carvings, some of them in erotic postures. Few surfaces of this temple are left without the
exuberant grace of these carved figures which are about two feet high.

PHOTOGRAPHY DATA: Morning, normal lens. (Both photographs)

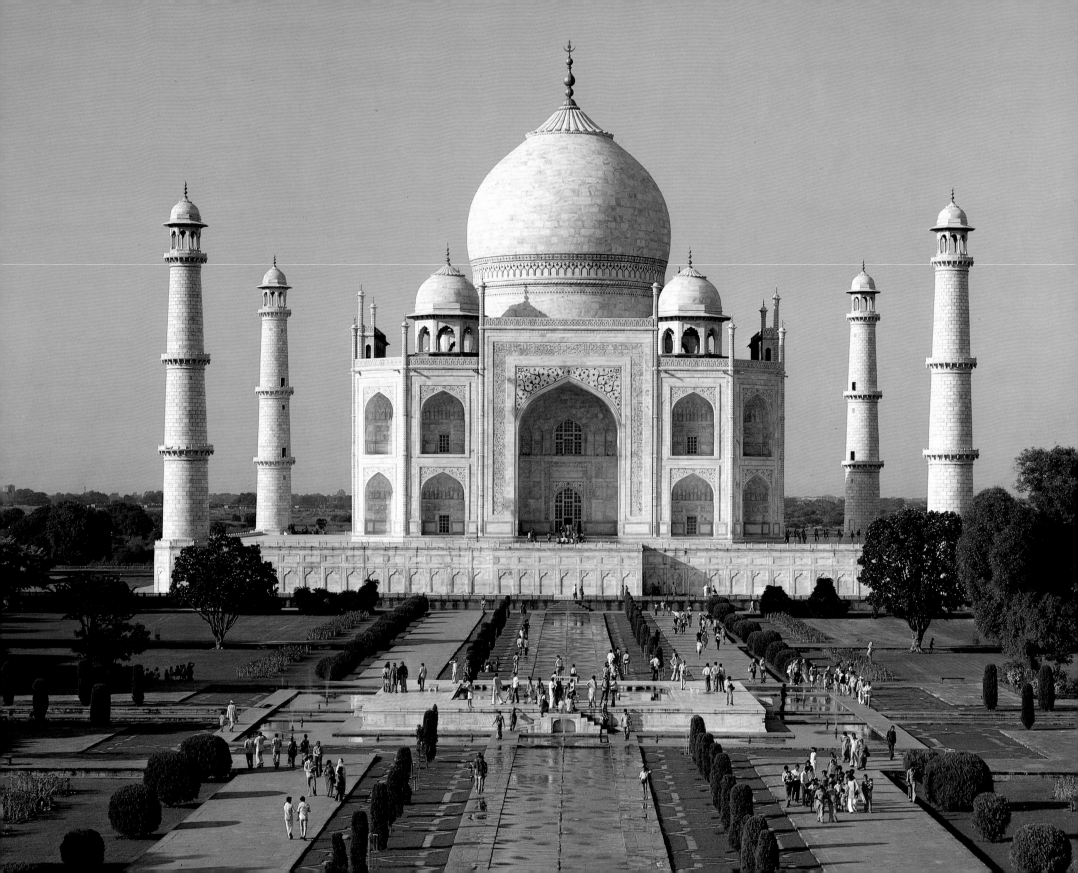

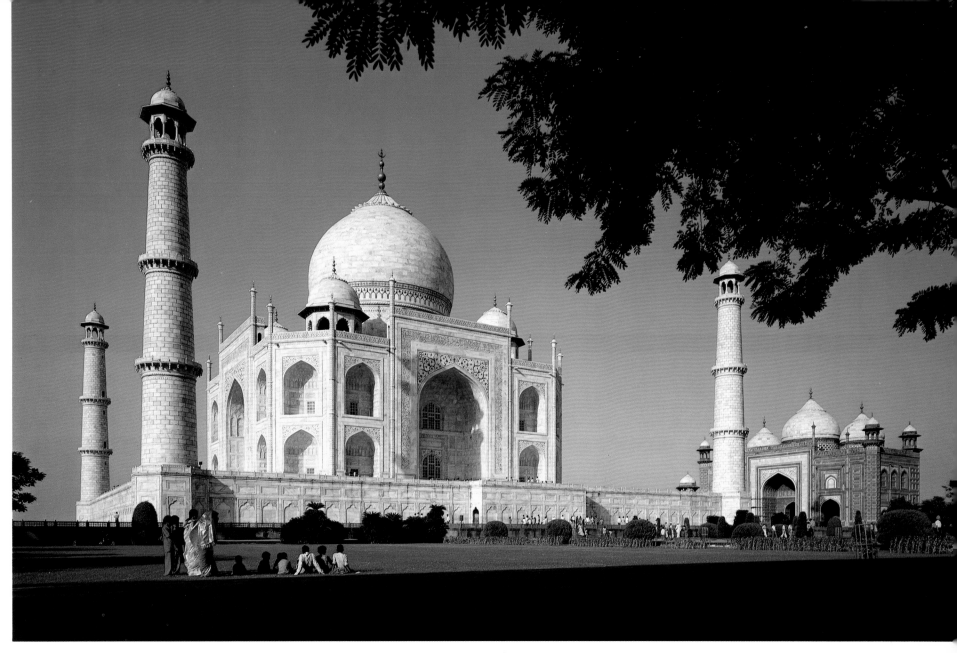

The Taj Mahal, Agra, India

LEFT AND ABOVE: Built not to immortalize its builder, Shah Jahan, but his favorite wife, Mumtaz Mahal, the Taj Mahal is much more than just a magnificent tomb. Perfectly proportioned, this beautiful architectural masterpiece is built of white marble with minarets and domes in the Islamic style of Persia. Shah Jahan then surrounded it with fountains and a lovely formal garden. The workmanship and beauty of the Taj just cannot be described with words or exclamations. A first view of its perfection as you enter the large gateway makes an everlasting impression. The Taj Mahal is just as breathtaking on the second visit or the sixth!

PHOTOGRAPHY DATA: ABOVE: Afternoon, wide-angle lens. LEFT: Afternoon, long lens. This, my sixth visit, was the first time the garden, weather and other factors (no scaffolding!) were all favorable.

Fatehpur Sikri, near Agra, India

Mogul King Akbar (1556–1605) devoted much of his effort and time to the erection of a complete city of pink sandstone, Fatehpur Sikri, 23 miles from Agra. Its great battlemented walls, courtyards, palaces, and great mosque were built over a period of 16 years, but within 50 years it was deserted, mainly due to a lack of water.

PHOTOGRAPHY DATA: Morning light, normal lens.

Jain Temple, Calcutta, India

RIGHT: Jainism is an ancient monastic religion of India. Jains do not accept Hindu scriptures and rituals but they do believe that people go through cycles of rebirth. Jains are extremely careful to observe the rule of not injuring any living creature.

Their temple in Calcutta, though not large, is extremely ornate. Dragons, mermaids, elephants and other figures grace the formal garden and brilliant mosaics decorate columns and outside facades.

PHOTOGRAPHY DATA: Morning, normal lens.

Victoria Memorial, Calcutta, India

RIGHT: The imposing Victoria Memorial is a large museum which details the history of British rule in India. Masses of humanity from teeming Calcutta throng its surrounding park to relish the sight of trees and grass.

PHOTOGRAPHY DATA: Morning, normal lens.

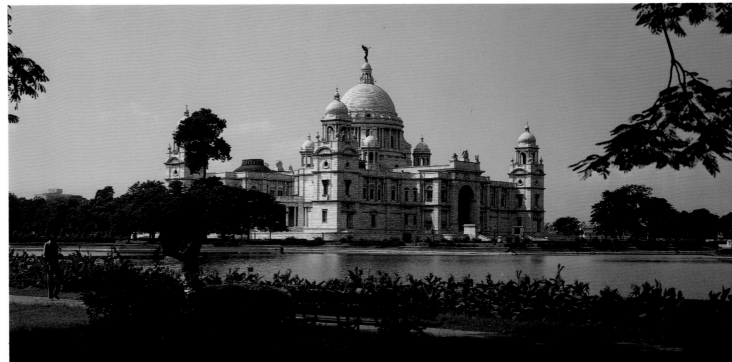

157

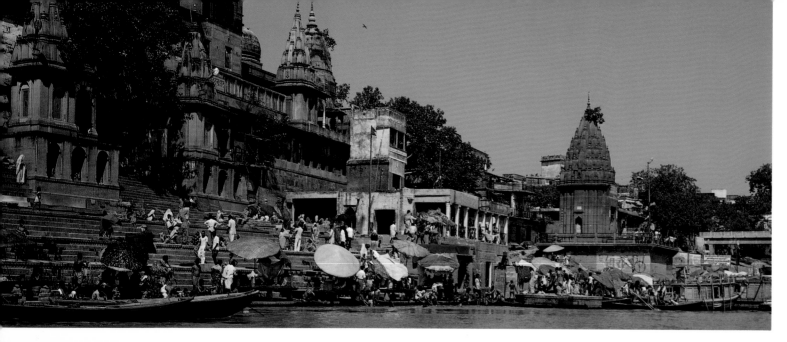

Bathing Ghats, Varanasi (Benaras), India

LEFT: Considered the holiest city to the Hindus, Varanasi on the Ganges River has approximately 1,500 temples, shrines and mosques. It is always crowded with pilgrims who travel to the Bathing Ghats (steps) where they bathe in the Ganges River hoping for absolution from their sins. At death, their hope is to be cremated at the burning ghats on the riverside and the ashes scattered in the sacred river.

PHOTOGRAPHY DATA: Morning, normal lens. Photographed from a rowboat on the Ganges River.

Golden Temple, Varanasi, India

EXTREME LEFT: In Varanasi, formerly Banaras or Benaras, the opulent Golden Temple is hidden among narrow winding passageways, thronged with trinket vendors. The gleaming Golden Temple is covered with sheet gold and though only Hindus are admitted inside, a peek at the interior can be gained from a neighboring shop.

PHOTOGRAPHY DATA: Mid-morning, wide-angle lens.

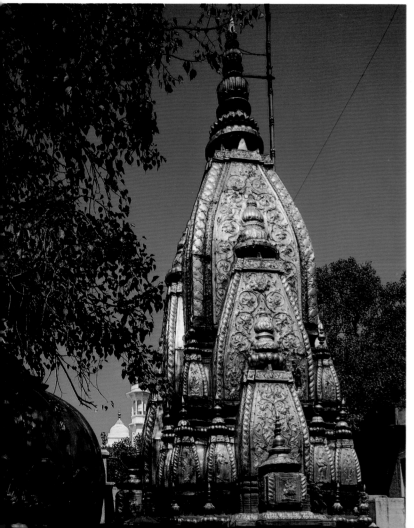

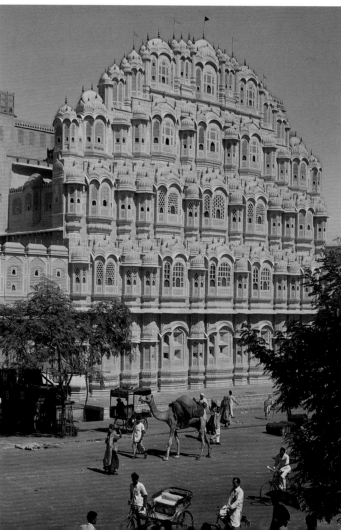

Jaipur, India

LEFT: Until the British gave India its independence in 1947 the pink city of Jaipur was one of 18 princely states in India ruled independently by Rajas or Maharajas. Behind the lacy facade of the Palace of the Winds were the living quarters of the harem. The harem could sit behind the pink arches and fretwork and watch the busy street scene below and yet remain unseen themselves. A spectacular pink sandstone palace, the Palace of the Winds could accomodate a sizeable harem.

PHOTOGRAPHY DATA: Morning, normal lens.

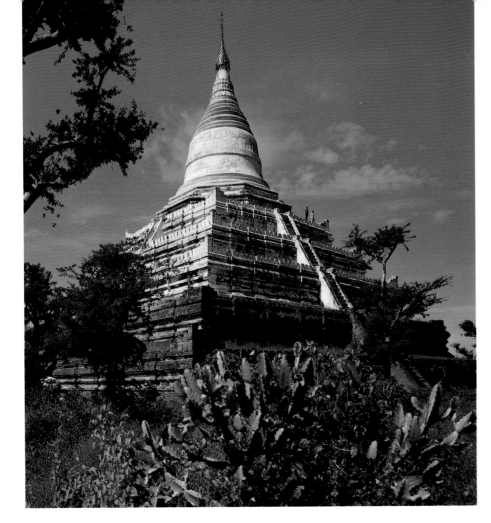

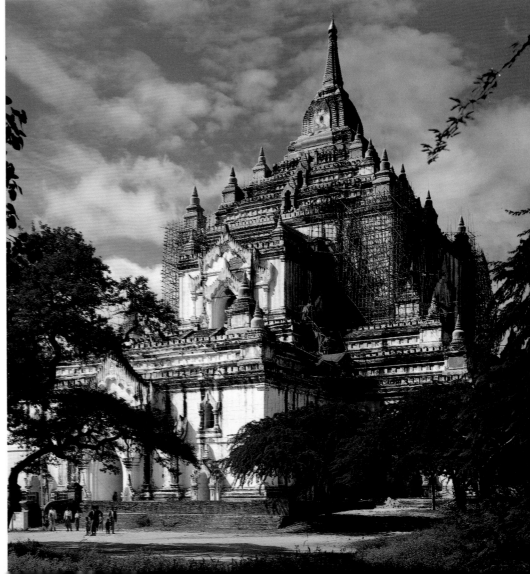

BELOW: Thatbyinnyu (Thatpyinnyu) Temple is the tallest structure in Pagan, with two main stories and the image of Buddha on the upper floor. From the top of this temple a sweeping view of the ancient city of Pagan reveals the impressive number of shrines.

PHOTOGRAPHY DATA: Morning, wide-angle lens.

Pagan, Burma

ABOVE: Pagan, on the Irawaddy River, was once Burma's capital. In no other place in the world is there such a concentration of religious shrines. Known as the city of four million pagodas, built from the 11th to the 13th centuries, even now the remains of about 5,000 can be traced in a 16 square mile area along the wide Irawaddy. An unusual feature is that the buildings were of brick, many handsomely carved. Some are now simply piles of ruins while others are quite well preserved, though much damage was recently done by a 1975 earthquake.

The Shesandaw Pagoda is a bell-shaped stupa atop a series of five receding terraces. It is said to have some sacred hairs of Buddha enshrined in it.

PHOTOGRAPHY DATA: Morning, wide-angle lens.

159

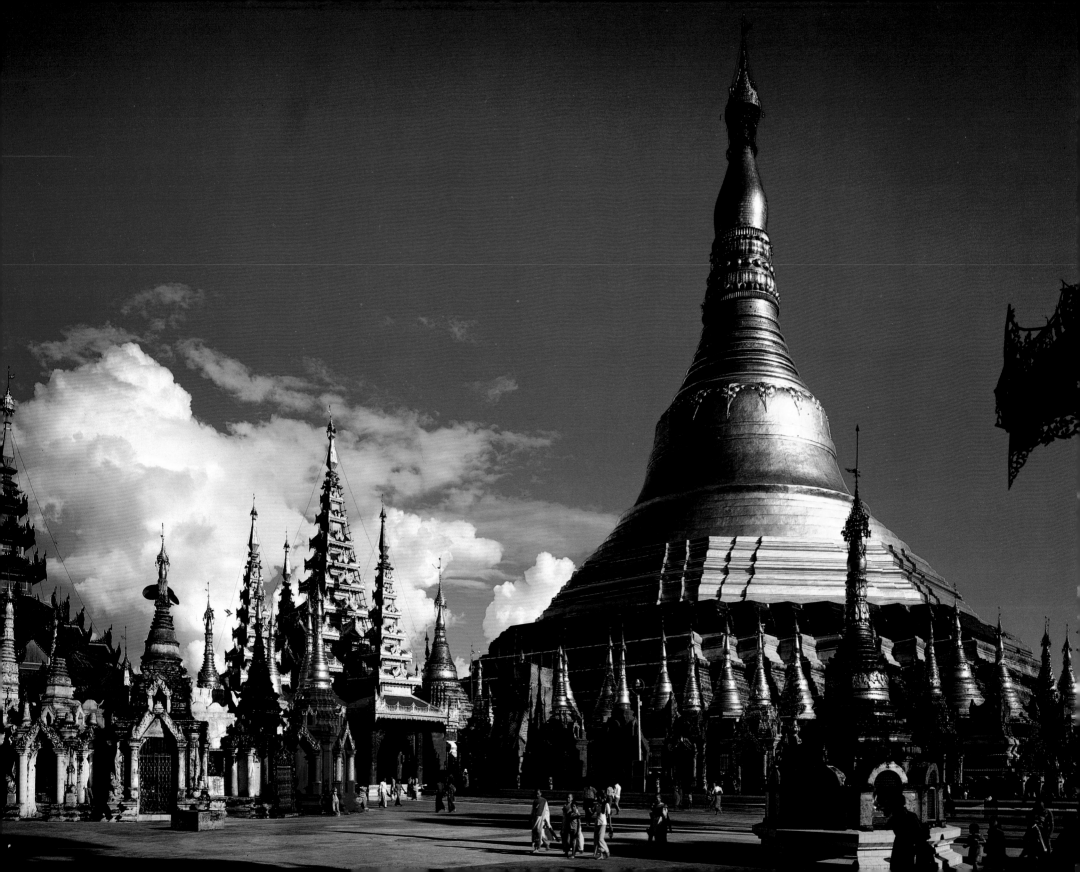

Shwe Dagon Pagoda, Rangoon, Burma

The focus of interest in Rangoon is the imposing 326-foot
high Shwe Dagon Pagoda. Its golden mass rises above the
hundreds of images and shrines surrounding its base.
Perched on a hill 168 feet above the city, the huge golden
bell-shaped stupa presides over the city as well as the
surrounding countryside. Studded with gold, diamonds,
emeralds and rubies on its umbrella crown near the top of
the spire, it is the noblest of Burma's thousands of Buddhist
temples. We were fortunate to be in Rangoon during a
religious festival and saw huge crowds of Burmese
worshipping at this exceptional temple and lighting
thousands of candles at dusk. It was a very moving
experience.

*PHOTOGRAPHY DATA: Day Scene: Late afternoon,
wide-angle lens. Night Scene, wide-angle lens; Time
exposure. Mercury vapor lighting records green without
proper filtration.*

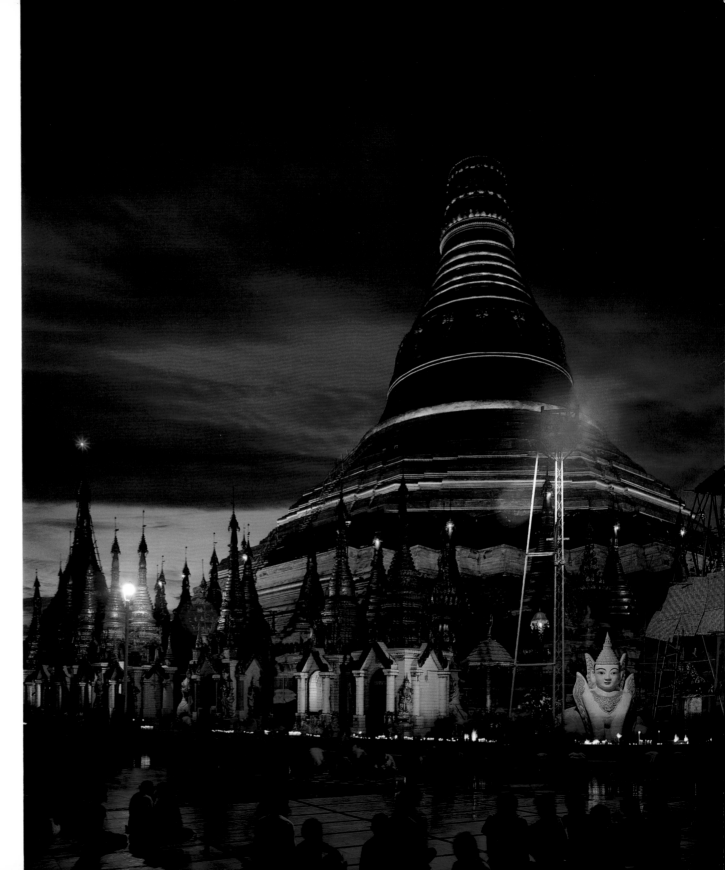

161

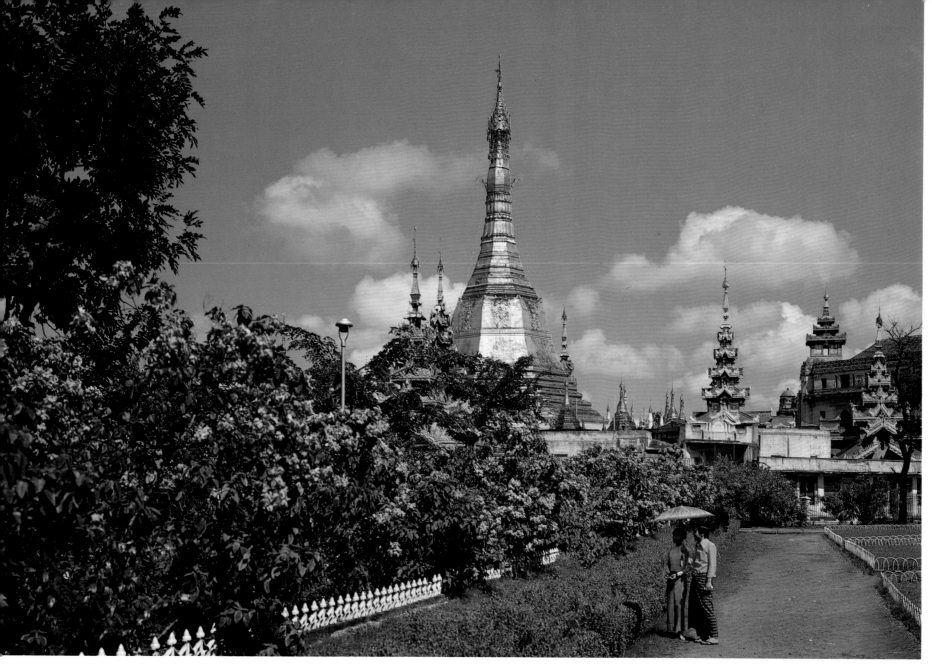

Sule Pagoda, Rangoon, Burma

ABOVE: Sule Pagoda's golden spire is part of the downtown scene in Rangoon. Small shops encircle its base and a green park is nearby.

Colorful Burmese clothing, worn by both women and men, is a sarong-like skirt called longyis, though some men are beginning to adopt western type apparel.

PHOTOGRAPHY DATA: Morning, normal lens.

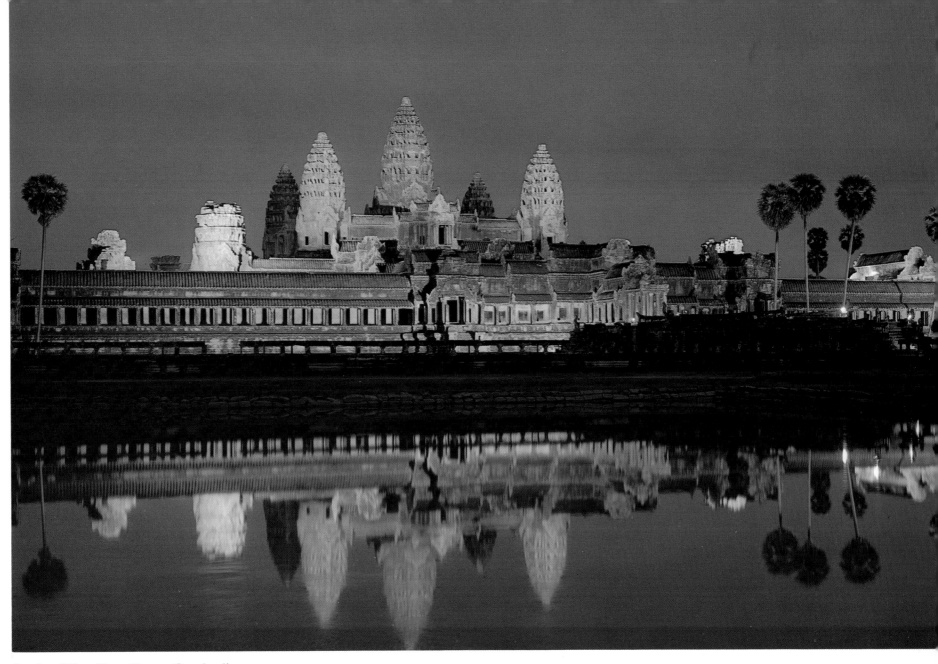

Angkor Wat, Siem Reap, Cambodia

ABOVE: Massive towers crown Angkor Wat, built in the 12th century by the Kmer ancestors of modern Cambodians. Thai troops besieged and conquered them and the Kmers abandoned their city in1432. For over 400 years this great stone empire lay abandoned. Heavily overgrown by the jungle, only the gray towers were visible when a French naturalist, Henri Mouhot, came upon it in 1860. So completely had the jungle taken over, however, that Mouhot could not realize the full magnitude of his discovery. It was 1908 before the many ruins were cleared and the complex converted into a park.

PHOTOGRAPHY DATA: Night, normal lens; Double exposure.

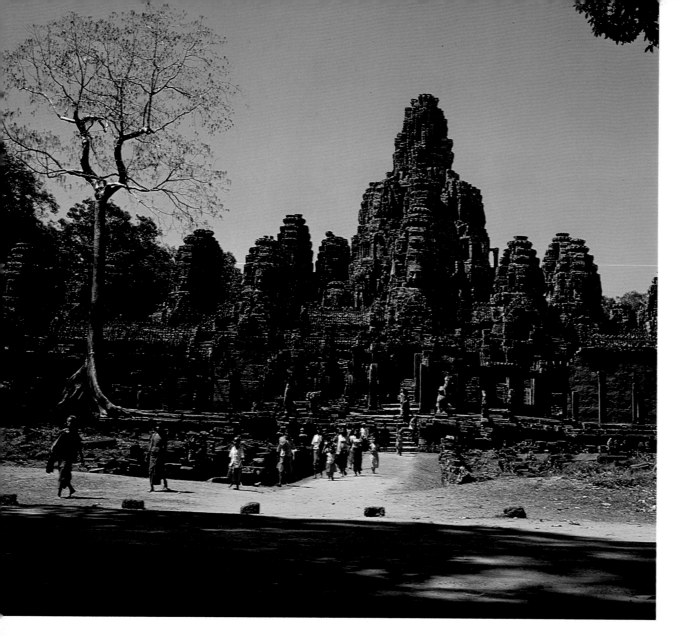

The Temple of the Emerald Buddha, Bangkok, Thailand

RIGHT AND PAGE 166, 167: The Royal Palace, formal gardens and a bewildering conglomeration of pagodas with gold leaf, mosaics and bright tile roofs are enclosed in the stone walls of the Temple of the Emerald Buddha, the King's own Temple. Glowering ogres are guardians of the gateways to the Royal Temple which holds Bangkok's most sacred treasure, the exquisite Emerald Buddha. Made of a single chunk of polished dark green crystal (probably jasper), it looks somewhat like real emerald and is 26 inches high.

Thailand or Siam, as it used to be called, teems with magnificent temples, for by building or gilding a wat (temple) faithful Buddhists earn merit in this life and the next. Most young Thai men spend at least three months of their lives in total service to Buddha as novice monks and wear the traditional saffron robes. As Upholder of the Faith, the King himself once served as a monk. The enormous worth earned by having been a monk stays with a man forever.

PHOTOGRAPHY DATA: All three photographs; Morning, wide-angle lens. Each subject must be carefully separated from the confusing background—a low camera angle is necessary.

Angkor Thom, Siem Reap, Cambodia

ABOVE AND RIGHT: Angkor Thom (great city) is centered around the Bayon, which was a Buddhist Temple with unusual carvings and great stone faces. The Temple and walls of the old palace quarter with the Elephant and Leper Terraces spread to the north.

It seems miraculous that these wonderful temples were ever found and freed from their jungle grave. They were overgrown with gigantic silk-cotton trees, the banyan trees' aerial roots and choked by vines and other vegetation.

PHOTOGRAPHY DATA: Both photos: Morning, normal lens.

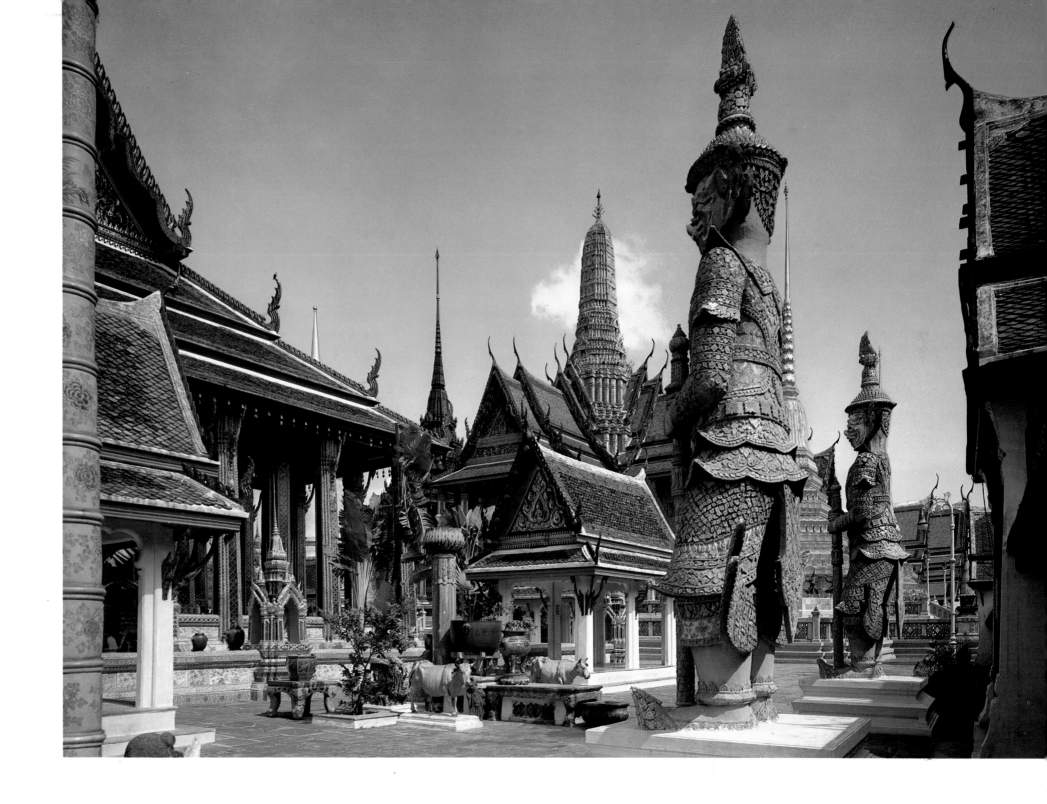

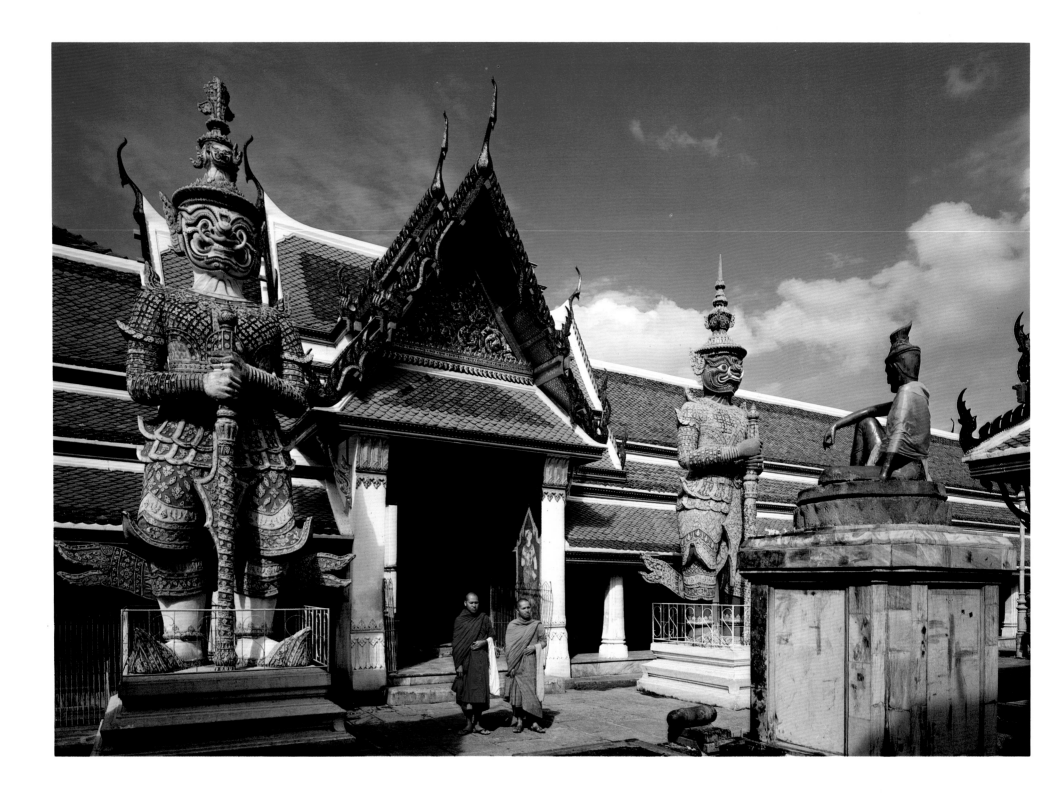

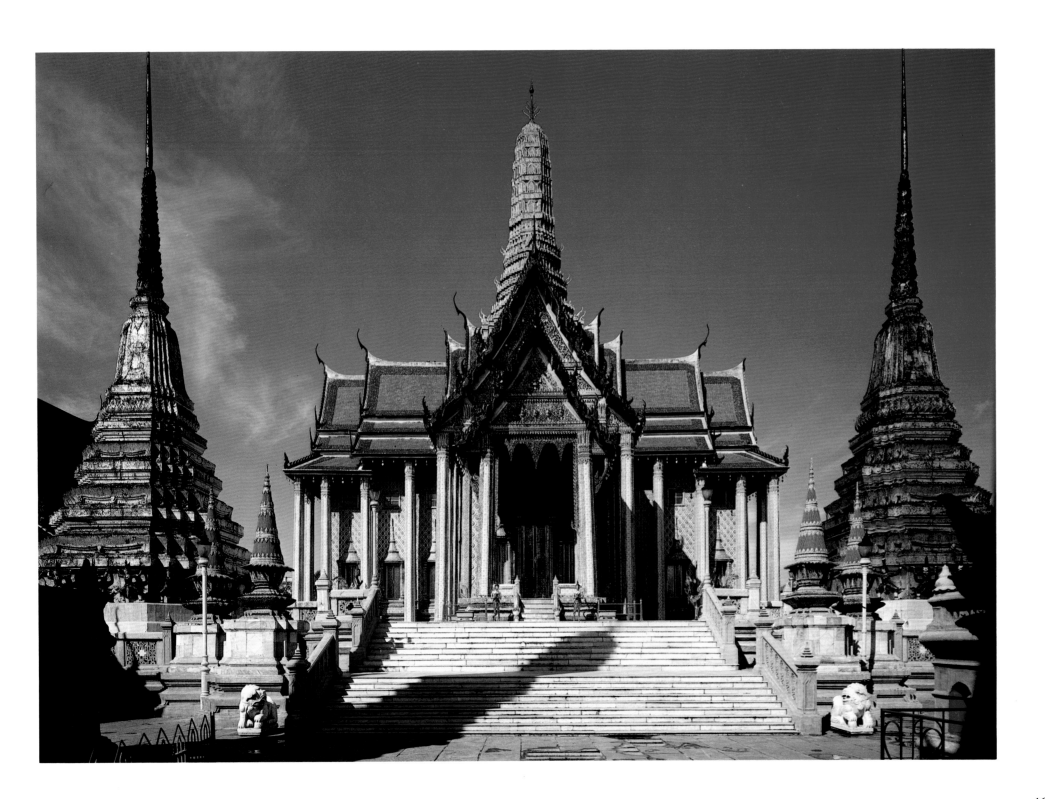

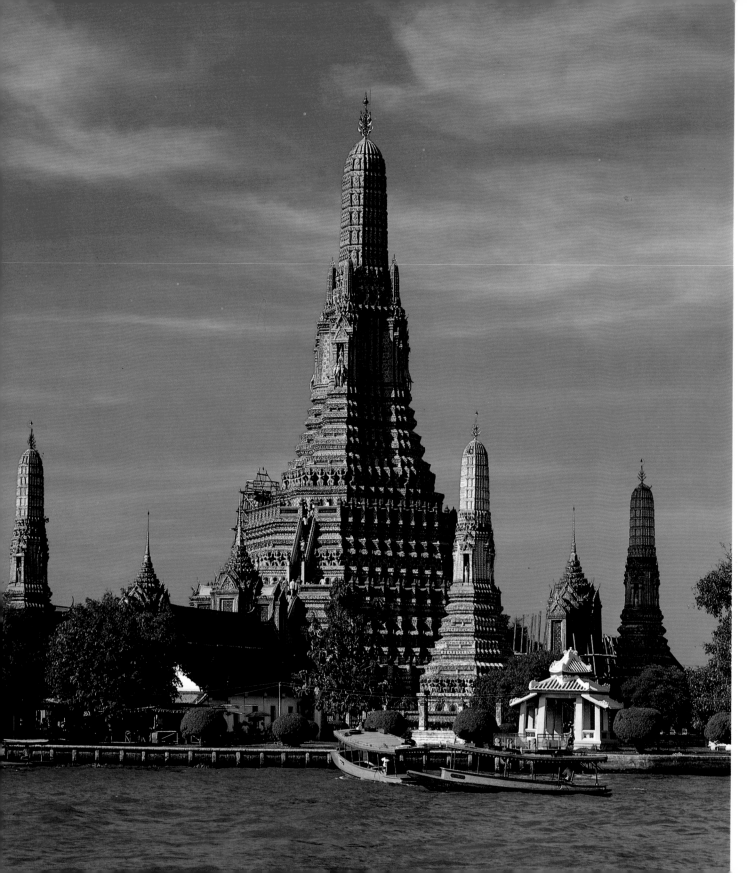

The Temple of Dawn (Wat Arun), Bangkok, Thailand

LEFT AND RIGHT:
On the Chao Phraya River that flows through Bangkok, the Temple of Dawn's tallest prang (tower) soars high above the city, with four lesser prangs surrounding it. Wat Arun, which is decorated with floral frescos of procelain, has very steep steps climbing its terraces. Its gateway is guarded by the traditional ominous ogres as is the Temple of the Emerald Buddha across the river. Some 300 temples in Bangkok are vivid spots of color in the city, with their brightly tiled roofs, lofty towers and distinctive architecture.

PHOTOGRAPHY DATA: RIGHT: Morning, wide-angle lens. LEFT: Morning, long lens; Polaroid filter.

168

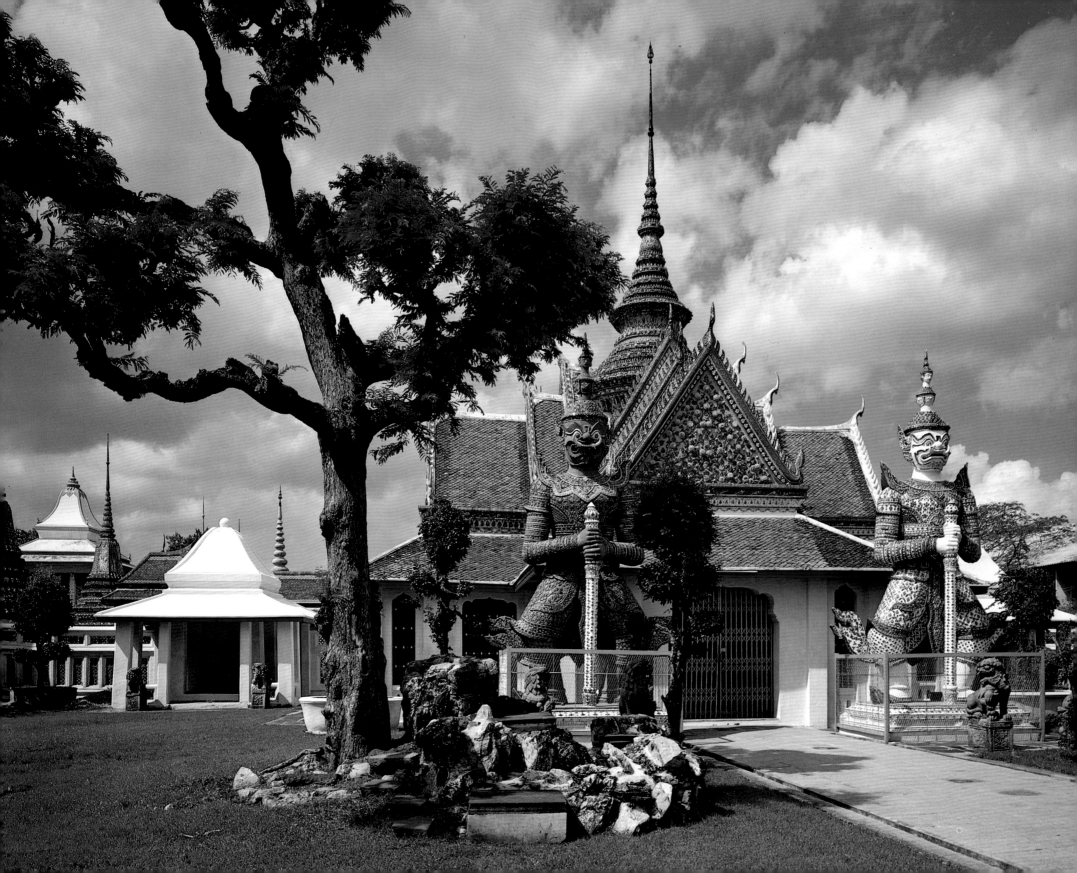

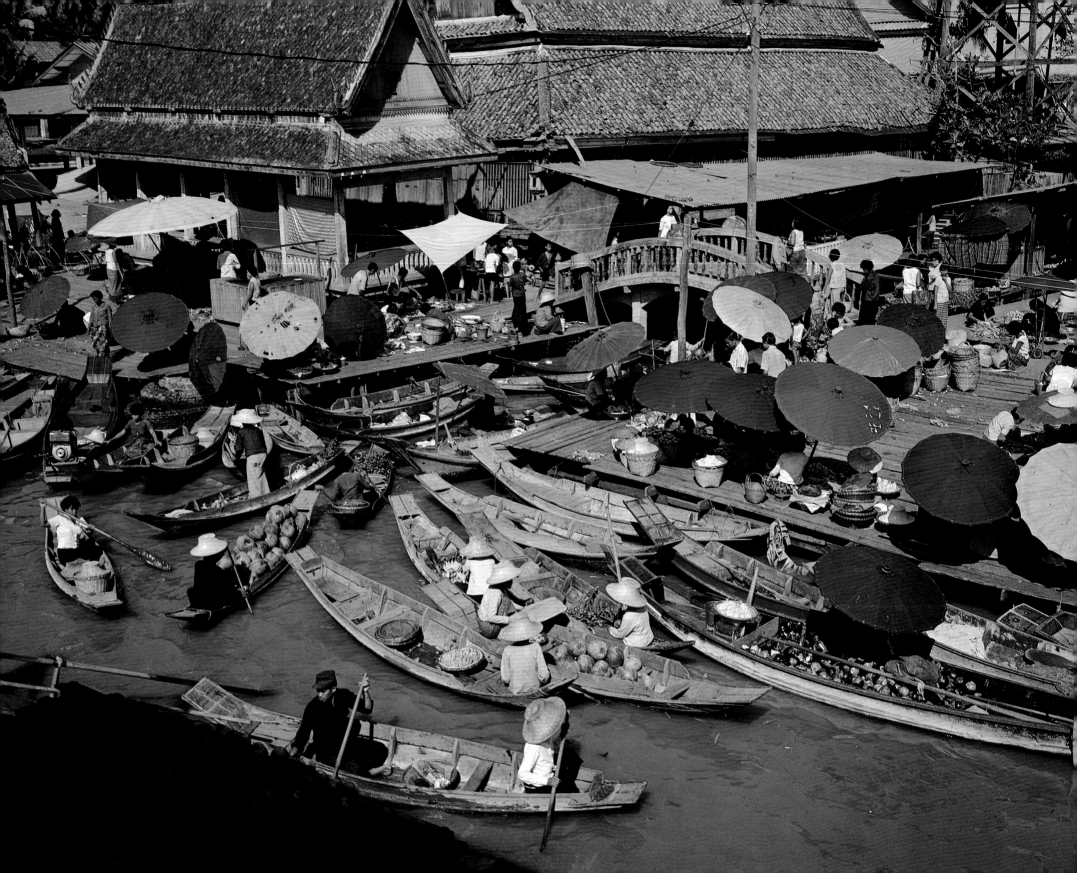

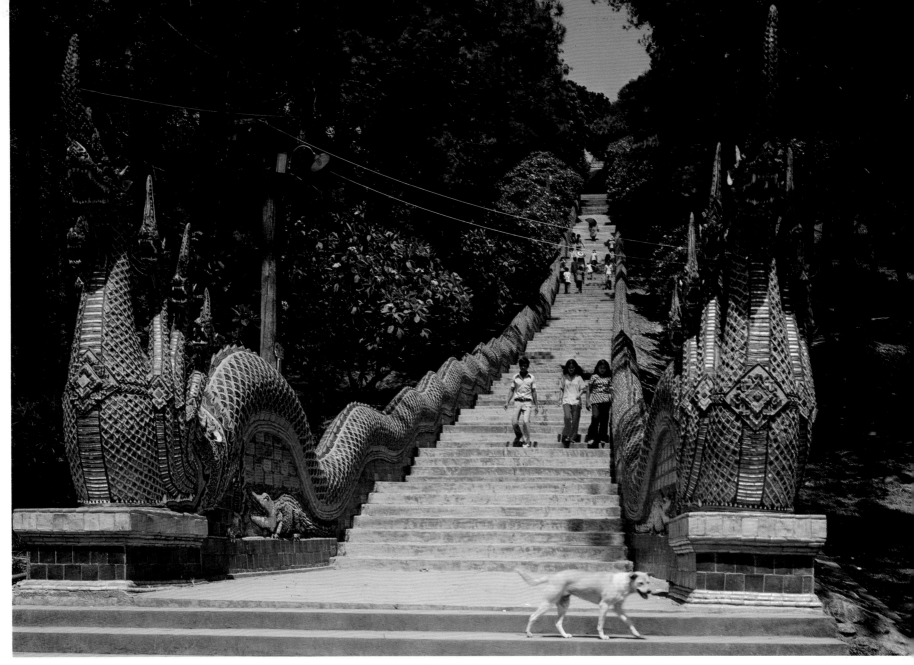

Floating Market, Bangkok, Thailand

LEFT: Although Bangkok is a modern city it still retains its section of klongs (canals), along which many Thais live. Here sampans become floating markets selling fruits, vegetables, meats and notions. Hot food cooked on one of the sampans is also popular. Often called the ''Venice of the East,'' the city's klongs eventually empty into the wide Chao Phraya River. Homes along the many klongs use them as traffic arteries as well as for drinking and bathing. The gayly colored parasols provide shade from the hot sun for the sampan owners who may be on the klongs for hours before their wares are all sold.

Chiang Mai, Thailand

ABOVE: Chiang Mai on the Ping River in northern Thailand is its second largest city. Thai craftwork in silver, teakwood, pottery and the famed Thai silk are produced in this area. The high dragon staircase to a Thai temple is a curiosity here. Like ornate handrails, two large dragons writhe and undulate down the hillside from top to bottom of the staircase.

PHOTOGRAPHY DATA: Afternoon, normal lens.

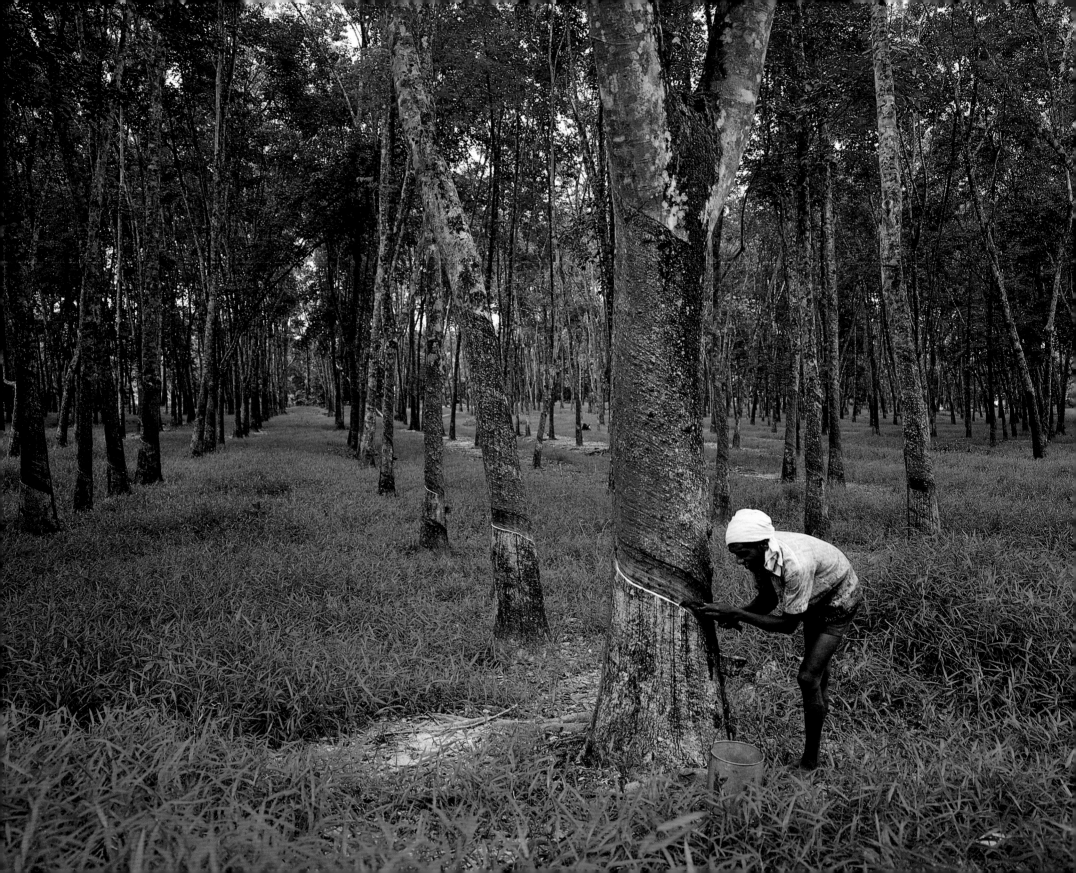

Rubber Plantation, Kuala Lumpur, Malaysia

LEFT: Malaysia is a federation occupying the southern half of the Malay Peninsula and the northern section of Borneo. The world's leading producer of tin, Malaysia also contributes about 35% of the world's rubber supply. Near Kuala Lumpur many rubber plantations produce latex, a milky fluid used in paints, adhesives and rubber. A spiral cut is made in the trunk of the tree to the inner bark and latex flows slowly from it into a receptacle at the base of the cut. Trees are tapped every other day, with one worker in charge of servicing about a thousand trees. These fine rubber plantations were originally planted by the British in 1896.

PHOTOGRAPHY DATA: Morning shade, cloudy sky, wide angle lens

Batu Cave, Malaysia

RIGHT: Batu Cave is only a few miles drive out of Kuala Lumpur, Malaysia's burgeoning capital city. It is reached by a short cable car ride up the side of the cliff or a vigorous climb up the 272 steps of the wide staircase. Batu Cave is the largest of several in the huge limestone cliff and is a Hindu shrine.

PHOTOGRAPHY DATA: Overcast morning, normal lens.

173

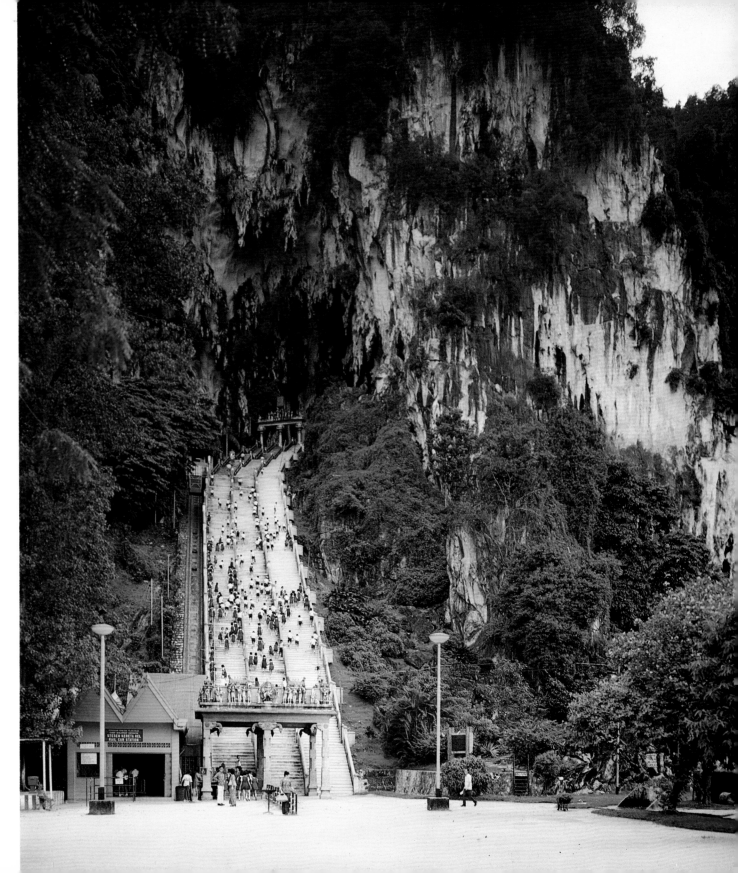

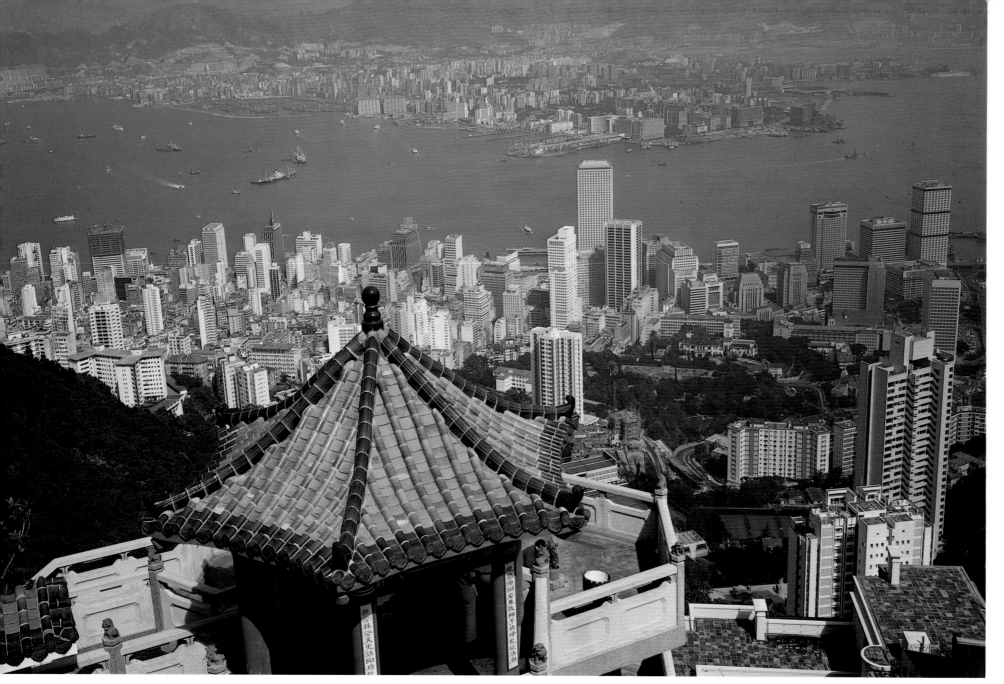

Hong Kong

The British Crown Colony of Hong Kong (Fragrant Harbor) is located in south China less than a hundred miles from Canton. Victoria is the capital city on the Island of Hong Kong, and Kowloon is her sister city on the mainland peninsula. Neither city ever sleeps because life in Hong Kong is a 24-hour affair. Nearly 3 million of the almost 4 million inhabitants are squeezed into a 40-square mile area here. The others are in the New Territories on the mainland and some of the 235 islets in the South China Sea.

PHOTOGRAPHY DATA: Morning, wide-angle lens.

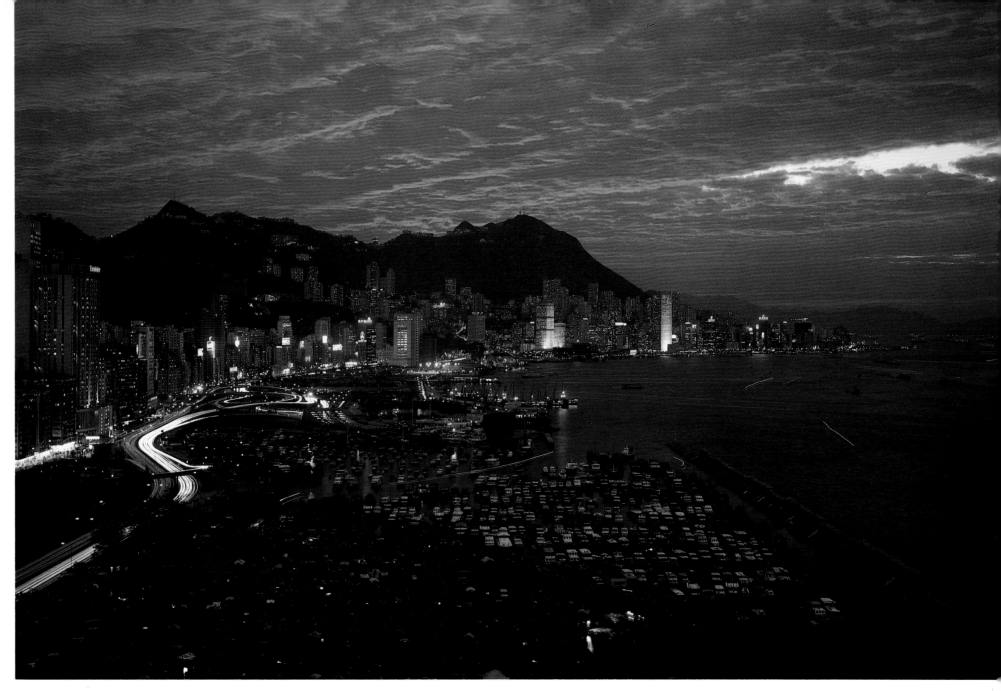

A birds-eye view of the spectacular harbor and mushrooming commercial district of Hong
Kong is revealed from high on Victoria Peak. A cablecar ride on the Peak Tram transports
you 1800 feet above the city.

A vivid sunset and city lights reflect like glittering jewels in the waters of the harbor.
Sampan's in the Causeway Bay Typhoon Shelter also have small lights and cookfires.
Victoria Peak's dark silhouette is laced with twinkling illumination.

PHOTOGRAPHY DATA: Afternoon, normal lens. Sunset, double exposure, normal lens.

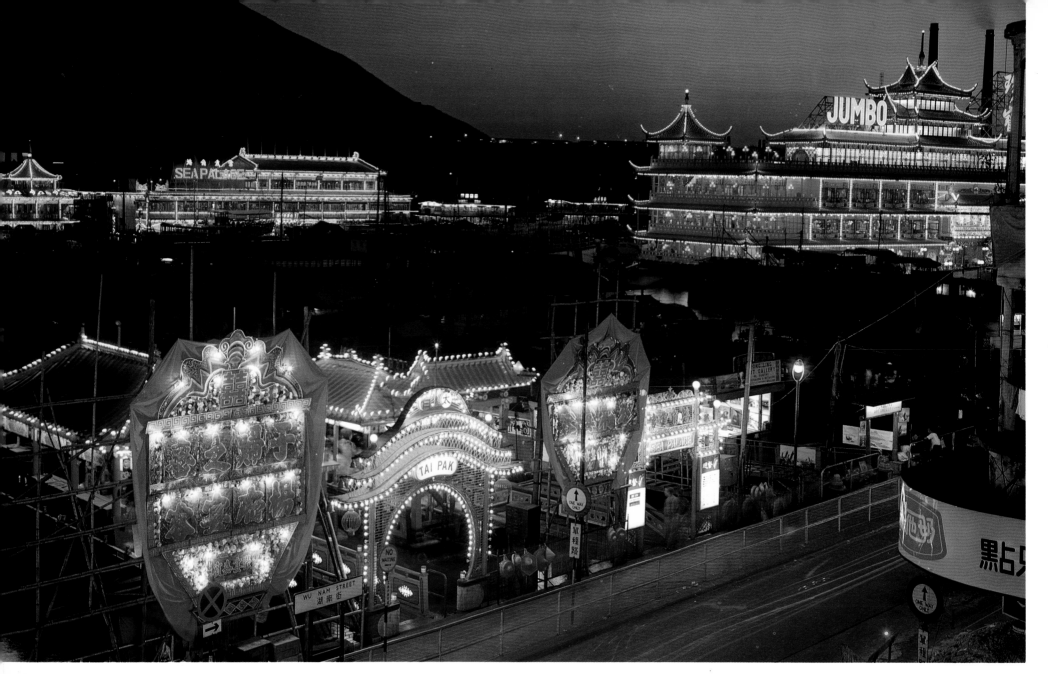

Aberdeen, Hong Kong

ABOVE: Aberdeen is Hong Kong's main fishing village and has the greatest share of the 65,000 people who live afloat on the Colony waters. A throng of sampans and junks are pressed together, almost overlapping. The large floating restaurants in the junk harbor are usually reached by sampan.

PHOTOGRAPHY DATA: Dusk, wide angle lens.

The Ginza, Tokyo, Japan

RIGHT: Edo or Yedo was the small village which became Tokyo, today the world's largest city. It was divided into blocks where each tradesman pursued his specific skill. The Ginza is both a street and the principal shopping area of Tokyo. By night it glows with neon signs and lights in the manner of Times Square or Piccadilly Circus. Traffic and business are as active and spirited as during daylight hours.

PHOTOGRAPHY DATA: Night, time exposure, normal lens.

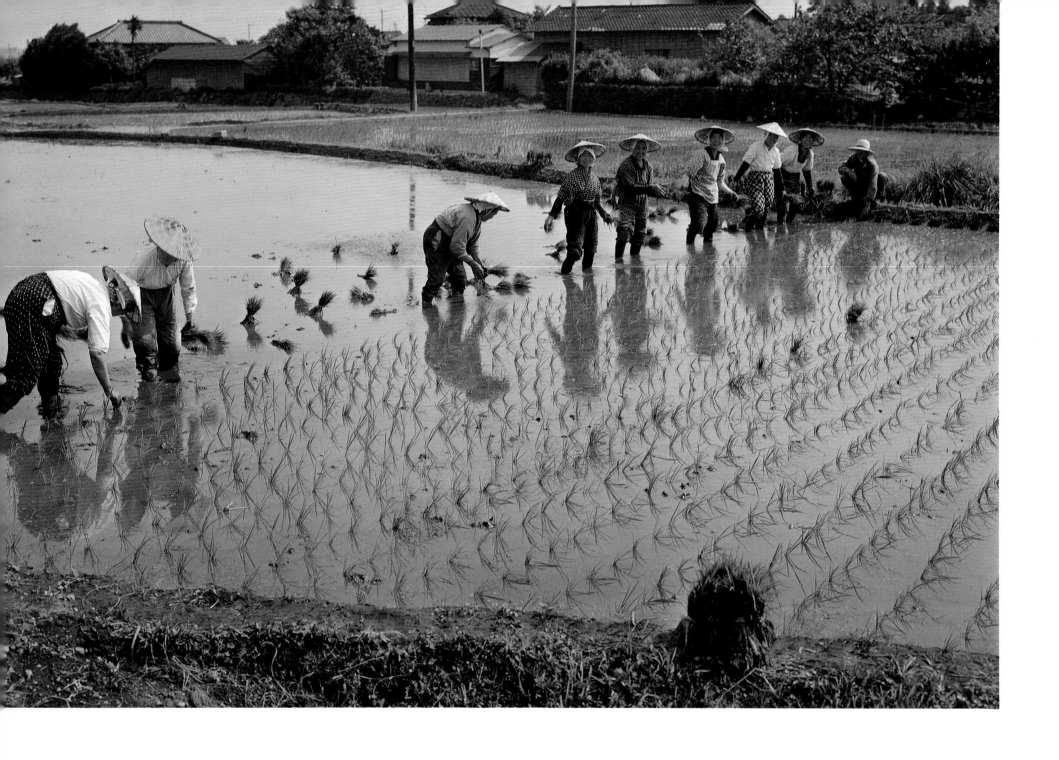

Rice Planting, Japan

LEFT: The staple food in densely populated Asia, rice is said to provide food for more people than any other of the world's cereal grains. Most rice is grown in water until maturity. Japanese women gather bundles of young shoots from the nursery and meticulously transplant each stalk beneath the mud of the flooded rice paddy.

PHOTOGRAPHY DATA: Afternoon, hazy sunlight, wide-angle lens.

The Great Buddha, Kamakura, Japan

RIGHT: The Great Buddha was originally within a temple in the seaside town of Kamakura, a short train ride from Tokyo or Yokohama. In 1495 a tidal wave carried away the sheltering building but left the massive bronze statue. Time and the elements have deposited a soft green patina to this remarkable image of Buddha. Though racked by earthquakes and typhoons through seven centuries, the Great Buddha continues its serene meditation.

PHOTOGRAPHY DATA: Afternoon, wide-angle lens.

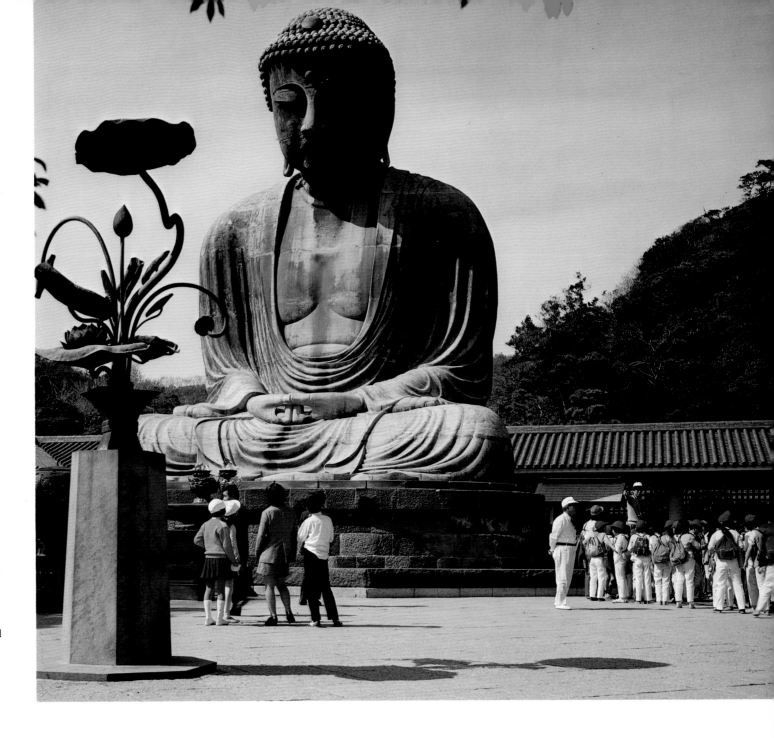

179

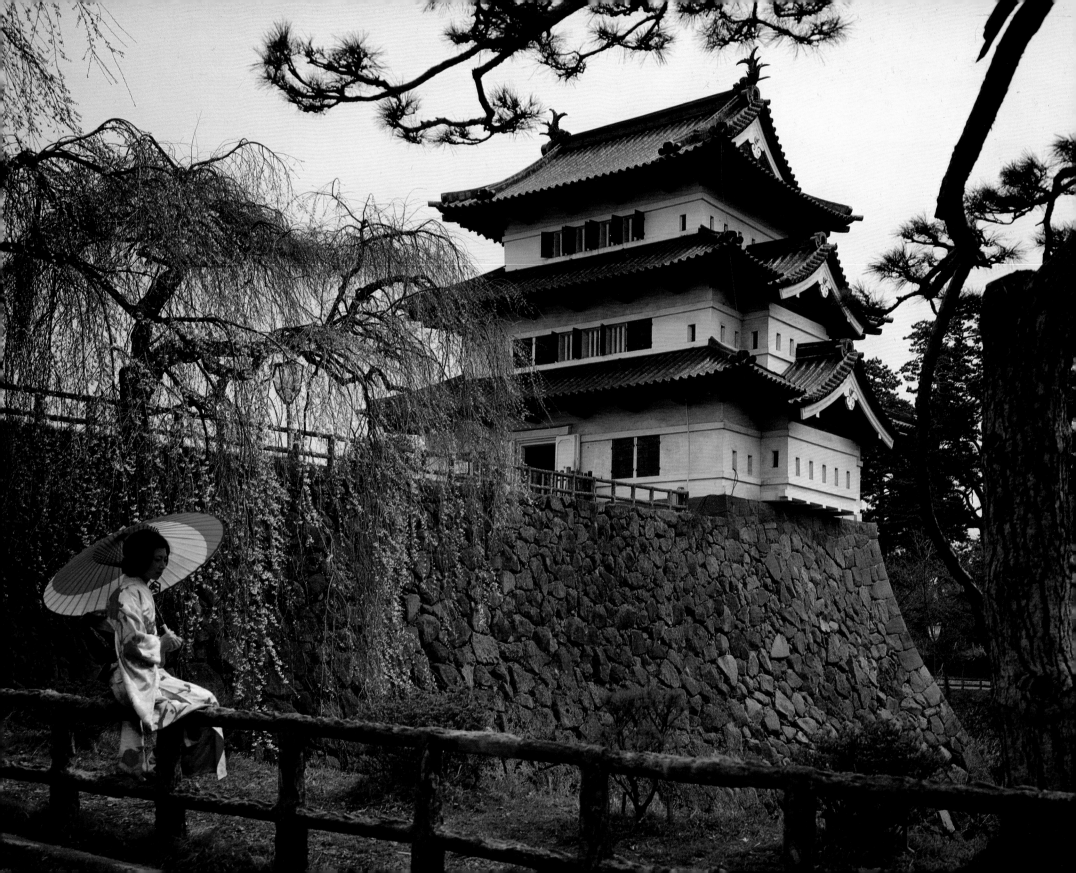

Hirosaki Castle, Japan

LEFT: In the far northwest corner of Honshu is the town of Hirosaki, noted for its ancient castle (1611) of distinctive Japanese architecture. Hirosaki Park, which occupies a part of the old castle grounds, is famed for the lavishness of the cherry blossoms that bloom there in springtime. Many tourists try to time their visit to Hirosaki Castle to coincide with the Cherry Blossom Festival.

PHOTOGRAPHY DATA: Morning, wide-angle lens.

Torii, Miyajima, Japan

RIGHT: The great red torii at Miyajima, the Shrine Island near Hiroshima, is the symbolic gateway to the Shinto Shrine of Itsukushima, which was established on the sacred island. Built 100 years ago, the 50-foot high camphor-wood torii is the largest in Japan. Rising from the blue waters of the inland sea near the shores of the island, the ornate torii can be reached on foot at low tide.

PHOTOGRAPHY DATA: Morning, normal lens.

Torii, Hakone, Japan

RIGHT: When Japan was ruled by the Shoguns (military dictators), Hakone was a hot-springs spa between Edo (Tokyo) and Kyoto where they could rest and refresh their elegant caravans. Today it is still a popular hot spring and mountain resort and forms a part of the Fuji-Hakone-Izu National Park. It is also the site of a venerated torii near Lake Ashi.

PHOTOGRAPHY DATA: Morning, wide-angle lens.

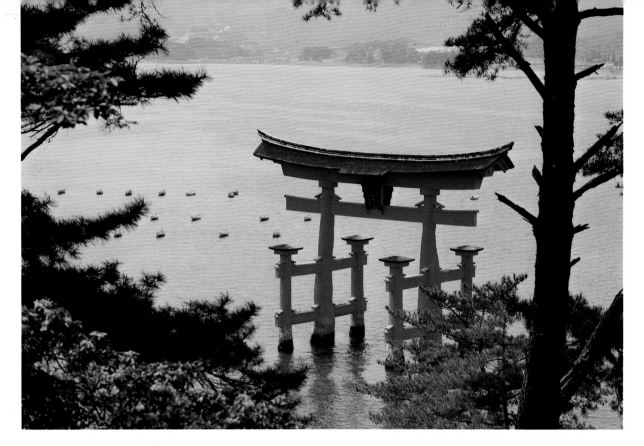

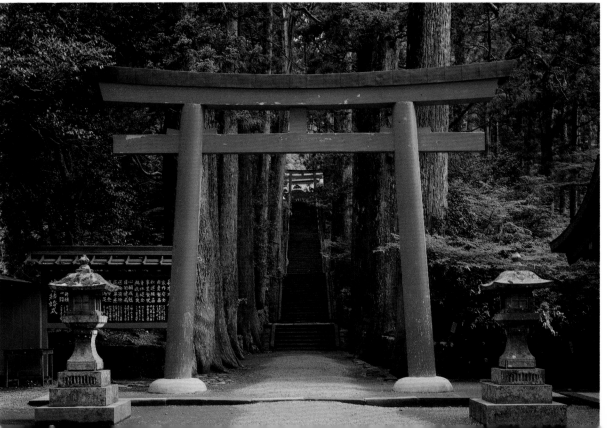

181

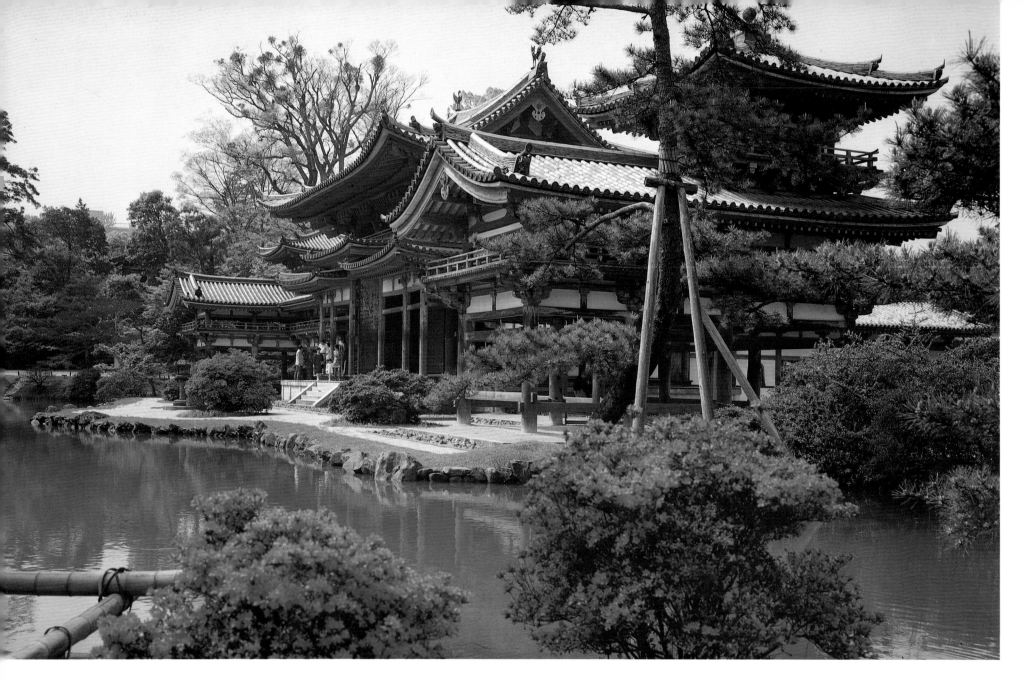

Phoenix Hall of Byodo-in Temple, Kyoto, Japan

ABOVE: Kyoto was the capital of Japan for more than ten centuries (794–1868). Imposing shrines, temples and palaces with elaborately designed gardens attest to the splendor of the ancient city. Some extravagant private villas, such as Byodo-in, were converted into Buddhist temples. Its architectural plan resembles the large mythical bird, the Phoenix.

PHOTOGRAPHY DATA: Morning, hazy sunlight, wide-angle lens.

Kintai Bridge, Iwakuni, Japan

RIGHT: Undulating across the Nishiki River, the Kintai Bridge in the town of Iwakuni was originally built in 1673 by a feudal lord of this district. Stone piers support the five graceful wooden arches. Also known as the ''Bridge of the Brocaded Sash'' this uniquely Japanese structure accomodates pedestrian traffic only. In 1950 a raging flood washed away the bridge and it was reconstructed in its exact original shape in 1953.

PHOTOGRAPHY DATA: Morning, normal lens.

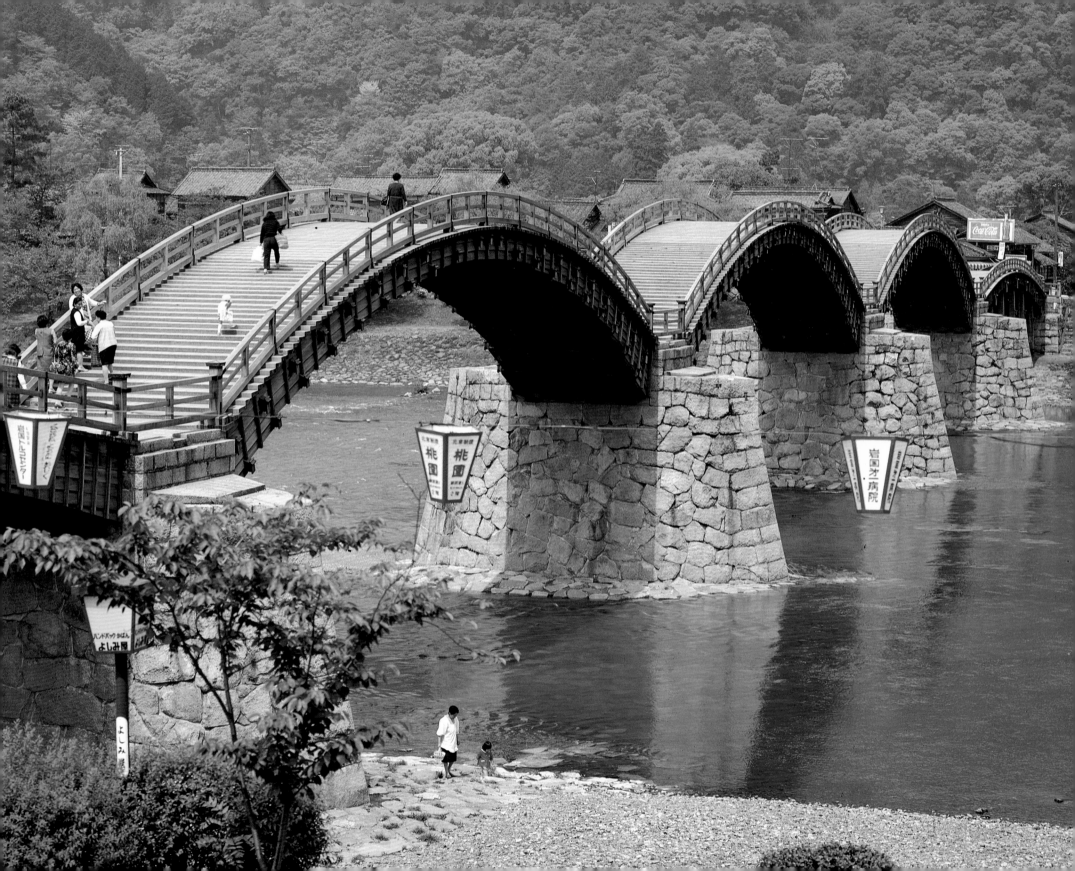

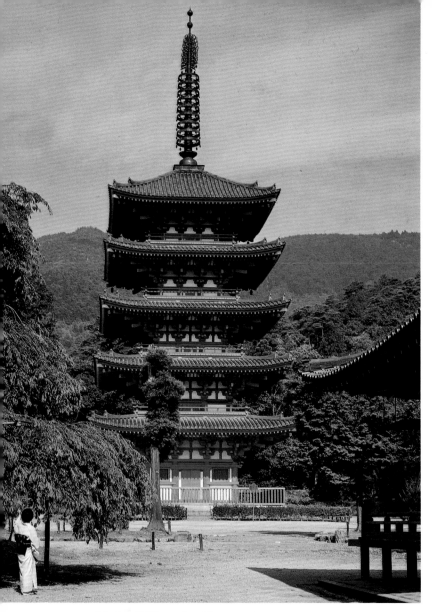

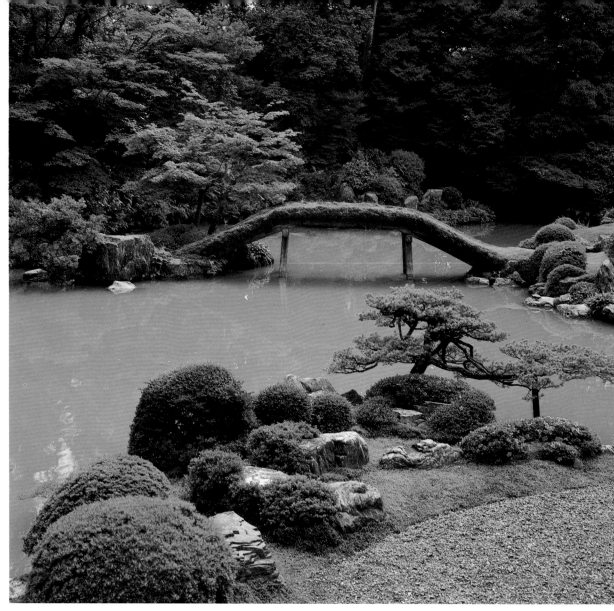

Daigoji Temple, Kyoto, Japan

ABOVE: Protected as a "National Treasure" of Japan, the five-story pagoda of the Daigoji Temple on the outskirts of Kyoto dates back to the year 951. This temple contains two sections, Upper Daigo and Lower Daigo, each containing ancient buildings but the latter's lofty pagoda is the oldest existing structure in Kyoto.

Daigoji Temple's landscape garden is one of the finest specimens in Japan. This highly revered temple and its beautiful garden with cherry trees, rocks, ponds and even a delicately arched bridge, draws large crowds of visitors especially in spring when the cherry blossoms burst forth in all their glory.

PHOTOGRAPHY DATA: Morning, normal lens. Afternoon, normal lens.

Harbor, Manila, Phillipines

RIGHT: The most strategic harbor in the Phillipines is Manila Bay, where Spanish galleons were once the economic lifeline between China and Europe. A 1564 expedition from New Spain (centered in Mexico City) led by Miguel López de Legaspi began the Spanish conquest of the Phillipines. In 1571 Legaspi founded the city of Manila and by the end of the 16th century it was the foremost commercial center of the far east.

PHOTOGRAPHY DATA: Sunset, normal lens, direct meter reading of brightest sky area.

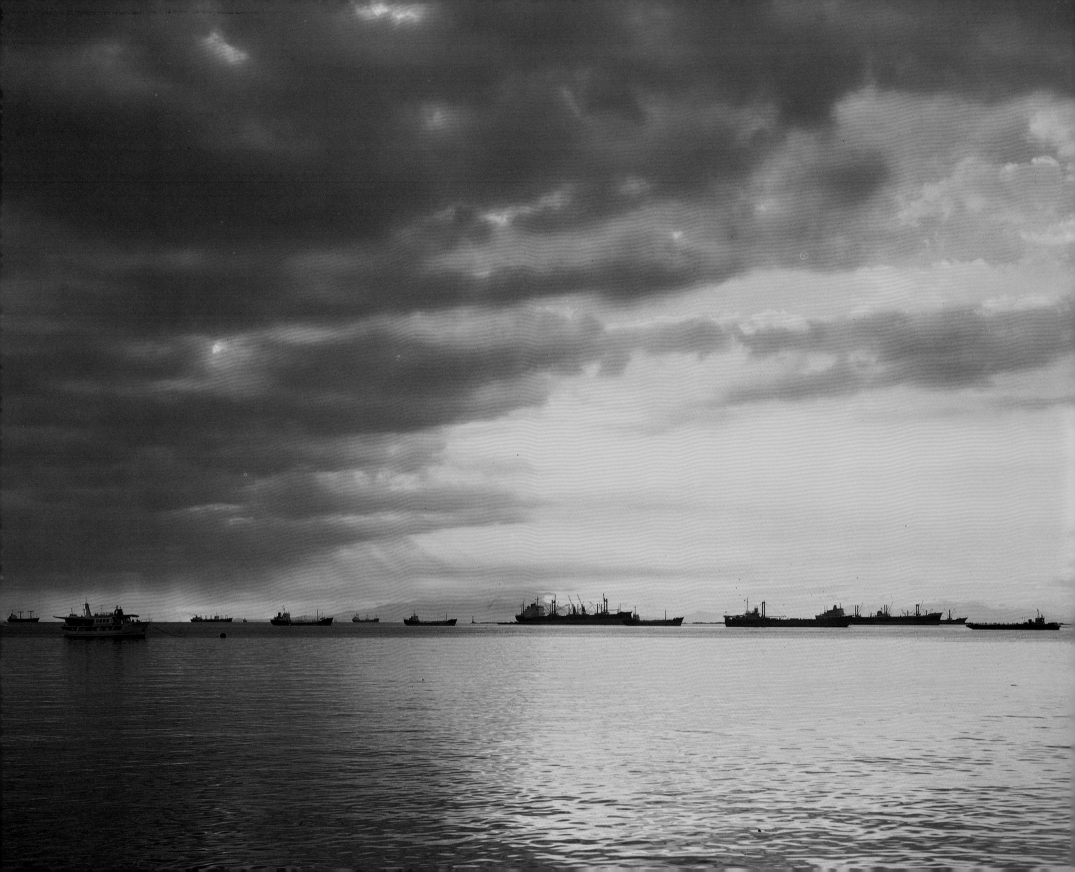

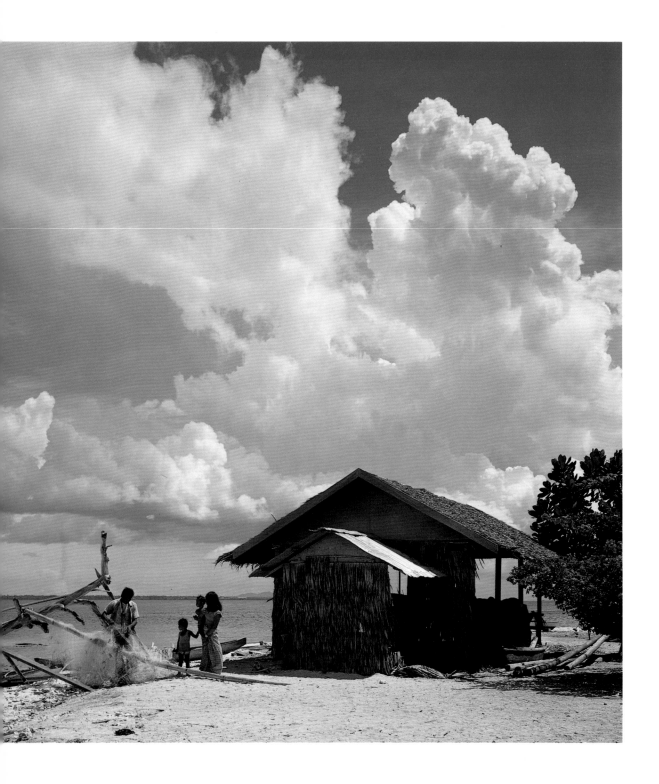

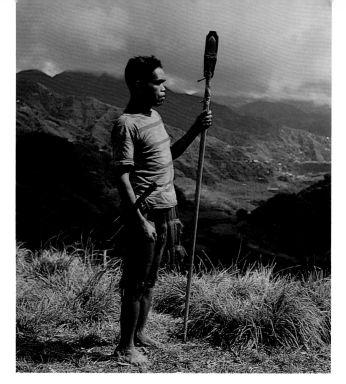

ABOVE: The Ifugaos, an ethnic unit of the large Igorot tribe, have straight hair and dark skin. Their heritage is mainly Malayan and Indonesian with some Negrito and their home territory is the rice producing area of northern Luzon.

PHOTOGRAPHY DATA: Early morning; normal lens.

Rice Terraces, Banaue, Philippines

RIGHT: In Banaue the mountain sides are hewn into stair-step rice terraces that are farmed by the Ifugao tribe whose ancestors labored to build them over a 2,000 year period. Watered by torrential rains and an irrigation system that utilizes bamboo pipes, these phenomenal rice terraces have been called the ''Eigth Wonder of the World.''

PHOTOGRAPHY DATA: Early morning; wide-angle lens.

Santa Cruz Island, Zamboanga, Philippines

LEFT: Santa Cruz Island, just off Zamboanga, is home to many Muslims who live there in a village on stilts. Fishing and gathering sea shells and coral are their livelihood on this delightful tropical island.

PHOTOGRAPHY DATA: Mid-day, normal lens. Bright sands and clouds require careful exposure metering.

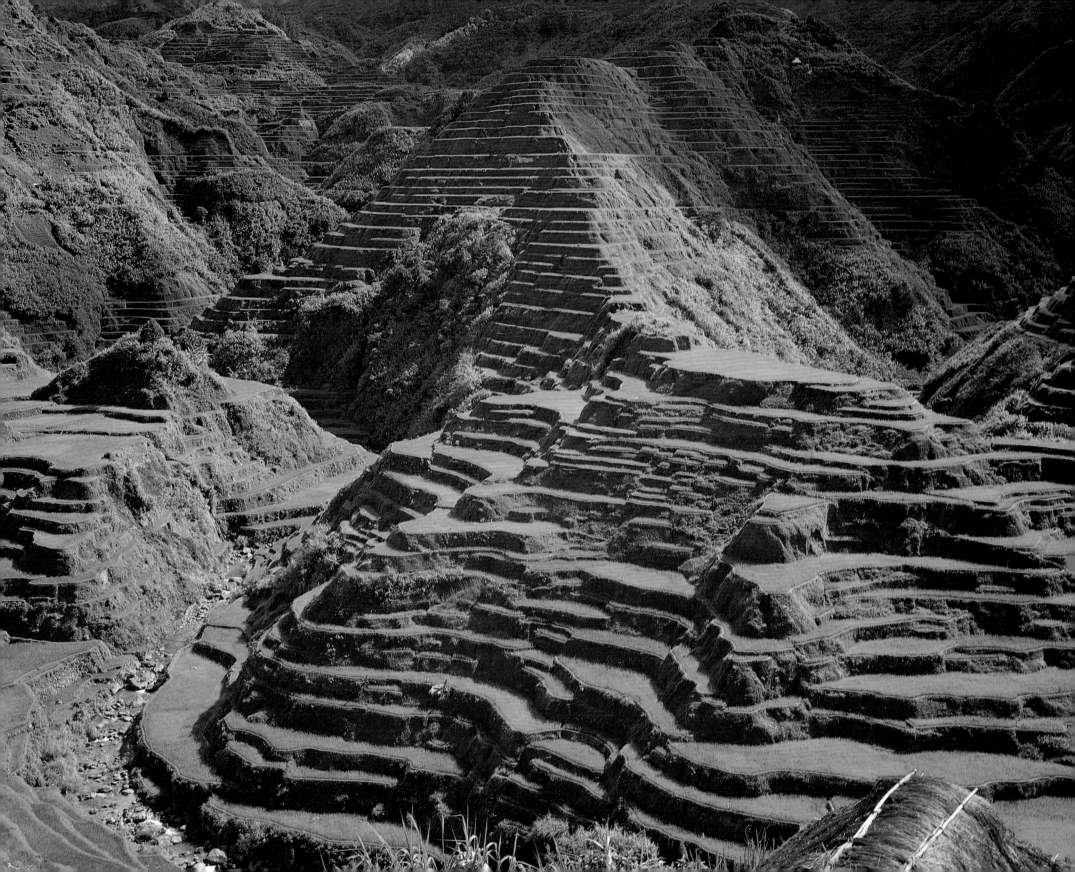

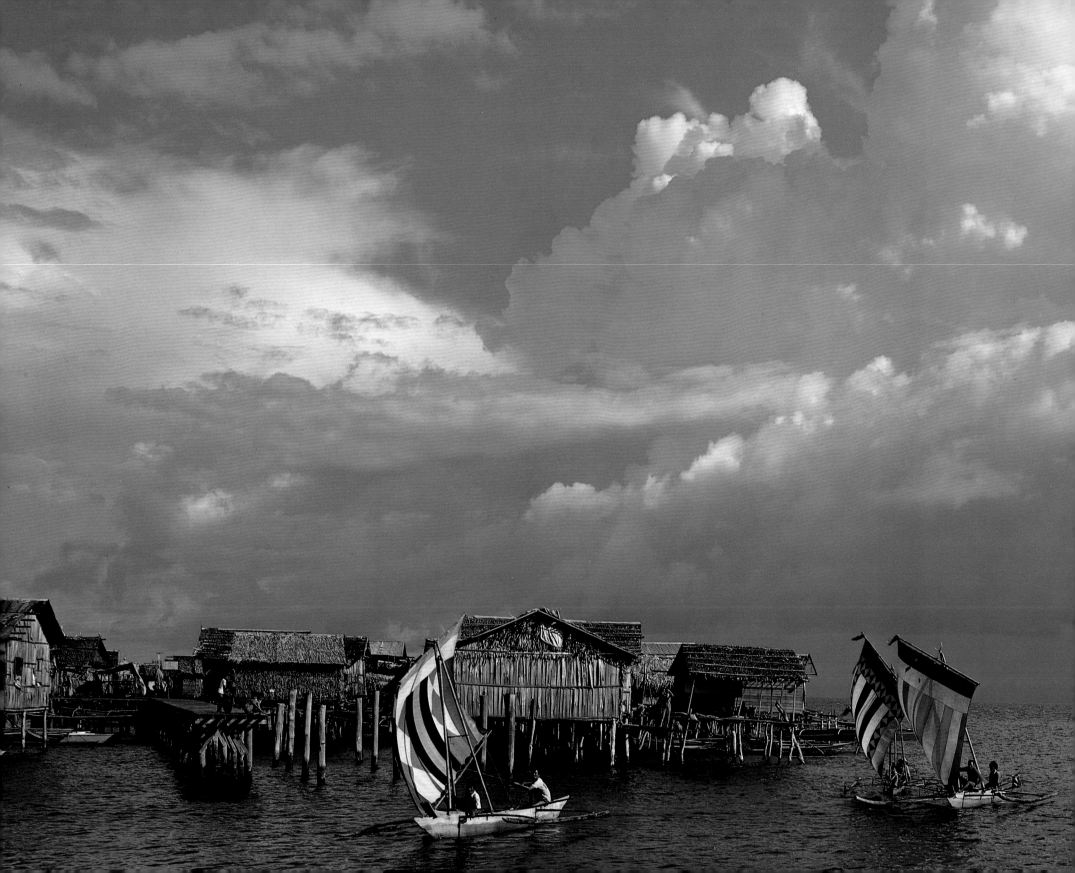

Zamboanga, Philippines

LEFT: More than 7,000 islands rise from the seas
to form the Philippines, but only 10 percent of them
are inhabited. The two largest islands, Luzon
and Mindanao, contain most of the population.

Romantic-sounding Zamboanga (from a Muslim word
meaning "Place of Flowers") is on the southern-most
island of Mindanao and it is here that the small outrigger
canoes called "vintas," with their varicolored sails, are
seen scudding past the Muslim village. Muslims settled
here long before the Spanish arrived in the Philippines.
Their houses on stilts over the water are kept cool by the
sea and breezes; the pilings make a convenient place to
tie the vintas underneath.

PHOTOGRAPHY DATA: Mid-afternoon, normal lens.
The muslim fishermen and shell vendors return home
throughout the afternoon and evening. The colorful sails
are used for festive occasions.

Bowen Falls, Milford Sound, New Zealand

RIGHT: The most enjoyable way to see Milford Sound is
to take a short cruise. The boat will carry you past some
of the main sights, which include Mitre Peak and Bowen
Falls, where the Bowen River tumbles about 560 feet
down a precipice, in a cloud of mist, into the Sound.

PHOTOGRAPHY DATA: Afternoon, normal lens.

189

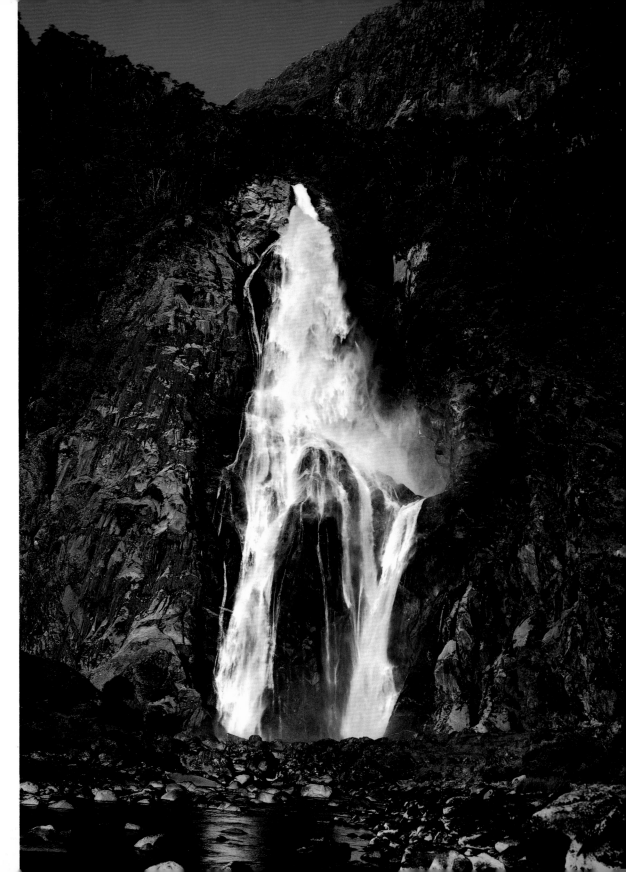

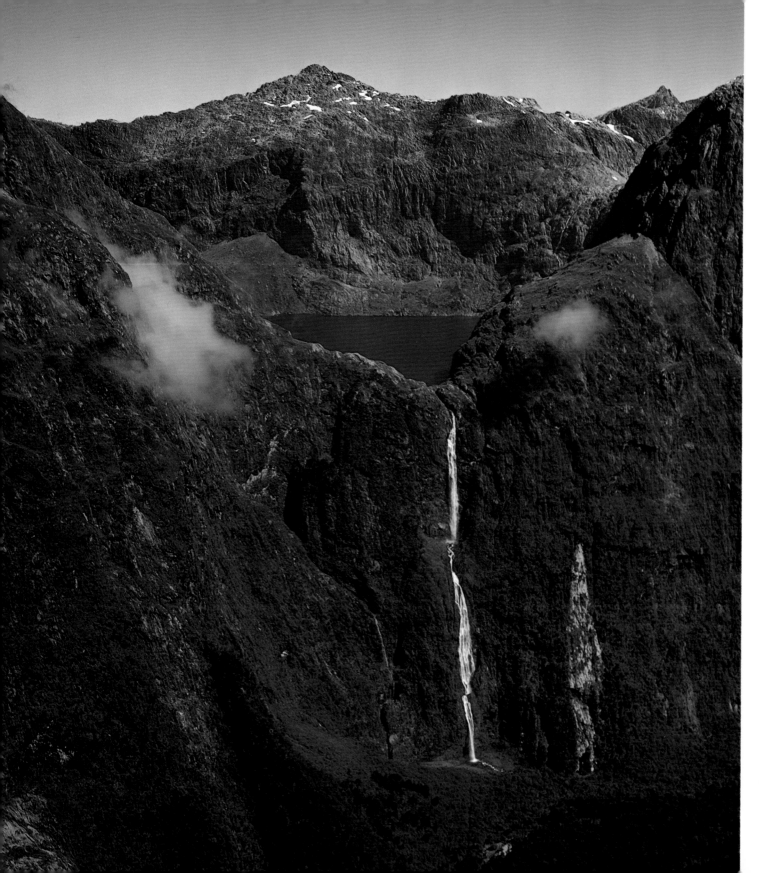

Sutherland Falls, New Zealand

LEFT: Breathtaking Sutherland Falls are named after Milford Sound pioneer Donald Sutherland, who, along with prospector John McKay,discovered them in 1880. Sutherland Falls plummets down a 1904-foot triple drop from glacier-formed Lake Quill. Seen either from the air or when hiking on the Milford Track, Sutherland Falls is an impressive and beautiful sight.

PHOTOGRAPHY DATA: Mid-day, normal lens. This aerial photograph of the world's second highest waterfall is one of the scenic rewards of my career. The cloud cover parted as our small plane approached.

Milford Sound, New Zealand

RIGHT: Milford Sound, in Fiordland National Park on New Zealand's South Island, is the country's best known fiord and has a deep anchorage in which ocean-going liners have moored. A true glacial fiord, Milford Sound is a misnomer. Sounds are generally formed by the action of wind and erosion; fiords by glacial action. Fiords were the sites of large valley glaciers during the Ice Age. Dramatic Mitre Peak rises abruptly to its mile-high grandeur from the deep waters of the fiord.

PHOTOGRAPHY DATA: Midday, normal lens.

190

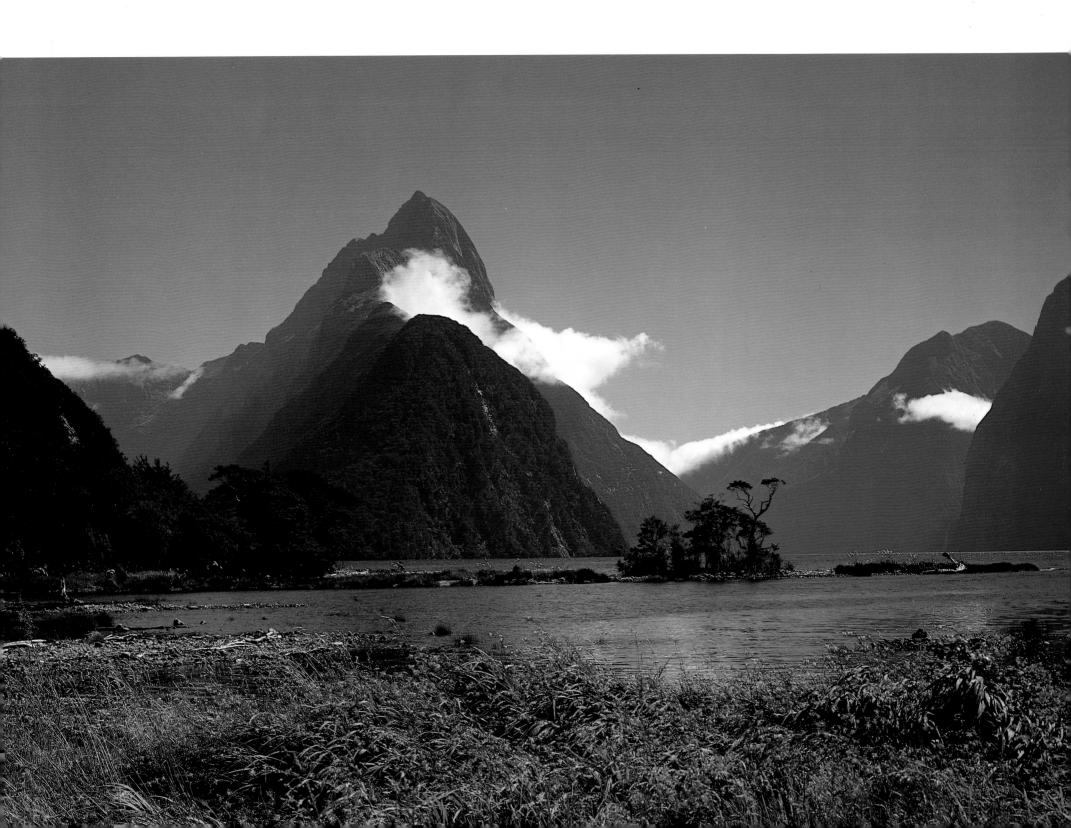

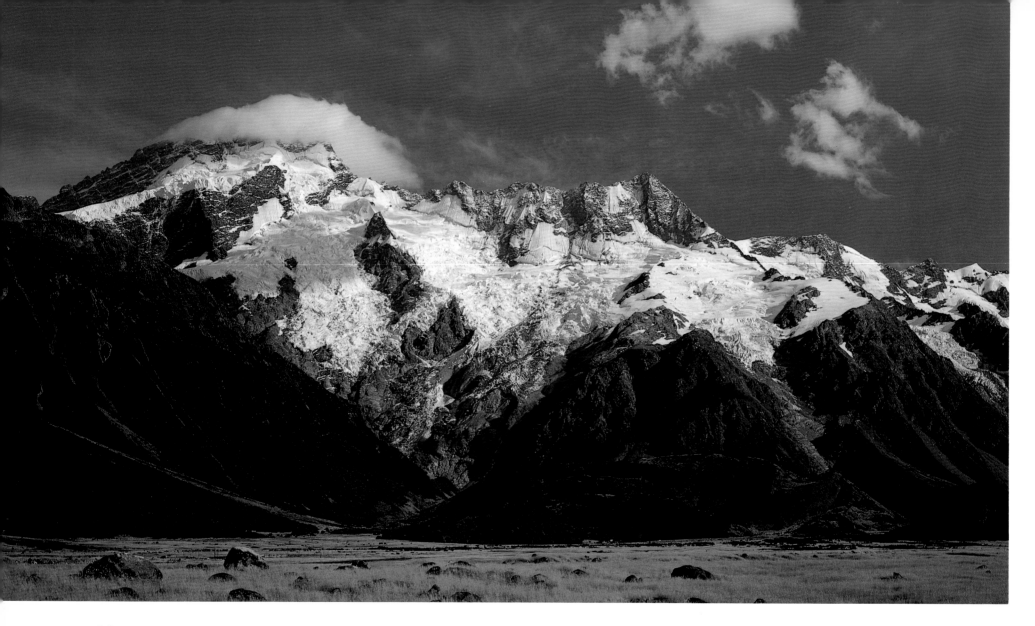

Mount Sefton, Mount Cook National Park, New Zealand

ABOVE: Massive Mt. Sefton and the Footstool tower over the village of Mt. Cook which is at their base. On a clear day it dominates the view and when wreathed in mists and clouds reveals only tantalizing bits of its substantial face.

PHOTOGRAPHY DATA: Morning, normal lens with polaroid filter.

Mt. Cook, Mt. Cook National Park, New Zealand

RIGHT: New Zealand's Southern Alps extend the full length of South Island, with their many fiords, lakes and rivers. Mt. Cook National Park includes about 40 miles of the Alps rugged magnificence and is named for the loftiest of its many peaks. Mt. Cook, at 12,349 feet, is known as the "Cloud Piercer" and is surrounded by 21 other mountains higher than 10,000 feet. Mt. Tasman (11,467 feet), adjacent to Mt. Cook, is famous for its tremendous glacier. When a glacier's descent is steep, it forms an "icefall," a jumble of broken ice. In this scene showing mighty Mt. Cook and Mt. Tasman, Hochstetter Icefall, on a tributary of Tasman Glacier, is visible.

PHOTOGRAPHY DATA: Late morning, normal lens. This aerial photograph was made from a tourist flight at 9,000 feet.

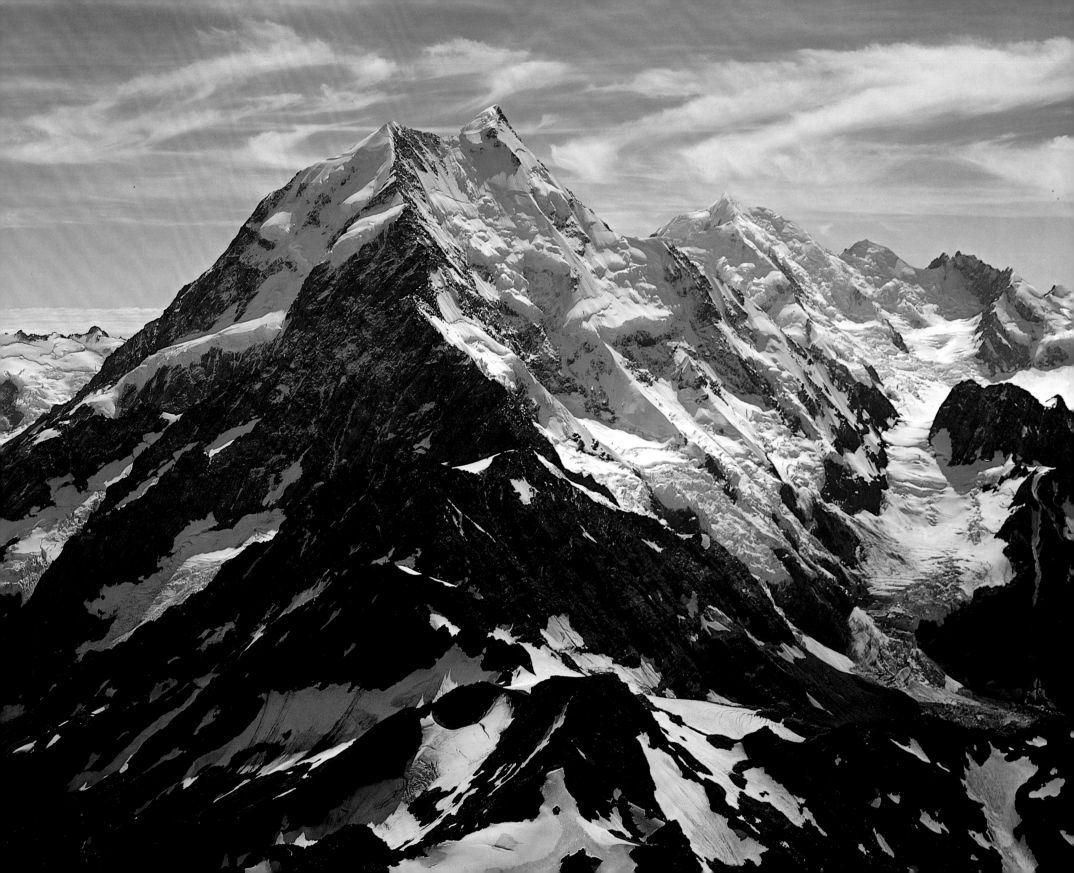

Cathedral Square, Christchurch, New Zealand

LEFT: Christchurch has been called by many admirable names, including the Cathedral City, the Garden City, the City of Trees and the most "English" city. Lined with weeping willows, the lovely Avon River winds through the heart of this fair city. Christchurch was founded in 1850 when the Church of England sponsored four ships and their passengers to colonize the province. These early pilgrims began construction of the Church of England Cathedral on the Square in 1864, where it now stands as a fitting monument to them.

PHOTOGRAPHY DATA: Morning, wide-angle lens.

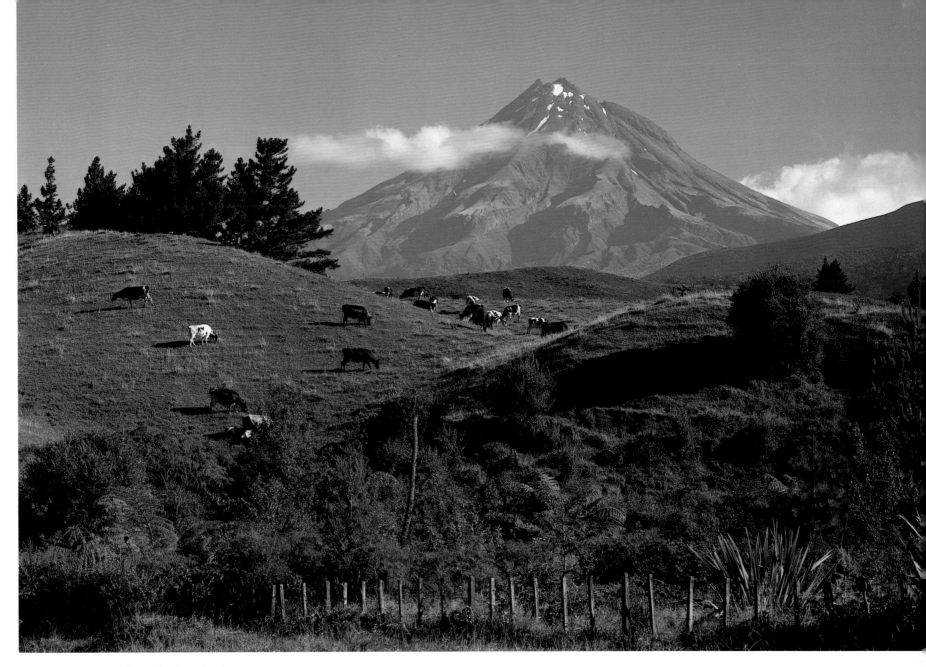

Mount Egmont, New Zealand

ABOVE: A short drive from New Plymouth on North Island, symmetrical Mt. Egmont, in Egmont National Park, is an extinct volcano. Under good weather conditions Egmont is an easy mountain to climb. Every year when deep snow and ice give way to bare rock, hundreds are guided to the summit in organized climbs. New Zealand's extensive grazing lands support some 60 million sheep, in addition to cattle.

PHOTOGRAPHY DATA: Late afternoon, long lens.

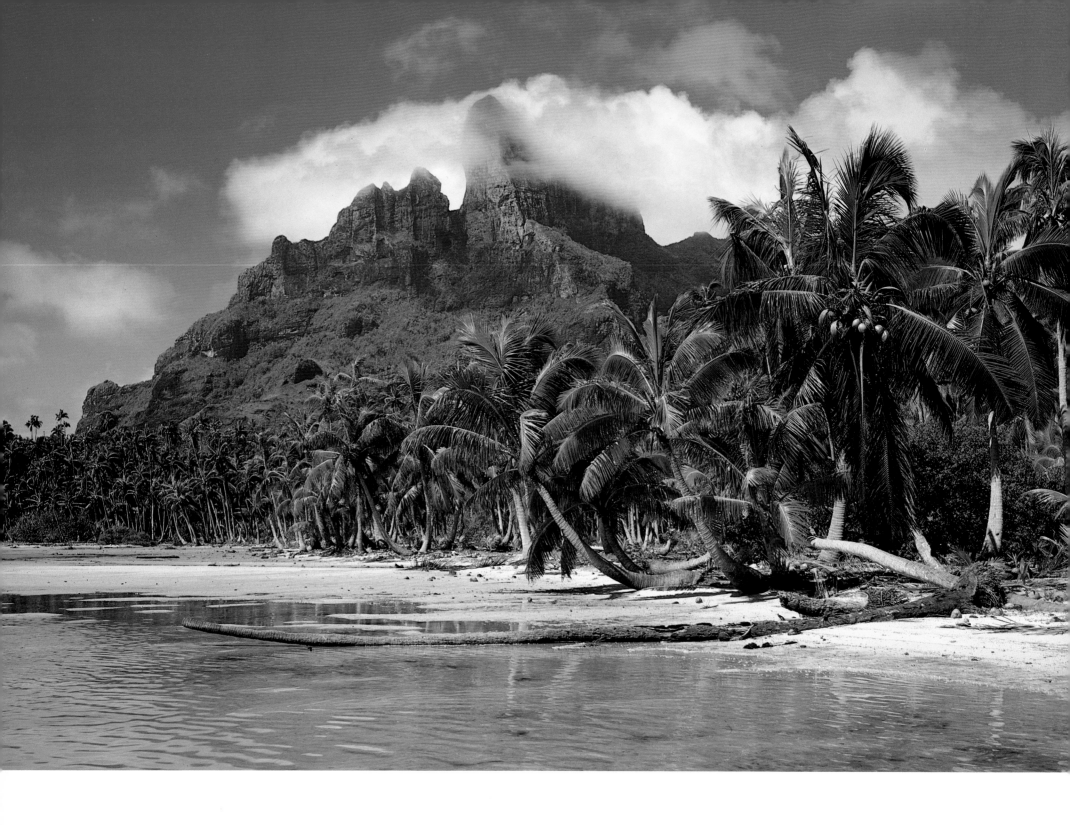

Bora Bora, French Polynesia, Society Islands

LEFT: Bora Bora, sometimes called "the pearl of the Pacific," is crowned by two majestic peaks, Pahia and Temanu, and has one of the loveliest lagoons in all of Polynesia. When visited by air, the plane lands on a small atoll off Bora Bora and a launch delivers you in 30 minutes to the island's business center.

PHOTOGRAPHY DATA: Morning, normal lens. The peak finally emerged from the clouds after I had waited in the shallow lagoon for over three hours. Sunburn is another hazard of photography!

Cook's Bay, Moorea, French Polynesia, Society Islands

RIGHT: Separated from Tahiti by a narrow strait, Moorea is a small but spectacular island with sharp peaks, deep valleys and inviting lagoons. Steep-sided Tohivea rises abruptly behind Cook's Bay, providing a magnificent backdrop for the sailboats anchored in the blue-green waters.

PHOTOGRAPHY DATA: Morning, normal lens.

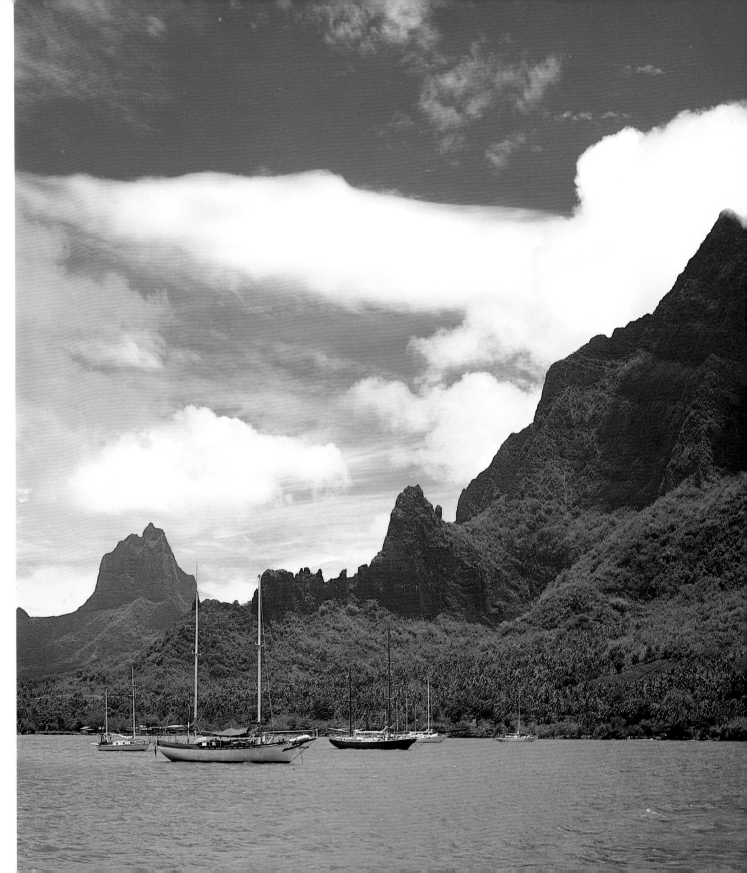

197

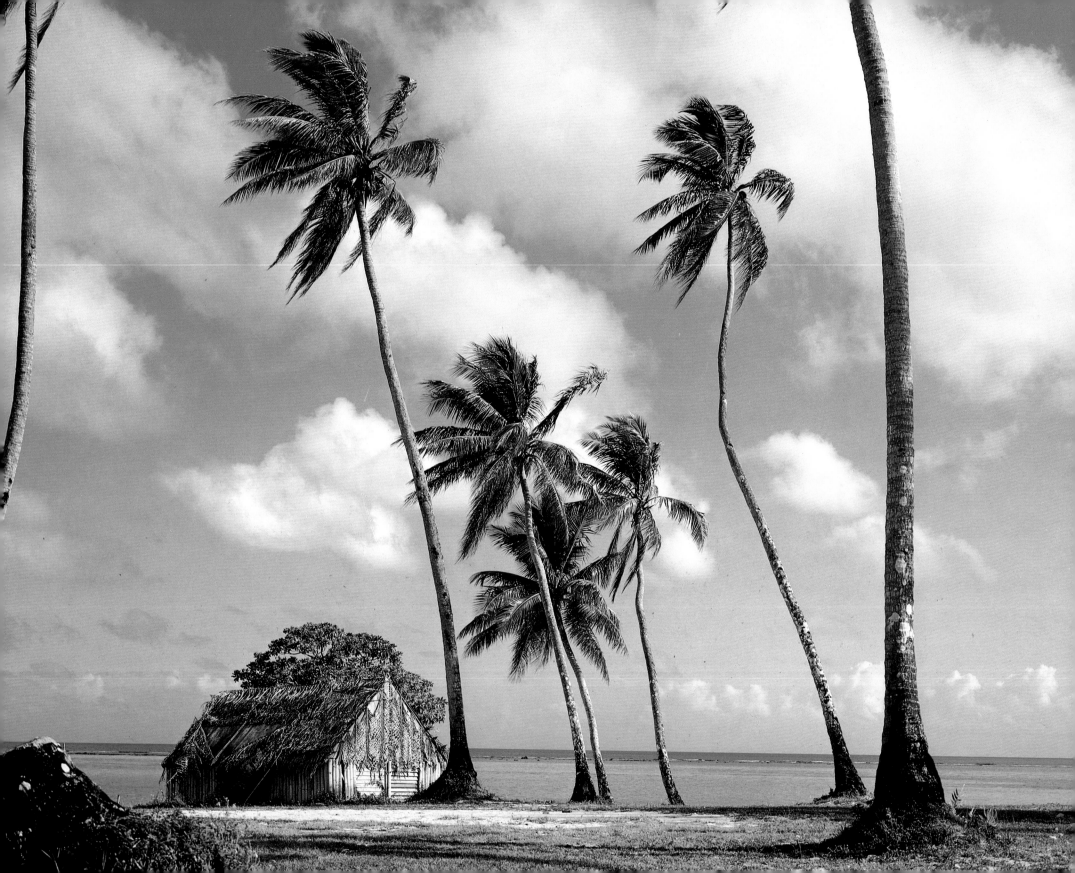

Guam

LEFT AND RIGHT: Guam, the largest of the volcanic Marianas Islands, is a territory of the United States with a major naval air base and ship yards. Tropical Guam's temperature varies only from 70 to 90 degrees fahrenheit and lures many tourists, more than half of them Japanese. An around-the-island highway is about 50 miles long but in its length can be seen much of Guam's thousands of years of history as well as its scenic splendors. Beauty can be found in the peaceful setting of a fisherman's simple hut, the perpendicular green cliff of "Lovers Leap" and the white coral beaches with windswept coconut palms.

PHOTOGRAPHY DATA: Left, Fisherman's Hut; Morning, normal lens.
Right, Lovers Leap: Afternoon, normal lens.

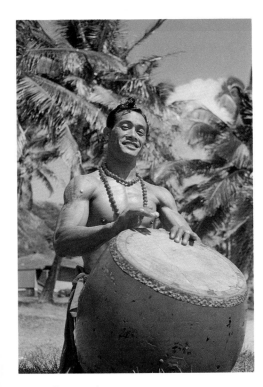

ABOVE: Samoan drummer.
PHOTOGRAPHY DATA: Morning, normal lens.

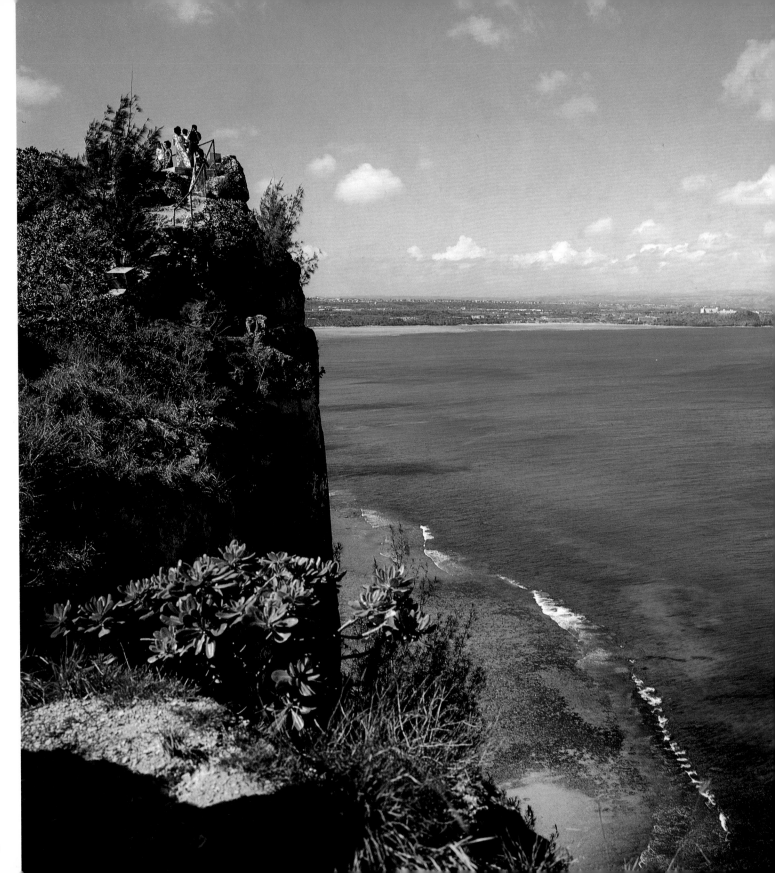

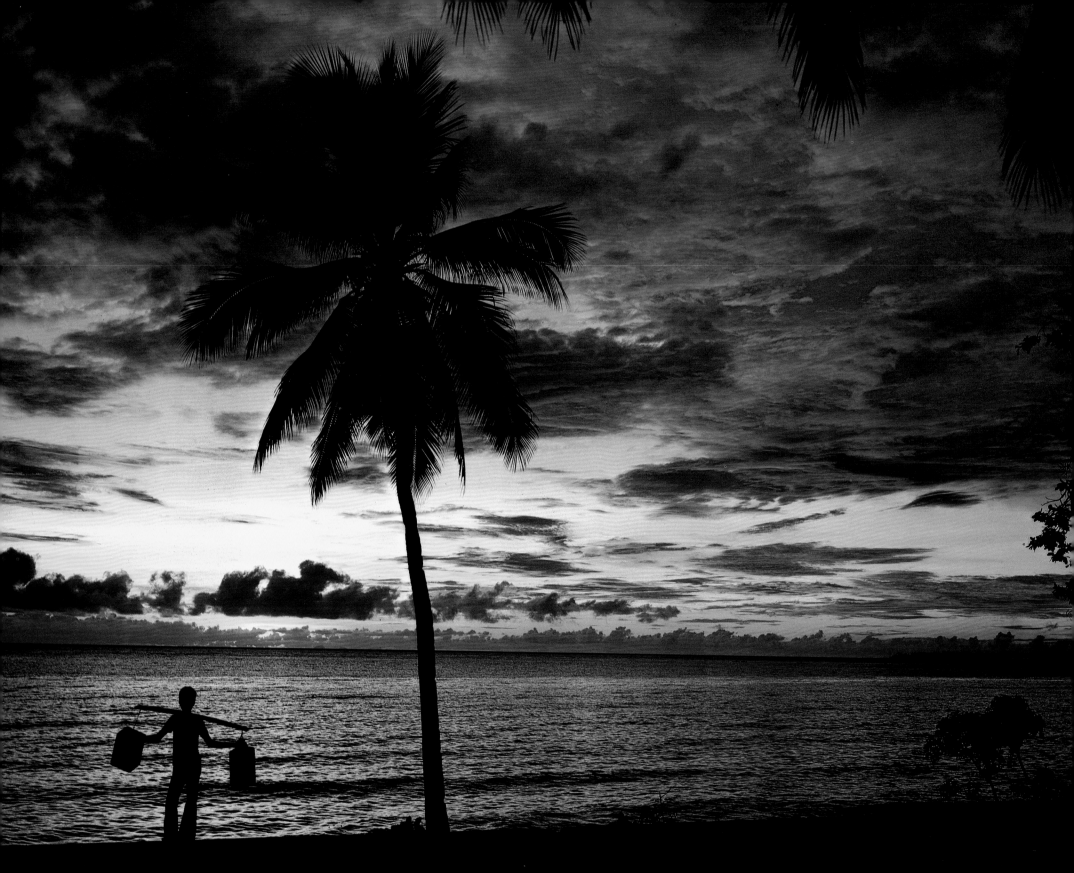

Sunset in the South Pacific

LEFT: A tranquil expanse of beach, tall coconut palms rustling in the tropical breezes, and a glorious sunset reflecting on the blue sea, are all a part of the irresistible fascination of the romantic South Pacific.

"The heavens declare the glory of God." (Psalm 19)

PHOTOGRAPHY DATA: Sunset, normal lens. Exposure is metered by reading brightest sky area.

Kauai, Hawaii

RIGHT AND PAGE 202: The oldest, wettest and greenest island of the Hawaiian chain, Kauai has a superabundance of beauty in its vertical peaks, deep canyons, luxuriant vegetation and sandy beaches. Mt. Waialeale on Kauai, with an average annual rainfall of 460 inches, has earned the dubious honor of being "the wettest spot on earth." Even so, the sun often shines on Kauai! It is possible to see and photograph the steep green pinnacles and to stroll in solitary bliss along an isolated beach, with only the lulling sound of the waves lapping against the shore. Lumahai Beach, on the north side of the island, is just such an enchanting and perfect place. Kauai, the Garden Isle, is one of the choice places in Hawaii, though the other islands of our very beautiful 50th state have much to offer too.

PHOTOGRAPHY DATA: Morning, normal lens. (Both pictures)

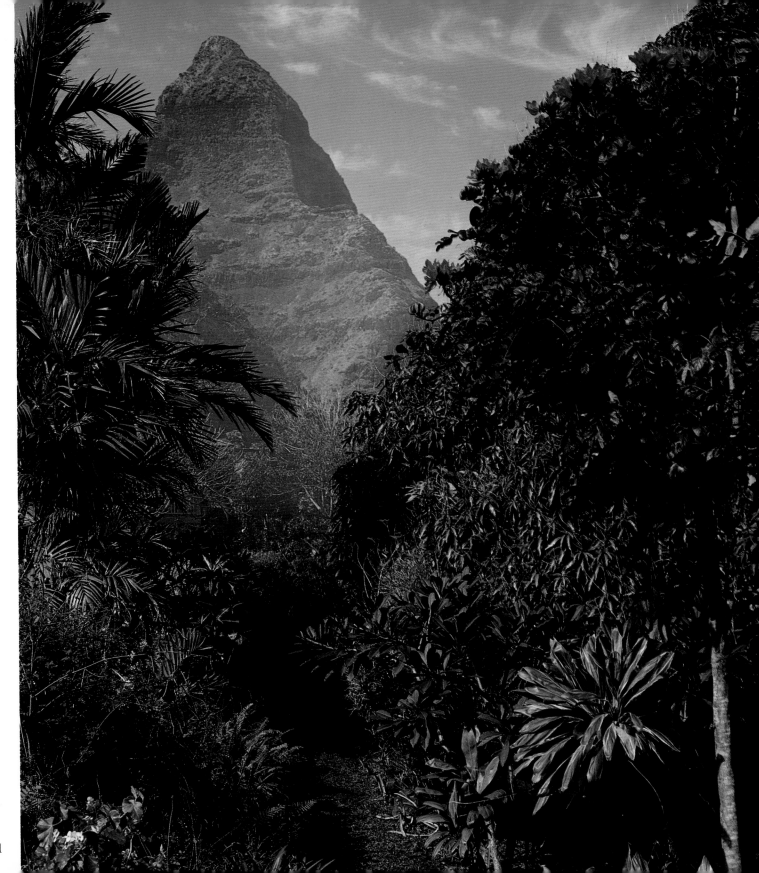

201

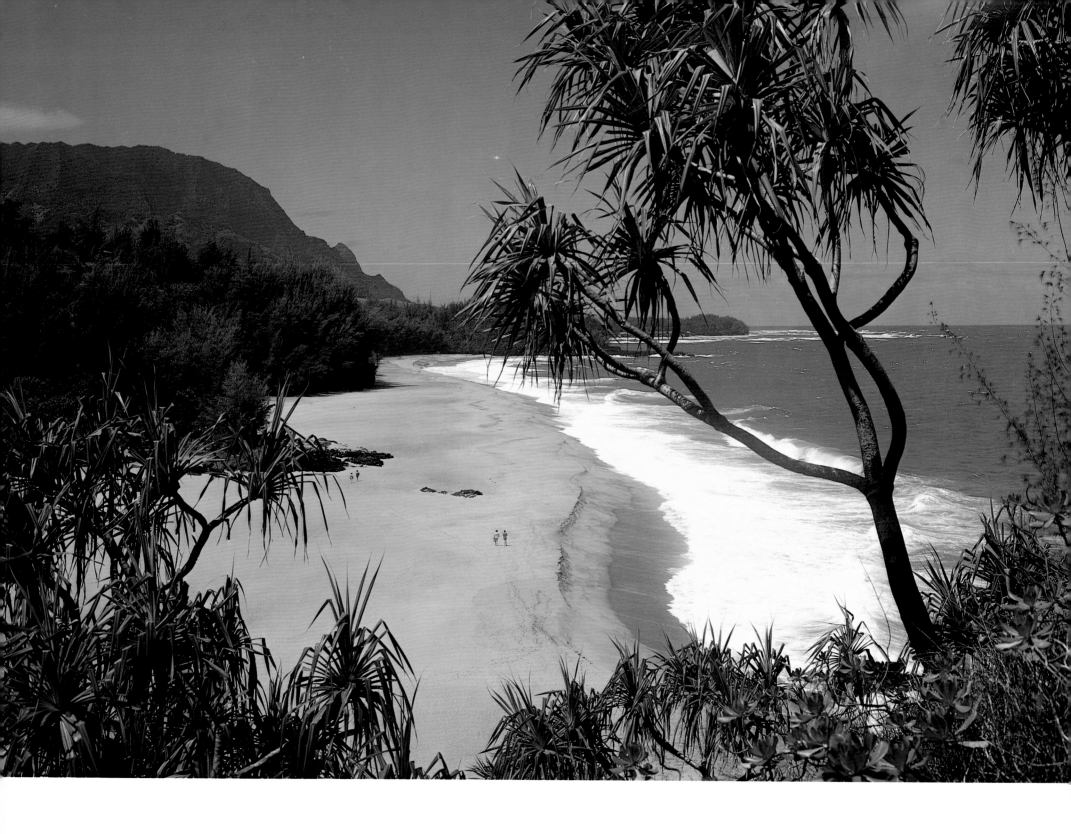

Lake Titicaca, Peru—Bolivia Border

BELOW: In the Andean highlands at an altitude of 12,500 feet, Lake Titicaca is the highest large navigable lake in the world. Straddling the borders of Peru and Bolivia, the 900 feet deep lake accommodates large ferry boats on its 120 mile length but is most famous for its native reed boats. Buoyant reeds, which grow profusely in Lake Titicaca's shallows, are used by the Indians to fashion the boats, called balsas, which eventually become water-logged and have to be replaced.

Market day in Bolivia or Peru is a colorful event with the ladies dressed in their best clothes and hats. Bolivians usually favor a bowler, while the Peruvian women generally choose a Panama-style hat.

PHOTOGRAPHY DATA: Lake Titicaca—Morning, normal lens. Market—Morning, normal lens, open shade.

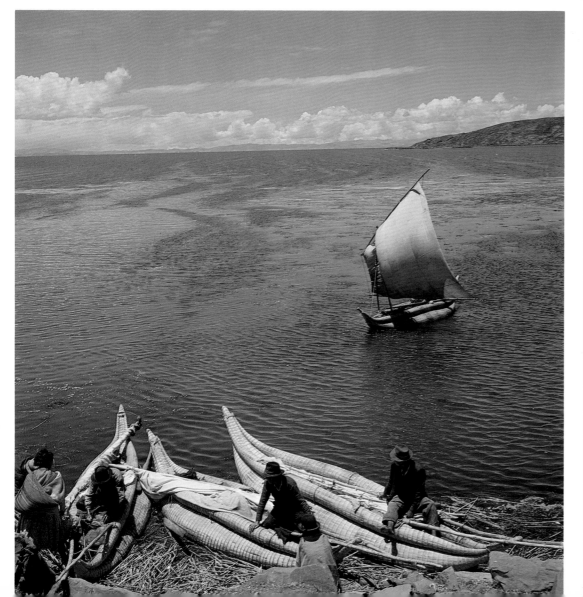

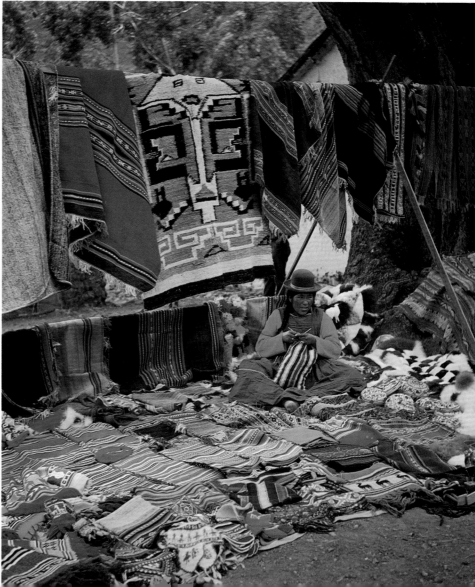

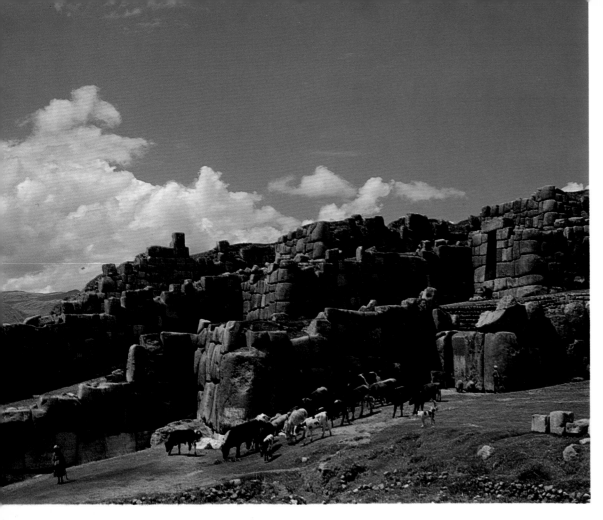

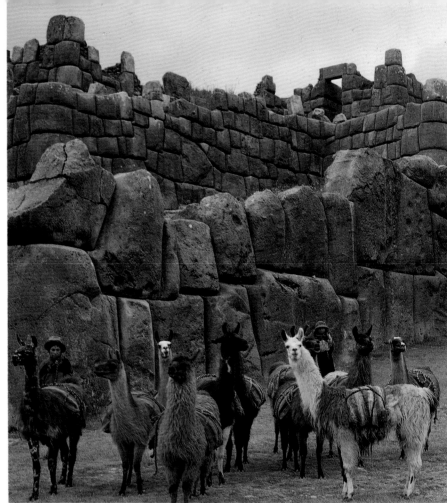

Sacsahuaman, Cuzco, Peru

ABOVE: The massive fortress of Sacsahuaman stood vigil on a hilltop over Cuzco, capital of the ancient Inca Empire. Today the impressive remains of the walls and towers of this mountain stronghold show tremendous single limestone blocks of sometimes more than 16 feet in one dimension, and weighing some 300 tons each. Built by a people who had no machinery—not even the wheel!

The llama, a South American mammal related to the camel, was used by the Incas as a beast of burden. Though only able to carry a load of 80 or 90 pounds, the llama was important to them on the steep Andean trails. This slow and contrary animal is still used for transporting goods. A source of meat, leather and tallow, the llama also provides wool and its droppings are collected for fuel. Like the camel, the llama has a well-aimed and arrogant spit when annoyed.

PHOTOGRAPHY DATA: Morning, normal lens. (Both pictures)

Machu Picchu, Peru

RIGHT: Machu Picchu, the ruins of an ancient Inca city, sits on a high rocky shelf (8000 feet) between two mountain peaks. Only 50 miles in a direct line from Cuzco it is reached by a 70-mile downhill railroad trip. Leaving Cuzco, which is at a breathless 11,000 feet, the train travels its downward course to the railroad station on the Urubamba River at the foot of Machu Picchu. To reach the ruins, invisible from the station, you must ascend by bus over 2,000 feet on dizzying switchbacks. Machu Picchu, the "Lost City," remained hidden from the world until 1911 when it was discovered by American explorer Hiram Bingham. Covered by vegetation, subsequent excavations removed the jungle growth to reveal the most spectacular relic ever found of the Inca's great empire.

PHOTOGRAPHY DATA: Morning, normal lens.

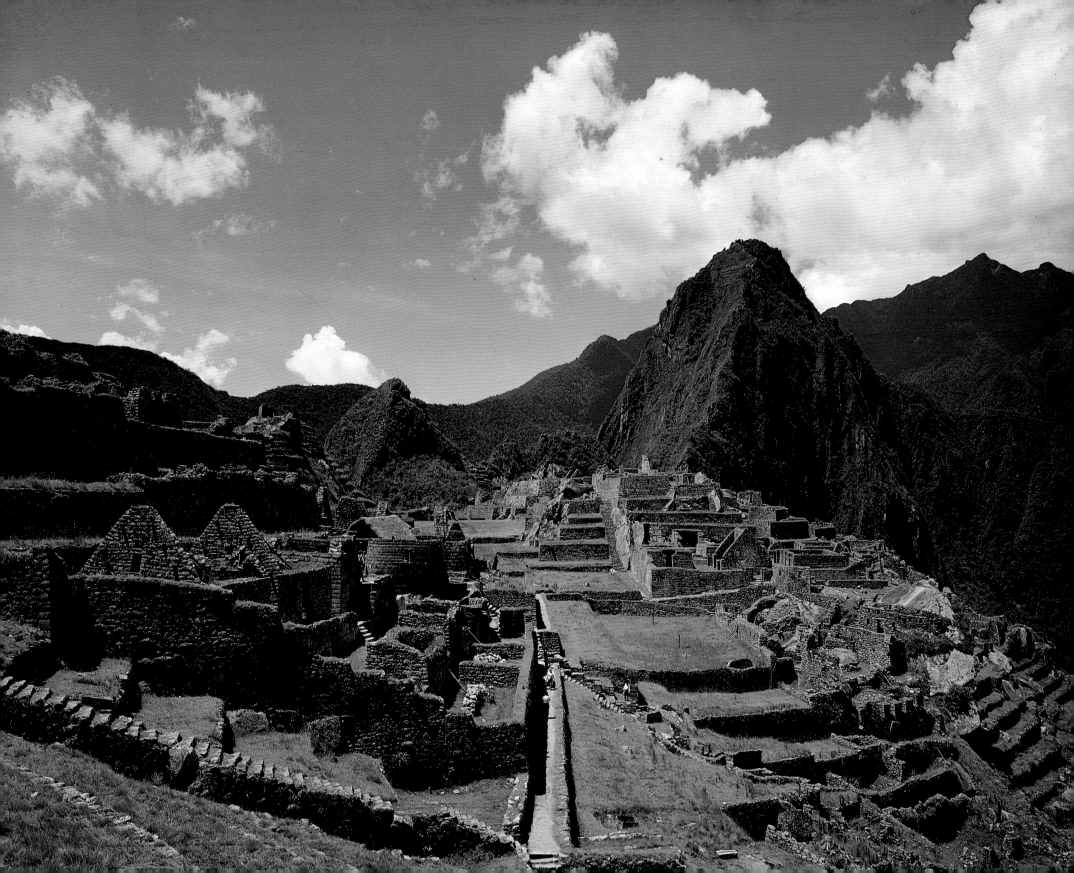

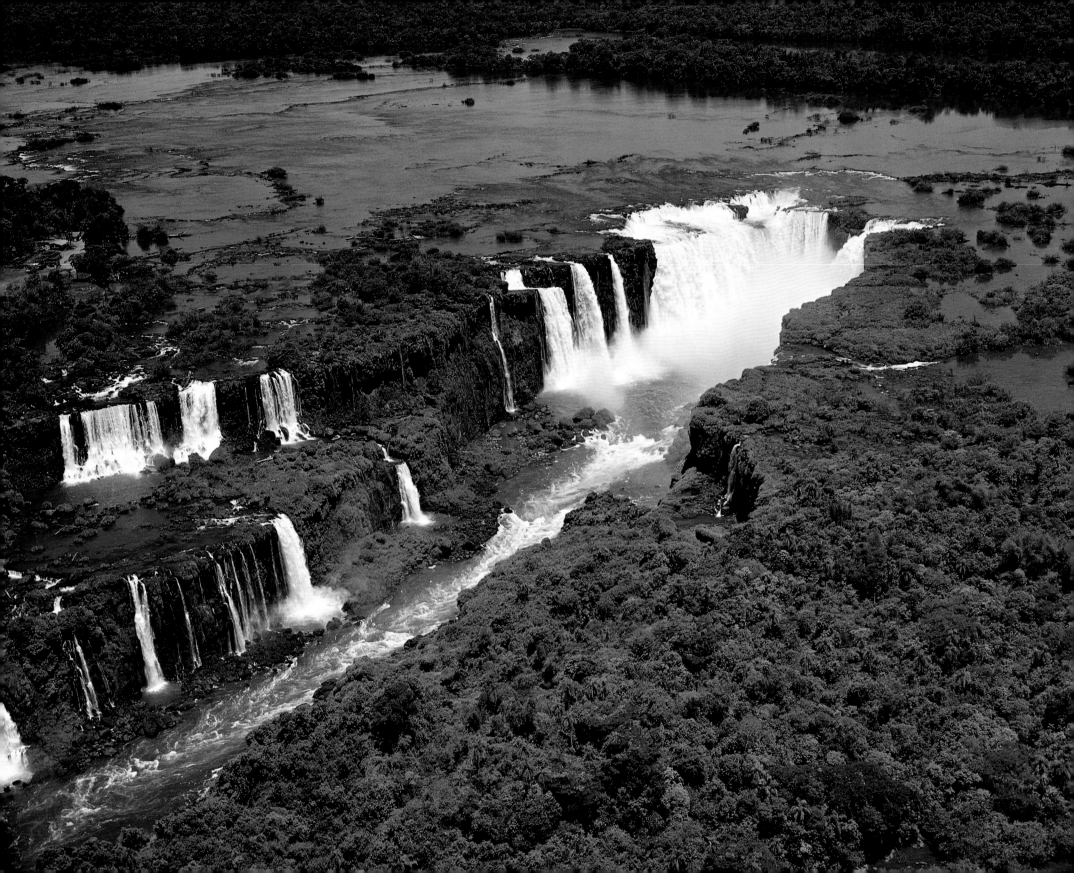

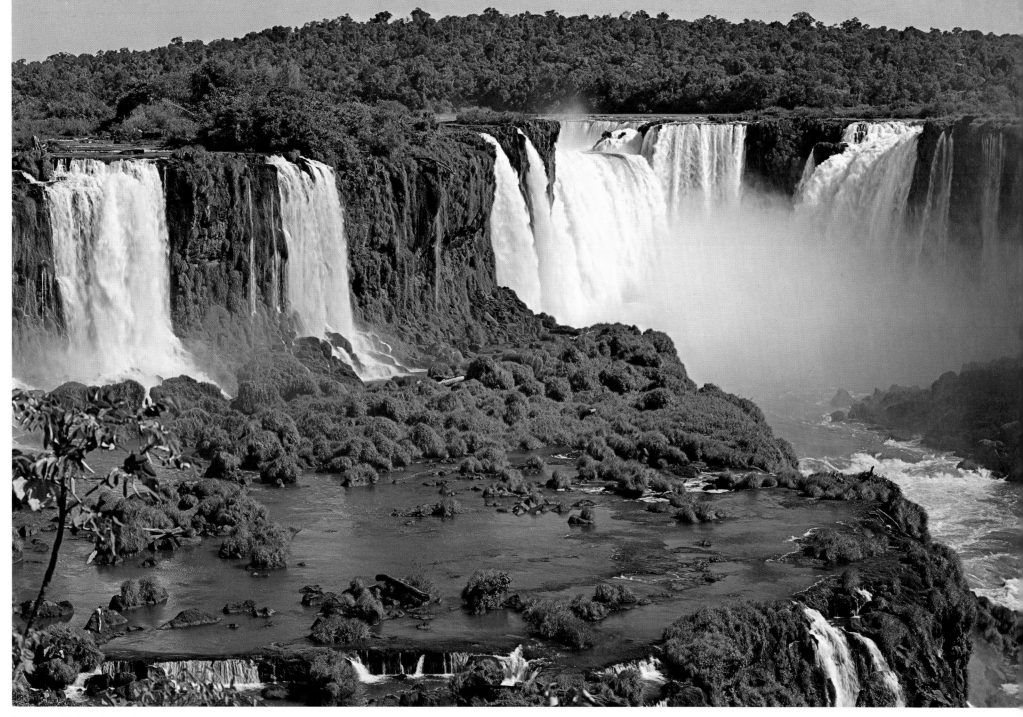

Iguassu Falls, Brazil

LEFT AND ABOVE: On the border of Brazil and Argentina, Iguassu Falls is actually a series of some 275 separate falls in a 2½ mile long horseshoe. Cascading into the narrow gorge below, it produces multiple rainbows. Iguassu's numerous falls are separated by small islands of lush tropical vegetation. The aptly named ''Devils Throat'' is beneath the central cataract, Union Fall. Sixteen miles below the falls the Iguassu River joins the great Parana. Both

Brazil and Argentina have established national parks on either side of Iguassu which protect the grandeur and sheer beauty of these unique falls.

PHOTOGRAPHY DATA: Mid-day, normal lens (aerial view was made from a small airplane. The commercial flight usually flies over the falls when it lands nearby).

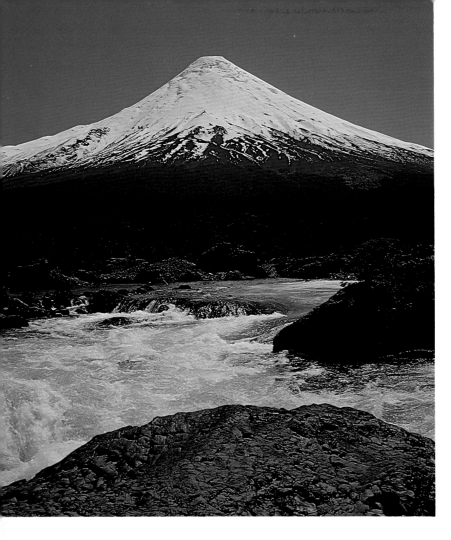

Mt. Osorno, Chile

ABOVE: Mt. Osorno, a landmark in the magnificent Chilean Lake District, is a snow-capped volcanic cone whose near-perfect symmetry brings to mind Japan's renowned Mt. Fuji. The usual lake excursion from Puerto Montt to Bariloche is made by alternating from boat to bus. Along the route are marvelous ever-changing vistas of the emerald or deep blue lakes against the backdrop of the Andes Mountains.

Many of the Chileans living along the lakes of this region are of German ancestry. Their forebearers immigrated to South America in the middle of the 19th century and their farms, ranches and dairy herds can be seen along the lakes and foothill slopes of the Andes.

PHOTOGRAPHY DATA: Afternoon, normal lens.

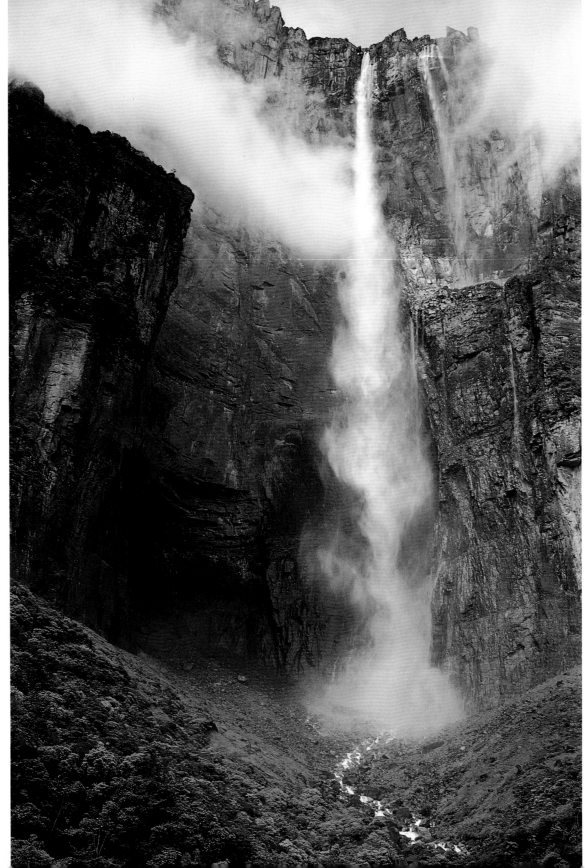

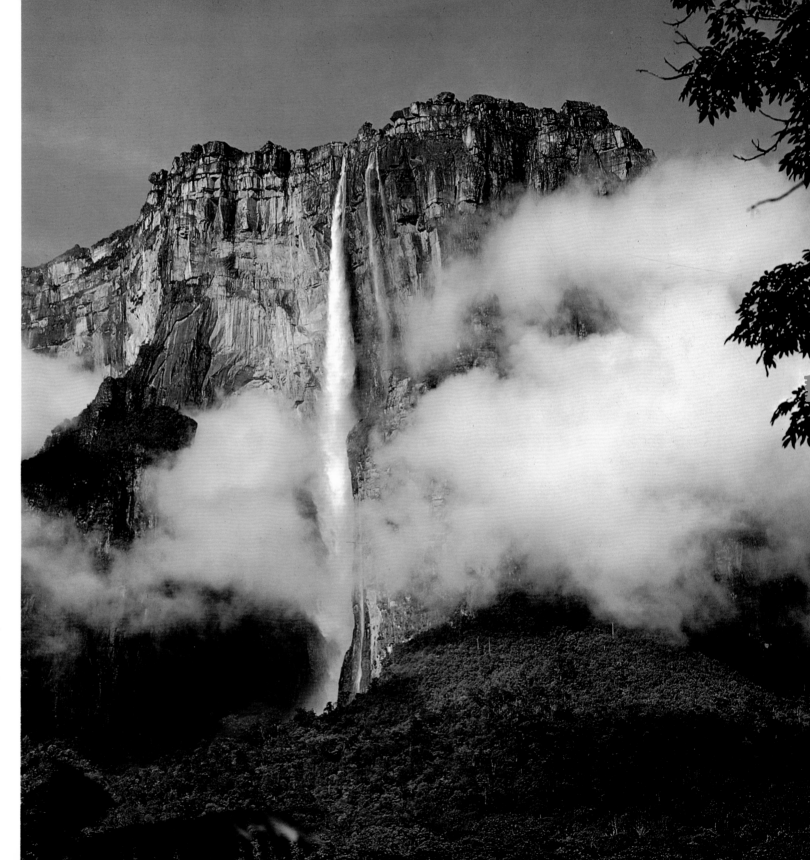

Angel Falls, Venezuela

LEFT AND ABOVE: From a high plateau in the Guiana Highlands of Venezuela, Angel Falls drops in a narrow ribbon of water that ends in a plume of mist as it finally reaches the ground, a mind-boggling, 3,212 feet below. The highest uninterrupted waterfall in the world, Angel Falls can only be seen fleetingly from an airplane or by an adventurous motorized dug-out canoe trip from above Canaima. What a thrill it was to reach the falls on the third day just as the cloud cover began to dissipate so we could get our first ground view of incredible Angel Falls!

Jimmy Angel, an American explorer, was looking for the legendary treasure of El Dorado in 1935. He discovered the falls, subsequently named for him, when his plane crash-landed on the marshy surface of the mesa behind the falls. Since that time many have seen fabulous Angel Falls but relatively few have reached it by river.

PHOTOGRAPHY DATA: Late morning, normal lens. (Both photographs)

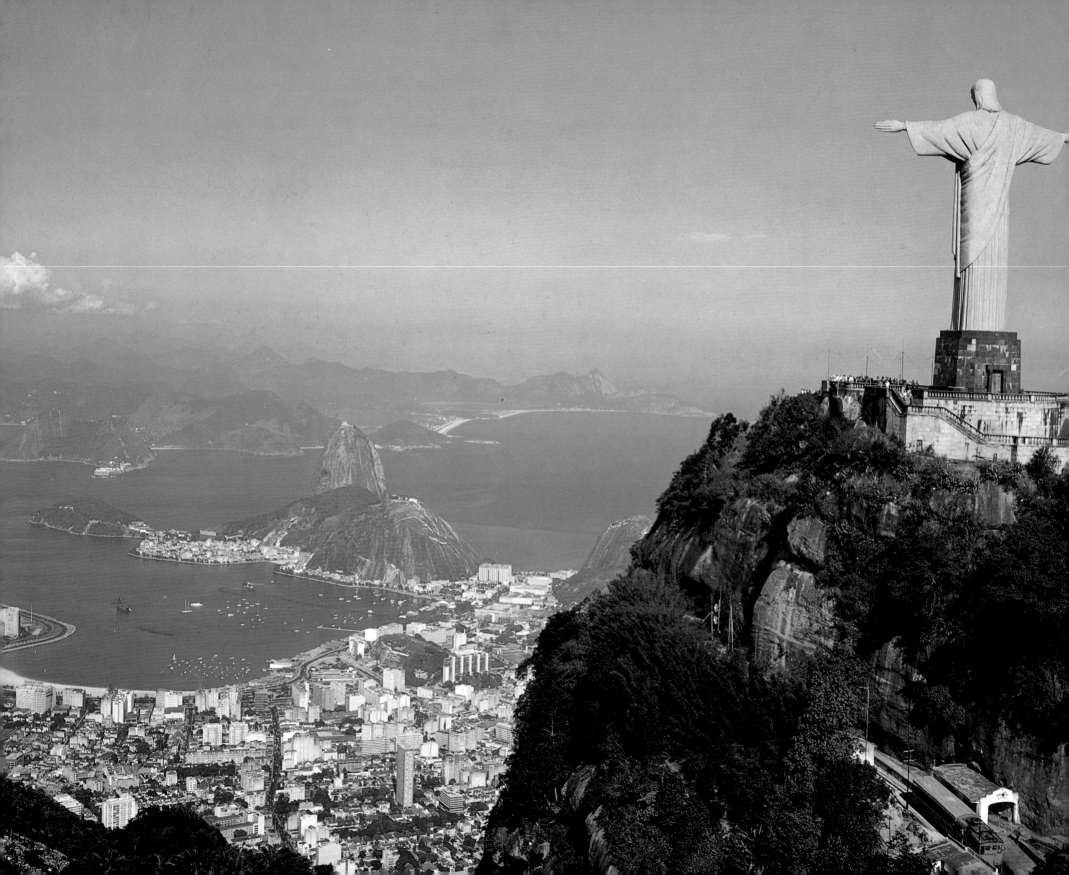

World Travels/INDEX

Rio De Janeiro, Brazil

LEFT: Rio de Janeiro is well-known for the striking beauty of its natural setting and scenic harbor. The blue harbor, curving white beach and mountain backdrop are readily identifiable as Rio. To see this impressive city from good vantage points, go up the famous Sugar Loaf and Corcovado peaks, though clean atmosphere above the busy metropolis is a sometime phenomona. Haze or fog often obscure the harbor view and big city smog is frequently thick. On Corcovado is the poignant statue of Christ the Redeemer with arms outstretched and Sugar Loaf's distinctive form rises from the harbor entrance. Brazil is a large country covering almost half of South America.

PHOTOGRAPHY DATA: Afternoon, normal lens, photographed from a small helicopter.